Introduction to the History
of Communication

PETER LANG
New York • Washington, D.C./Baltimore • Bern
Frankfurt • Berlin • Brussels • Vienna • Oxford

Terence P. Moran

Introduction to the History of Communication

Evolutions & Revolutions

PETER LANG
New York • Washington, D.C./Baltimore • Bern
Frankfurt • Berlin • Brussels • Vienna • Oxford

Library of Congress Cataloging-in-Publication Data

Moran, Terence P.
Introduction to the history of communication: evolutions
and revolutions / Terence P. Moran.
p. cm.
Includes bibliographical references and index.
1. Communication—History. I. Title.
P90.M595 302.209—dc22 2010021536
ISBN 978-1-4331-0412-1

Bibliographic information published by **Die Deutsche Nationalbibliothek**.
Die Deutsche Nationalbibliothek lists this publication in the "Deutsche
Nationalbibliografie"; detailed bibliographic data is available
on the Internet at http://dnb.d-nb.de/.

FSC
Mixed Sources
Product group from well-managed
forests, controlled sources and
recycled wood or fiber

Cert no. SCS-COC-002464
www.fsc.org
©1996 Forest Stewardship Council

The paper in this book meets the guidelines for permanence and durability
of the Committee on Production Guidelines for Book Longevity
of the Council of Library Resources.

© 2010 Terence P. Moran
Peter Lang Publishing, Inc., New York
29 Broadway, 18th floor, New York, NY 10006
www.peterlang.com

Printed in the United States of America

To my wife, Elise,
and our children,
Danielle and Morgan

CONTENTS

ACKNOWLEDGMENTS

Like all authors, I am indebted to a long list of thinkers, writers, teachers, and colleagues who have helped me to think critically about the history of human communication. Most of my intellectual debts are noted in the specific references found in this book, but here I wish to pay special attention to some people most directly responsible for the conception and execution of this book. Although we never met in person, I have read most of the works of Jacques Ellul published in English, and for some years prior to his death in 1994 we carried on a charming correspondence via old fashioned air mail. Among authors I read and met are Joseph Campbell, Edmund Carpenter, Eric Havelock, Marshall McLuhan, and Lewis Mumford. All helped me to think more critically about communication, media, and change. While a student at New York University, I had the good fortune to study with three pioneers of modern media study—Charles Siepmann, George Gordon, and Neil Postman.

Neil was my teacher, my advisor, and my mentor. Later, we became colleagues and friends. Neil and I shared an office, ideas, and some key friends—chiefly Charles Weingartner and Christine Nystrom. Together, Neil and I, aided by Charlie's sage and cynical advice, and Chris's invaluable help, created the graduate program in Media Ecology at New York University in 1970 dedicated to exploring human communication through a multidisciplinary critical

inquiry approach in which both professors and students explored ways to ask useful questions about media, culture, and communication. Our graduate program spawned an undergraduate program in 1985. Both programs provided the foundations for the present Department of Media, Culture, and Communication in the Steinhardt School of Culture, Education, and Human Development at New York University.

In all of my explorations into understanding communication, I have been supported and challenged by gifted colleagues and students who prodded me to try to answer all questions but always to question all answers. Pam Baldwin, my invaluable assistant, typed three quarters of the manuscript, with my wife, Elise, typing the rest, including many of the corrections.

I need to acknowledge the encouragement and excellent professional assistance I have received from Mary Savigar, my editor at Peter Lang, and her associates.

No one writes a book without the support and encouragement of friends and family. My oldest friend and fellow Marine Corps veteran, Peter Flynn, although a Red Sox fan, provided encouragement and fidelity. My New York University friend, Denis Donoghue, provided a role model for scholarly writing. I am fortunate to have shared over 35 years of lunches with a hard core of friends called the First Friday, all of whom know who they are. Mattie Maher and his family and staff at McSorley's Old Ale House have given me over 40 years of friendship and good cheer. This book was truly a family affair with my wife, Elise, and our children, Danielle and Morgan (our own computer genius), and Sorayah Okcuoglu helping all the way. Most of all, I am thankful to Elise for being herself.

TERENCE P. MORAN
NEW YORK UNIVERSITY

· 1 ·

UNDERSTANDING EVOLUTIONS AND REVOLUTIONS IN HUMAN COMMUNICATION

Perhaps the most basic questions in life are these: Why is there something rather than nothing? Why is there a universe, our solar system, our earth? Why is there life on earth? Why is there a life form on earth capable of asking such questions? The simple answer to all of these questions is: That's the way it is. But the way *it* is, is dependent upon our perception of the ways that things appear to be to our limited human senses and upon the conceptions we are able to frame because of our species-specific ability to engage in symbolic thinking and communicating that is both reactive to our environment and reflective about our thinking and behaving. All human communication is founded upon our language-structured ability to stretch the boundaries of our senses by inferring how the realities of time/space and energy/matter operate, and to imagine, design, and construct techniques and technologies of communication that are able to provide and share more information than is naturally available through our sensory receptors. The French mathematician and philosopher, widely regarded as the father of modern scientific inquiry, Rene Descartes (1596–1650), famously summed up this point with his pithy epigram: "*Cogito, ergo sum*" (I think, therefore I am). But we humans do more than just think; we communicate our thoughts with other humans, thereby sharing information about our experiences, our ideas, our hopes, and our fears. In addition to the biological inheritance that made us human, we have added cultural her-

itages that make us users of techniques and technologies that extend our command and control over ourselves and our world through communication. In sum: We communicate; therefore, we are.

Given the profusion of the techniques and technologies that structure the many media of communication that are so central and essential to our lives in the modern Global Technological Society, we face a media environment today unlike any other in the history of human communication. For all of recorded history since the invention of writing in Egypt and Sumer some 5,000 years ago, and from what we can discover about the prehistory of communication since we became human some 200,000 to 50,000 years ago, the basic problem faced by most people and most societies was trying to survive with too little information from too few sources carried by too few media. Today, we face a present and a future in which our survival is challenged by too much information from too many sources carried by too many media. The key value here is survival. In the work of Charles Darwin (1809–1882), the English scientist who proposed the theory of evolution of all species by natural selection, we find an idea that may be summarized as follows: It is not the strongest of the species that survive, nor the most intelligent, but the ones most responsive to change.

Evolution by natural selection provided humans with a symbolic communication system we call language. It is language which allows us to think conceptually and to extend our thinking through media that extend our senses. All information comes to us and is transferred by us through our five physical senses of sight and sound, smell and taste, and touch. These senses shape the limitations of our interactions with our fellow human beings and with our environments. These five senses provide us with survival strategies and tactics that we share with many of our fellow creatures, especially with our closest relatives among the great apes—the bonobos, the chimpanzees, the gorillas, and the orangutans. But our hominid ancestors' responsiveness to change allowed for the development of human language that facilitated our ability to extend the natural limits of our senses in time and space through the manipulation of energy and matter. The history of human communication is a story of change, of slow evolutions and abrupt revolutions that altered how we acquired, stored, and shared information.

Conduct a brief survey of the communication techniques and technologies available to you right now. How has your sense of *sight* been extended? Do you wear contact lenses or eyeglasses? Do you have access to a magnifying glass, telescope, microscope, camera, television set, computer screen, video game player, cell phone with visual imaging, or binoculars? Have you been examined by

X-ray, CAT scan, or MRI? Reading and writing provide a wide range of sight extensions, not only of basic human language but of such specialized systems as mathematics and scientific formulae. Do you have a watch or a clock? These extend not only our sense of sight but also our conception of time by making concrete the abstractions we call seconds, minutes, and hours.

The modern digital electronic computer with its connection to the Internet and the World Wide Web operates as a kind of mega-medium that connects all of these and other extensions of sight and reaches out across time and space to connect us to databases of information from the past and present across the globe. With each of these extensions of sight, we are enhancing our ability to control the generation, storage, and sharing of information needed for our symbolic thinking and communicating. The limits of human sight have been expanded by techniques and technologies made possible by our language instinct, that special gift that is the synthesis of natural processes and cultural practices.

To comprehend the extent of our developments in communication by extending sight, close your eyes and consider all of the techniques and tech-nologies of communication now unavailable to you. Now open your eyes and consider all of the extensions of sight made possible not by nature but by cul-ture. Nature endowed us with sight but human culture is responsible for all of the media we use to see beyond the limits of the here and now. Without human intervention, there are no drawings, no paintings, no statues, no writ-ing, no reading, no photographs, no moving pictures, no television, no computer-generated graphics, no text-messaging.

In terms of human communication, the sense of *sound* plays a key role in that speech and hearing are dependent upon the sending and receiving of sound waves between people. Hearing provides a significant amount of infor-mation needed for basic survival, and speech allows people to communicate information within a language group. The interaction between nature, in the form of speech and hearing organs, and human beings, in the form of develop-ing specific languages, allowed us to send and receive sound signals through the air even when we cannot see one another. Human beings have extended sym-bolic sound beyond the here and now with musical instruments to send mes-sages over greater distances covered by the unaided voice. Megaphones and spaces chosen or designed for their acoustical resonance also extended the human voice. Syllabic and alphabetic writing systems extended the human voice in visual form. It was the electromagnetic revolution that captured sound for distant communication with the clicks of the telegraph in its wired and wire-

less forms, but it was the actual transmission and recording of actual sound, including human speech, by the telephone and phonograph that truly extended communicative sound through time and over space by means of electromagnetic cycles harnessed for human use.

Consider how your sense of sound, in both hearing and speaking, plays a significant part in your daily communication. How has your sense of sound been extended? What techniques and technologies of communication that are central to you depend upon sound? If you could not hear or speak what would be lost? Consider the communication world of the hearing-impaired who rely upon sight (in the form of lip reading, signing, and gestures) and touch (using specific touches for the letters of the alphabet). Until the 19th century in Europe and North America and the 20th century in the rest of the developed world, the hearing-impaired (usually called "deaf and dumb") were regarded as less than fully human, frequently unprotected by law and social norms.

The visual world of sight and the acoustic world of sound provide us with sensory information critical for our physical survival, but these senses also provide us with the natural materials and abilities that we have developed into very sophisticated systems of symbolic sharing among people within a culture. In the world of orality, speaking and listening provide us with our primary message system of language that, in turn, makes all human culture possible by encoding–decoding and sharing of messages essential for the cultural and physical survival of individuals, groups, tribes, clans, and nations. Our very identities are shaped by and are dependent upon our language. More than the other senses, sight and sound have provided the central media that we have used for communication to enhance our survival and to promote cultural evolution and revolution.

While early technologies, including image-making, writing, and printing, enhanced the sense of sight at the expense of sound, later inventions tended to restore the balance between the two senses. While photography and early cinematography continued the extensions of sight, the telephone and phonograph enhanced sound. Samuel Morse's telegraph began by extending sight but quickly became a system that also enhanced sound as telegraphers became adept at decoding the clicks, representing dots and dashes, by sound alone. The integration of sight and sound with talking motion pictures reunited these key senses. While radio extended sound, television provided a rebalancing of the senses; the latest developments in digital electronic communication systems all involve systems that provide both sight and sound in integrated communication.

[handwritten margin note: also sound has been extended]

[handwritten note at bottom: extension of our natural abilities]

The senses of *smell* and *taste* play significant roles in intimate and social communication, but they have been almost totally unrepresented in the realities of public communication. Both senses provided valuable information for individual survival, but, except for enhancing the smells and tastes of consumer products and appealing to those senses in commercial advertising, they continue to play only minor roles in communicating information in the public sphere.

The final sense of *touch* plays a significant, some would say primary, role in intimate communication between people in terms of both love (handshakes, kissing, hugging, holding hands, and other forms of tactile intimacy) and hate (slapping, hitting, and other forms of tactile violence). Touch also plays a role in social communication within groups in terms of ritualized movements (waving, dancing, and other forms of symbolic kinesis) and in terms of how people use space to signal culturally expected and preferred distances to be maintained in different contexts (what Edward T. Hall called *proxemics*). Some recent developments in computer-generated systems have extended the sense of touch over time and space from the now and here to other times and places through robotic technologies and virtual realities in which people can reach out and touch someone and something in shared environments that exist only in cyber-time and cyberspace.

Human evolution equipped us with these five senses, but human beings have succeeded in extending these senses by overcoming their natural limitations through the use of techniques and technologies that have enhanced and enriched each of these senses. In the area of communication, sight and sound have been the senses that have been most enhanced and extended by the various media we have created to improve human communication. For those of us who live in the Global Technological Cybersociety, the limits of our world have been expanded and extended far beyond the gifts provided by nature. Through culture and technology, we have changed ourselves and our communication environments profoundly. Today, we are not simply talking apes but cyborgs who embody both natural abilities and technological enhancements to be communicating humans.

Consider how you use the technologies available to extend yourself in time and space. How do you bring the outside world to you? How do you communicate with the outside world through cybernetic technologies? Are you a generator of information? In what areas? In what forms? For what purposes? How do you store information? In what areas? In what forms? For what purposes? What is the size of your storage capacities? Do you share information with other people? With whom? In what areas? In what forms? For what purpose? With

what results? Do you think that you can successfully generate, store, and share information? How do you make this judgment?

A general assumption underlying most work in human communication is that what people need is more and better communication to improve their understanding of other people and, thus, their own lives, thereby improving their chances for survival. Our current communication environment may be hampering our chances for survival by providing us with too much information from too many sources in too many areas through too many media. If information overload is as threatening as information insufficiency, what may be needed are new ways of managing our enriched information and media environments. All of us currently do this in our individual lives with various systems for information management.

Consider, to take one example, the role played by Wikipedia, the Open Source, open-receiver model of information sharing that is changing our conception of what is worth knowing, of what sources of information have validity and reliability, and of who has control over messages and message systems. And Wikipedia is only one example of what users call Open Source production that uses the Internet to link together critical masses of individuals into cyber-networks of information.

But, in addition to these technical solutions to the problem, we need some conceptual strategies for managing not only the problems of the present but the sure and certain problems of the future because, barring some catastrophic regression to a new Dark Ages of Communication (as occurred in Europe with the fall of Rome in the 5th century), information and information techniques and technologies will continue to expand with geometric progression. The expansion of information and the systems that carry information to more peoples and cultures across the globe may not solve the key problem that has always limited human communication. Some Holy Grail of Total Communication will not be reached through expanded communication any more than it has been reached through some secret knowledge. Simply put, total human communication is not possible because humans are fallible creatures. We have no perfect word or language, no perfect medium or armada of media that will provide us with total understanding and, therefore, control of ourselves and our world. We are imperfect beings in an imperfect world. Our tasks are to understand our own imperfections and the imperfections of the systems we create. If we focus on recognizing and overcoming our imperfections and limitations, some progress may be possible. It is the thesis of this book that this approach can explain how human communication was able to move from speech and visual representa-

tions to the present reality of cybernetic media.

The early 21st century has been heralded variously as the Information Age, the Digital Age, the Cybernetic Age, and the Age of Total Communication. Whatever the label, the focus is the same: We can best understand ourselves and our age by examining the communication techniques and technologies that are central to our time. Whether as prophets of progress through technological change or Cassandras warning us to beware the threats of these very changes, all analyzers of our contemporary world focus on communication and change as the key components for understanding our cosmos and our place in that cosmos. It is a central tenet of this book that in order to understand where we are now in terms of human communication, we need to understand how we got here. To have some sense of where we may be going in the future, we need to identify some principles of change that have been central to the evolutions and revolutions of human communication in the past and present. But no single approach or theory can hope to explain all of the history of human communication, much less predict its future direction. The limits of any approach need to be acknowledged at the outset and serve as a caution against overgeneralization and reductionism to a single cause-effect model. The model used in this book is a *media ecological* one that attempts to explain the evolutions and revolutions in communication media in terms of the context, the motivations, and the techniques and technologies of the people central to some key moments of development of these media. The key to understanding changes in communication techniques and technologies is *survival*—physical survival, economic survival, social survival, and cultural survival.

Many years ago, at the United States Marine Corps Recruit Training Base on Parris Island, South Carolina, our Senior Drill Instructor, Staff Sergeant P. E. Voelker, gave a platoon of new recruits some valuable advice: "Rules and regulations are for the guidance of the wise and the obedience of fools." What was true then and is still true now for the Marine Corps is equally true for those of us engaged in the study of media, culture, and communication: No model can explain all of communication history, much less predict its future development. But we can be guided by some reliable generalizations about how changes occur in media, culture, and communication that lay no claims to omniscience or ideological rigidity. My hope is that all users of this book will read it critically, evaluating and challenging every assertion, every claim, every conclusion, and every judgment. We are all human; therefore, we are all limited in what we know and think. But because we are human, we can learn from the past how to understand, to a limited but perhaps increasing degree, something of the

course of the evolutions and revolutions that have marked our human journey from environments structured by natural evolution to environments structured by cultural evolutions and revolutions in media, culture, and communication.

A General Theory of Human Communication

What this book proposes is a general theory of how human communication evolved from oral and visual signs and symbols to today's Cybernetic Age by examining the evolutions and revolutions involved in six key changes in how information is generated, stored, and shared:

1. Becoming Human—The Evolution and Revolution in Language that spawned Speech and Visual Communication

2. Becoming Literate—The Evolution and Revolution in Writing and Reading that facilitated Civilization, History, Literature, and the Beginnings of Science

3. Becoming Typographic—The Evolution and Revolution in Print Techniques and Technologies that nurtured the Modern World

4. Becoming Hypergraphic—The Evolution and Revolution in Photography and Cinematography that changed Image-Making

5. Becoming Electric—The Evolution and Revolution in Electric Techniques and Technologies that gave birth to the Age of Modern Mass Media

6. Becoming Cybernetic—The Evolution and Revolution in Digital Techniques and Technologies that wrought the Age of Cybernetic Communication.

A concluding chapter will attempt to provide guidelines for thinking critically about how evolutions and revolutions in communication can be understood. The approach taken in this exploration is predicated upon a nexus of ideas that can be summarized as a media–ecological approach to identifying some key variables that underlie each of the six great evolutions–revolutions that have changed and continue to change human communication from the Dawn of Humanity to the Age of Cybernetic Communication. These key variables involve how information is generated, stored, and shared in terms of time and space, energy and matter.

Some key terms need to be defined:

Change is alteration of the status quo in any system that significantly affects how that system operates. We will focus on two types of changes—evolution and revolution.

Evolution is gradual change over time that can result in significant change if the evolutionary change reaches a critical mass capable of changing a given system.

Revolution is either rapid significant change or the moment when evolutionary change reaches a critical mass that results in significant change in a system.

Communication consists of the sharing of information between and among humans and the systems they construct by means of agreed-upon conventional signs, symbols, and structures. In this text, we will use communication in two distinct but interrelated ways, what the linguistic anthropologist Bronislaw Malinowski called *emphatic communication* and *phatic communication*. Simply put, *emphatic communication* is what we usually mean when we reduce uncertainty by sharing specific bits of information. *Phatic communication*, on the other hand, refers to those messages that are used to keep communication systems open and functioning but do not convey specific information. Both are required for communication to take place.

Culture is the totality of ways and means that people in groups develop and sustain themselves over time in order to survive in given environments. It includes customs, mores, norms, and taboos, providing both the ways people are expected to believe and behave and the reasons for these beliefs and behaviors. In essence, culture consists of the shared communication of a group of people.

History is comprised of the narratives that people in a culture tell about the past, thereby remembering what they think is worthwhile. *History* is usually separated from *prehistory* by the introduction of literacy in Egypt and Sumer some 5,000 years ago. Therefore, *history* consists of what people have written down in various cultures in the past five millennia. Given that time did not begin with literacy, we are fortunate that we are able to use techniques made possible by science and technology to make educated inferences about what is likely to have happened in prehistory in terms of human evolution and cultural change. This text is focused on the history of human beings and human cultures

from *Homo sapiens* to *Homo cyberiens*.

Information is the nonrandom element capable of combating *entropy* (the tendency of all systems to degenerate from order to chaos). In the technical sense, one bit of information is the amount of data necessary to reduce uncertainty by half.

Techniques are the ways that people and cultures employ to communicate information in specific media systems.

Technologies are the specific tools and technical systems that people and cultures use to encode, store, transmit, receive, and decode information.

What ties all of these words and their definitions together is what Claude E. Shannon called "A Mathematical Theory of Information"[1] and what Shannon and Warren Weaver called "The Mathematical Theory of Communication" in 1948.[2] It is also what Norbert Wiener called "cybernetics," which he defined as "communication and control."[3] By whatever name it may be called, it is an attempt to create a rational structure-based theory to explain how information is communicated (shared) within any system, whether biological, chemical, or technological. This approach takes as givens the key constructs of Einsteinian physics: that time and space are relative to each other and that matter and energy are also relative to each other and, therefore, interchangeable. Albert Einstein's famous formula "$E = mc^2$" expresses exactly these relationships: that *energy* is equal to *mass* (matter) times the speed of light squared (the time it takes for light to travel through space).

In *A Brief History of Time*, Stephen W. Hawking, the Lucasian Professor of Mathematics at Cambridge University (once Isaac Newton's position), reminds us that all time–space, energy–matter, and information began with what Edwin Hubble called The Big Bang.[4] As Hawking notes, "We must accept that time is not completely separate from and independent of space, but is combined with it to form an object called space–time."[5] Similarly, energy and matter are not separate entities but form a common unit we can call "energy–matter." These two constructs—time–space and energy–matter—will be central to the analyses conducted in the book. According to recent estimates by astronomers, all time–space and all energy–matter began at the Big Bang some 13.7 billion years ago.[6] From a universe of "zero size" that was "infinitely hot," the Big Bang began an expansion that continues today.[7] Some 380,000 years after the Big Bang, the expanding universe began to cool sufficiently for protons and elections to form hydrogen atoms, thereby releasing the first energy waves which are detectable today as microwaves. When the first stars formed some 12 billion years ago, the

first true light waves began traveling through the cosmos, providing us with ways of measuring time–space in light years (the distance traveled by light in one earth solar year) and in light seconds (roughly 186,000 miles or 300,000 kilometers per second).

The Earth is some 4.7 billion years old, with early life forming some 4 billion years ago. In one sense, we are children of the Big Bang, with all our energy and matter having been created in that primal explosion. We belong to a subkingdom called Metazoa, of the animal kingdom, in a phylum called Chordata, a subphylum called vertebrates, in the class of mammals of the order of primates which has existed for some 50 million years. Some seven million years ago, the hominids branched off from our primate relatives and evolved into a line of non-ape primates of which we are the sole surviving species.

In terms of time, our species came very late to the evolution of the cosmos and of life on earth, arriving some 200,000 to 50,000 years ago with only a few genus cousins to keep us company. What distinguishes us from all of our ancestors and all of our other relatives in the animal kingdom are our highly developed symbolic structures that allow us to use and create tools, use language and symbol systems, and conceive of ways to adapt to our environments and to adapt our environments to us through what we call human culture.

Obviously, no human being was around to observe and record these cosmic developments. What we think we know about these occurrences comes from inferences formed by our observations of natural phenomena, limited by our senses and technological extensions of those senses to note regularities that can be used to identify predictable cycles that allow us to find order in the cosmos.[8] These theories and laws of how the natural world operates are never absolute and always provisional in that they can never be proven to be true.[9]

What these observations and theories tell us is that the cosmos is vast and filled with more information than mere mortals can ever observe or hope to understand fully. As Stephen Hawking notes, "We now know that our galaxy is only one of some hundred thousand million that can be seen using modern telescopes, each galaxy containing some hundred thousand million stars."[10] In addition, the total universe is expanding "by between 5 percent and 10 percent every thousand million years."[11] If nothing else, the magnitude of these numbers should make us humble in proposing any explanations for how the universe operates. But still we must try, for it is the very essence of being human to seek to understand and explain what seem to be the vast mysteries of existence.

Fortunately, human communication—while a product of the Big Bang and Expanding Universe—is infinitely smaller than the cosmos. There are still

uncertainties in our quest to understand how and why human beings commu-
nicate, but we can ground our searches in principles of the physical world, in
the evidence available to our senses, and in the conceptualization made pos-
sible by our minds. Central to any ecological approach to understanding human
communication is the recognition of the distinctions that the British philoso-
pher Michael Oakeshott draws between the *processes of nature* that are subject
to scientific study, therefore containing a high degree of probable predictabil-
ity, and the *practices of human beings* that are subject to human behavior, there-
fore containing less predictability. Human communication contains both of
these constructs and we need to take care in keeping these two variables sep-
arate by not confusing one with the other. It is as intellectually questionable
to think that the *processes of nature* are mere social constrictions of reality, and
thus open to human control, as it is to reify the *practices of human beings* into
immutable laws of nature. In this book, I shall try to follow one central precept
for all critical thinking: All human beings are fallible; therefore, all models cre-
ated by human beings are fallible, including the ones used in this study.

In terms of communication, human fallibility begins with language itself.
For human beings, language is our core communication system from which all
other systems develop. At this moment I am expressing language—the instinc-
tive ability to conceptualize reality in symbolic structures and to use outward
manifestations of those structures to communicate my thoughts to other peo-
ple—in the form of standard written American English of the early 21st cen-
tury. As the great 20th century philosopher Ludwig Wittgenstein once noted,
"The limits of my language are the limits of my world." All of us attempt to
extend our world by extending our language through adding structure to our
syntax and words to our vocabulary. Each subject area of human interest is a
special kind of language system, and the language of the history of human com-
munication is no different. But, in my judgment, language itself is the core sys-
tem because it seeks to understand the *how*, the *what*, and the *why* of human
communication. Without language, human communication would be little
different from the communication systems that evolved with our nearest rela-
tives among the primates—the bonobos, the chimpanzees, the gorillas, and the
orangutans. Actually, without language, it is debatable whether we would be
here at all since our survival as a species appears to be highly dependent upon
the communication skills the language gave us for survival—the ability to use
our oral–aural delivery system for signals and symbols to communicate infor-
mation among our fellow humans to facilitate our survival. Of all of the descen-
dents of the first hominids that branched away from the primate family some

five to seven million years ago, we are the sole survivors. It would seem that without a fully developed symbolic language system, a human being is only an incompetent ape incapable of enduring, much less prevailing, in the struggle to survive in the natural world. We survived because we used language to understand ourselves and our world and to modify both our behavior and our environment to enhance our chances of survival in an environment shaped not only by nature but by cultures as well.

One of the main messages that Charles Darwin gave to humankind was that it is not the strongest of the species that survive, nor the most intelligent, but the ones most responsive to change. And that has been the special gift of humans—to survive by changing our behavior and our environment. All of our primate cousins among the great apes adapted to nature some five to seven million years ago and became successful survivors. Ironically, their continued survival seems to be contingent upon the descendents of their weak hominid relatives because humans now represent the greatest threat to the rest of the primate family. A central ecological principle is that significant change does not merely add or subtract one variable in a system but changes everything within that system. Thus, language does not merely make us apes with one added skill but a significantly different species. That is why *we* write books about the bonobos, chimpanzees, gorillas, and orangutans; why *we* study them, cage them, experiment upon them, and even attempt to teach them to engage in human symbolic communication in an attempt to break down the communication barrier between ape and human. We think that if we can find a language bridge between apes and humans, we can make what is unique to humans universal for all primates. It is exactly what we humans have been trying to accomplish among our own species from the dawn of *Homo sapiens*.

Among scholars of communication, a vast number of words are spoken and written to debate the dichotomies of the unique versus the universal, to contrast the information, interpretation, representation, hopes, fears, knowledge, truths, and wisdoms of a particular individual or culture with some human-wide universal principles of communication. In an ecological perspective, this is a false dichotomy. What we are facing is not a dichotomy at all but a dialectic that offers us not an either–or choice but a this-and-that relationship. In this book, the approach to understanding all human communication systems incorporates this dialectic principle and views opposing variables in change as dynamic partners in an evolving communication environment. And these communication environments construct the limits of how we perceive and conceive the world.

The limitations of my own language skills are painfully apparent to me as I attempt to translate into words the information and concepts that I have received from the spoken and written words of other people—some long dead but not forgotten—and from my own thinking on the subject. I am keenly aware that despite my most earnest efforts, some communication will be lost between my thinking and my writing, and between my writing and your reading. The very structure of the printed book carrying the typed words and punctuation of my writing limits our sharing of information, meaning, and understanding. There is nothing abnormal about this imperfect sharing because we are all unique human beings who bring to the communication exchange our own limitations based upon who we are and what we have experienced. The profound meanings that humans have woven from what Plato called "the loom of language" will be explored in the next chapter, but it is well that we note the dangers of being seduced into thinking that language is some neutral describer of ourselves and the reality we perceive. I will try, and I trust that you will help me, to avoid this trap of thinking that my words are unbiased representations of what they symbolize.

An old saying among semanticists is that words have no meaning, only people do. True enough, but communication between and among people is only possible if we share enough of a language's vocabulary, syntax, and delivery systems to make some common meanings understandable. The history of human communication is a struggle to overcome the limitations of our media to expand our shared understandings with the ever increasing numbers of our fellow human beings. We use our evolutionary-inherited gift of language to expand our communication systems through the cultures and technologies we develop to improve upon that inheritance.

In trying to make sense of our place in the universe, we tend to base our understanding on three conceptualizations of how we relate to reality. One approach can be labeled *realism*—the belief that reality exists outside and independent of human perception. All that we can do is to find ways to describe and understand that reality through the limited and fallible senses that are given to us by nature—the senses of sight and sound, of smell and taste, and of touch. The task of the *realist researcher* is to seek the truths of reality through examination and testing.

A second approach can be labeled *relativism*—the belief that reality is only a conceptual construction based upon our limited senses and dependent upon our social and cultural environments. Thus, our focus of study should be upon these sensual–social–cultural constructions of reality, especially the key

role that language plays in such constructions. The task of the *relativist researcher* is to uncover the epistemological, logical, political, social, and cultural biases that frame the ways we construct reality in order to deconstruct those constructions.

A third approach can be called *transactional* or *ecological*—the belief that reality exists but that our understandings of reality are always mediated by our senses and how our minds process the information gathered by our senses. The task of the *transactional researcher* is to examine how we perceive and understand reality and the reality that is revealed by our perceptions and understandings.

While all these approaches have much to recommend them and each provides special insights into how humans interact with nature, this book tends to uphold the third approach as the most ecologically sound perspective from which to explore the history of human communication from language to digital data processing and beyond.

The Great Mythic Questions

All humans, in all societies, at all times have faced the same cosmic questions of existence. All have tried to find ways to understand and to provide answers to what can be called the Four Great Mythic Questions of Life. Here, myth is defined as self-evident truths accepted by and acted upon by groups of people gathered together into cultures. Culture, itself, is a word and a concept that is, at once, both commonplace and somewhat difficult to define easily. In communication studies, it can refer to popular culture, resulting from mass media, to high culture, resulting from aspirations to achieve the finest possible expressions of human thoughts and feelings. Here, I am using *culture* as Edward Burnett Tylor defined it in 1889: "That complex whole which includes knowledge, belief, art, morals, customs, and any other capabilities and habits acquired by man as a member of society."[12] I would, however, focus Tylor's definition on the role played by language and other communication media in shaping thought and behavior.

Whatever the culture at whatever time, all peoples have tried to provide answers to Four Mythic Questions of Life: Identity, Creation, Destiny, and Quest. Within the realm of human communication, these questions can be focused as follows:

Identity: Who are we as communicating animals? How are we different

from all other animals in terms of communication? How have these differences shaped human culture? How do our communication systems shape us as human beings? Do different communication systems shape peoples and cultures differently?

Creation: When, where, how, and why did our communication systems evolve? What roles did nature and culture play in these creations? To what extent were these creations evolutions? To what extent were they revolutions?

Destiny: What are the purposes of our communication systems? What problems of human communication were addressed by the different communication systems inherited or developed by humans? Where do we want our communication systems to take us? What do we want them to help us to achieve? Is there an ultimate goal to human communication systems? Instantaneous Total Universal Communications? Overcoming time–space limitations? Integrating energy and matter?

Quest: What have we done in the past to achieve our goals? What changes were introduced to improve human communication? What are we doing today to achieve our goals? What future changes can we propose to help us to improve human communication?

One useful triad for organizing how different people and cultures have attempted to answer the Four Great Questions of Life was provided by the linguistic anthropologist Bronislaw Malinowski in *Magic, Science, and Religion*.[13] *Magic* is the belief that forces exist that can control nature, that these forces can be located in air, water, fire, earth, trees, rocks, the sun, moon, planets, and stars. Thus, if people can learn the secrets of the magic powers, they can gain control over these powers, or, at least, placate them in ways that ensure the survival of the group. Myths are the narratives that tell us how these powers work and rituals are the acting out of the myths that can be used to influence these powers. *Religion* also encourages belief in supernatural forces that exert their will on the natural world, but rather than seeking to control these forces as in magic, religion recognizes that these spiritual forces can only be partially understood, and must be obeyed and prayed to for help and salvation. Religion uses both myth and ritual in its attempts at communicating with the universe but acknowledges the essential weakness of human beings and our inability to ever know fully all of the mysteries of the Universe, which are knowable only to the Supreme Being some call God. Thus, all we can do is to seek wisdom from the words of God as received through Divine Revelation and thereby seek eter-

nal salvation by following God's will. *Science* is the belief that while humans cannot ever know the total secrets of the Universe, all of the forces operating in the Universe are not spiritual but understandable in terms of time–space, energy–matter, and information. In brief, the Universe is organized and human beings are especially endowed by nature to be able to perceive, conceive, and understand the essential nature of the Universe. In some respects, magic, and science share a belief that humans can uncover the secrets of nature and gain some control over the forces that drive the world. The essential difference between a magical incantation and a scientific formula is that the latter is always subject to refutation while the former can never be proven or disproven. Science recognizes human limitations but also knows that human understanding and control of nature can improve and expand through the scientific method of testing all hypotheses. That is why, for example, astrology is basically magic while astronomy, which evolved from astrology, is science. In essence, science changes because of findings while magic relies upon fundamental truths that are unchanging despite whatever modern calculations of the heavenly bodies are incorporated into incantations. As with all systems that involve communication, change is the ever-present factor.

A second triad that is useful in considering how cultures have attempted to answer the Four Great Mythic Questions can be found in the work of the American anthropologists Edward T. Hall and George L. Trager. In *The Silent Language*, Hall explicates a tripartite theory of culture as being composed of *formal, informal, and technical* variables. *Formal learning* is essentially a patterned binary system of yes–no, good–bad, right–wrong, do–don't do, prescriptions imposed on the young by their elders. In essence, the carriers of a culture instruct the young in the proper ways of thought and behavior by invoking the ultimate cultural commandments: "This is what *we* believe" and "This is the way that *we* do it."[14] *Informal learning* is based upon providing models to be used for imitating the language and behavior expected in a culture in terms of customs, mores, and norms. *Informal learning* is, at once, a powerful socializing agent and a largely overlooked component of how people are encultured.[15] *Technical learning* consists of explicit rules based upon logical analysis and clarity of instruction. In its developed format, technical learning is devoid of emotions and personal or cultural desires. Science provides an excellent example of a technical system in operation.[16]

This triad of formal, informal, and technical can be used to examine a cultural environment in terms of learning, of attitudes toward change, how time is conceptualized, rules of behavior, and how we communicate. Each evolu-

tion–revolution in human communication involves formal, informal, and technical variables that need to be examined and understood in order to have some clarity in our perceptions and conceptions of how different communication systems operate. In human communication, from language to the latest cybernetic technology, all three variables play significant roles that need to be made manifest.

Media and Messages

It is a basic assumption of this book that we can conceive of all human communication systems as *media*. Simply put, a *medium* is anything in the middle, as in Marshall McLuhan's pun that "Television is a medium because it is rarely well done." Some, including McLuhan himself, tend to equate media with technology. I prefer to follow Neil Postman's idea that a medium is what we do with technology: The total system of communication that is created and structured by the particular techniques and technologies that support that medium. Thus, language is a medium that is created by the brain, the central nervous system, the speech and hearing organs that allow us to articulate and receive symbolic sounds, and the air that carries the sound waves from mouth to ear. Similarly, computing is what all of the technologies involved in modern electronic computing and data transfer allow us to achieve. Therefore, a medium is what technology does. In this book, we will examine language as a medium by examining how speech and hearing are used to share meaning. Then, we will examine how writing as a medium began as a notation system and evolved into highly developed logographic systems and, eventually, into alphabets. Next, we will explore printing as a medium that extended written language through a number of technological developments. Visual communication began as an extension of language and became image-making throughout history through a series of evolutions and revolutions in media that continue today. The electric revolution in communication brought a number of new media to carry sight and sound faster than human, animal, or mechanical transportation could. Finally, the Cybernetic Age will present us with a plethora of media that emerge, nurture, and die in seemingly rapid change.

What all of these evolutions–revolutions have in common are the media that are central to each. In thinking about media not as technologies but as communication environments created by technologies, we can begin to describe four central characteristics of all media.

First, media differ in their *forms*, both symbolic and physical. Each medium contains a symbolic form that encodes and decodes the information shared by the sender and the receiver of the message. In speech, for example, the sounds that form the smallest significant sounds of a language (the *phonemes*) are combined into meaningful clusters called *morphemes*, which can be bound (like American English prefixes and suffixes that have meaning but are also never used alone) or free (like American English words that can convey meaning in themselves). These *morphemes* then need to be placed in a context, into a *syntax*, that makes even more sense—what we conventionally call a sentence. Of course, individual sentences usually need to be combined into larger contexts that allow the sender and receiver some confidence that the message being shared is understood to have highly similar meanings for each party to the communication. Obviously, "$E = mc^2$" should carry more shared meaning than, say, "I love you." Confusing the meaning of the second message may lead to unhappy relationships but confusing the meaning of the first could lead to nuclear annihilation. The different symbolic forms, with their different systems of encoding and decoding information, tend to have different *cognitive* and *emotive* biases, favoring some kind of information generation, storage/transfer, and sharing while ignoring or downplaying other kinds of information to be generated, stored or retrieved, and shared. Thus, "$E = mc^2$" favors precise cognitive information with little or no emotional involvement required for understanding the equation. Of course, the pragmatic implications of actually employing the equation to set off an atomic chain reaction in the form of an atomic bomb do carry their own emotional connotations. On the other hand, less precise messages, like "I love you," carry more emotional meanings than cognitive information. Media also possess *physical forms* in terms of the technologies that allow the symbolic codes to be shared from one human being to another. In speech, whether you say "$E = mc^2$" or "I love you," the physical forms that carry the messages are identical, involving all parts of the human anatomy that produce and receive oral–aural language transmission through the airwaves from one person to another. These different *physical forms* of media also contain built-in biases of their own, in the ways that they extend or limit our biological senses of sight, sound, taste, smell, and touch. These physical forms also affect how we deal with information storage and sharing over *time* and *space*. Simply

put, some media are better at preserving information over time while other media are better at moving information through space. Human speech, of course, is both time and space bound in the now and the here. Speech acts occur in the present as it becomes the past and in the physical space bound by the limits of the human voice. With pure speech, human memory is the key storage center for overcoming the limits of the now and here. We extend time by remembering information as individuals or as members of a collective group. Memory also allows us to carry information in space away from the *here* to other places. In both cases, however, there is always the problem of having to store increasing amounts of information without loss of significant details. In a very basic sense, all of human communication history can be summed up as a search for ways to overcome the limitations of the *now* and the *here* by extending our senses through time and space via media technologies.

Second, the symbolic and physical forms of media contain biases in how they provide *accessibility* to the information they carry. *Accessibility* involves both the question of who will know the information and the question of what will be the conditions under which the information will be accessible. In oral–aural communication individual languages define who will understand what is being said, thus assuring group identity and cohesion. But even among speakers of the same language, it is not only possible but common for individuals or small groups to be in possession of secret languages that contain the codes for understanding the cosmos through magic, religion, or science. In a sense, every branch of knowledge is based on a specialized language system that defines that branch and limits who will have access to and be able to understand that knowledge. This holds true whether we are considering tribal astrologers, shamans, soothsayers, and magicians involved in magic: prophets, priests, and theologians involved in religion; astronomers, biologists, chemists, geologists, and physicists involved in science; or anyone involved in the social sciences, the arts, and the humanities. Each subject is formed around a universe of discourse that, however open, will always include some and exclude others, whether that inclusion–exclusion is based upon race, sex, age, family, wealth, education, individual gifts, or whatever. Even in the Age of the Internet and the World Wide Web, universal information available universally to all people is still a dream for the future. Information is

never freely accessible to all and is never used equally by all. Our task is to examine information accessibility with different media in different contexts and to identify the conditions that govern accessibility to different groups of people. The *conditions of attendance* required by the symbolic and physical forms of media result in different biases among media and thereby limit the accessibility of information carried by different media.

Third, different media contain biases in terms of their information flow. Media differ in terms of the speed at which information can be shared across time and space. Media differ in terms of the quantity of information that is available and can be conveyed in a given length of time over a given expanse of space. And media differ in the directions in which information tends to flow: from one source to many, unidirectional flow, bidirectional flow, or multidirectional flow. Involved in these time–space biases of media are the correlating biases of energy–matter. Simply put, all technologies of media communication, whether natural or human created, require the transformation of matter into energy over time through space in order to carry the messages that humans use to try to make some sense of our existence and to try to improve our chances of survival in an uncertain cosmos.

Fourth, different media are controlled differently by different factors in whatever contexts they operate. The question of *control* is central to understanding how all media operate in society. Are the structures of some media more conducive to different kinds of control? Is control of media dependent upon form? Upon culture? Upon political structures? Upon economic factors? Upon social values? Upon chance? Upon the technologies themselves?

The task before us is to examine critically the content (cognitive and emotive), time–space, energy–matter, cultural, sensory, and control biases that are fundamental to each of the dominant media in the six evolutions–revolutions in human communication covered by this text. In this endeavor, we need to be careful about leaning toward a reductive cause–effect explanation that would assign to technologies of media power to shape how human beings and cultures react to and use different media to communicate the messages they deem significant for their survival. Rather, the approach here is *ecological* in that it tries to examine the totality of the context, or contexts, in which each evolution–revolution occurred. We will keep foremost in our thinking the

distinction between processes of nature and practices of human beings. While we humans are constrained by our biological and physical structures, I do think that we have some measure of volitional thinking and acting, some exercise of free will within the constraints of nature and our own natures. I believe neither in some sort of technological predestination (whether optimistic or pessimistic) nor in some utopian concept of total freewill by which human beings become the Masters of the Universe. What is required is some reasonable middle position in which the dialectic of nature and nurture, of processes and practices, can be examined as human beings move from the world of nature into new worlds shaped by human culture and technology.

Change in Human Communication

Such a dialectic model for understanding change in human communication systems from the Dawn of Humanity to the Cybernetic Age begins with four fundamental concepts:

First, all changes in communication techniques and technologies are ecological in that the effects will be felt not only in one area of an environment but in all areas of that environment. However, not all areas will be affected equally and not all changes will have the same influences in all environments because the ecological wholes could be quite different. Our task is to note these differences in impact while trying to identify some general tendencies encouraged and discouraged by the introduction of some key changes in techniques and technologies into specific environments.

Second, all changes in communication techniques and technologies must be examined within specific ecological contexts. Therefore, we need to examine the key variables connected to time–space, energy–matter, information, and the peoples and cultures in the environments within which significant changes occurred. What variables within a particular environment welcomed the changes, resisted the changes, or were indifferent to the changes? What aspects of the environment were affected the most and the least? What aspects of the environment were damaged or challenged by the changes? What variables within an environment aided the successful adaptation to changes in techniques and technologies of communication media?

Third, all changes in the techniques and technologies of media used to

communicate meanings are in response to some perceived problem, ideal, or desire related to the generation, storage–transmission, and sharing of information. When and where did these problems arise? Why? What were the problems, needs, and desires of communication addressed by the changes? How well were they addressed? What continuing problems, needs, and desires were generated by the new media? How were these continuing and emerging problems, needs, and desires addressed?

Fourth, all changes in communication are *Faustian Bargains* that will have positive, negative, and unforeseen effects for different human senses, ideas, values, beliefs, lifestyles, groups, individuals, societies, and cultures, with winners, losers, and unaffecteds in each category.

From Aristotle to Cybernetics

Some 2,300 years ago, the Greek philosopher Aristotle (384–322 B.C.E.) provided Western thought with its first theory and model of how persuasion in public discourse operated. In his *Rhetoric*, Aristotle provided us with a four part construct within which to examine how one person convinces other people to accept his message. Simply put, Aristotle instructed us to examine the *setting* within which the persuasion occurred—the time, place, people, events, and circumstances. Within that setting, the *ethos of the speaker* is dependent upon the speaker's reputation for knowledge of the subject and truthfulness, what we today call credibility. The third element is the *logos of the speech*—the logical arguments that can be tested for internal consistency and external verification. Finally, there is the all-important *pathos of the audience*—the feelings of the audience toward the setting, the speaker, and the speech. In 20th century America, Aristotle's *Rhetoric* was updated with some label changes and a few additions. The *setting* became the *context*. The *speaker* became the *source* and we became concerned with the source's *credibility* rather than the speaker's *ethos*. The *speech* became the *message* and our focus was not on *logos* but on cognitive and emotional appeals. The *pathos* of the audience was relabeled *biases*. Two significant elements were added to Aristotle's model—the *media* of communication used to carry the message and the *effects* of the persuasion on the audience.

At the close of the first half of the 20th century, three remarkable men provided a more comprehensive explanation (theory and model) of how communication must take place in any system. In 1948, Claude E. Shannon published

"A Mathematical Theory of Information" in the *Bell System Technical Journal* on the protocols and problems involved in the transmission of messages from sender to receiver.[17] That same year, Shannon was joined by Warren Weaver to produce *The Mathematical Theory of Communication*, which expanded Shannon's theories from information to communication.[18] Working on similar problems, but not directly with Shannon, was Norbert Wiener, a professor at the Massachusetts Institute of Technology, who in 1948 coined the term *cybernetics*, which he borrowed from the Greek *kubernetes* (steersman) and which Wiener defined as "communication and control."[19] To Wiener, "...society can only be understood through a study of the messages and the communication facilities which belong to it...."[20] To these men, human communication was not simply one attribute of being human but the defining attribute. In a universe where *entropy* (the lack of order or chaos) is the norm, communication functions as a negentropic counterforce to this norm, providing "islands of locally decreasing entropy."[21] Here, information is defined not simply as any data on a subject but specific data relevant to decreasing entropy. As Wiener puts it, "To live effectively is to live with adequate information."[22] In other words, too little information and too much information are both forms of entropy, as are irrelevant data which contain no information at all.

Wiener also introduced the concept of "feedback" into communication models. Not mere effects, "...feedback is a method of controlling a system by reinserting into it the results of its past performance."[23] Today, these then-revolutionary concepts of how communication functions have become commonplace in both scholarly and popular thinking. The general model provided by Shannon, Weaver, and Wiener provides a sound framework upon which to construct a dynamic model of human communication. Below is my interpretation of that model, which could be called the Aristotle–Shannon–Weaver–Wiener Cybernetic Model of Communicating Information among Human Beings.

As I see it, there are twelve variables that need to be considered in using this model to describe human communication:

1. The *context* in which the messages are shared.
2. The *source* of the messages to be shared.
3. The *content* of the messages to be shared.
4. The *encoding* of the messages into signals that carry the messages.
5. The *transmitter* that sends the signals that carry the messages.
6. The actual *signals* sent by the *transmitter*.

7. The *channel* that carries the signals.
8. The actual *signals* received by the *receiver*.
9. The *receiver* that receives the signals carried by the *channel*.
10. The *decoding* of the signals into messages.
11. The *destination* for the messages (both intended and unintended).
12. The *feedback system* that informs the source that the messages were received and how their meanings were understood.

We begin with an analysis of the *context* within which any communication of messages occurs. When and where did the communication take place? Why *then* and *there* and not at some other time and place? Who were the people involved and what kind of culture did they have? What were the key circumstances and events that shaped the culture? How did the context influence the messages and message systems central to the communication? How did the messages and message systems influence the context?

The second variable is the *source* of the messages. Who were the key sources involved in this evolution–revolution of communication? What types of messages were generated by the sources? How was information generated and used by these sources? What were their restrictions for sending the messages? What benefits did they expect to attain? What benefits did they actually receive? How did the sources exercise command and control over the messages and message systems? How did people become sources in the particular context? How open and closed were the opportunities for becoming sources?

The third variable involves the *content* of the messages. What constituted the first messages of the evolution–revolution in human communication? What categories of information were present in the system? What kinds of messages were carried by the media central to this evolution–revolution? What new kinds and categories of information were encouraged by this evolution–revolution? What older kinds and types of information were downgraded or made obsolete by this evolution–revolution? Who had command and control over the content of and access to the information? How was the content shaped by the context, the sources, and the structures of the media central to this evolution–revolution?

The fourth variable is the *encoding* of the message. What were the symbolic forms and technical mechanisms involved in encoding the message? What protocols governed the encoding? Who had command and control over the encoding? What roles did the encoding play in determining who could encode messages and what information could be contained in the messages? What were

the key strengths and limitations of the encoding system?

The fifth variable is the *transmitter* that actually sends the signal through a channel to the receiver. What were the physical forms of the transmitter that actually sends the signal through a channel to the receiver? What determined the forms of the signals sent? Who had command and control over the transmitter? What were the time–space biases of the transmitter? How was energy–matter involved in the transmitter? What were the key strengths and limitations of the transmitter?

The sixth variable is the *signal sent* by the transmitter through the channel in the direction of the receiver. How was the signal sent? What was the physical form of the signal? Who had command and control over the sending of the signal? How was time–space involved in the signal? How was energy–matter involved in the signal? What were the key strengths and limitations of the signal sent?

The seventh variable concerns the *channel* through which the signal is carried from transmitter to receiver. What were the physical forms that constituted the channel? Who had command and control over the channel? How was energy–matter involved in the operation of the channel? What were the key strengths and weaknesses of the channel?

The eighth variable is the *signal received* by the receiver through the channel. How was the signal received? Who had command and control over the receiving of the signal? What was the physical form of the signal? How was time–space involved in the received signal? What were the key strengths and limitations of the received signals?

The ninth variable is the *receiver* that actually receives the signal sent by the transmitter through the channel. What were the physical forms of the receiver? What determined the forms of the signals received? Who had command and control over the receiver? What were the time–space biases of the receiver? How was energy–matter involved in the receiver? What were the key strengths and limitations of the receiver?

The tenth variable is the *decoding* of the signal into a message. What were the symbolic forms and technical mechanisms involved in the decoding of the signal? What protocols governed the decoding? Who had command and control over the decoding? What roles did the decoding play in determining who could receive signals and what information could be contained in these signals? What were the key strengths and weaknesses of the decoding systems?

The eleventh variable is the *destination* for the messages. What were the key destinations involved in this evolution–revolution of communication? What

types of messages were received by these destinations? Who had command and control over the destinations? How was information received and used by these destinations? What were the motivations for receiving information? What benefits did they expect to attain? What benefits did they actually receive? How did the destinations exercise command and control over the messages received? How did people become destinations in this particular context? How open or closed are the opportunities for becoming destinations?

The twelfth variable involves the *feedback system*. How did feedback operate in this evolution–revolution? Who had command and control over the feedback system? What were the sources, contents, encodings, transmitters, signals, channels, decodings, receivers, and destinations of the feedback? What were the time–space biases of the feedback system? What was the energy–matter form of the feedback? What were the key strengths and limitations of the feedback system?

In each and every variable of this model, the problem of *entropy* is involved. In all communication systems, there is a general tendency toward disorder that threatens the efficient and accurate sharing of information among people. For communication to take place, the destination must share with the sender a sense of what the messages mean to both. Some theorists of communication have proposed that all human communication can be classified as either *dialogue* with the goal of achieving total sharing of messages and meanings among people or *dissemination* in which the source encodes and transmits messages to an audience with little or no feedback or interaction between the source and the destination.[24] With or without feedback, entropy plays a role in all communication. The *context* itself could involve ambiguity and uncertainty for everyone involved. The *source* may not know or fully understand the information to be shared. The *information* could be inaccurate incomplete, or even false. If the information is mistakenly false, we label it *misinformation*; if it is deliberately false, we label it *disinformation*. In either case, increased entropy enters the system. The *encoding* process may carry its own entropy by the use of inaccurate or imprecise symbols that signify different meanings for the source and the destination (called *bypassing* by semanticists). The *transmitter* used to send the signals may be defective or impaired. The *signals* may be weak or unclear. The *channel* may be filled with competing signals and other forms of noise. The *receiver* may contain defects or limitations that impede the clear reception of the signals. The *decoding* of the signal into a message may be inaccurate. The *destination* may not understand the received message or may misunderstand it because of the limitations of the human being involved. Finally, the *feedback*

system may be limited in terms of time and space, access, and all of the sources of entropy present in the sending–receiving process.

For communication to take place, the destination must share with the source some understanding of the context, encoding, transmitter, channel, receiver, and decoding systems that constitute the total communication system. Feedback allows the destination to become a sender of messages back to the source (who now becomes a destination). One key difference between different systems of human communication is the feedback system itself. If the feedback system is limited to providing the source with information about how the source's messages are received and command and control of the message system remain with the source, the result is likely to be manipulation. If, however, the source and the destination use feedback to share command and control of the messages and the message system, genuine communication in the form of mutual sharing of messages may occur. The difference between the two systems is that the former enables and encourages persuasion and propaganda while the latter holds out hope for true human communication.

What the Cybernetic Model of Communication proposes is a way for exploring how all human communication systems can be examined and understood by identifying key fundamental elements and principles present in all of our communication systems, from language to cybernetic systems and beyond. In *Grammatical Man*, Jeremy Campbell attempts to present Information Theory as *the* theory to explain all of existence, insisting that "sense and order…can prevail against nonsense and disorder" and that "grammatical man inhabits a grammatical universe."[25] My goal is simpler because all human communication is founded upon language, that uniquely human instinct that allows our species to conceive of and represent our perceptions and conceptions of ourselves and our universe in signs and symbols encoded into syntactic forms and conveyed in sight and sound to be shared with our fellow humans.

The key to understanding how it is possible to communicate at all is the principle of redundancy. Simply put, any system can only communicate if some rules are inherent in the system itself. Thus, when two people speak to each other in the same language, they share a set of rules governing pronunciation, vocabulary, and syntax that allows them to share information. In any given message, simple redundancy in the form of repetition of words and phrases, paraphrasing, using synonyms, etc. also contributes to shared understanding. But consider this sentence in contemporary American English: "Him and me loves Mary." Despite three clues that indicate that *Mary* is the subject and *him* and *me* are the objects of the verb *loves* (which indicates a singular subject),

the meaning is perfectly clear to native speakers of American English because the word order overrides all other rules of case that would apply in Latin, for example.

For Claude E. Shannon, the redundancy provided by the structure of a language strongly influences what we can say or else nonsense would result. Creativity in expression, therefore, is limited, but we benefit with increased sharing of information. If information were totally free of all rules, there would be no communication possible because each bit of information would exist independently of all other bits and of all content. Similarly, if information were totally controlled by rigid rules, there would be no communication possible because there would be endless repetition of already known data. What is needed is a balance between total freedom and total control; and redundancy provides that balance in any message system.[26] As a media ecologist would put it: We cannot live with too little information or with too much information.

We bring order to anything by noting differences among things. Uniformity is a form of entropy, but differentiation is the key to order because it allows us to arrange different things in relation to each other and to the whole of the system. Consider the first time a baby hears a person speaking or we encounter someone speaking a language unknown to us. The baby and we have no understanding because the sounds we hear are all one continuous jumble. Only when the baby and we are able to recognize the separate syllables and the phonemes carried by those syllables can we hear the distinct morphemes of the language. Of course, we have to also learn the vocabulary and syntax of that language in order to make any sense of what we are hearing. Any order we are able to bring to understanding a system depends upon information sharing among people. Our understanding of ourselves and other human beings and the cosmos is dependent upon our human sensory systems and the brain and central nervous system that allow us to obtain and to process information. We use language and the techniques and technologies that language allows us to develop and extend our human senses to understand and to seek to control ourselves and our environments.

Change and Progress

The environments of concern for this text are those shaped by the significant communication systems available to and developed by human beings over the course of our existence on earth. This course extends back into prehistory to our becoming fully human with language and moves forward into history itself

with the invention of writing systems beginning some 5,000 years ago and continuing through the communication evolutions–revolutions that brought us modern science and technology and the digital age. Our long journey is far from over but we can pause at this stage to look back in time in order to seek some understanding of where we come from, how we got to the now and here, and where and how we are likely to move forward in the future.

There is a temptation in looking at any history to see change as progress. Certainly, in studying the history of science and technology that temptation is very great for the simple reason that both science and technology can be shown to have progressed over time with new techniques and technologies surpassing older systems in terms of efficiency in overcoming time–space limitations and in using energy–matter to a greater effect. With human communication, it is easy to demonstrate the greater efficiency of each new media system over a previous one, but as Norbert Wiener warned us, "Our worship of progress can be discussed from two points of view: a factual one and an ethical one…."[27] We have certainly overcome problems of time and space that limited earlier systems but the question remains as to whether we have improved our chances for survival through improved communication systems. Indeed, the implementation of Einstein's "$E = mc^2$" may well result in the end of human beings on earth.

Still, the history of human communication can be read as a series of evolutions–revolutions that improved the systems used by people to generate, store, and share information. And these improved systems provided power to some peoples, groups, and nations to exercise greater control over themselves, over other peoples, and over their environments. Information has the potential to bestow power on those who control the messages and message systems in any culture, and any culture with communication systems more developed than other cultures will tend to exercise control over those cultures with less-developed systems. I am not proposing some iron law of communication history here, but it is, I think, a valid generalization that can serve to guide our explorations into six key communication changes that have had significant impacts upon all human history.

A Model for Examining Changes in Communication

For each of the six evolutions–revolutions in human communication surveyed in this text, our explorations are organized under six general categories: the *con-*

text within which the change began and spread; the central *people* involved; the *messages* shared; the *media* used to share the messages; the *impacts* of the change on people and cultures; and the *limitations* of the messages and message systems of this evolution–revolution that would provide the motivation for additional change.

1. **Context**: When, where, how, and why did this evolution–revolution begin? What problems of acquiring–generating, coding–decoding, storing–transmitting, and sharing of information were the motivations for this change? When, where, how, and why did this evolution–revolution spread to other places and times, peoples and cultures? What environmental variables facilitated and/or hindered this evolution–revolution?

2. **People**: Who were the central people involved in the birth and spread of this evolution–revolution? What were their motivations? What were their rewards? Who had command and control of the central media? Why?

3. **Messages**: What were the messages central to this evolution–revolution? What areas of cultures were involved in these messages? How were the messages shaped by these areas? How were the areas changed by the messages? How were the messages shaped by the cultures and/or by the media?

4. **Media**: What were the central media involved in this evolution–revolution? What techniques and technologies were needed to shape and maintain these media? What problems of communication did these media address? What were the symbolic and physical forms of these media? How did they encode–decode and store–transmit messages? Which sense or senses did these media enhance and extend? Which sense or senses did these media ignore or suppress? How were command and control exercised with these media? What did these media allow or encourage in terms of command and control, messages, and uses of communication?

5. **Impacts**: What impacts did this evolution–revolution in communication have on the peoples and cultures involved in its birth and spread? Were these impacts similar for different peoples and cultures at different times in different places? What were the major benefits bestowed by this evolution–revolution? Were the benefits distributed equally and equitably? What were the major disadvantages wrought by this evolu-

tion–revolution? Were the disadvantages distributed equally and equi-tably? What unexpected impacts came with this change in communication?

6. **Limitations**: What were the major limitations of the evolution–revo-lution in communication in terms of: time–space and energy–matter; extension of senses; source and destination; encoding–decoding; send-ing–receiving; storing–sharing; and using of information? What old problems of communication were not addressed by this evolution–rev-olution? What new problems of communication were generated or revealed by this evolution–revolution? How did these limitations influ-ence future evolutions–revolutions in communication?

Armed with the strategic and tactical weapons of critical thinking provided by this ecological approach to understanding how the continuing evolutions and revolutions in human communication are connected, we are able to begin our explorations into the history of how humans have used the techniques and tech-nologies of communication systems to shape ourselves, our cultures, and our environments during the past 200,000 years of our existence as a separate species within the primate family.

The media ecological model advocated by this book invites each of us to undertake an intellectual journey through time and space, back to our begin-nings as talking primates who used symbolic language to communicate through speech and visual imagery. We will journey through the evolutions–revolutions that gave us writing; printing; photography and cinematography; the electric capturing and sending of sound and image; and the digital marvels of the Cybernetic Age. If the history of human communication reveals anything, it is this: Our journey is far from over. Whatever the limitations of today's media, humans will try to find ways to overcome these limitations to create new tech-niques and technologies that will further extend our senses through time and space. If the advocates of the Cybernetic Theory of Communication are right, we humans are uniquely endowed with abilities to understand the universe and through that understanding to engage in a symbolic relationship with Nature that allows us to change both ourselves and our environments.

Journeys in human communication may not return us to some mythical beginning where we were one with nature. Such journeys may not even allow us to achieve perfect and total communication among all human beings. But it is my hope that our journeys into the history of human communication will give us some understanding of how we got to this time and space and where we

might be voyaging in future times and places. In the most fundamental and profound sense, we are all voyagers in time and space, time travelers and space travelers not only in our own individual lives but as members of the human species who can trace our ancestry to the very beginnings of time and space, energy and matter, and information some 13.7 billion years ago. The future may be uncertain and uncharted, but we have our knowledge of the past and some understanding of how evolutions and revolutions in communication have taken us to where we are today and will carry us into the future. Let our voyages begin.[28]

· 2 ·

BECOMING HUMAN

EVOLUTION AND REVOLUTION IN LANGUAGE, SPEECH, AND VISUAL COMMUNICATION

Context

Human beings are inheritors of both biological evolution and cultural change. To understand our dual heritage, we need to strip away 50,000 to 200,000 years of communication history and return to a time before we possessed language and all that language has made possible. First, we need to remove all of the techniques and technologies made possible by the digital evolution–revolution of the past 60 years. Second, we need to remove all of the techniques and technologies wrought by the electromagnetic evolution–revolution that began in 1841 with Samuel Morse's electric telegraph. Third, we need to remove all of the techniques and technologies that came with the evolution–revolution in graphics some 200 years ago. Fourth, we need to remove all of the techniques and technologies brought to us by the printing press that evolved in China, Japan, and Asia more than 3,000 years ago and was revolutionized in the 1450s by Johann Gutenberg's mechanical printing press with moveable type. Fifth, we need to remove all of the techniques and technologies made possible by the evolution of writing in Egypt and Sumer some 5,000 years ago. Finally, we need to remove language itself and return to a time before we became human, when we were relatively weak and insignificant members of the primate family.

As we examine the techniques and technologies of human communication that we inherited from nature and created through culture, four points stand out. First, our natural and created techniques and technologies are extensions of our senses of sound and sight. Second, the number and sophistication of these techniques and technologies have expanded exponentially from language to writing to printing to photography and cinematography to electromagnetic communication to the digital age. Third, the vast majority of the techniques and technologies that we employ daily in our communication systems are the results of the Cybernetic Revolution that began in the second half of the 20th century and continues to expand in these early years of the 21st century. Fourth, all of these techniques and technologies are made possible by the gift of language itself. Each evolution–revolution in communication was built upon the evolutions–revolutions that came before, and to understand the history of human communication, we need to understand the essential nature of language that helped to make us human and that provided the matrix for all human culture.

We are all travelers in time and space in our individual lives as we move forward through experience and look back through memory. Let us return to a time before language, a time before we were fully human, when time itself was a cosmic phenomenon but not yet a cultural artifact. In our own lives, all of us have made this journey because we are born without language. While all physiologically and neurologically normal newborn babies possess a species-specific instinct for language development, we all need to develop within a language environment that will nurture our natural instinct. For all animals, life is very much an eternal becoming of the now and here, an existence circumscribed by the need for daily survival by avoiding dangers and finding water, food, and protection. As humans, we survived infancy by being cared for by other humans—by being nurtured and protected until we could care for ourselves. Those of us who live in the Global Technological Culture are still dependent upon other people for our survival. Indeed, the key to human survival from the time we separated from our primate family has always been centered on improving communication to improve our chances of overcoming challenges to our extinction as individuals and as a species.

While time–space, energy–matter, and information can all be said to have begun some 13.7 billion years ago with the Big Bang, our human conceptions and representations of these key variables of communication can be traced back to the evolution of human language that is part of all evolution of life but that reached a significant point some seven to four million years ago when our

hominid ancestors separated from the rest of the primate family. In evolutionary terms, our relatives among the great apes had all achieved successful adaptations to their natural environments. Bonobos, chimpanzees, gorillas, and orangutans are all competent apes, able to survive and procreate without further significant natural evolution. Today's descendents of these species are almost identical to their ancestors while we are profoundly different from our earliest ancestors.

It is possible that the evolution of language could have begun as early as four million years ago with *Australopithecus afarensis* (southern ape—Africa) or possibly later with *Homo habilis* (able man) some two to two and a half million years ago. A safer choice may be *Homo erectus* (erect man) who emerged in Africa between one and a half million to 500,000 years ago and knew how to control fire and create tools. The safest choice would be modern *Homo sapiens* (thinking man) who emerged in Africa some 200,000 years ago. Anatomically, these ancestors were identical to modern humans. In brief, they were us.[1] All of our other hominid relatives, including the Neanderthals who co-existed with our ancestors for thousands of years, have disappeared into the mists of extinction. We are the sole survivors of evolutionary experiments that tested the survival choices of a succession of incompetent apes without great strength, without the agility to climb trees easily, without fangs and sharp nails, without even sufficient body hair to protect them from the sun, the elements, and, the natural environment.

Since there is nothing fair about life or Nature, we need to account for our survival as a species against the vast odds that wiped out all of our ancestors and close relatives. It is the contention of this text that language provided *Homo sapiens* with the abilities needed to adapt, improvise, and overcome in a hostile environment by replacing slow natural evolution with quicker and more flexible cultural changes that were responsive to changing natural environments.

People

What is unquestioned is that some 30,000 years ago, *Homo sapiens* became the most dominant, and eventually the only humans with the extinction of the last Neanderthals in what is called the Upper Paleolithic, during the last great Ice Age which ended some 10,000 years ago. Our ancestors not only left behind fossil evidence that they were physically identical to us but also evidence that they engaged in symbolic communication of a highly-developed style and

complexity not achieved earlier by any species of ape or hominid. Given the evidence of the uniqueness of their achievements in sophisticated toolmaking, habitations, clothing, ornamentation, and visual signs and symbols, it seems reasonable to conclude that it was language that explains their survival. We see clearly that these same achievements were carried on and improved upon by their descendents who survived the last Ice Age and formed the first permanent settlements and later civilizations (10,000 to 5,000 years ago) that invented writing, separating history from prehistory. Language provided our species with the ability to share our feelings and thoughts, strategies and tactics, and techniques and technologies through sign and symbol, thus providing us with weapons of mass survival. Being human and being symbolic, human beings were able to bring together Nature and nurture, evolution and culture to try to control the environment through improved communication of information needed for the physical, social, and cultural survival of ever-larger groups of *Homo sapiens*.

In terms of evidence for communication among our early ancestors, a significant cultural transformation occurred in the development and sophistication of tools and techniques used to create visual representations of the people we call *Cro-Magnon*, after the region in today's France that contains some of their earliest fossil remains and significant symbolic images. Beginning some 50,000 to 40,000 years ago, our ancestors drew and painted pictures on cave walls, incised and sculpted images on bone and stone and in the clay, fashioned adornments for personal wear, shaped and used musical instruments, and created and developed ever-increasing sophisticated tools and tool making methods.[2] These abilities to gain and communicate information about themselves and their environments through the manipulations of symbols and natural objects signify an ability to think and to communicate in symbolic structures. Surely these extensions of information over time and space by using energy and matter are outward manifestations of our innate language instinct. Given the harsh realities of existence during this glacial time, these manifestations cannot have been mere decorations or frivolous pastimes; rather, they must have represented basic strategies and tactics for surviving in a hostile world.

Naturally, without recording devices to represent what our ancestors actually said, we can only infer what meanings they gave to the artifacts that remain. But given that these ancestors were anatomically identical to modern humans and that their descendents developed writing some 5,000 years ago, it may be reasonable to infer that the evidence of symbolic representation present in prehistoric art and tools supports the conclusion that these Paleolithic

people were engaged in symbolic communication. Today, despite the vast dif-
ferences in the scientific and technological development and sophistication
between global mega-societies and tribal cultures, all existing languages are
equal in terms of phonology, grammar, vocabulary, and pragmatics that meet
the needs of the people who use these languages. All languages differ, but
there are no inferior and superior languages, no primitive and developed
languages.[3]

Although physically weaker than other animals, including their
Neanderthal cousins, our ancestors possessed some key attributes for survival.
In stature, they were relatively taller and able to walk upright on two legs, leav-
ing their arms free for other uses and providing better sight lines for detecting
food and predators. Their brains were more developed and capable of abstract
symbolic thought, including language and sophisticated toolmaking, which
allowed them to develop a wide variety of cultural adaptations to changing envi-
ronments. And this ability to adapt, improvise, and overcome provided the key
to change that we call progress by which improvements can be found for com-
munication, culture, and survival.

All of these abilities to survive were enhanced, even made possible, by lan-
guage which gave humans the techniques and technologies of communication
that allowed them to move beyond the now and the here of the phenomeno-
logical reality of experience. In terms of communication, signalic information
is vital in the immediate environment of the now and here. The warning
"Watch out!" still inspires immediate responses to a present danger. Eating
something and saying "Good" or even "Umm" can signal to others that the
object tastes good and, therefore, could be safe to eat. Survival depends upon
knowing what can help us and what can harm us. Signalic communication can
provide survival information but is limited to the now and here of the imme-
diate environment. It is context-specific and has a limited capacity for gener-
alizing the information to other times and spaces and other contexts.

In symbolic communication, the sound signals (words) need not be limit-
ed to the now and here. Consider "Watch your step!" In the immediate con-
text, it is a warning against a specific danger, but it can be expanded
symbolically to provide a more general caution not only in walking, but
metaphorically in making a move of any kind. Simply put, symbolic commu-
nication in the form of language freed us from the time–space bindings of one
immediate context and allowed us to gather and store information for uses at
other times and in other spaces. It also allowed us to move beyond one con-
text in our use of tools. Many of our primate relatives are quite capable of using

objects like sticks, branches, leaves, stones, and rocks as tools for specific purposes. At times, they even modify the found objects to make them efficient. Where humans differ is in moving from the use of natural objects, even with modifications, for specific uses in specific contexts to crafting objects from stone, wood, ivory, and bone for more general uses over time and space and in different, even unique, contexts. The key change here is a new conception of time–space and the increased control that this new conception gave to human beings. Rather than depending upon found objects for uses in specific contexts, humans can create tools that can be carried for future uses warranted by the new context. You could say that our ancestors and we follow the Boy Scout Motto here: "Be prepared."

The key to sophisticated toolmaking and tool-using is found in what makes us human—symbolic communication based upon human language. Although our Neanderthal cousins created and, to some extent, modified tools during their time on earth, we find limited developments from their early tools to ones from their last days. Even with *Homo sapiens*, the changes in toolmaking during our first 170,000 years (200,000–30,000 B.C.E.—Before the Common Era, a dating system made possible only by the invention of writing and founded on the Christian calendar marking the birth of Jesus of Nazareth) were slow and evolutionary until a cultural Big Bang brought greater sophistication to the material representations of human culture. In the symbolic representations found in tools, clothing, adornments, ornaments, and the graphic images we call prehistoric art, I think we find evidence of significant changes in how early humans thought and communicated within a culture. It was the culmination of biological evolution that made possible the cultural revolution that finally made us truly human.

In the Upper Paleolithic Age that extended from 40,000 to 10,000 years ago, *Homo sapiens* moved from handheld stone axes to stone axes grafted onto animal bones or wooden handles that provided more control and greater striking force. Wooden spears became slimmer and topped with bone, flint, ivory, or obsidian points and augmented by spear-throwers that could be thrown at prey or enemies from greater distances with more accuracy and greater safety. Bows and arrows later provided lighter weapon systems with increased range and accuracy. The simple throwing of rocks and stones at enemies and prey, using hand–eye coordination and estimates of where the target would be when the projectile hit, evolved into the crafting of projectiles for specific targets and the invention of energy-enhancing force-multipliers like the slingshot and catapult to improve their deadly efficiency. These enhancements of energy and matter

provide examples of how early humans gained more control over their environ-
ment and thus increased their chances for survival.[4] As Arthur Ferrill notes in
The Origins of War, "Prehistoric warfare...was as independently important in
early society as the discovery of agriculture, the development of proto-urban set-
tlements, and the emergence of organized religious systems."[5] What all of
these human developments have in common are the human communication
systems that make them possible and efficient. Language is the key to these
communication systems.

Understanding the many uses, both practical and symbolic, of controlled
fire allowed early humans to move beyond its uses for light and heat, protec-
tion from cold and predators, and the preparation and preservation of food into
an energy that could shape and improve tools. In essence, fire consists of the
processing of matter into energy. The harnessing of fire constitutes a major phys-
ical triumph of people over Nature, but of even greater significance is that this
harnessing of fire constitutes an understanding of the processes of the natural
world that can be seen as the beginning of scientific inquiry. Fire is also cen-
tral to magical and religious beliefs and rituals. As symbolic communicators,
humans rarely see even something as elementary and natural as fire as limited
to the physical world alone. We make symbols of all of our experiences because
we are symbol-making animals.

What is important to keep in mind is that while natural selection allowed
the evolution of *Homo sapiens* as a species with a special instinct for language,
this change was accompanied by a cultural evolution in which Nature and cul-
ture formed a matrix from which human being came into being. As *Homo sapi-
ens* migrated out of Africa and spread across the globe, they encountered new
and more challenging environments. These new realities of climate, terrain,
flora, and fauna required new strategies and tactics to adapt, improvise, and
overcome in these new environments. The last great ice ages and their warm-
ing interludes (roughly 180,000 to 10,000 years ago) challenged the survival of
our species. The secret of our survival may well have been woven by what Plato
called "the loom of language."

Consider how unique language is in the world of animal communication.
The concept of a *word* represents not just an individual thought or experience
but an extension of our very beings. In the experiential reality of existence,
humans share with other life forms the needs for air to breathe, water to drink,
and food to eat. We also need protection from the dangerous elements in any
environment. We survive by joining together for security and mutual protec-
tion. By translating our experiences and thoughts into language we are able to

share with our fellow humans information needed for mutual survival. With the sharing of information, we use the principle of redundancy to ensure that the information has less chance of being lost or forgotten. The greater the shared knowledge within a group, the greater the chances for survival of its individual members and, more importantly, of the group itself.

Language not only allows the human mind to symbolize thoughts and experiences but also to become conscious of itself as it thinks and communicates. This self-consciousness, which many psychologists think is unique to human beings, allows for introspection, re-examination, and innovation, thereby increasing our chances for survival. We use language not only to share information with other people but to examine language itself. We consider what we mean by the words we use, how we can express our meanings with greater clarity, and what effects our words might have on our listener. We use the feedback from other people to help us to communicate better. We use language not only to communicate information but to understand ourselves, our fellow humans, our cultures, and our environments.

Each of us is alone in our individuality. Everything outside of us is external and separate. For each person, it is literally "I and the cosmos." But language, expressed as symbolic speech and visual communication, provides us with ways to connect our individual consciousness with other people's consciousnesses. While these connections are always incomplete in many ways, human beings have forever struggled with and agonized over our inability to forge some blending of many minds into one unified totality of perfect communication.

From at least the time of ancient Athens, critics of communication have noted the limitations of all modes and media. In *Phaedrus*, Plato reports Socrates as objecting to rhetoric because it replaces the sharing of ideas available through the dialectic provided by dialogue with the mere dissemination of information, judgment, and opinion provided by public rhetoric. Socrates also finds writing to be lacking in its similar inability to foster true communication. This criticism and its counterarguments have been a central theme in all examinations of communication and media ever since. At the core is how we define communication. Taken from the Latin *communicare*, it means to share in common. In that primary sense of the word, communication means that A and B share equally in the dialogue toward the goal of mutual understanding. But communication also has at least two more general meanings: to exchange information from A to B and from B to A; and to transfer information from one source (A) to one or many receivers (B, C, D, E, etc.).

To some commentators, the desire to achieve full and total sharing of

information is a mere dream, the stuff that myth, legend, and science fiction are made of while the exchanging and transfer of information represent the realities of the phenomenological reality of experience in the real world. To these critics of Socrates, his "dream of communication as the mutual communion of souls" is just that—a dream.[6] But we need not be forced into taking sides in this continuing controversy. As with almost all polarizing positions, we need not accept an Aristotelian either–or dichotomy of this *or* that, but instead, choose a more ecological position that embraces this *and* that. In the history of human communication, we will encounter numerous instances of communication systems that facilitate sharing, exchanging, and transferring of information.

While it is the position of this book that the structures of different media techniques and technologies tend to encourage or discourage certain modes of communication, none of these media is a monolith in its uses and impacts. While total sharing of information seems to be impossible, the other extreme leads to solipsism—the belief that all experience and communication are limited to each individual. In the real world of existence, human beings actively engage in the sharing, exchanging, and transforming of information with mixed results. While all communication is limited, because all human beings are limited, we can still strive toward overcoming some barriers to sharing, exchanging, and transferring what we know with our fellow humans.

That limitation may well be the prime motivation that has propelled the evolutions and revolutions in human communication systems throughout history. Despite its imperfections, language has given human beings their key techniques and technologies for communication and survival. But human communication and cooperation have not been used for some universal communion of all peoples. From the beginning, human beings have banded together not only to fight nature but to fight each other. Conflict, whether between families and tribes or between nation states and empires, has been the norm. From Paleolithic times to today's global age, it has been my family against your family; my cave against your cave; my tribe against your tribe; my clan against your clan; my nation against your nation; my empire against your empire; my religion against your religion; my alliance against your alliance; my ideology against your ideology; my worldview against your worldview.

In this clash between cooperation and conflict, we can find an interesting parallel with the continuing debate found in language studies between those who hold language to be one universal human system of communication with only superficial differences among specific languages and those who hold that each language family is unique in how it perceives and represents reality. This

tension between the *universalists* and the *relativists* will be a constant presence in all of the communication systems inherited and devised by human beings, perhaps because they are all extensions of language itself. Throughout this book, we will be examining whether the differences we note among languages and other human communication systems make any significant difference in our perceptions of reality or how we communicate or act.

The people we are examining are ourselves. To trace the evolution and rev-olution of language, we need to follow the available evidence that reveals our earliest expressions of symbolic communication. Our search takes us to Western Eurasia during the last Ice Age (35,000 to 10,000 years ago). While we focus on this group of *Homo sapiens*, there is no assumption that these humans were in any significant way different from all other *Homo sapiens* in terms of cogni-tive development, language, or culture. What did make a difference were the specifics of the environments in which particular groups of humans lived over time and across the earth. In our physiology of body and structure of minds, all humans share a common inheritance. In our use of symbolic language, all humans possess the same capabilities and potentials. But we differ in how our groups respond to the environmental contexts in which we struggle to survive.

Biological adaptations to changing environments allowed *Homo sapiens* to survive when all of our ancestors and nearest relatives among the hominids per-ished. One answer to why we survived may be found in language itself, the abil-ity to express experiences and thoughts in symbolic structures that facilitate the acquiring–gathering, storing–transmitting, and sharing of information needed to survive in larger amounts, with greater accuracy and precision, to more spe-cific receivers. From the vast and ever-expanding realities of experiences avail-able through our senses, we need to select out those bits of information that we need to survive. We need to know what enhances and what threatens our chances for survival. Those who possessed special knowledge and skills could find food, water, and shelter, and create the tools needed to win the survival game. Humans began as gatherers and scavengers of food but, in time and with tools and weapons, eventually became hunters, what some anthropologists call "the killer apes." In both gathering and hunting, there is added efficiency and security in numbers, in the cooperative accumulation and sharing of food within a group. To know *what* and *how* to gather and hunt requires the cogni-tive skills and understandings involved in coordinating procedures needed for efficient acquisition of food. In the nomadic life of early humans, *when* to gather and hunt was equally important as *where* to gather and hunt. In freeing human communication from the immediate now and here, language allowed

humans to conceptualize both time and space in abstract terms, with temporal references to past, present, and future and spatial references to here and there. Language not only facilitated the remembrance of events and places in the past but also allowed the planning of events and places in the future.

Understanding time has been a central concern for all humans and all societies. Consider how we experience time in our own lives. What information is provided by our senses? Change is the key here. Our eyes tell us that light (day) is different from dark (night) and that this light–dark change is cyclical and therefore highly predictable. We can also note that the light (day) begins with the apparent rising of the sun in the same general direction (what we call *east*), reaches an apex with the sun overhead (what we call *noon*), and ends with the apparent setting of the sun in another general location (what we call *west*). The sun provides both light stimuli to our eyes and heat stimuli to our skins. What we call night is darker than day, illuminated by lights we call moon, planets, and stars.

The inconstant moon not only rises and sets but also changes shape from full moon to dark moon, then back to full moon again in a predictable cycle of 29 days (actually, 29 days, 12 hours, and 44 minutes by modern calculations). These moon cycles can be correlated with the cycles of the seasons (spring, summer, autumn, and winter in the northern hemisphere of Western Eurasia). While we have no discreet evidence that our Upper Paleolithic ancestors had some abstract concept of the cycle (of moons, sun, earth, or stars) we call a year, it seems reasonable to assume that they must have noted the cyclical appearances of the seasons because of the changes in weather, growth and decline of flora, and migration of animals, birds, and fish. In *The Roots of Civilisation*, Alexander Marshack makes exactly this claim based upon his examinations of Paleolithic carvings for evidence of moon and season cycles.[7]

Life in the Upper Paleolithic was "nasty, brutish, and short," with no time to be wasted on endeavors not contributing to survival. For Marshack, the evidence for "time factored and time-factoring" among humans in the Upper Paleolithic can only mean that this information was significant for survival.[8] To be able to keep track of time and to note the cycles of day–night, the phases of the moon, the seasons, and perhaps the year itself provided vital information that could be correlated with cyclical behaviors of animals, birds, fish, and vegetation. Those who possessed such knowledge would possess great power as individuals and as groups. In all human societies at all times, information and knowledge of how to use information are keys to power.

Obviously, knowledge and information are stored in individual minds, in

what we call memory, but human memory is both fallible and limited. To preserve information, humans need to encode it in narratives that can be shared and passed down from generation to generation within a group. Memory aids, what we call mnemonic devices, like rhyme, rhythm, imagery, metaphor, repetition, alliteration, and assonance, among others, help to preserve information within individuals and groups. But these mnemonic devices themselves have limitations, and some outward symbols were needed to preserve the information and knowledge needed for survival. In Marshack's view, cave art was used as *aides de memoir* to predict the cycles of time and their correlations with the cycles of food availability. While this knowledge did not give early humans control over nature, it did provide them with information needed to exploit nature for their own survival needs.

Our ancestors possessed physical and mental abilities as evolutionary gifts, and language was an essential part of that inheritance. Language is a species-specific instinct in human beings, and human beings without language would not be human at all but only an underdeveloped and, most likely, extinct subspecies of the primate family. Language and its symbolic extensions in aural–oral and visual communication and in toolmaking techniques and technologies provided the key to survival in a world we did not make but one we would try to remake in both symbol and reality. Evolution provided the instincts and motivation for survival, and the evolution–revolution of language provided key strategies and techniques for humans to survive. Our ancestors from 50,000 to 30,000 years ago were biologically, physiologically, and cognitively identical to humans living today. Obviously, their lives were different from ours because of environmental factors and their cultural responses to these factors. In the human blending of nature and culture, natural processes and cultural practices became closely entwined as we sought ever-greater understanding of and control over ourselves and our environments. Language provided the codes needed for early and later humans not only to endure but to prevail over the natural environment.

The Medium and the Messages

The messages that were acquired–generated, stored, transmitted, and shared by early modern humans would of necessity have been concerned with survival in all of its forms—physical, cultural, and spiritual. In the most basic sense, language is the perfect manifestation of Marshall McLuhan's famous aphorism— "The medium is the message"—precisely because the medium of language

provides the very structures that make all messages possible. All subsequent messages are expressions and expansions of that language instinct—the ability to render our thoughts, experiences, and feelings into symbolic structures that we use to communicate with our fellow human beings. In *Origins Reconsidered: In Search of What Makes Us Human*, Richard Leakey and Roger Lewin put the case as follows:

> Equipped with language, or, more specifically, the facility for reflective thought, our minds create a model of the world that is uniquely human, capable of coping with complex practical and social challenges....That mental model was the product of an emerging hunter–gatherer way of life.[whose] primary product was human culture, a mix of things practical and things spiritual: a uniquely human model of the world, woven on the loom of language.[9]

Language, then, is the unique medium of communication bequeathed to us by evolution. We are shaped by language, but we also shape our languages by our thoughts and experiences. Language is the *exemplar par excellence* of change itself because change is the natural evolutionary reality of all living languages. In a symbiotic relationship, our language shapes us and we shape our language in an unending cycle that is both conscious and unconscious.

In talking about language, we must of necessity talk of languages, for the six billion-plus people who inhabit the earth today speak no fewer than 6,000 different languages. What is worth noting is that while there are more people living today that at any time in the past, fewer languages are spoken today, with a steady loss as minority languages are overwhelmed by mass languages. From its beginnings with one family of language users, language expanded into a galaxy of some 30,000 to 500,000 languages.[10] Of the 6,000 languages spoken today, linguists estimate that half will be extinct by 2100. A 1999 survey found that 96 percent of these 6,000 languages were spoken by only 4 percent of the world's people. Civilization, communication, globalization, modernization, transportation, urbanization, and other forces of centralization are replacing languages spoken by small groups of people with the mega-languages that come armed with numbers and economic, educational, military, political, and technological advantages.[11] In terms of numbers of first-language speakers, the top twenty mega-languages are Chinese (Mandarin and others), English, Spanish, Hindi–Urdu, Arabic, Portuguese, Bengali, Russian, Japanese, German, French, Javanese, Korean, Italian, Punjabi, Marathi, Vietnamese, Telugu, Turkish, and Tamil. Together, they account for more than half of all first-language speakers.[12]

For reasons having more to do with power than with poetry, English

became the main global language with the dominance of the British Empire in the 18th and 19th centuries and the rise of the United States in the 20th century. In the 21st century, English is being challenged by Russian in Eastern Europe, Spanish in Central and South America, and Chinese in Asia.[13] What is important to keep in mind is that language dominance has nothing to do with linguistic values and everything to do with power and prestige. To steal from William Shakespeare's *Twelfth Night*, some people will be born into English-speaking communities, some will achieve proficiency in English as a second language, and some will have English thrust upon them. According to surveys, "English is used as an official or semi-official language in over 60 countries, and has a prominent place in a further 20. It is either dominant or well-established in all six continents."[14]

As a language, English is relatively new, having evolved from Proto–Indo European through the Germanic family of languages and brought to the British Isles by invading Anglo–Saxon tribes and later modified by Catholic Church Latin and the Norman French invasion of 1066. The evolution of English from the Anglo Saxon of *Beowulf* (early 8th century) or *The Anglo Saxon Chronicle* of King Alfred (*circa* 891–924) to Geoffrey Chaucer's *Canterbury Tales* (*circa* 1387–1400) to the works of William Shakespeare (1564–1616) takes us on a journey from Old English to Middle English to Early Modern English. The changes in English from 1600 to today have been much less radical than the changes from Old to Middle to Shakespeare's English. Modern English is a language of both conquerors and conquered, with a syntax based on word order and a vocabulary drawn overwhelmingly from a vast variety of languages other than English. Even if English should retain, or even expand, its role as the global language, we should not expect this position to result in one global union of those nations and peoples who use English as their native or second language.

If the history of language teaches us anything, it is that linguistic domination does not equal political domination. Consider, for example, the English-speaking Americans, Irish, and Indians who rebelled against the British Empire to establish or reestablish their own national identities. Even if everyone on earth spoke only English (or Chinese, Russian, Spanish, or any other global language), miscommunication would continue to be more common than communication, with mutual understanding still a distant dream.

The problems involved in communicating within a language and communicating between languages have been persistent subjects of inquiry dating back at least as far as ancient Greece. The debate has tended to be polarized into two camps—language universalists and linguistic relativists. In *After Babel: Aspects*

of Language and Translation, George Steiner summarizes their differences:

> The one declares that the underlying structure of language is universal and common to all men. Dissimilarities between human tongues are essentially of the surface.[15]....The contrary view...holds that universal deep structures are either fathomless to logical and psychological investigation or of an order so abstract, so generalized as to be well-nigh trivial. [16]

The first view, very much the more modern of the two, was best articulated by Noam Chomsky in *Syntactic Structures* (1957) and in *Aspects of the Theory of Syntax* (1965) where he called for an analysis of the deep structures that must underlie all languages. As Chomsky wrote, "...it is possible to convey any conceptual content in any language...a direct denial of the Humboldt–Sapir–Whorf hypothesis in its strongest terms."[17] Steven Pinker, a former student of Chomsky and now a professor of cognitive psychology at Harvard University, is even stronger in rejecting linguistic relativity. In his influential *The Language Instinct* (1994), Pinker criticizes Wilhelm von Humboldt, Edward Sapir, Benjamin Lee Whorf, George Orwell (for "Newspeak" in *1984* and for "Politics and the English Language"), and anyone who espouses what he calls "the Standard Social Science Model" that claims that "the human psyche is molded by the surrounding culture."[18] For Pinker, "People do not think in English or Chinese or Apache; they think in the language of thought."[19]

The second view, much older in Western thought, can be traced back to Plato's concept of the "loom of language." George Steiner, in *After Babel,* cites two European advocates for linguistic relativity. In 1697, Gottfried Leibniz (1646–1716), the German philosopher and independent formulator of calculus, declared, "Language is not the vehicle of thought but its determining medium. Thought is language internalized, and we think and feel as our particular language compels and allows us to do."[20] A generation later, the German philologist, statesman, and educator Wilhelm von Humboldt (1767–1835) provided an even more forceful metaphor in connecting language and thought: "Language is a 'Third Universe' midway between the phenomenal reality of the 'empirical world' and the internalized structures of consciousness."[21] In the 20th century, the Austrian-born and later British philosopher Ludwig Wittgenstein (1889–1951) advocated critical analysis of language as the method for understanding philosophical problems, as can be seen in his famous aphorism: "The limits of my language are the limits of my world." In his *Philosophical Investigations,* we find his expression of this idea: "When I think in language

there are not 'meanings' going through my mind in addition to the verbal expressions; the language itself is the vehicle of thought."[22] In *The Essential Wittgenstein*, Gerd Brand summarizes Wittgenstein's position with these words: "Language is the only language there is. The language in which I speak about language is language itself."[23] Two other 20th century linguists connected to the linguistic relativity position were Edward Sapir (1884–1939) and his student Benjamin Lee Whorf (1897–1941) whose 1941 essay "The Relation of Habitual Thought and Behavior to Language" is perhaps the most-cited text for what many people call "the Sapir–Whorf Hypothesis."[24]

This debate between universalism and relativity will be a constant throughout the history of communication from language itself to words versus images, orality versus literacy, chirography versus typography, typography versus electromagnetic media, and analog versus digital communication. Here, we are only concerned with the questions of whether and to what degree language structures how people perceive and represent their thoughts and experiences differently from other animals. The historical evidence strongly supports the conclusion that human beings think, communicate, and behave differently from all other animals. That is the gift given to us by language.

Whether language is universal to all peoples in terms of how it shapes our perceptions and communication, one observation is obvious: When we communicate with one another, we do so through external manifestations of our inner thoughts and feelings through our senses of sight and sound, with touch essential for close interpersonal contacts. For the sharing of particular information in the group or larger social sphere, language manifested as speaking and listening is the central medium. At the center of speech is the *word*, that almost magical rendering of our inner thoughts and feelings and our personal experiences into outer manifestations of spoken words arranged into syntactic structures and articulated in the phonemes of a given language shared by a group of people. When we say that we *use* words to communicate information, we really should say that we *share* words because unshared words (whether unheard, misheard, or misunderstood) have no meanings outside of the individual who uttered the sounds.

Babies provide excellent examples of how meanings of words require sharing. At birth, babies neither understand nor produce words but rather communicate with sounds, movements, touch, taste, and smell. By 18 months of age, average normal babies speak about 50 words and understand some 100 to 250 more. At two years, the spoken words increase to more than 200, at three to 2,000, and at five to over 4,000 words.[25] Developmental linguists and psychol-

ogists tend to make connections between improved articulation of phonemes, growth of vocabulary, sophistication of syntactic structures, and intellectual and communicative development in children. Most of us have few or no memories of this learning curve in our own lives, but we can observe and record this journey into language in the lives of other babies we can study. While Noam Chomsky and Steven Pinker would likely disagree, the immense power of the *word* seems clear to many people. A particularly significant and poignant account of the power of words can be found in Helen Keller's account of her own revolution in achieving language. Rendered blind and deaf by disease at 18 months of age, Helen lived in a world separated from her family. Anne Sullivan, hired to be her companion and teacher, attempted to teach the child to communicate with signed English—spelling words with her fingers on Helen's hands. Despite weeks of effort, the then-seven year old Helen had not grasped the essential key to understanding language: that words can represent referents. In her 1902 *The Story of My Life*, Helen Keller gave us an account of her breakthrough from pre-language to language:

One day, while I was playing with my new doll, Miss Sullivan put my big Rag doll into my lap also, spelled "d-o-l-l" and tried to make me understand that "d-o-l-l" applied to both. Earlier in the day we had had a tussle over the words "m-u-g" and "w-a-t-e-r." Miss Sullivan had tried to impress it upon me that "m-u-g" is *mug*, and "w-a-t-e-r" is *water*, but I had persisted in confounding the two. In despair she had dropped the subject for the time, only to renew it at the first opportunity. I became impatient at her repeated attempts and, seizing the new doll, I dashed it upon the floor. I was keenly delighted when I felt the fragments of the broken doll at my feet….I felt my teacher sweep the fragments to one side of the hearth, and I had a sense of satisfaction that the cause of my discomfort was removed. She brought me my hat, and I knew I was going out into the warm sunshine. This thought, if a wordless sensation may be called a thought, made me hop and skip with pleasure.

We walked down the path to the well-house, attracted by the fragrance of the honeysuckle with which it was covered. Someone was drawing water and my teacher placed my hand under the spout. As the cool stream gushed over one hand she spelled into the other the word *water*, first slowly, then rapidly. I stood still, my whole attention fixed on the motion of her fingers. Suddenly I felt a misty consciousness as of something forgotten—a thrill of returning thought; and somehow the mystery of language was revealed to me. I knew then that "w-a-t-e-r" meant the wonderful cool some thing that was flowing over my hand. That living word awakened my soul, gave it light, hope, joy, set it free! There were barriers still, it is true, but barriers that could in time be swept away. I left the well-house eager to learn. Everything had a name, and each name gave birth to a new thought. As we returned to the house every object which I touched seemed to quiver with life. That was because I saw everything with the strange, new sight that had come to me….I learned a great many new words that day.[26]

What happened to Helen Keller on that day and in the years that followed as she learned to communicate with touch, spelled and signed English and learned to read with the Braille system was a dramatic revolution that gives us some insight of the great divide between human beings with and without language. Keller's subsequent success in graduating *cum laude* from Radcliffe College (Harvard University) and becoming a world-renowned author and lecturer provides further evidence of the power of language as a medium of communication for all human beings. Each of us in our own way has made a journey similar to Keller's but our journeys have been more evolutionary than revolutionary. I suspect that our *Homo sapiens* ancestors underwent a similar journey, not as individuals but as families and groups. For Helen Keller and for all human beings, once language is learned and words become our shapers and carriers of messages, language and learning become closely integrated. As Helen Keller wrote, "Everything had a name, and each name gave birth to a new thought."

Naming is the key to understanding language and languages. Is there anything we cannot name? Does naming give us control over that which we name? Is naming central to magic, to religion, to science? To all human activity? In language, words are the semiotic codes that embody meanings, but the words need to be articulated into speech sounds and structured in syntax for the meanings to be shared among people. But it is the *word* itself that provides the essential foundation for all languages, but defining exactly what constitutes a word in a given language turns out to be problematic. In linguistics, the smallest significant sound in a language is a *phoneme*, and a *morpheme* is the smallest sound that carries meaning. Linguists call morphemes that need to be connected to other morphemes *bound morphemes* and morphemes that carry meanings by themselves *free morphemes*. In English, for example, the word *unfeeling* contains three morphemes—*un*, *feel*, and *ing*—with only *feel* likely to be a stand-alone free morpheme (or word). The "*un*" and "*ing*" rarely by themselves carry meaning. In writing, we usually separate words with spaces between them. In speech, the separations are not so clearly designated, even to native speakers of a language.

Since Greek and Roman times, scholars have tried to separate words according to their functions in communicating meaning. One possible, and quite common, system looks like this: *nouns*—names of persons, places, things, ideas, etc.; *pronouns*—words that represent nouns; *adjectives*—words that modify nouns; *determiners*—words that are used to signify nouns; *verbs*—words that describe actions or states of being; *auxiliaries*—words that are used with verbs

to mark grammatical distinctions; *adverbs*—words that modify verbs, adjectives and other adverbs; *prepositions*—words that connect nouns and pronouns to other words; *conjunctions*—words that connect words, phrases, or clauses; *gerunds*—verbs ending in "ing" used as nouns; *gerundives* (participles)—verbs ending in "ing" used as adjectives; and *interjections*—words with emotive meanings that do not have grammatical relationships with other classes of words. These categories come from Greek and Latin descriptive grammars and have been challenged by modern linguistics as being misleading in trying to describe the English language in any of its manifestations. Rather than attempting to define words by meanings, modern linguists "focus on the structural features that signal the way in which groups of words behave in a language."[27] In English, for example, *nouns* can be modified to be singular or plural, to be possessive, and are signaled by determiners (a, the, some, many, no, all, etc.). *Verbs* can be modified to express time and condition (I play. I played. I did play. I have played. I will play).

Linguists are interested in identifying language universals. For example, all languages ever examined reveal the use of nouns and verbs.[28] These concerns of linguistics are important for understanding the inner workings of any language, but those of us who speak a language do so with no conscious understanding of any of the rules of phonology, morphology, or grammar identified by linguists. Long before any linguists existed and everywhere today where people communicate in languages uncharted by linguistic scientists, people were and are quite capable of communicating information pragmatically and efficiently. Our concern here is with how real people in the real world communicate the information they need to enhance their survival prospects.

Obviously, for all peoples at all times and in all places, having names for food and the locations where food can be found facilitates the communication of vital information. Of equal significance are names for time cycles when food will be available and abundant. Rather than relying upon one person to remember the right time and location of food, it is infinitely more efficient to be able to share that information with the group. The more precise the words used, the more useful the shared information.

Consider a possible scenario in the Upper Paleolithic. A band of gatherers–hunters some 30,000 years ago in what is now the Dordogne Valley in Southwestern France is emerging from another cold winter into the annual warming we call spring. Food has been scarce during the winter with little edible vegetation and few game available. Now, the snows are melting and the sun shines longer each day. From past experiences and collective memory, our

band knows that certain fish, say salmon, will be making their annual swim upstream to spawn and are both plentiful and easy to catch at this time. Our band also knows in its collective memory that some animals will be giving birth at this time, making both mothers and newborns vulnerable to hunting. Birds will be migrating north and can be snared with nets. Bushes, grasses, plants, and trees will soon be growing and yielding up their bounties. The band's collective memory equips the members with knowledge of these coming events based upon past experiences encoded, stored, and retrieved through language manifested in narratives, visual images, and rituals. Language also enabled our ancestors to improve upon the designs and uses of tools by giving them names to share information more efficiently. With everyone and everything having a name, communication and control became more efficient and contributed to the survival of the individual, the group, and, most importantly, the species.

The gathering and hunting for food can be carried out by individuals, but these survival activities are more efficient if conducted by groups working together. In addition to improving efficiency in gathering and hunting, such group activities also provide security from dangers posed by the environment, by predators, and by other humans. Shared information about the best techniques and technologies for gathering and hunting in groups enhanced the overall efficiency of the gathering and hunting, allowing those with knowledge and information to share what they knew with the less experienced members of the group. Improved hunting techniques and technologies enhanced the efficiency of the group, allowing relatively weak humans to track, stalk, and trap larger, stronger, and faster animals. Advanced tools in the form of axes, spears, bows and arrows, flint knives, and the like facilitated the killing, skinning, and carving up of the hunted animals. All of these improvements were enhanced by language.

The cooperation made possible by humans banding together into cohesive social groups, perhaps beginning with family units, provided early humans not only with the security needed to safeguard their survival needs but also with the added benefit of being part of a community of caring and trust that would nurture the young and their mothers, and care for the sick and elderly. Belonging to a group also provided humans with identities as individuals and as group members. Names and relationships were essential for locating individuals within the family, tribe, clan, or nation, just as they continue to be in all cultures today. Even in the most technologically advanced global cultures of the 21st century, our individual identifications (in the form of names, identification numbers, and the like) and our group memberships (local, regional, national,

global) signify our identities and our places in the world.

The significant messages that early humans used to share were both *phatic* to keep the communication systems operating and *emphatic* to convey specific information needed to survive not only in the physical sense but also as social groups. For group survival over time, key social messages in the form of narrative, myth, and ritual would be needed. The great questions of life would need to be asked and answered: *Identity* (Who am I?), *Creation* (Where did I come from?), *Destiny* (Where am I going?), and *Quest* (How do I reach my destiny?).

Identity is both an individual and a group designation that defines one's place, relationship, status, responsibilities, rights, privileges, and sense of being, connecting the microcosm of each person to the larger macrocosms of family, group, tribe, clan, nation, species, and the cosmos itself. How do you answer this question? What labels do you apply to yourself? What labels are applied by others? Try making a list of all the identities used to name you. The answer you give will reveal not only your own sense of self but the sense of self shaped by the larger social systems. If you asked your family, friends, colleagues, associates, acquaintances, officials, and outsiders, your list would become longer, with perhaps some contradictions, inconsistencies, and revelations. Since our focus is on communication and survival, you will need to ask how these identity markers are connected to your chances of surviving. All cultures provide their members with group answers to this question, answers that are designed to ensure the survival of the culture. In general, the more threatened the culture's chances for survival, the more emphatic and limited will be the answers. Only in developed societies, with survival not in imminent danger, are individuals free to engage in individual explorations of this question with the possibility of living with divergent answers. What survival value did identity have for our ancestors in the Upper Paleolithic?

The mystery of *creation* concerns all peoples at all times. All cultures provide stories that explain how everything began, from the cosmos to the earth and the creatures on the earth, especially human beings who are typically given special status in the creation narratives. Creation myths from many cultures have been compiled and analyzed for their structural similarities by such scholars as Joseph Campbell in his *The Hero with a Thousand Faces* and his four-volume *The Masks of God*, Siegfried Gideon in *The Eternal Present*, and, especially, Claude Levi-Strauss in his four-volume *Introduction to a Science of Mythology* and *Structural Anthropology*.[29] All creation myths provide humans with explanations of how and why everything came into being, including the

material world of the temporal and the spiritual world of the eternal. All human cultures provide answers that can be grouped under magic, religion, and science. Even in today's technological societies, each of these three areas continue to provide people with explanations of creation. What creation stories do you believe? Why do you believe these stories? How do you act upon these beliefs in your life? Why do you think people need these stories? What roles do magic, religion, and science play in the lives of people? What survival values did creation narratives have for our ancestors in the Upper Paleolithic?

The question of *destiny* is obviously connected to creation and assumes that existence has a purpose. Our Ice Age ancestors left only scarce clues to their cosmological conceptions, but it seems reasonable to assume that they shared with all humans a need to explain the great mysteries of life and death. When Bronislaw Malinowski separated human quests for knowledge into magic, religion, and science, he was imposing a modern classification onto what is usually an interconnected and interrelated whole. Myths tend to be combinations of all three domains, providing magical incantations, potions, rituals, and spells to control natural and supernatural forces, religious ceremonies, prayers, and rituals to worship the divine, and scientific methods, practices, and theories to understand the laws of the natural world. Significantly, all cultures, including our own today, have assumed that there exists a realm not detectable through our physical senses, a realm of spiritual powers that have real impacts on our physical world. Whether these powers exist in spirits found in the elements and the creatures of the earth, in supernatural gods and goddesses, in demons or spirits, or in physical subatomic structures of the universe, people seek to understand, placate, and use these powers to control their lives by identifying the destinies ordained for them by natural and supernatural forces.

To reach these *destinies*, human beings need guidance to embark on the *quests* needed to reach their intended goals. Magic supplies the proper mixtures, curses and hexes, materials and rituals needed to enforce one's control over other people, the natural world, and the realm of the supernatural, seeking the future in readings of horoscopes, palms, tea leaves, omens, signs and the like from fortunetellers, oracles, and soothsayers. Religion supplies a set of beliefs and behaviors designed to guide people in ways dictated by a Divine Being or collections of divine beings. Science attempts to replace belief with inquiry, certainty with doubt that questions all answers through rigorous testing. As Karl Popper noted in *The Open Society and Its Enemies*, "Thus we can say that in our search for truth, we have replaced scientific certainty by scientific progress."[30] What Popper means here is that fallible humans can never know the truth but

we can discover what is not true by using the scientific method, defined by Popper in a now-classic formulation: "In so far as scientific statements refer to world of experience, they must be refutable; and, in so far as they are irrefutable, they do not refer to the world of experience."[31]

Ultimately, the answers to these questions provided by the narratives of any culture need to carry both practical and symbolic guides for survival. In the Upper Paleolithic, our ancestors in Southwestern Eurasia established a culture that continued through the last Ice Age, some 25,000 years until some 10,000 years ago when the ice receded and humans migrated to river valleys and began permanent settlements. Of necessity, the core messages would have had to include information vital to survival—when, where, and how to gather and hunt food; when, where, and how to find and build shelters; how to control and use fire; how to fashion and use tools and weapons; how to create garments; how to structure social groups for continuity and efficiency; and generally how to survive.

As with all developments, the uses of techniques and technologies expanded beyond their primary purposes. In becoming efficient hunters of animals, early humans also became efficient killers of other human beings, adapting their hunting patterns into strategies and tactics, and axes, spears and bows and arrows into weapons of war.[32] These proto-developments of organized conflict would eventually develop into full warfare with the coming of permanent settlements like Jericho (settled between 8350 and 7350 B.C.E.) that contain evidence of fortifications against outside attacks. As Arthur Ferrill notes in *The Origins of War*, "The earliest civilizations inherited from prehistoric ages a legacy of weapons development, offensive and defensive strategies and a sense of territoriality. As soon as man learned to write, he had wars to write about."[33] While not extensive, there are some examples of Neolithic cave art that "show us scenes of bowmen apparently opposed in conflict."[34] The exaltation of warriors and warrior-kings so common to all early and later civilizations and empires surely did not arise suddenly with civilizations but evolved over the millennia of human culture during the Upper Paleolithic Age. The narratives of oral gatherer–hunter bands became the epic tales of literate civilizations.

Media

Language is different from all other media that humans use to communicate with each other in that language is both a medium and its content. It is also the foundation for the creation and development of all the mediated extensions

that we have shaped to free our messages from the now and here. Language pro-
vided humans with the ability to acquire, encode, store, and share symbolic mes-
sages needed for survival. All human communication systems employ signals,
or symbols, or a combination of the two. For our Neolithic ancestors, language
was externalized mainly through the senses of sound, sight, and touch.
Oral–aural transmissions of messages were encoded in speech and provided the
foundations for individual and group identities in terms of the shared naming
of their perceptual reality and conceptual constrictions. The human survivors
of the last Ice Age had learned how to control and use fire, to record natural
time cycles, to make and employ tools and weapons of increasing sophistica-
tion and efficiency, to gather and hunt for food with greater success, to fash-
ion garments from animal skins and furs, and to create drawings, paintings,
carvings, and sculptures of tremendous complexity and sophistication.

On the basis of the evidence of their accomplishments, it seems reasonable
to conclude that humans in the Neolithic Age possessed the mental ability to
think symbolically and to use this symbolic thinking to convey their messages
through spoken language. Signalic speech would have been essential for deal-
ing with immediate challenges, dangers, and opportunities, as it continues to
be for all humans today. But it was symbolic thinking and speech that provid-
ed humans with greater control over time and space by using words structured
into sentences as substitutes for experience. Speaking the same language,
which essentially means sharing vocabulary and syntax, made human commu-
nication more efficient by reducing entropy. The *word* signifies the referent and
allows more efficient sharing of information than is possible by gestures or sig-
nalic cries. Words allowed humans to domesticate time and space as they
would eventually domesticate animals, plants, trees, grasses, and other living
organisms, providing greater control over both their symbolic and actual envi-
ronments. The tyranny of the eternal present of the natural world imposes with
each change a new challenge to survival. The key to understanding change and
how to respond to it is found in the ability to make valid and reliable predic-
tions about the future based upon understanding how change can be concep-
tualized. If everything perceivable in the real world could be named, then
everything conceivable in the imagined world could also be named. And nam-
ing conveys power, whether we call the naming magic, religion, or science.

In order to keep our language systems functioning properly, we need to use
both *phatic* and *emphatic communication*. *Phatic communication* is used to estab-
lish and maintain connections among people, in order to provide the commu-
nal context in which *emphatic messages* can be used to share specific information

with some assurance that these messages will be received, understood, and acted upon. If we only shared *emphatic messages*, our communication would resemble telegrams, or recipes, or technical directions. It is the embedding of *emphatic messages* within an overall system of *phatic communication* that unites content with context to form a meaningful whole. In any communication environment, it is the blending of *phatic* and *emphatic communication* that provides the dynamic interaction that translates messages into shared meanings.

If our Neolithic ancestors behaved at all like humans of whom we have specific knowledge, they would have used speech to tell tales of who they were, of how the world and they were created, of their purpose and destination in life, and all of the specific paths they needed to follow to achieve their destinies. By symbolically coding time and space, early humans gained some control over both the natural world and their own understandings of their place in that world. By learning how to use energy and matter, early humans were able to generate energy by converting matter into energy, and to use energy, largely in the forms of human effort and controlled fire, to alter matter itself. Tools crafted from bone, ivory, stone, tree, vine, and other natural objects provided humans with implements for securing food, and weapons for hunting prey and defending themselves against animal and human predators. By being able to name the cycles of the days, the moon, the seasons, and the sun, humans reaped both material and spiritual benefits by being able to predict future cycles with regard to climate—weather, growth of edible foods, migration of animals, birds, and fish, and the bearing of offspring. By knowing how to navigate within the environments in which a nomadic band moved, humans possessed mental maps that facilitated more efficient traversing of territory in order to find water, gather food, hunt prey, and locate the raw materials to be crafted into tools–weapons, garments, shelters, and decorative items. By combining their symbolic understanding of the interrelations between time and space, humans gained control not only over the now and here but other and future thens and theres.

Language provided humans with the ability to construct narratives that carried the collective memories of the group. Obviously, group memory reinforced by ritualized recitations of information enhanced the choices for the survival of the information. People remember what is memorable and what is most memorable is what people decide they need to remember in order to survive as a group in both material and cultural terms. From the evidence found in the remains of Neolithic human living spaces in the form of musical instruments, mainly drums and flutes, it would appear that music and ritual dancing may have accompanied these retellings of tribal tales, as they do in all of the

societies we have examined. Like speech, music and dance are outward man-
ifestations of human language. All can be seen as extensions of the language
instinct, as media for carrying the messages needed to enhance the chances of
survival in a very cold and hostile world.

Language extended human communication not only in the aural–oral
realm of speech but also in the realm of sight with culturally-determined ges-
tures and movements, body alterations and decorations, special boundaries and
markers, and other signifiers used by people. Language also manifested itself in
material representations that we conventionally call arts and crafts, the visu-
al image-making found in buildings, carvings, drawings, paintings, sculptures,
and the like. The prehistoric art of our Upper Paleolithic ancestors provides the
most direct evidence of the cognitive abilities of our early ancestors. In Siegfried
Gideon's view, "Art came into being with *Homo sapiens* when man's brain
reached its full dimensions."[34] Whether in realistic representations of what early
humans could see in their environments or in clearly abstract expressions of
what could only be imagined, all art is essentially abstract in that it can never
represent what people see or imagine with total accuracy. All signs and sym-
bols are simplifications of human perceptions and conceptions united "…with-
in an eternal present, the perpetual interaction of today, yesterday, and
tomorrow."[35] Rather than dismissing the images from prehistoric art, or of art
from any time and place, as mere decorations, we need to consider all human
manifestations of symbolic thought and behavior as survival strategies and
techniques. In Siegfried Gideon's words, "Symbols were mankind's most effec-
tive weapons of survival when confronted with an inimical environment."[36]

Whatever the multiple meanings, significances, and uses of visual symbols
by our prehistoric ancestors, we can safely conclude that communication was
central to their efforts, that the images (whether signs or symbols) were out-
ward representations of information that needed to be remembered in order to
enhance their chances for survival. While the visual images created by our
ancestors in the Upper Paleolithic contain meanings and mysteries about
which we can never be certain, some scholars of prehistoric art have suggest-
ed a number of possible conceptual frames within which we can examine these
artifacts of their culture. Early theorists suggested hunting magic, religious rit-
ual, sexual signification, and even art-for-art's-sake explanations. In the most-
extensive survey of prehistoric art in what is now Western Europe, the French
scholar André Leroi-Gourhan in *Treasures of Prehistoric Art* provides a catalogue
of 2,188 animal figures found in 66 caves and rock shelters. Among the most
represented are these: "610 horses, 510 bison, 205 mammoths, 176 ibexes, 137

oxen, 135 hinds, 112 stags, 84 reindeer, 36 bears, 29 lions, and 16 rhinoceros-
es."[37] Other animal representations include "8 large-horned deer, 3 undefined
carnivores, 2 boars, 2 possible chamois, and 1 probable saiga antelope."[38]
Included among non-animal figures are "6 birds, 8 fishes, and 9 monsters."[39]

For communication scholars, the depictions of human beings are of great
interest. They are not numerous and tend to signify females and males, with lit-
tle or no representations of human sexual copulation.[40] In the early period,
there are more female than male representations; in the later periods this is
reversed with more male and fewer female representations.[41] According to
Leroi-Gourhan, "Faces without bodies make up the majority of male represen-
tations."[42] The faces are not very resolute, in sharp contrast to the animal
images that are largely recognizable. This is also true for female figures which
contain abstracted images of faces and bodies that are more symbol than sign.
At times, female and male representations are reduced to vagina and phallus
abstractions.

One figure has fascinated and troubled scholars since Abbé Henri Breuil
copied its image in the cave at Lascaux found by four French schoolboys and
a dog in 1940 in the Dordogne Valley in Southwestern France. Labeled "The
Sorcerer," the image is twenty-nine and a half inches (79.93 centimeters) high
and is an etched and painted image of a frontal humanlike face with large round
eyes. The body appears to be covered with the hide of a reindeer or stag, with
antlers on the head, and a flowing tail. Human male genitalia are portrayed in
a prominent manner. Whatever the meanings embodied in this image by our
ancestors, we can infer that it must have carried symbolic information central
to the survival needs of those who created and used this image.

Among the most poignant images in prehistoric art are those of human
hands, imprinted usually in outline. Some 90 percent appear to be of left
hands, but evidence suggests that some of the imprints may have been made
with right hands pressed palm-up against the cave walls. It appears that the
majority of these hand images were made by women and children. There are
also a large number of imprints in the caves made by children's feet.[43] Again,
the specific meanings symbolized by these images elude us, but given the
extreme difficulties of creating these images and the continuity of their use over
some 20,000 years of prehistory, it seems reasonable to conclude that they
held significant value for our ancestors. For John E. Pfeiffer, prehistoric art rep-
resents what he calls "the start of the Information Age" during which the
caves functioned as carefully constructed learning environments in which the
young were educated in the knowledge and values of the group through a kind

of shock indoctrination.[44] During this time, early humans were developing increasingly sophisticated tools and weapons for coping with a changing ecological environment. For Pfeiffer, the caves provided a ritualized journey from daylight into darkness where illumination was provided by lamps carved from stone and fueled by animal fats controlled by juniper wicks. The years from 30,000 to 10,000 years ago contained both an Industrial Revolution in tools and toolmaking and an Information Revolution in thinking and techniques for creating, improving, and employing these tools, all driven by the need for survival in a changing and threatening world.

The Lascaux Cave in France's Dordogne Valley contains what was long thought to be the apex of prehistoric art, dating back some 17,000 years. From its discovery in 1940, Lascaux became celebrated as a major repository of early human image-making, with Abbé Henri Breuil calling it "the Sistine Chapel of Prehistoric Art." More recent discoveries now tell us that Lascaux, while significant in terms of the beauty of its images, is but one achievement in the long history of human image-making. In terms of time, Lascaux dates from some 17,000 years in the past, but the Grotte Chauvet, also in today's France, is some 15,000 years older, dating from some 32,400 years ago. Thus, Lascaux stands halfway between today and the Grotte Chauvet's mixture of Aurignacian (40,000 to 28,000 years ago) and Gravettian (28,000 to 22,000 years ago) cultural styles. Evidence from this earlier cave clearly reveals a developed sophistication in the styles and image-making of our ancestors, with careful choosing and preparation of the surfaces, complex techniques and technologies of the actual etchings and paintings, and refined skill in the actual representations.[45]

In a 2008 article on cave art, Judith Thurman sums up the significance of the symbolic achievements of our ancestors in the Ice Age:

> What those first artists invented was a language of signs for which there will never be a Rosetta Stone; perspective, a technique that was not rediscovered until the Athenian Golden Age; and a bestiary of such vitality and finesse that, by the flicker of torchlight, the animals seem to surge from the walls and move across them like figures in a magic lantern show (in that sense; the artists invented animation). They also thought up the grease lamp—a lump of fat, with a plant wick, placed in a hollow stone—to light their workplace; scaffolds to reach high places; the principle of stenciling and Pointillism; powdered colors, brushes, and stumping cloths; and…the very concept of an image.[46]

Despite the absence of a Rosetta Stone to decode any system of meaning, almost everyone who has studied these images felt the need to provide an interpretation. Early scholars, like Abbé Henri Breuil, Count Henri Bégouën, and Salomon Reinach, saw in these images evidence of sympathetic magic and

[handwritten: survival is our main concern + language makes survival possible]

totemism or art-for-art's-sake self-expression.[47] In the 1950s, French Structuralism influenced such scholars as Annette Laming, André Leroi-Gourhan, and Max Raphael to see cave art as organized symbolic systems in which meaning is found in the holistic totality rather than in each separate image.[48]

Those who study prehistoric art, whether in anthropology, archaeology, art history, communication, ethnology, genetics, human evolution, pre-history, or other disciplines, tend to fall into polarized and frequently-combative camps: those who think that they can construct theories to explain the culture that produced the art and those who think that no one theory or even a cluster of theories can explain the culture that produced that art. In its core, this is the same conflict that exists between those who seek universals in language and those who insist on linguistic relativity and uniqueness. But, in both areas, we need not accept this either–or dichotomy. Rather, we can search for universals that are shared by all human communication systems. For example, all humans possess language and express their language in sound, sight, movement, and touch. For all humans, survival is the core concern, and survival can be aided by our abilities to generate, store, and share information needed for that survival. Among the information needed for survival, knowledge of how to understand and control time–space and energy–matter is central to all peoples and all cultures. Without knowing exactly what Ice Age *Homo sapiens* meant by the images, markings, shapes, tools, and weapons they left behind, we can reasonably infer that any tradition of signs carefully designed and maintained over some 25,000 years was neither insignificant nor peripheral to the peoples and cultures of the last Ice Age. Life in that era was challenging and harsh, and our ancestors had little or no time for anything not centrally focused on their survival.

Using Marshall McLuhan's conception of media as extensions of human beings, we could include here our ancestors' great skills in designing and creating tools and weapons, garments and cooking utensils, techniques and technologies for the gathering and hunting of food, and the construction of dwelling sites. All of these remnants of their lives contain evidence of complex and extended symbolic communication made possible by the language instinct that helped to shape our humanity. While scientists in 2009 managed to reconstruct the genome of our last hominid relatives, the Neanderthals, that indicated that they possessed two key changes in a gene essential for language, there is no evidence that *Homo neanderthalis* and *Homo sapiens* interbred and produced offspring. After the hominids separated from other members of the pri-

mate family some 5.7 million years ago, hominid evolution later separated Neanderthal from the direct ancestors of modern humans some 300,000 years ago. When Neanderthals became extinct some 30,000 years ago, *Homo sapiens* were the last hominids alive. It may be that language and the symbolic structures and expressions made possible by language gave our ancestors an edge in the struggle for survival. The answers to the questions of how like us Neanderthals were and whether or not they possessed language could be found in recreating a Neanderthal genome, inserting it into a chimpanzee cell, and generating in a chimpanzee's womb a mutant chimp that was a Neanderthal genetically.[49] Presumably, the ethical and ecological consequences of such an experiment would involve not only scientists and governments but science fiction authors and theme parks in the *Jurassic Park* tradition.

Impacts

The impacts of the evolution–revolution of language, with its extensional manifestations in such forms as speech and visual imagery, art and music, clothing and shelter, myth and ritual, and toolmaking techniques and technologies, can be summed up in one brief statement: Symbolic language made possible all of the developments of human media, culture, and communication. With language, *Homo sapiens* evolved into a species capable of challenging the limitations of time–space and energy–matter imposed by Nature by supplementing natural evolutionary change with cultural evolution–revolution through which humans were able to adapt to changing environments and to change these environments to better serve human needs and wants. By moving from the largely-signalic communication, common to all primates to a mixed system of signals and symbols, humans became separated from all other animals, enabling our species not only to endure and survive but also to attempt to exercise dominion over all other creatures and over Nature itself.

As all other hominid species disappeared from the earth with the extinction of the Neanderthal some 30,000 years ago, *Homo sapiens* was able to grow from an estimated population of one to ten million some 10,000 years ago (at the end of the last Ice Age)[50] to an estimated 6,906,558,000 in 2008 and a projected 9,191,287,000 by 2050.[51] Humans now inhabit all of the land masses capable of sustaining life and have extended our explorations into areas naturally uninhabitable like the Arctic and Antarctic. We have attempted to reverse the expansions of deserts with irrigation and air-conditioning. The question is still open as to whether humans will be able to succeed in our expan-

sions into space and under the waters, realms previously explored only in myth, religion, and science fiction.

In becoming the symbolic species, humans used language to create the extended communication systems that allowed us not only to survive but to understand ourselves, our world, and our survival in a self-conscious realization of how things function. Not content with merely understanding *how* things functioned, we were driven by our symbolic language to try to understand *why* things functioned as they do. It is this internal drive to understand ourselves and our world that stimulates change and that is likely to continue until our species itself changes.

Language allowed our ancestors to move from being foragers and scavengers to becoming producers and predators in gathering and hunting with information stored in memory of when and where food was available; of how to use energy and matter to create and employ tools and weapons; to use and control fire; to cook and cure food for easier digestion and preservation; to craft garments from animals and plants; to build shelters from wood, leaves, and animal skins and bones; to organize and maintain a social order needed for group survival; and, above all, to adopt, improvise, and overcome whatever environmental challenges threatened our survival. Language allowed humans to accomplish all of these achievements by providing the symbolic foundation not only for improved storage of information in memory but also for improvements in the acquiring of information from improved perceptions and conceptions of what is and what could be. In sum, language was one of the key contributors that made us into fully human beings. Language is the core of all human communication and without language it is doubtful that any of our ancestors would have survived because, without language, humans are merely incompetent, ineffectual, and very naked apes.

All of the achievements that we list under culture can be attributed to language, from conceptual thought that propelled us to seek and to create new information to improved memories that allowed the storage of more and better organized information and to vastly improved ways to share information with an ever-widening circle of other people.

Since language was the result of evolutionary mutation and natural selection, we cannot assume that early humans expected language to have any consequences other than the ones they were living with as they moved from experiential learning limited to the now and here to conceptual learning that allowed information to be carried to other times and places, to be stored in memory, and to be projected into future times and places and circumstances.

But one unexpected and challenging consequence surely was the accumulation of information at an exponentially increasing rate. Despite the gift of language, perhaps because of that gift, human beings are possessed of a sense that we can never know enough to fully understand ourselves and the cosmos. To have a sense of the future also means that we have a sense of our own deaths. To be able to imagine nonmaterial worlds also means that we now fear the powers of these spiritual worlds. Language, expressed outwardly in myths and narratives, in arts and rituals, in customs and cultures, gave us some answers to the great mysteries of identity, creation, destiny, and quest. But these answers would lead, in some environments, to alternate answers and new questions that challenged accepted beliefs and practices. To some, this questioning of traditional answers would lead to dangerous heresies that threatened the very existence of the group. To others, this questioning would lead to improvements that facilitated future survival. In both cases, the dynamic struggle between preserving tradition and challenging tradition would shape human thought, culture, and history from the Age of Orality to the Cybernetic Age.

Language allowed us to communicate more efficiently in terms of sharing information, but it also facilitated our ability to distort, lie, misrepresent, and manipulate information to deceive ourselves and our fellow humans. As my old friend and mentor Charles Weingartner liked to say, "The major purpose of language is to create the illusion of certainty in an uncertain cosmos." These illusions of certainty sustained our ancestors as they moved out of Africa and migrated all across the globe, becoming ever more numerous and separating into different groups with diverging languages and customs. In time, these early humans begat more humans and more groups, with languages changing to represent the separations, providing each group with a separate identity that increased the separations among humans. Ironically, the very instinct, language, that enabled humans to communicate more effectively and efficiently with each other provided a major obstacle to widespread shared communication and understanding. From the beginning of recorded history some 5,000 years ago, and most likely for millennia prior to writing, human beings have found many reasons to fight and kill each other, but whether the causes are found in reality or in symbols, language has been at the core of the conflicts. It is possible that our language development, with its concomitant developments in improved conception, communication, tools, and weapons, provided humans with the survival edge over our Neanderthal relatives. They, of course, were big losers in this survival struggle, but language was not an unalloyed blessing for *Homo sapiens*.

The *Faustian Bargain* was in effect even with our first evolutionary development in becoming fully human with the revolution of symbolic language. Language gave us greater command and control over our environment, but it also brought us a keen awareness of the ultimate fate of all living things—aging and death. As we were able to explore and understand some of the mysteries of existence, we also became cognizant of all that we did not know or understand. Because we can symbolize, we tend to symbolize everything and to impose meaning on the unknown by representing it through magic, religion, and science. Following the work of the Scottish anthropologist Sir James Frazer (1839–1941), whose comparative study of myth and religion was published in his twelve-volume *The Golden Bough* (1890–1915), Bronislaw Malinowski distinguished between magic and science in these terms:

> Early man seeks above all to control the course of Nature for practical ends, and he does so directly, by rite and spell compelling wind and weather, animals and crops to obey his will. Only much later, finding the limitations of his magical might, does he in fear or hope, in supplication or defiance, appeal to higher beings; that is, to demons, ancestor-spirits or gods. It is in this distinction between direct control on the one hand and propitiation of superior powers on the other that Sir James Frazer sees the difference between religion and magic.[52]

In our attempts to gain some understanding of and control over the forces of Nature, human beings have submitted themselves to the higher authority, power, and wisdom represented by religious beliefs that accept that the mysteries of life are largely unfathomable to fallible humans except as revealed through divine grace. Both magic and science, on the other hand, assume that humans can discover the laws of nature and, thus compel Nature to do our bidding. Citing some critics and followers of Frazer, Malinowski makes this distinction between science and magic:

> Science is born of experience, magic made by tradition. Science is guided by reason and corrected by observation, magic, impervious to both, lives in an atmosphere of mysticism. Science is open to all, a common good of the whole community, magic is occult, taught through mysterious invitations, handed on in a hereditary or at least in a very exclusive felicitation. While science is based on the conception of natural forces, magic springs from the idea of a certain mystic, impersonal power, which is believed in by most primitive people.[53]

In these definitions, magic and religion are both relatively closed systems, resistant to change from within, while science is the best example of an open system that encourages and thrives upon changes from within the system itself.

While we may never know with any certainty what our prehistoric ancestors believed and thought, we can see evidence in the arts and artifacts they left behind that hints at magic, religion, and science. In their study of images of gods and goddesses from the Neolithic Age (10,000 to 5,000 B.C.E.) to the Copper Age (5500 to 3500 B.C.E.) and the Bronze Age (3500 to 1250 B.C.E.), Anne Baring and Jules Cashford find a declining emphasis on the female goddess figures and the gradual rise of predominantly male god images. Their *The Myth of the Goddess: Evolution of an Image* fails to provide a conclusive answer to the meaning of prehistoric images, but they do note that the decline of the goddesses and the rise of the gods coincide with the evolution–revolution of writing and the coming of civilization.[54]

Although magic and science are related to each other, with many sciences tracing their ancestry to magic as in astrology becoming astronomy, alchemy becoming chemistry, and numerology morphing into mathematics, at their cores magic and science are in direct conflict with each other. In the Cybernetic Age, science has largely replaced magic for explaining and controlling Nature. But all cultures tend to seek understanding of life through a mixture of magic, religion, and science, with beliefs in charms and spells and deities mixed with very practical and pragmatic theories and empirical methods for testing all theories. The symbolic evolution–revolution of language that helped our ancestors survive the last Ice Age by providing the cultural techniques and technologies needed for survival continues to guide our lives today.

For most of the past 5,000 years since the revolution of writing, most people and most cultures survived by using the same symbolic structures and strategies that allowed humans to move from nomadic to settled lives, from gathering–hunting to farming–herding, from bone, stone, and wood tools and weapons to metallurgy, from small tribal groups to large bureaucratic societies, from symbols expressed in words and visual imagery to the beginnings of recorded history with the evolution–revolution of true writing. The tribal identities formed in the Upper Paleolithic continue to define much of human culture to this day, even in the technologically advanced centers of globalism. Tribal loyalties based on race, ethnicity, religion, skin color, caste, and language continue to define and divide people all over the world. Nation states, themselves, are largely based upon the subjugation of local tribal loyalties to one national identity forged through a common language and a common culture.

In Europe, nation states were formed largely by force of arms and the imposition of a common language and culture. The lack of one shared common

language is now testing the limits of the European Union's efforts to forge one common European identity among its ever-growing nation-states. In Asia, Japan is largely a homogenous island state but does have some minorities like the native Ainu and Koreans and other immigrants. China, in its recent communistic–capitalistic global marketing system, is striving to eliminate all traces of non-Han culture, pushing Mandarin as the one common Chinese language system for its 1.3 billion population. The other mass population country of India continues to struggle with its thousands of different languages. While the amended constitution of 1967 named English and Hindi as the two key common languages, it also recognized 22 other official languages, another 33 languages, and over 2,000 dialects.

The United States of America, which prides itself on its multiplicity of peoples and cultures, still proclaims its motto as: *E Pluribus Unum*—"Out of many, one." Discovered by explorers from Europe, the United States was founded largely by descendants of English colonists, mixed with some Dutch, French, German, and other settlers. The great emigrations of the 19th century brought forth waves of German, Irish, Italian, French, Scandinavian, and other nationalities. The American Nation absorbed these immigrants and through public schools and other institutions educated and indoctrinated them into the American–English speaking culture. Rather than being based upon race, religion, ethnicity or language, American identity was based upon a commitment to self-identity as an "American." While the United States has no official language, American English functions as the common language binder. Recently, the growing populations who speak languages other than English as their first tongue have prompted some groups to advocate a constitutional amendment calling for "English First" or "English Only" as the common language for all Americans.

Despite a long-term trend toward the replacement of small, local languages and dialects with larger, more centralized languages, there exists some resistance to this movement. As globalization moves people and societies into something resembling Marshall McLuhan's "Global Village" or only a Global Mall of competing ideologies and languages, we will witness whether large national or global systems will overwhelm local resistance to losing their identities based upon language and culture. Human beings will continue to shape and be shaped by language and all of its external manifestations that attempt to overcome the limitations of time–space and energy–matter needed by the species to endure and to prevail in the struggle for survival.

Limitations of Language

Despite the immense survival advantages bestowed upon human beings by the evolution–revolution of symbolic language manifested as speech and visual imagery, limitations in the acquisition, storage, and sharing of information would in a very few places in very specific times inspire some peoples to develop some of their visual images into coherent codes for representing concepts and words that would forever separate prehistory from history. At the end of the last Ice Age, some 10,000 years ago, as humans moved into the newly-fertile river valleys and changed from nomadic gatherers–hunters into more settled farmers and herders, human populations grew and human societies moved from small tribal groups to larger, more heterogeneous settlements and, eventually, cities. It was a cultural evolution from an age of stone and imagery whose meanings remain a mystery to an age of metallurgy and writing whose meanings can be deciphered, understood, and translated into modern languages.

While language allowed humans to expand their acquisition of information through symbolic labels that provided names for people, objects, events, and processes, speech itself disappears even as we speak. All information contained in speech must be stored in human memory, the same repository for all information gathered through experience and observation. While language translated experience and observation into symbolic structures that could also represent concepts and ideas, the limits of human memory were also the limits of both the quality and quantity of the information to be retained, retrieved, and shared. To check information for accuracy, reliability, and validity, people needed to compare memories to reality and to other memories. This text has taken the position that the Ice Age images were aids to memory, devices to help early humans to organize the storage and retrieval of the information needed for survival. But as life in the post-Ice Age became more complex with more information that needed to be acquired, stored, and shared among ever-increasing populations, the limits of orality become apparent in some locations.

Some method of extending human memory beyond internal storage augmented by group narratives and ritualized images on bones, ivory, and cave walls was needed if expanding populations were to live in larger groups, if cities were to grow and develop, and if societies were to become more complex and more organized. The information gathering, storing, and retrieving systems that had served Ice Age humans so well for more than 25,000 years proved to be inadequate to deal with the new civilizations being created in the Valley of the Tigris and Euphrates in Sumer and in the Nile Valley in Egypt some 5,200 years ago,

in the Indus Valley some 4,200 years ago, and in the river valleys of China some 3,300 years ago. These emerging civilizations, composed of complex bureaucratic, economic, government, and political organizations, needed more than tribal narratives and visual images to encode and decode the vast amounts of information needed to keep these complex systems operating and surviving.

What was required was some system of external information storage and retrieval that could codify the key information needed to sustain the social system through time and across space. Such a system would need to have limited ambiguity to ensure accurate sharing of information. It would need to encode and store information in order to provide maximum durability through time for the generations to come and to provide maximum movement of information through space to bind together the distant reaches of the growing city-states. It would need to provide accurate record-keeping of the population; of the economic, government, legal, military, political, religious, and secular institutions; of the culture and history of the empires engendered by these new institutions.

The evolution–revolution of human language from sign to symbol took many millennia as we evolved from hominid apes to full *Homo sapiens* between 200,000 and 40,000 years ago. The language revolution made us fully human by providing the foundations for all human communication and culture, but language alone, even aided by visual imagery, could not provide the media necessary for civilization to develop. The term *civilization* itself needs to be clarified. In conventional usage, it frequently is used to distinguish between barbarians and those with more development, whether cultural, economic, social, or technological. Here, I am using the term to specify a type of human society based upon the Latin root *civis* which means a citizen governed by the laws of a city. What early city-states had in common that distinguished them from earlier bands, tribes, or chiefdoms was summarized by Jared Diamond in *Guns, Germs, and Steel: The Fates of Human Societies:* A city has a large population living in fixed locations organized by class and residence with one or more ethnicities and languages under a centralized government with a complex bureaucracy and developed legal system controlled by a power center. The economy is based on intensive food production with clear divisions of labor, redistribution of resources (in the form of taxes and other obligations), and a mixture of private and public control over land. The society is stratified but not exclusively by kinship, with luxury goods for the elite, public architecture, and, significantly, indigenous literacy available to provide the information needed to keep all of these systems operating.[55]

The emerging cities of Sumer and Egypt required greater abilities to generate and gather information, greater capacities to store more information, and more efficient systems for retrieving and sharing information than could be provided by language and pre-writing images and signs. The changes in communication needed for and wrought by these early civilizations were both qualitatively and quantitatively different from speech in scope and reach, creating new centers of command and control of information that lead to new ways to invent and exploit the techniques and technologies that fostered the evolutions–revolutions of communication that would extend human understanding, knowledge, and power in the world.

Human language was a triumph of biological evolution that allowed early humans to adapt, improvise, and overcome the challenges of change in the world of Nature by nurturing a human culture based on understanding and controlling the forces of Nature and of human behavior. But the limitations of orality can be illustrated by the simple fact that we do not know the name of one single person from prehistory or the names that were used to signify the elements, the animals, the vegetation, and everything else that coexisted in the world before writing. With writing, we can name names, provide more precise dating, chart the heavens and the earth with maps, keep track of time, and know what the ancient peoples of Sumer and Egypt thought, felt, experienced, and hoped for. We know the names of their gods and goddesses, their conceptions of life and death, their understandings of themselves, and their sense of the cosmos.

Writing was a triumph of cultural evolution that not only improved the generation, storage, and sharing of information but helped to create a new type of human being and human culture. Civilization, at its core, is founded on human communication extended by standardized codes that visually represent words and concepts with less ambiguity and greater information-preservation than was possible with proto-writing systems provided by cave art and later notation systems. Writing signifies the beginning of history because it allowed people to leave behind decodable records of their lives and cultures, using energy and matter to overcome the limitations of time and space that bind oral communication. While language was a necessary component in the complex biological–ecological mixture needed for the evolution–revolution that made modern humans possible, writing seems to have been a necessary component in the complex cultural–ecological mixture needed for the evolution–revolution that made civilization possible. And despite setbacks and even reversals, civilization has been a major player in the history of the world for over 5,200

years. Without writing, what we know about history and prehistory would consist exclusively of tribal narratives carried by human memory augmented by rituals and visual symbols. And, as is true of all cultures of the past not encoded in writing, we would know almost nothing of all the peoples and cultures that perished. Nature gave us no choice in providing language to help us to survive, but human beings chose writing to help meet specific challenges faced by early civilizations in their struggle for survival.

When and where would the next evolution–revolution in human communication come? What would be the environmental variables that would create the need for change? Who would be the central people involved in meeting these changes? What techniques and technologies of communication would be needed to meet the needs for the change? What impacts would these new techniques and technologies have on the people and cultures involved? How would these new media develop and spread? What would facilitate and/or restrain their development and use? What would be the limitations of these new techniques and technologies that would encourage the development of a new evolution-revolution in human communication?

· 3 ·

BECOMING LITERATE

Evolution and Revolution in Writing and Reading

Context

For all physiologically and psychologically normal humans raised in any linguistic environment, language is a birthright that allows them to participate in the speech–hearing (oral–aural) community of those who share a common system of phonetic, semantic, and syntactic codes we call a *language*. As we grow into our different language communities, sharing a common tongue becomes so natural part of our lives that we rarely think of its extraordinary nature but accept it as a normal part of our daily living. Even in the most enlightened societies of the 21st century, people without full language-development are frequently looked upon and treated as being somehow less than fully human beings.

For those of us who live in modern civilized societies, signified by living in a permanent settlement of sufficient size to be called a *city* with a complex, non-sanguine social structure based upon literacy and technological development, writing and reading seem to be as normal and natural as speaking and hearing. We exist in a world shaped by language extended in orality and literacy, with a symbiotic connection between speaking–hearing and writing–reading for those of us who use an alphabetic-based writing system. But

while orality is a biologically-inherited instinct, writing is very much a cultural creation of a limited number of civilizations thousands of years ago and only in the latter half of the 20th century becoming a stated goal for most nations. In 2006, the United Nations Educational, Scientific, and Cultural Organization (UNESCO) estimated that some 862 million adults were illiterate. Given an estimated world population of some 8.7 billion and figuring in the number of preliterate young people, this indicates that more than 10 percent of the world's population are not able to read and write even at the minimal threshold used by UNESCO: "At any minimum level, literary may be vaguely defined as 'ability to read and write in a language.'"[1]

In actuality, children normally learn to speak a language by being in a specific language community, becoming proficient at both hearing and speaking in predicable learning stages. Reading and writing are not natural but cultural, requiring specific and, at times, difficult teaching and learning. While most people are able to learn a language as children without specific instruction, most of us require extensive and specific instruction to become proficient readers and writers. In *Tarzan of the Apes* (1914), Edgar Rice Burroughs has his orphaned boy raised by apes teach himself to read English by decoding the books he finds in his dead father's library by connecting pictures with "bugs"—what you and I call "letters." As Burroughs tells us, "And so he progressed very, very slowly, for it was a hard and laborious task he had set himself without knowing it—a task which might seem to you or to me impossible—learning to read without having the slightest knowledge of letters or written language, or the faintest idea that such things existed."[2] Even more remarkably, he also taught himself how to understand the alphabet and to write, an achievement possible in fiction but rarely, if ever, duplicated in the real world.

To be literate is to be a participant in the world of ideas and information beyond the limits of the now and here, to transcend time and space, to share messages with other people in other places and other times. But literacy did not come easily to human beings, nor did it become the norm for most people and societies until the past six decades. The history of reading and writing is not the story of an evolution–revolution that involved all *Homo sapiens*—but of an evolution–revolution in graphic communication that moved beyond image-making to extend the language instinct in systematic codes of communication that would use sight to augment sound in sharing information among a limited number of specific groups of people united by common cultures into civilizations.

When the last great Ice Age ended some 10,000 years ago, nomadic

gatherer-hunters began to settle down in areas that promised an easier strug-
gle for survival—in river valleys and along coastal plains. Central to the devel-
opment of semi-permanent and later permanent settlements were more
dependable sources of food than could be harvested from gathering and hunt-
ing alone. The harvesting of wild cereals and grains was replaced with the delib-
erate planting, cultivating, and harvesting of domesticated cereals, grains,
fruits, and vegetables. The hunting and herding of wild or semi-wild animals
were augmented and then replaced by the full domestication of animals to be
used for food and materials, for power and transportation, and for companion-
ship and protection. Approximately 11,000 to 9,000 years ago, nomadic peo-
ple began settling down in the valleys formed by the Tigris and Euphrates
rivers in Mesopotamia, the Nile River in Egypt, the Indus River in
India–Pakistan, and the Yellow River in China (to use our modern names for
these rivers and locations).

The information generation–storage–transmission systems available
through orality, augmented by graphic symbolization, would become inadequate
to deal with the needs of an ever-changing and ever-challenging environ-
ment. The mnemonic devices developed to store and transmit information in
oral–aural cultures would be tested by the need to record more information
about more items to be shared by more people over longer stretches of time and
over greater distances in space. The proto-writing etched on bone, ivory, flint,
and stone and drawn and painted on cave walls during the last Ice Age helped
our ancestors to cope with and survive in a decidedly hostile environment. In
the new environments provided by the warming climate and more hospitable
physical landscapes, human beings began to spread out and to populate ever-
greater expanses of the entire earth.

Along with the movement from a Neolithic culture into one increasingly
shaped by metallurgical transformations of ores into copper, gold, silver, tin, and
other metals, came the knowledge and skill in using controlled heat to cast and
to forge decorations, tools, and weapons from these metals and from alloys of
these metals, turning copper and tin into bronze, a much more desirable and
therefore more useful metal, and gold and silver into electrum. Later, the forg-
ing of iron from ore would provide another foundation metal still in use today.

All of these improvements in the techniques and technologies of social
organization; in the materials and sophistication of building structures and cities
from wood, clay, and stone; in the domestication and presentation of food, in
the weaving and sewing of garments; and in the crafting and improving of stone,
wood, and metal decorations; tools and weapons were based upon the human

instinct for language which provided ways for improving human life and survival through understanding and controlling the forces of Nature.

What were needed to organize and sustain all of these revolutionary developments in human culture were ways for commanding and controlling the information and the message systems required to keep these new complex societies operating by balancing chaos with order. It required a cultural evolution that took a period of 5,000 years from the end of the last Ice Age to the dawn of civilization in Mesopotamia and the Nile Valley around 3100 B.C.E.

THE NEED FOR WRITING

As Albertine Gaur asks in A History of Writing, "What is writing and who needs it?"[3] A seminal thinker about inquires into writing, what he called "grammatology," was I. J. Gelb whose 1963 A Study of Writing provided a solid foundation for all studies into the history of writing. In that work, he notes that the English verb "to write" comes from Nordic roots that mean "to tear" or "to incise." He also notes that most languages used verbs for writing that mean "to cut" or "to paint"; for Gelb, these are clear indications that writing evolved from earlier graphic representations by pre-civilized cultures. At the core is the image itself, the human reproduction of what can be seen or imagined. In Gelb's analysis, image-making split into two later graphic representations: "(1) pictorial art, in which pictures continue to reproduce more or less faithfully the objects and events of the surrounding world in a form independent of language; and (2) writing, in which signs, whether they retrain their pictorial form or not, become ultimately secondary symbols for notations of linguistic value."[4]

In attempting to provide a common definition for writing, Gelb offers the following: "Writing is clearly a system of human intercommunication by means of conventional visible marks."[5] In studies of writing, different systems tend to be categorized according to whether they use signs to represent a phoneme (the smallest significant sound in a language), a syllable (the usual utterance of consonants, vowels, or combinations of the two), or a logogram (a sign representing a word or a concept). Written American English, for example, is largely based on a phonemic alphabet system augmented by an Indo–Arabic numeric system in which signs denote numbers and additional systems of signs that carry messages through punctuation, mathematical equations, and other logographic representations.

For Gelb, writing is based on the image. As he notes, "This is clear not only from the fact that all modern primitive writings are pictorial in character, but

because all the great Oriental systems, such as Sumerian, Egyptian, Hittite, Chinese, etc., were originally real picture writings."[6] Gelb's conclusion here would support a view that there is an evolutionary movement at work that is founded in language and that extends from prehistoric images and markings to tally sticks and other forms of mnemonic proto-writing to the emergence of seven fully-formed writing systems: Sumarian in Mesopotamia (3100 B.C.E.), hieroglyphs in Egypt (3000 B.C.E.), Proto–Elamite in Elam (3000–2200 B.C.E.), Proto–Indic in the Indus Valley (2200 B.C.E.), Cretan in Crete and Greece (2000–1200BCE), Chinese characters in China (1300 B.C.E.); and Hittite in Anatolia and Syria (1500 B.C.E.).[7] Of these seven original systems, only Chinese continues to be used for common communication today. But, as we will see later, Sumerian cuneiforms and Egyptian hieroglyphs most likely provided the concept and the forms for the consonant alphabet developed by some West Semites in Canaan around 1500 B.C.E. that was transformed in Greece around 700 B.C.E. into the full-consonant-vowel alphabet that is the base for all subsequent alphabets, whatever their visual forms.

To Albertine Gaur, "All writing is information storage."[8] Therefore, it is an improved and expanded way for people to record and store information they need to enhance their chances for survival. But it may be that even a new way to store information can have influence upon the acquisition, transfer, sharing, and impacts of information. The simple act of writing down information may change the form, volume, value, and accessibility of information without the consent of the writer and the reader. In Gaur's judgment, "What kind of writing a society evolves or chooses, depends largely, if not wholly, on the kind of society it is....The mere availability of writing does not transform a society."[9] This view is common among scholars of new techniques and technologies of human communication. It is countered by those who hold that the structures of media influence the content and uses of information for those cultures that employ these media. As Neil Postman puts it in *Technology: The Surrender of Culture to Technology* in discussing writing, "...the uses made of any technology are largely determined by the structure of the technology itself—that is, that its functions follow its forms."[10] Harold A. Innis, the Canadian economic historian, claimed that "Writing enormously enhanced a capacity for abstract thinking."[11] Building upon Innis, Marshall McLuhan and Robert Logan extended the argument that form encourages function by proposing that "Not only should one expect a major difference in the thought patterns of literate and pre-literate people, but one should also expect a comparable difference in the thought patterns of societies whose writing systems differ significantly."[12] At the

core, it is a question of whether context and intent hold power over form in determining the impact of a technique or technology. We will be encountering that debate throughout the rest of our explorations into the evolution and revolution in human communication that carried us from language to the Internet.

This debate about the impacts of communication techniques and technologies has a long history in Western thought. Plato (c. 427–348 B.C.E.), the Athenian philosopher, provides us with a dialogue between his teacher Socrates (c. 470–399 B.C.E.) and Phaedrus in which the relative values of speech and writing are discussed. To make his point clear, Socrates tells Phaedrus a story about Ancient Egypt and Theuth (Thoth), the ibis-headed god credited with inventing numbers, calculation, geometry, astronomy, and writing. In presenting his inventions to the god-king Thamos (Amun-Re), Theuth says of writing, "This knowledge, king, will make the Egyptians wiser and provide them with better memory; for it has been found as a drug for memory and wisdom."[13] To this bit of promotional hyperbole, the god–king Thamos has a counter-claim:

> Most artful Theuth, one person is able to bring forth the things of art, another to judge what allotment of harm and of benefit they have for those who are going to use them. And now, you, being the father of written letters, have on account of goodwill said the opposite of what they can do. For this will provide forgetfulness in the souls of those who have learned it, through neglect of memory, seeing that, through trust in writing, they recollect from outside with alien markings, not reminding themselves from inside, by themselves. You have therefore found a drug not for memory, but for reminding. You are supplying the opinion of wisdom to the students, not truth. For you'll see that, having become hearers of much without teaching, they will seem to be sensible judges in much, while being for the most part senseless and hard to be with since they've become wise in their own opinion instead of wise.[14]

In this passage, Socrates not only states an early case for function following form but also makes a case for inquiry-based critical learning over the accumulation of information favored by those concerned with providing students with ever-increasing amounts of information available in easily-assessable databases, a criticism leveled today against the Internet.

Still, despite the skepticism of Socrates, most people who have commented on writing have tended to praise it as the most wonderful human achievement. In his *Logic*, Aristotle (384–322 B.C.E.), Plato's student, wrote, "Spoken words are the symbols of mental experience and written words are the symbols of spoken words."[15] To the great 20th century Egyptologist James Henry Breasted, "The invention of writing and of a convenient system of records on paper has had a greater influence in uplifting the human race than any other

intellectual achievement in the career of man."[16] Breasted also insisted that "Writing exists only in a civilization and a civilization cannot exist without writing"[17] In *The Story of Writing: Alphabets, Hieroglyphs, and Pictograms*, Andrew Robinson introduces the subject with these words: "Writing is among the greatest inventions in human history, perhaps *the* greatest invention since it made history possible."[18]

And this may be the greatest impact from the evolution–revolution of literacy—that of separating pre-history from history. Even if we begin our chronology of human communication as late as 50,000 years ago with the development of language among *Homo sapiens*, that still leaves 45,000 years of pre-history compared to a mere 5,000 years of history (and that restricted to very few people in very few societies for much of that time). Most human beings and most human societies have managed to survive without literacy and written history since we became fully human. Only in a few places at specific times did peoples and cultures feel challenged to find new ways to encode, store, and retrieve information vital to their survival.

The explorations into literacy that follow are guided and shaped by the work of I. J. Gelb who provided two basic premises for understanding the history of writing:

> **Premise I**—From the point of view of the theory of writing the evolution is from a word-syllabic writing through a syllabic writing to an alphabetic writing.
>
> **Premise II**—From the historical point of view the development is from the Egyptian writing through the West Semitic writing to the Greek writing.[19]

In taking this direction, I am fully cognizant of other scholars who insist that there is no progression in the history of writing, that logographic and syllabic systems are neither forerunners to nor inferior to alphabetic writing.[20] Let us examine the historical record in our explorations of these conflicting viewpoints.

People

Before writing, human beings exhibited the capacity to create and use graphic representations and visual images to convey information among people

sharing a culture. The Ice Age carvings, drawings, and paintings provide evidence of a 20,000 year legacy of visual communication we could label "proto-writing." In addition to prehistoric images, our ancestors kept count with tallies recorded on bones, stones, and sticks or in knots on natural or manufactured lengths of animal hide, cotton, thread, rope, and the like. The use of clay tokens containing lines and notches has been offered as evidence of pictographic writing in embryonic form.[21]

Ancient Sumer

The oldest forms of time writing so far discovered consist of clay tablets from the city of Uruk in Sumer that have been dated as coming from 3300 B.C.E. The later pictograph system of some 700 signs seems to be concerned with the pragmatics of commerce and trade, with identifying commodities, amounts, and transfer of ownership. By 3100 B.C.E., these pictographs had evolved into a more abstract system of cuneiform (wedge-shaped) signs pressed into wet clay by a stylus. This cuneiform writing continued to be used in Mesopotamia by succeeding civilizations using different spoken languages from Sumerian to Akkadian to Babylonian to Aramaic, a 2,300-year history that we can now read in translation.[22] By about 2500 B.C.E., cuneiform was being used by the Sumerians to organize the state in terms of how the government and the economy were administered. Writing provided the techniques and technologies necessary to keep the city-state operating as it listed its citizens, ran its bureaucracies, policed its populace, structured its army, collected its taxes, and established its laws.[23]

Sumarian writing evolved from early pictographic to syllabic cuneiform signs pressed by a reed, bone, or ivory stylus into clay. The signs and related images were also carved into stone and etched into glass, ivory, metal, and wax to be used as cylinder seals by royals, nobles, and officials.[24] In a sense, this first writing system was a prototype for all subsequent writing. A human being used hands to wield tools for imprinting signs on surfaces that were transportable over space (clay tablets) or were durable over time (stone pillars, blocks, and the like). The code moved from pictographic (representational) to syllabic (abstract) and consisted of a relatively large number (700) of signs which required formal training as a scribe to achieve literacy.[25] Thus, literacy in all of the history of the succeeding civilizations in Mesopotamia remained scribal, commanded and controlled by the power elite who ran the government, the economy, the army, and the religion. Along with written language, the

Sumerian system also allowed for numbers and mathematics, beginning with a base 60 system (still in use as our way of dividing up time and angles).[26]

Whether writing originated in one place and was transferred to other places through what anthropologists call "blueprint copying"—the direct copying or modifying of an original design, or "idea diffusion"—the knowledge of a concept that inspires the development of a new system that shares only the concept (writing) with the original, Sumer in 3100 B.C.E. provided the world's first fully developed writing system. Some scholars are adamant about insisting that "fully developed writing was invented in southern Mesopotamia for the first and perhaps the only time."[27] Others are more cautious, crediting the Sumerians with being the first but leaving open the possibility that other people could have developed writing on their own. As Jared Diamond notes in his Pulitzer Prize winning *Guns, Germs, and Steel: The Fates of Human Societies*, "With the possible exceptions of the Egyptian, Chinese, and Easter Island writing to be considered later, all other writing systems devised anywhere in the world, at any time, appear to have been descendants of the system modified from or at least inspired by Sumerian or early Mesopotamian writing."[28]

As the people of Sumer moved from proto-writing to actual writing from 3300 to 3100 B.C.E., the book-keeping impetus for writing expanded to record other areas of the culture. As Joan Oates claims in *Babylon*:

> By far the greatest number of these documents are economic in content, dealing with such mundane transactions as sales of land and loans. There exist also royal inscriptions, usually records of a king's military campaigns or building activities; letters, myths, proverbs and other literary texts; school practice tablets, mathematical, astronomical and other "scientific" texts; and many other varieties.[29]

Like all early writing systems, the Sumerian system was essentially a scribal-controlled set of techniques and technologies that restricted the spread of this new way to record and recall information. This command and control of written information by the power elite can be observed in the ways that Mesopotamian writing treats the history of the culture. The "king-lists" and other chronicles were not intended to provide accurate recordings of the past but to provide authenticity and legitimacy for the then current rulers. Thus, much of what we now call Babylonian history is based on sources and documents that were intended for propaganda purposes.[30] This last use is an example of how a technique or technology (writing) designed to serve one purpose (record-keeping) can quickly be used to serve many purposes not considered by the inventors.

ANCIENT EGYPT

A second culture in the Ancient Near East that has a claim for consideration as a birthplace of literacy is Ancient Egypt. At roughly the same time period that cuneiform writing was evolving from Sumerian pictograms, Egyptian hieroglyphs seem to have emerged full-blown in the Nile Valley. Evidence of hominid existence in this area dates from some 700,000 years ago in the form of stone tools.[31] About 90,000 years ago, Neanderthals migrated into the Nile Valley where evidence of a more efficient and sophisticated technology of toolmaking suggests that early *Homo sapiens* soon followed.[32]

Geographically, Egypt exists as a habitable environment for humans because of the Nile River which flows north from Africa and empties into a delta where the river reaches the Mediterranean Sea. It is a land divided into two parts by the Nile—the Black Land (*k-m-t* to the Ancient Egyptians) surrounding the Nile River and the Red Land (*d-s-r-t*), the vast stretches of arid desert east and west of the Nile. From the earliest written records we learn that Egypt was also divided into two political entities—the two kingdoms of Upper and Lower Egypt that were united by the possibly mythical first pharaoh, Narmer/Menes, the Lord of the Two Lands, who united the two kingdoms into one empire around 3100 B.C.E., a date which coincides with the emergence of a full writing system composed of carved hieroglyphs and cursive hieratics. As Michael A. Hoffman notes, "Almost universally, the presence of writing is taken as a sign that a society has made or is making the transition from prehistory to history."[33] What seems remarkable about Egyptian writing is that it appears to have been well developed from the beginning, appearing "on stone grave markers, jar sealings, wooden and ivory labels and plaques, and ceramic and stone vessels."[34] One distinguished Egyptologist, John Wilson, thinks that the Egyptians clearly borrowed the idea, but not the form, of writing from Sumer, using symbols to represent words or ideas and the rebus-principle to provide phonetic connections to the sounds of the Ancient Egyptian language.[35]

In the narratives of Ancient Egypt, it was Narmer/Menes, the King of Upper Egypt (southern Egypt geographically), who united the two lands of Upper and Lower Egypt, most likely by force of arms, and founded the first pharaonic dynasty in the newly built city of Memphis (*circa* 3100 B.C.E.). No contemporary account exists for this seminal event, with the Palermo Stone's listing of ancient kings crafted some 700 years after Narmer/Menes.[36] Whether the Egyptians borrowed the idea of writing from Sumer or developed it independently, they did have a fully functional writing system in place by the time

of the unification of Upper and Lower Egypt. We owe our understanding of the history of Ancient Egypt to the work of Manetho, a priestly advisor to a much later Greek general and statesman, Ptolemy, who ruled Egypt as governor (323–305 B.C.E.) for Alexander the Great and later as Pharaoh (305–282 B.C.E.). Manetho's list of dynasties and rulers began with the unification of Egypt in 3100 B.C.E. and ended with the death of Nectanebo II (343 B.C.E.), the last Egyptian pharaoh.[37] Manetho seems to have based much of his early chronology on Egyptian records going back as far as the Palermo Stone.

Of special interest to Egyptologists is a large white limestone ceremonial mace head depicting a pre-dynastic ruler called Scorpion after the image of a scorpion depicted near the king. Scorpion appears to be digging a canal for irrigation for agriculture. Significantly, Scorpion is depicted wearing the tall white conical crown of Upper Egypt. Scorpion is usually thought to be the predecessor of Narmer/Menes, the reputed unifier of the two lands.[38] Dating from about 3000 B.C.E. is the Narmer Palette, a greenish siltstone tablet carved to represent a palette but clearly designed for ceremonial rituals. Some 25 inches in length and carefully carved on two surfaces, the palette depicts Narmar (literally *Nr-mr*, "The Stalking Catfish") on one side wearing the white conical crown of Upper Egypt and preparing to strike a cowering enemy with a mace. Above Narmer is the falcon image of the god Horus signifying his approval. On the reverse side, Narmer is depicted wearing the low red crown of Lower Egypt. Together, the two sides of the palette represent the Unification of the Two Lands.[39] Whatever the exact dates of this event, we now know the foundations for what we call *history*, the recording of significant people, deeds, and events in some chronological order that separates cultures that develop writing from their predecessors and from all other cultures that continue to rely upon human memory and associated mnemonic devices to store and retrieve information.

The history of Ancient Egypt is now quite well understood because of the recovery of the coding systems we call *hieroglyphic*, *hieratic*, and *demotic* made possible by the discovery of the Rosetta Stone by soldiers of Napoleon Bonaparte's French Revolutionary Army in Egypt. In July 1799 in the village of Rashid, the soldiers found the granite slab which measures 3 feet 9 inches high, 2 feet 4.5 inches wide, and 11 inches deep, and weighs some 1500 pounds. The key to the decipherment was that the Rosetta Stone contained three different writing forms; from top to bottom, these were hieroglyphic, demotic, and Greek alphabetic signs. Copies of the inscriptions were made available to language scholars in Europe. In England, Thomas Young (1773–1829), a Fellow of the Royal Society, began the work in 1814 but it was a Frenchman, Jean-

Francois Champollion (1790–1832), who decoded the three writing systems in 1823 largely by noting the hieroglyphic, demotic, and Greek representations of the *cartouches* (literally "cartridges" in French, which the soldiers called the roped enclosures that contained the names of the gods and royals) of Ptolemy and Cleopatra, the throne names of the kings and queens of the Greek rulers of the Ptolemaic Dynasty (305–30 B.C.E.) which ended with the death of Cleopatra VII and her son Ptolemy XV (Caesarian) in 30 B.C.E. .[40]

Egypt, as a pharaonic empire, existed from the unification of Upper and Lower Egypt in 3100 B.C.E. with Scorpion and Namer, achieved greatness with the building of the pyramids by Djoser, Khufu, Khafre, and Menkaure at Saqqara and Giza in the Old Kingdom (2606–2181 B.C.E.), recovered from the Hyksos invasion and restoration of the country by the rulers of the New Kingdom (1570–1070 B.C.E.), notably Ahmose I, Queen Hatshepsut, Tuthmose III, Akhenaton (the heretic believer in one sun god), his ill-fated successor Tutankhamun (the boy king made famous by the splendor of the riches found in his largely intact tomb), and the Rameside family, notably Ramses II (1279–1212 B.C.E.) who ruled for an astonishing 67 years, had eight great royal wives, countless concubines, and hundreds of children, declined with invasions from Kush (today's Sudan) and Persia (525–404 B.C.E.), and ended with the Ptolemaic Dynasty (305–30 B.C.E.). After 30 B.C.E., the Romans ruled the country with some of the emperors being depicted on temple walls as pharaohs.[41] What is astonishing is that for more than 3,000 years, the cultural, economic, political, religious, and social structures of Ancient Egypt exhibited a continuity and continuance unequalled by any other civilization. A large measure of that stability can be attributed to the writing system that incorporated first hieroglyphics, then hieratics, and later demotics to help keep the socio-cultural institutions intact. The language and culture of Ancient Egypt were preserved not only for the Egyptians but also for future civilizations who were able to decode the writing system for a further understanding of the lives and achievements of people long dead. Unlike the people of prehistory of whom we have only their tools and images by which to guess at the ways they lived and their accomplishments, the names, lives, and accomplishments of the Ancient Egyptians are as known to us as are those of our own recent history. Simply put, with writing comes history, a chronological record of the past that is preserved for the future.

What seems clear from the early histories of writing in different places and times, whether in Sumer or Egypt around 3100 B.C.E., in the Indus Valley around 2200 B.C.E., or in China around 1300 B.C.E., is that the techniques and

technologies of the systems of communication were commanded and controlled by the power elites of each of these civilizations. This use of writing as both symbol and weapon of power would continue to be a hallmark of every culture that embraced this visible means for encoding, storing, and sharing information. Writing became the prime tool for organizing not only information but society itself in terms of economic, government, military, police, religious, and other forms of power. It is power that provides the key for command and control, and power can be found in possessing not only the information needed for survival and dominance but also control over the communication systems of a society.

The kings and rulers of Ancient Sumer, Egypt, India, and China would later be joined by other power elites who would use writing in their quests for command and control, whether in Ancient Greece and Rome, in Medieval and Renaissance Europe, or in the Modern World. The struggle would go between those trying to limit writing, and therefore information and knowledge, to the few and those seeking to extend these gifts to the many. Control of writing would be attempted by all rulers through customs, laws, and sanctions but would also be facilitated by the very form of the writing itself. If knowledge is power, then restricting writing is one way to ensure control over this most powerful extension of language.

As Gelb notes, the Sumerian writing system was in response to the need for record-keeping for economic and administrative requirements within a state-controlled agricultural and trading environment.[42] Early signs were logographic (word signs) and identified "numerals, objects, and personal names."[43] Personal names were frequently impressed into clay by means of cylinder seals, rather as a signet ring or stamp seal is still used today to identify the owner without having to write the name repeatedly. From its origins in service to the rulers of Sumer, cuneiform was adopted by a number of other peoples who encountered the Sumerians, beginning around 2500 B.C.E. "by the Semitic Akkadians and a little later by their Near Eastern neighbors, the Elamites. In the second millennium, it was the Hurrians of northern Mesopotamia and the Hittites of Anatolia who borrowed the writing of the Akkadians."[44] But no matter which peoples adopted the cuneiform system, they used it to preserve the power of the elites, restricting its use to the few by continuing its complex system of some 700-plus signs that were both logographic and syllabic, making no real effort to change the writing system to accommodate the different phonetic sounds found in each of these different languages.

All known writing seems to be based upon three general approaches that

attempt to convey information by having a written sign signify a word, a single syllable, or a single phoneme. Interestingly, the earliest forms of writing seem to have been based upon the most complex representation—that of an entire word or concept represented by a sign. Thus, Sumerian cuneiforms, Egyptian hieroglyphs, and Chinese characters all began as logograms, representations of words; however, all of these systems also contained phonemic and syllabic elements. This is also true of modern alphabetic writing. In American English, for example, a quick look at your computer keyboard will reveal a large number of logograms in the form of our Indo–Arabic numeral system and other signs like @, $, %, &, +, −, ÷, ×, and =, which stand for at, dollar, percent, and, plus, minus, divided by, multiplied by and equal respectively.

All writing systems that are logographic have a large number of signs (700 for Sumerian cuneiform, 700 for Egyptian hieroglyphics and hieratics, 50,000 for classical Chinese), requiring extensive and intensive training for professional scribes, thus limiting literacy in those cultures to craft (scribal) literacy. The reluctance to change to a more syllabic or alphabetic system on the part of the power elites in Sumer, Egypt, and China may stem in part from their desire to limit literacy to the few who could more easily be controlled by the leaders of those societies. Simply put, it was not in the self-interests of Sumerian kings, Egyptian pharaohs, or Chinese emperors to develop systems of writing that would make social literacy a reality. In Egypt, for example, scribes were essential helpers to the pharaohs who ruled with the assistance of bureaucrats, governors, military leaders, and priests of the temples. In Egypt, there was no separation of church and state, as the pharaoh was not only the chief priest of the central religion but also the supreme ruler of the government and the commander-in-chief of the armed forces. He was the living god of Egypt, the earthly embodiment of the hawk-headed god Horus, son of Osiris and Isis, who restored order by defeating Seth, his uncle who had slain Osiris. As the living god of Egypt, the pharaoh commanded and controlled all aspects of life, including writing itself. Without writing, no records could be kept, no history recorded, no propaganda created to extol pharaoh and Egypt. Writing itself was a pathway for advancement in a culture that would remain remarkably intact for some 3,000 years. The words of a bureaucrat named Dua-Khety to his son Pepy resonate with us from some 4,000 years ago: "It is to writing that you must set your mind....I do not see an office to be compared with [that of a scribe]....I shall make you love books more than your mother, and I shall place this excellence before you."[45]

Young scribes, like Pepy, learned their craft during grueling years of toil to

master the intricate writing system, practicing their brush strokes on flat pieces of limestone and broken pottery or inscribing hieroglyphics and hieratics on erasable writing boards covered with a mixture of plaster and glue before finally being permitted to write on the sacred papyrus sheets created by pounding strips of a papyrus plant into flat surfaces to be dried in the sun, to carve hieroglyphs into stelle, obelisks, and other stone surfaces, or to etch and paint hieroglyphs onto the wet plaster covering temple and tomb walls. The Egyptians called writing *mdw ntjr*, literally "The words of the gods," signifying the magic and the power of writing as symbol and ritual.

The people who invented or adopted writing and the people who employed scribes to keep records of their societies were people who had moved from the nomadic and semi-nomadic societies of the Neolithic Period to permanent settlements in the city-states of the Early Bronze Age (3100–2100 B.C.E.). The word we use to describe these new societies is *civilization*, derived from the Latin *civitas*, meaning "city." Thus, civilization means living in cities distinguished by large-scale holdings and walls to protect the city and its people. These permanent and safer settlements attracted growing populations which generated economic growth, including the hoarding of resources and the need for a system of written record-keeping.[46] Their motivations were fundamentally based upon survival for themselves and their cultures, but survival quickly moved from economic survival to encompass political survival, social survival, and even symbolic survival in the form of state religions, all commanded and controlled by the power elites, usually in the form of kings, priests, and warriors, frequently united in one figurehead, as with the pharaoh of Egypt. Their reward was power itself, and they used writing to augment their economic, political, military, and religious power. In essence this power was based entirely upon symbols, and writing multiplied the force found in spoken words and visual images to forge formidable organization for producing what will later be called propaganda, the deliberate manipulation of symbols and messages to shape a mass audience's perceptions and behavior according to the desires of those in command and control of the dominant media in the culture.[47]

Messages

Writing began as a visual system for storing information, usually records of the production, storage, and transfer of commodities, and for establishing ownership, trade obligations, and tax payments. It also provided for the identification of individuals by their names or signs in cylinder seals, signets, and signs. The

contents of early writing systems in Sumer and Egypt, and later in India and China tend to be similar. In addition to identifying individuals in terms of power kings and pharaohs in Sumer and Egypt, rulers and emperors in India and China—with appropriate messages proclaiming their divine right to rule and their magnificence, other early writing also concerned itself with providing for the legitimacy and organization of the city-state with laws, regulations, statutes, and the like. In short, the messages contained in early writing provided the symbolic structures needed to organize a large-scale civilization capable of extending its reach through both time and space. As is true of all human communication systems, writing was used to enhance the culture's chances of survival.

Survival, of course, refers to the actual survival of the people and their culture in any society by ensuring that their physiological, security, belonging, esteem, and aspirational needs are met. Writing provides both the description of and the justification for how civilization is structured, with clear descriptions of how every member of the system relates to the whole. In Ancient Sumer, cuneiform signs pressed into soft clay recorded accounts of the temples and the priests, and rulers who represented the gods on earth. In answering the mythic question concerning creation, the Sumerians provided a cosmology that Joseph Campbell summarizes as follows:

> First was the primal ocean…which generated the cosmic mountain, which consisted of heaven and earth unified; An (the Heaven Father) and Ki (the Earth Mother) produced Enil (the Air God), who presently separated An from Ki and then himself united with his mother to begat mankind.[48]

Although writing began in Sumer in 3100 B.C.E., the earliest date we can rely upon is from about a thousand years later. Even the chronological lists of kings are not entirely trustworthy until the reign of Sargon of Akkad (2360–2305 B.C.E.), one of these near-mythic heroes who rose from a humble birth to achieve greatness with the help of a goddess (Inanna/Ishtar) by becoming the warrior king who took the throne by force of arms.[49]

The Evolution of the Alphabet

From all available evidence, the evolution of writing is a continuation of the image representations found in prehistoric art, especially in the tokens used to count objects, track time, or indicate ownership. While a full system of writing seems to have come earliest in southern Mesopotamia around 3100 B.C.E., other places have claims for developing full writing systems. Egypt, the Indus Valley, and China and Mesoamerica are all contenders. But the evolution of

writing that led to the alphabet can be traced to the Middle East. Beginning with the Sumerians and the Egyptians, early writing systems began to incorporate phonetic principles into their signs, most likely to distinguish between signs with more than one possible meaning (as we do with spelling *their, there*, and *they're* differently to signify the different meanings for the same sounds).

Whatever the motivation, it was a group of West Semites, living in what is today's Israel, Lebanon, Palestine, and Syria, who most likely used the phonetic principle found in cuneiform and/or hieratics to shape a new writing system. These Canaanites were essentially middlemen trading in the nexus "of the Egyptian, Hittite, Babylonian, and Cretan empires...[who] needed a script that was easy to learn, quick to write, and unambiguous."[50] Although alphabetic representations existed in both Akkadian cuneiform and Egyptian hieratics, neither culture developed them into free-standing systems of writing. In the history of communication, we will see that changes in the techniques and technologies of communication do not always come from the culture possessing the most advanced system at the time. Indeed, it could be that change is more likely to come from those who are more open to the new and resisted by those who are heavily invested in the status quo. In any case, the most likely inventors of the first consonant alphabet were the Canaanites of some 1500 B.C.E.

The next major players in this evolution of writing from pictogram to full alphabet were the people we call Phoenicians, the great trading masters of the Mediterranean at that time. Their name is one used by the Greeks and may mean "traders in purple." The Greeks would also use the term "Phoenician alphabet" for the writing system they adapted, hence our current use of "phonetic" to mean "sound," as in phonograph (sound writing) and stereophonic (hard sound). This Phoenician alphabet contained 22 signs (letters) to denote consonant sounds, but there were no signs for vowels, possibly because Semitic languages rarely use vowels to carry significant meanings. "In any case...the names of the letters are the same as those used by Hebrews and today in the Hebrew script."[51] In order they are: *aleph, beth, gimel, daleth, ke, waw, zayin, heth, teth, yod, kaph, lamed, mem, nun, samekh, ayin, pe, sade, qoph, reš, šin, taw.*

In their interactions with the Phoenicians in either Greece, Phoenicia, or both, the Greeks, some time between 1000 and 800 B.C.E., began to use and adapt the Phoenician alphabet. This estimate is based upon examinations of the directions of Phoenician and Greek writing. Early Phoenician writing was not fixed in one direction, right to left, until about 1050 B.C.E. and Greek writing was itself unstable, moving from right to left, left to right, or in alternat-

ing lines between the two in a style called "boustrophedon" (as the ox plows).[52] The 22 Phoenician signs were adapted by the Greeks to represent both consonants and vowels in a 23-sign system: *alpha* (now a full vowel), *beta, gamma, delta, epsilon, zeta, eta, theta, iota, kappa, lambda, mu, nu, xin, omicron, pi, rho, sigma, upsilon, phi, chi, psi,* and *omega.*

Whatever their motivations for adopting and adapting the Phoenician alphabet, the Greeks quickly went beyond mere recordkeeping and used their new system to create written poetry by transcribing their epic songs.[53] In *Origins of Western Literacy*, Eric A. Havelock, a scholar who chaired the classic departments at both Harvard and Yale, identified the differences between craft and social literacy as depending upon three conditions: "First, that the coverage of linguistic sound offered by the writing system should be exhaustive....Second, this function should be performed unambiguously....Third, the total number of shapes must be held to a strict limit to avoid overwhelming the memory with the task of mastering a large list of them before the process of recognition, that is reading, can even begin."[54] Only when these three conditions are met can it be possible for reading and writing to become part of children's learning process before they reach puberty and are fully fluent in their spoken language.[55] In rejecting claims for a "Northeast Semitic Graeco–Roman–Etruscan alphabet," Havelock writes, "The Greek alphabet was a true alphabet because it was the first and only system to achieve concurrently the three conditions for reading I have previously analyzed."[56] In stressing the Greek contributions to literacy, Havelock notes that the word *alphabet* is itself derived from the first two letters of the Greek system *alpha* and *beta.* As he puts it, "The Greeks did not just invent an alphabet; they invented literacy and the literate basis of modern thought."[57]

Seeing the alphabet as the most efficient system for representation of spoken language, Havelock nevertheless acknowledges the varieties of alphabets that have been spawned by the Greek triumph. For the Western World, the adoption–adaption of the Greek alphabet by the Romans was the most influential since it provided all of the peoples of Western Europe and the Americas with what we call the Roman alphabet. This evolution was one not governed "by phonetic logic but by politics in the general sense of that term."[58] The core of Havelock's argument is that the alphabet can be viewed as a long evolution from proto-writing to pictographic to logographic to syllabic to partial (consonant) alphabetic writing to the revolution of the Greek alphabet and its subsequent spread throughout the world. Today, the Roman script and variations of its 26 letters are the foundation for Western literacy: A, B, C, D, E, F, G, H,

I, J, K, L, M, N, O, P, Q, R, S, T, U, V, W, X, Y, Z.

The Greek alphabet gave the Greeks a way to extend their epic poetry, with its tales of gods and goddess, heroes and heroines, monsters and villains, hope and despair, over time and space. It allowed Plato to quote (or misquote) Socrates, Plato to move from dialogue to essay in *The Republic*, Aristotle to analyze everything from poetry, drama, and rhetoric to biology and politics, Herodotus (480–425 B.C.E.) and Thucydides (460–400 B.C.E.) to create history as an art form, Aeschylus (525–456 B.C.E.), Sophocles (496–405 B.C.E.), and Euripides (480–405 B.C.E.) to create tragedies that touch us today, and countless early scientists and scholars to probe the mysteries of life and death, of the earth and the universe.

The Romans continued this tradition of literacy, copying the left to right direction of the Greek letters but altering them in form and position. As in Greece, literacy became more than the exclusive province of the scribes controlled by the leaders. In both cultures, literacy moved from a scribal craft to a more widespread social accomplishment. Although scribes continued to be used widely, increasing numbers of free citizens of Rome were given schooling in reading and writing, usually in Latin and Greek. Roman tradition dated the founding of the city to 735 B.C.E. by Romulus, and from 753 to 31 B.C.E., the Roman Republic conquered all of Italy and controlled most of the lands surrounding the Mediterranean Sea. Along with its army, imposed law and order, and extensive system of transportation by roads and sea lanes, Rome ruled this domain through the unifying command and control system of information made possible by alphabetic writing. Even after the fall of the Republic and the emergence of the Roman Empire (27 B.C.E.–476 C.E.), writing played a central role in maintaining communication and control over an empire that stretched from Egypt in the east to the shores of the Rhine River in Germany, encompassing all of today's Spain, Portugal, France, Germany, parts of England, and most of Balkans. The fall of the Roman Empire in 476 was symbolized by the loss of literacy as much as it was by the loss of military power.[59]

The fate of literacy in the West now depended upon Roman Catholic monks, many of them Irish, who preserved the new scribal literacy through the long years of the Dark Ages and the Middle Ages (500–1300) until the Renaissance (1350–1600) and the return of social literacy. Although no longer regarded as a time of total stagnation, the period from 500 to 1300 is still a time when literacy reverted from an increasingly social skill to a largely scribal activity.[60] The Renaissance and the Protestant Reformation (1517–1648) challenged the control of literacy by the Roman Catholic Church and helped

to usher in the age of modern thought characterized by a scientific method of inquiry based more upon thesis testing than on received wisdom and an increased interest in expanding literacy made possible by the revolution of printing begun by Johann Gutenberg's printing press in Mainz, Germany in the 1450s.

European explorers, adventures, and colonists would carry literacy across the globe, notably to North and South America where Western alphabetic literacy would replace existing non-alphabetic systems or bring writing to cultures that had never known literacy.

The text you are reading and any notes you are taking by hand-writing or entering into a computer use an alphabetic system of writing that is a direct descendant of the Graeco-Roman revolution, with some changes over the years, largely in the form of upper and lower scripts and punctuation marks. Thus, all literate people are centrally involved in the continuance of writing as a social skill that extends our senses and our knowledge and understanding through the presentation of information over time and the spreading of information across space. The modern world is based upon the messages and the message systems made possible by literacy. All of what we call the arts, education, the humanities, the sciences, and the social sciences are predicated upon literacy. Without literacy and the messages it allows us to share over time and space, there would be no schools as we know them today. Our very definitions of information, intelligence, and knowledge would be quite different in a world without literacy. Writing, especially alphabetic writing, helps to free all humans from the tyranny of the now and here of any culture.

Consider, for a moment, your own experiences with literacy. When and how did you learn to read and write? What motivated you to learn these skills? How did literacy change your life? What messages and message systems are made possible by literacy that would be unavailable without reading and writing? How would you function without being able to read and write?

Media

In the beginning, all of the media of the evolution–revolution of literacy were based upon sight, with touch systems for the blind coming only in the 16th century with alphabetic letters engraved on wood and later on metal. Eventually these scripts were embossed on paper, but it was not until Louis Braille (1809–1852) developed his system of dots to represent letters that the blind could be taught to both read and write:

The Braille alphabet consists of varying combinations of one or more raised dots on a six-dot oblong known as a Braille cell, which is three dots high and two dots wide. There are sixty-three possible combinations which provide for all the letters of the alphabet and also for punctuation, contractions, etc. Combinations of dots have also been worked out to signify mathematics, music, and other specialized fields. Braille is written with the aid of a metal slate or on a specially-constructed Braille typewriter.[61]

The key point to note about Braille is that it is based upon the alphabet, that most efficient system of encoding-decoding of information in written form. Each system of writing—whether logographic like cuneiform or hieroglyphics, syllabic like Arabic, or alphabetic like the Hebrew, Greek, or Roman scripts—is a medium in itself in that each system shapes how information will be shared among people.

While non-phonological writing systems seem to have been common at the dawn of literacy, phonological systems constitute the vast majority of the 21st century writing systems, with Chinese (with some 2,000 signs needed for basic literacy) and Japanese (using some 1,850 signs) writing systems continuing to be largely logographic. Phonological systems can be divided into two realms: alphabetic and syllabic in which each sign (grapheme) represents a spoken syllable of a language, usually a consonant–vowel combination. Syllabics are found in the ancient world with Mycenaean Greek and in modern Amharic, Cherokee, and Japanese *Kona* (used to write foreign words). Alphabetic systems based upon the consonant alphabet developed around 1700 B.C.E. in the Middle East and became the foundation for the Hebrew, Arabic, and Phoenician scripts that carried the alphabetic principle across the globe. The efficiency of alphabetic writing can be found in the limited number of signs needed, ranging from a mere 11 needed in the Solomon Islands in the South Pacific to 74 used by the Khmer in Southeast Asia. The majority of alphabets in use today contain some 20 to 30 signs, with American English in the middle with 26 letters. But let us remember that we also use a large number of logographic signs as well in our writing, and especially in our typewriting, printing, and word processing.[62]

In addition to the actual scripts used, the media of literacy also include the surfaces upon which scripts are written. These range from natural stones and rocks to mineral modifications like slate, clay, pottery, and metals; vegetable modifications like palm leaves, tree bark, wood strips, cloth, papyrus sheets, wax tablets, and eventually paper; and animal modifications that yield bones and scraped skins in the forms of parchment (cow or sheep skin) and vellum (calf or lamb skin). In the latter category, we need to add silk woven from strands

created by silkworms. As Albertine Gaur notes, "Writing material is not neutral; it can shape and influence the development of scripts in matters of general appearance, the way individual signs are formed, and also as far as the direction of writing is concerned."[63] For an immediate test of this idea, imagine that this text were written on some surface other than paper, say bamboo, bone, clay, papyrus, parchment, slate, etc. In actuality, paper made this book possible, although the electronic book (like Kindle) may well offer us a more efficient (in terms of access and cost) technology for carrying the messages of a book to its readers.

As Harold A. Innis taught us, some of these writing surfaces tend to be time-biased, lasting over time because of the durability of the media, or space-biased being easy to transport over distances with relative ease. For Innis, time-biased media encourage centralized and conservative societies while space-biased media encourage far-flung empires and changing societies. He thought that a balance of both types of media was needed for a society to achieve both the continuity and change required for a system to survive.[64]

In the beginnings of writing in Sumer and Egypt around 3100 B.C.E., stone seem to have provided one of the earliest surfaces used. Either in its natural state or as quarried, carved, and polished slabs and stelae, stone is durable and time-biased, well-suited for preserving official messages from civic and religious power elites. From Uruk and Luxor to Athens and Rome, in India and China, and continuing through the Middle Ages in Europe to the Modern World, stone inscriptions on buildings, markers, and monuments continued to be used to signify power and permanence. Dried leaves of plants and trees also were used for writing surfaces, as were wood slats, tree bark, animal shells and bones, ivory from tusked animals, waxed writing tablets, lead pounded into thin sheets, precious metals, and textiles like cotton, linen, and silk. But the main materials crafted with writing in mind consisted of clay shaped and baked by sun or kiln, papyrus manufactured by pounding strips of the plant into sheets, parchment created by treating animal skins, and the all-important paper manufactured by combining fibers from tree bark, fish-nets and any cloth available. While papyrus was the principal writing surface for the Egyptians and continued to be used in Rome and the Byzantine Empire, the Chinese invention of paper in 105 was a revolution in delivery systems for writing.[65]

The story of paper begins in the reign of the Chinese emperor Wu Di of the Han Dynasty. According to Gaur:

> One can reconstruct the earliest techniques of paper-making as follows: tree bark was cut into pieces and soaked in water for a considerable period of time (100 days). The pieces were then pounded in a mortar to separate the inner from the outer bark which

was then removed. The remaining pulp was mixed with either lime or soda ash, heated over a fire to boiling point for at least eight days and nights, and washed repeatedly until the fibers were completely softened. The mixture was then strained and pounded into a soft doughy substance, and bleached. The bleach was removed by further soaking and the mixture was placed in a large vat and some starch added to prevent the finished sheets from sticking together. To make sheets, a frame was dipped into the vat, the sheet drained and eventually lifted from the vat and then well dried on heated wood or brick walls.[66]

This complicated and labor-intensive process was a carefully guarded Chinese state secret for over 600 years, until 751 when the forces of Islam conquered Samarkand and learned the secret paper-making process from Chinese captives. Samarkand became a paper-making center for a hundred years before the secret spread to other centers of the Muslim world, with rags replacing tree bark. In the 12th century, Moorish conquerors brought paper to Spain and Sicily. After the expulsion of the Moors by the Spanish, the secret of paper-making became known to Christian Spain. But before 1492, papermaking was known in other parts of Europe, possibly being carried there by returning Crusaders. The spread of paper manufacture in Europe is impressive: France (1332), Germany (1390), and Austria (1498). In 1690, English colonists in Pennsylvania established a paper mill.[67] Paper is one medium of literacy that is clearly traceable to one birthplace, and we can follow its spread throughout a wide range of civilizations to today.

Paper provides an excellent example of how the evolution and revolution of all human communication is dependent upon a symbiotic synthesis of a number of techniques and technologies that constitute a system of communication. Literacy is more than a combination of the techniques of writing and reading. It is also dependent upon having a system of signs for encoding–decoding, tools to do the writing (chisel, stylus, brush, pen, pencil, etc.), surfaces to write upon, and systems for storing and retrieving the writings. In Egypt, for example, papyrus sheets were usually pasted together and rolled into scrolls for storage and transportation. Later, individual papyrus sheets, with writing on both sides, were folded into two and bound together into codices (the forerunner of books). A codex proved to be more efficient than a scroll because it could be extended easily and the individual pages referred to more quickly (although these pages were not numbered, a practice not common until 50 years after Gutenberg's printing press system was invented in the 1450s). Later, parchment and vellum replaced the vanishing papyri, but the production of these writing surfaces was time and labor intensive as Innis notes in *Empire and Communication*:

> The untanned hides of calves or sheep were put into limewater and thoroughly soaked, the hair scraped off, and the skin stretched to dry on a frame. It was then rubbed with chalk and pumice-stone until it was even and smooth, and the finished product cut into pieces about the size of the pieces of wood covered with wax and written on with a stylus used for writing in Greece and Rome. The pieces were…arranged together in a codex. Used on both sides, parchment was economical, durable, convenient, easy to transport, to write on, to read, and to consult.[68]

The paper evolution–revolution would eventually replace almost all uses of papyrus, parchment, and vellum, except for ceremonial documents. (Universities in Europe and the United States used parchment [sheepskin] for their diplomas for some time, but, by the 21st century, almost all have turned to high quality bond paper for printing their degrees.) But paper was a delivery system for the future, not really achieving its near total dominance until the revolution of printing in the 1450s. From the beginning of true writing in 3100 B.C.E. until the Age of Print, most literate civilizations were dependent upon stone, tree bark, plant leaves and fibers, and animal skins for their writing surfaces. The evolution–revolution of paper can be traced from its epicenter in China in 105, eastward to Korea and Japan (around 600) and westward through Chinese-controlled territories to Samarkand. The Arab conquests carried paper to Baghdad and Damascus (around 793), to Cairo (around 900), to Fez (1100), to the Iberian Peninsula (around 1150), to France (1189), to Cologne (1332); a separate Arab trail carried paper from Cairo to Sicily (around 1100) to Italy (1276) and to Nuremberg (1390).[69] While people have written their scripts on every conceivable surface, from their own skins to natural, altered, and human-made surfaces, stone has served for public messages intended for the ages while silk, papyrus, parchment–vellum, and paper have been the main carries of messages intended for all other communication purposes, both private and public. For public inscriptions, buildings, slabs, statues, stele, and the like served as both writing surfaces and storage spaces for the information. Scrolls, codices, and books found their storage spaces in libraries established by religious and secular leaders. Later, libraries became an essential part of the triad of knowledge that provided the foundation of the university: the acquisition and generation of information and knowledge (research); the storage of information and knowledge (libraries); and the transmission of information and knowledge (teaching of students).

Impacts

It is tempting to sum up the impacts of any evolution–revolution in commu-

nication in one pithy statement. With writing, I am tempted to write, "While language helped us to become human, writing helped us to become civilized." In a general sense, I think that this is an accurate statement, but, obviously, it is too general and lacking in needed nuances and specifics. While writing began primarily as a system for more accurate and durable record-keeping of names of people, possessions, commodities, taxes, and the like used by rulers and priests to keep and extend their command and control of information, eventually it was to have broader impacts. All of the ancient cultures that developed writing, from Sumer and Egypt to the Indus Valley and China, limited their systems to large complexes of signs capable of being learned only with great difficulty over many years, thus limiting the extent of literacy within those cultures to special scribes controlled by the power elite. Even the consonant syllabics developed and spread by the West Semites and Phoenicians failed to extend literacy beyond the functions created for government, religion, and commerce. In Sumer and Egypt, writing helped to perpetuate the official stories that explained the world to the people through religious and political narratives that celebrated gods and goddesses, kings and queens. As Jared Diamond notes, surviving texts from Sumer, Egypt, Mycenaean Greece, India, China, and Mesoamerica are all limited to record-keeping at first, with narratives developing only at later stages.[70]

What is remarkable about early writing systems is how limited in number they were and how slowly they changed or spread beyond their cultures of origin. Diamond claims that writing was limited to those cultures that had already developed the cultivation of animals and crops required to create large stable social systems that needed writing to support such systems.[71] This position is reasonable but does not explain why Egypt, for example, never developed the 24 phonetic signs within its system of some 700 hieroglyphs into an alphabetic system. It is possible that the power elites (rulers, priests, et al.) of these early civilizations found their writing systems, perhaps because of their limitations, to be well suited to their needs and thus resisted change until it was thrust upon them by outside forces. Again, Egypt provides a powerful example of a writing system that changed little for some 3,000 years until it was replaced by an alphabetic system from outside conquerors (Greek, Roman, and Christian).

The West Semites (Canaanites and Phoenicians) who created a consonant system from the larger sign systems of Egypt, Sumer, or both failed to move beyond the syllabic principle by which a single sign stands for a syllable of a language. The limits of a syllabic system contain a paradox: to use a limited number of signs results in ambiguity in which, say B represents Ba, Be, Bi, Bo, Bu

(to use an American English example); to reduce ambiguity requires a larger number of signs. To use the above example, each consonant in our modern America English alphabet would require signs to distinguish the 5 vowel sounds. Instead of 21 consonant and 5 vowel signs, we should need 105 signs (21×5). It was the genius of the Greeks who adopted and then adapted the Phoenician consonant system to represent all of the significant sounds of their language with a single sign for each phoneme.[72] And that change made for significant differences in the impact that writing had on cultures and peoples. To Eric Havelock, a syllabic script fails to represent spoken language in its fullest expression because it has limited its reproduction to recording relatively non-ambiguous information. As Havelock notes, "The record of a culture which is composed under these restrictions is likely to center upon religion and myth...."[73]

With alphabetic writing, the Greeks introduced the possibility of achieving social literacy open to all people in the society. But even with a limited number of literate people in Ancient Greece, the culture was able to move beyond the oral recitations of epic poetry, notably The Iliad and The Odyssey by aidoi (singers) who would modify their performances depending upon the circumstances. In an oral culture, no stable version of a poem or narrative can exist. With writing, especially alphabetic writing, one version becomes the standard version, capable of being copied faithfully, with all audiences now receiving the same information in the same form. Eventually, the form itself would change as narratives moved from orality, dependent upon poetic construction to aid memorizing, to literacy which allowed narratives to move from poetry to prose because the information was now recorded in script for all readers to read, with no memorization required in the transmission.

Alphabetic literacy also moved the narrative of cultures from myth to history. In Henry Perkinson's analysis:

> With writing, history begins. The distinction between history and myth is not that one is a false record of the past whereas the other is a true record. For history, like myth, is the creation of fallible humans—so it, like myth, will always be false, inadequate, erroneous, mistaken. What makes history different from myth is that with history we have records of some previous descriptions and explanations of the past. History was made possible by writing—alphabetic writing. Syllabic writing did not produce history—it produced only chronology—because syllabic writing was never refined enough to record myths.[74]

Along with prose and history, alphabetic writing also provided the techniques

and technologies of communication needed for philosophy, the systematic examination of the nature of all phenomena, a way of knowing ourselves and our world. From Thales of Miletus (627–546 B.C.E.) to his pupil Anaximander (611–547 B.C.E.) to Anaximenes (585–525 B.C.E.), Greek thought moved toward systematic attempts to decode nature, with each philosopher critiquing his predecessor's formulations. Pythagoras (540–510 B.C.E.) continued the debate by "demonstrating that all physiological phenomena can be described in the form of mathematical equations."[75]

Mathematics, of course, is essentially dependent upon writing and rarely exists beyond counting, with simple addition and subtraction, in oral cultures even with some simple marking systems (counting pebbles, notching sticks, etc.). In one sense, all mathematics stems from the record-keeping function of writing that allowed people to keep lists of all types of information needed for a complex society to function. Counting, of course, is also fundamental to time-keeping in the forms of calendars and almanacs that provide visible connections between the past and the present and allow us to plan for the future. Ancient Egypt, for example, developed a solar calendar as early as the Third Dynasty (2686–2613 B.C.E.), based upon the heliacal (sunset) rising of Sirius (the "dog star") which coincided with the annual inundation of the Nile River in late June.[76] The Egyptian calendar divided the year into three four-month seasons: *Akhet*, the inundation of the Nile from June to October; *Peret*, the time of planting and growth from October to February; and *Shomu*, the low water time of harvesting from February to June. Each month consisted of 30 days for a total of 360; an extra 5 days were added as religious holidays to make a 365-day year. Since an actual year consists of some "365 days, 5 hours, 48 minutes, and 46 seconds of mean solar time," discrepancies arose that were never fully corrected.[77]

What calendars do is fix time by giving it a visual place value, reducing the continuous flow of time to discreet units that can be marked, counted, and captured in space. Writing also provided a way to fix places by translating mental conceptions of space into maps that visualize spaces in graphic rigidity. While it is possible that some sort of visual presentations of space were present prior to writing, mapmaking as a reliable method for recording places and distances became possible only with writing. According to John Noble Wilford, "All the evidence suggests that the map evolved independently among many people in many separate parts of the Earth."[78] While mapmaking seems to have existed in many cultures over time, "The earliest direct evidence of mapmaking comes

from the Middle East, where archeologists have discovered several maps on clay tablets....[O]ne of the earliest of these clay maps was found at Nuzi, in Northern Iraq, and dated 2300 B.C., the age of Sargon of Akkad."[79]

These early maps seem to have been used to record settlements and cultivated plots of land, perhaps for establishing ownership and/or for taxation. An Egyptian map from 1700 B.C.E. located gold mines in Nubia (today's Sudan), an essential piece of information for a people obsessed with gold ("the skin of the gods"). City maps were drawn in Ancient Mesopotamia, and the Babylonians seem to have created the first map of the world itself that was more fiction than reality.[80] As an ancient and widespread method for charting space, mapmaking can be identified as a basic form of human communication that abstracts from the vast possibilities provided by vision to provide a graphic representation of only those elements necessary to convey the information needed for specific purposes. While it is certainly true that no map can provide the fullness of the information found in any territory, the map, by abstracting the more significant from the less significant features of a landscape, provides us with one more aid to survival. Maps allow us to chart not only what is known today but, by pushing us to explore territories beyond those drawn on our maps, to chart undiscovered countries and space itself. The mapping of cities spread to the mapping of countries, continents, oceans, the entire Earth, the solar system, and the stars.

Time and space constitute the boundaries of the final frontiers of reality into which human beings have been going from our beginnings. By extending our perceptions and conceptions beyond the limits of our senses and oral language, writing helped us to become more than mere talking apes. Writing helped us to realize more fully the potential extensions of our minds and our cultures through techniques and technologies that pushed against the barriers of time and space. As Walter J. Ong claims, "Writing is a technology" and is therefore an artificial exterior aid to memory and an interior transformer of thinking.[81] While acknowledging that all techniques are artificial, Ong maintains that "artificiality is natural to human beings. Technology, properly interiorized, does not degrade human life but on the contrary enhances it."[82]

For Ong, the move from orality to alphabetic literacy can be mapped through a matrix of 11 variables that separate the two modes of human communication. *First*, in orality, words are magically connected to their referents while literate people see words as "labels." *Second*, in orality, information is restricted to that which can be recalled by the people in a culture while literate people have written texts to record what needs to be recalled. *Third*, oral

cultures tend to be additive rather than subordinative in organizing information. *Fourth*, oral cultures tend to be aggregative rather than analytic in information processing. *Fifth*, oral cultures tend to be redundant rather than precise in information transfer. *Sixth*, oral cultures tend to be conservative rather than novel in valuing information. *Seventh*, oral cultures tend to connect information to real experiences rather than to abstract formulations. *Eighth*, oral communication tends to be agonistically toned rather than separating information from its source. *Ninth*, oral learning or knowing tends to be "emphatic and participatory rather than objectively distracted." *Tenth*, oral cultures tend to be homeostatic, living in the present, rather than being aware of a past, present, and future that influence messages. And finally, "oral cultures tend to use concepts in situational, operational frames of reference" rather than as abstract conceptions.[83] In a sense, writing helped to free human beings from the restraints of our natural physiological limitations by providing us with artificial techniques and technologies that expanded not only our abilities to extend information in time and space but also our abilities to increase the sources, media, storage capacities, and receivers of information.

When we consider the length of time it took for even the earliest cultures to move from orality to literacy (conservatively, some 50,000 to 100,000 years), we can see that human communication moved at a very slow pace after the evolution–revolution of language itself. Even literacy moved slowly, from cuneiform, hieroglyphs, and other logographic systems (*circa* 3100 B.C.E.) to the Semitic consonant system (*circa* 1500 B.C.E.) that was carried by the Phoenicians (*circa* 1000 B.C.E.) to the Greeks (*circa* 900–700 B.C.E.) who developed it into the full alphabet. Still, the movement from logographic writing to the true alphabet took only 2,000 years, brief in comparison with the 50,000 to 100,000 years from orality to early writing. That alphabetic writing was invented at all seems almost miraculous. As Ong puts it, "The most remarkable fact about the alphabet no doubt is that it was invented only once."[84]

In addition to helping to organize large civic societies, writing also helped to organize the military for warfare, by making it more efficient in exercising command and control over "larger and more sophisticated armies and over how battles and wars were reported and, thus, remembered by a culture."[85]

It would be difficult to chart all of the impacts that writing had on the cultures, ancient and modern, that developed or embraced literacy. In addition to providing external ways to keep records, to mark time and to map space, writing may also have altered how people thought and what they thought about. Writing facilitated change and provided ways to understand and manage

change by exercising command and control over expanding information. Writing would give literate cultures an edge over oral cultures, allowing for the emerging empires in Mesopotamia, Egypt, India, China, Persia, Greece, and Rome that ruled over peoples and cultures limited to orality.

Perhaps the greatest impact of writing on human communication was writing itself. All of human existence prior to writing is called *prehistory* while everything that comes after writing constitutes *history*. Literacy eventually became the norm and we label people and cultures as *preliterate*, *nonliterate*, and *illiterate*, depending upon their relations to literate peoples and cultures. And it is this normative function of literacy that reveals how deeply it has shaped the ways that literate people think, encode, and communicate information, and exercise command and control over their own cultures and any nonliterate cultures they encounter. If language was a key variable in making us human, literacy was a key variable in making us civilized.

Limitations

Despite the great achievements of writing in extending the storing and sharing of information over time and space, some limitations of communication were still present. While some cultures found solutions to their problems of command and control of information through literacy, these cultures also restricted access to the techniques and technologies of writing to the power elite and their controlled scribes. The masses of the people were not directly involved with writing, although writing shaped their societies and, thus, their lives. In Mesopotamia, the cuneiform system served competing and succeeding civilizations quite well. In its 3,000-year history, cuneiform was used by some 15 languages in different civilizations from about 3100 to 100 B.C.E. Among the principal languages were Akkadian, Assyrian, Babylonian, Chaldean, Hittite, Elamite, Kassite, Old Persian, and Ugarite. Cuneiform served all of them well enough to be used with only minor variations, ending only with the ends of these cultures as significant powers.

In Egypt, hieroglyphs from the first dynasty (3100 B.C.E.) to the inscription on an entrance to a temple dedicated to Isis by Roman Emperor Trajan in 394 of the common era could be and were written and read by the literate elite, providing Egypt with a continuity of culture for almost three millennia.[86] With command and control of literacy firmly under the pharaoh and his government, military, and religious leaders, Egypt became and remained an internally stable civilization, threatened only by outside invaders who were either absorbed

into the culture or expelled by native Egyptians in time.

The writing system that began about 2500 B.C.E. in the Indus Valley (in today's India–Pakistan border regions) is yet to be deciphered, but it was used by a developed civilization of considerable size and sophistication. The main impediment to decoding this script is that it is in "an unknown language."[87] Because the script has not been decoded, we cannot obtain direct evidence of what these people did and thought. But we can examine the remains of the cities they built and see how well they were planned and constructed.[88]

The fourth early civilization in which we find writing is China, usually dating from 1200 B.C.E. with an oracle bone inscription which contain "records of divinations by the twelve kings of the later Shang Dynasty, who ruled from about 1400 to about 1200 B.C.E."[89] This early script eventually evolved into the Zhou Dynasty's Great Script (1028–221 B.C.E.) and the simplified small seal script of the united Qin Empire in 221 B.C.E.[90] For the past three millennia, the Chinese script has served as the written binder of Chinese culture and civilization, providing a common system of signs for at least eight mutually unintelligible regional variations of the Chinese language. As a logographic system, Chinese writing has had to continually add characters to deal with new ideas, experiences, etc. While the 50,000 total number of characters is known to no one person, Chinese characters were adopted by other peoples in East Asia, notably the Japanese and Koreans. What is impressive is that this 3,000-year-old script, however modified, continues to be used by well over a billion people today. While its future may be in some doubt, its survival as a writing system speaks for the power of tradition over efficiency in any culture.

From this examination of the four oldest systems of writing, we can draw some general conclusions about changes in human communication systems. In the most pragmatic sense, the writing systems developed in Mesopotamia, Egypt, the Indus Valley, and China clearly met the needs of those who controlled these civilizations. Obviously, the limitations of the logographic systems of Mesopotamia, Egypt, and China, so apparent to those of us who use alphabetic systems, were not felt by the peoples of these civilizations. It was other people, living in the interface area between Mesopotamia and Egypt, who adopted a limited number of phonetic signs present in the Sumarian and Egyptian logographic systems to fashion a limited system of signs that served their special needs for writing that could be used to facilitate trade throughout the Mediterranean World. Once again, the pragmatic needs of a culture provided the impetus for a major change in communication.

While the early consonant alphabets developed by the West Semites obvi-

ously met their needs for facilitating trade, they do not seem to have been used for building complex civilizations with extensive writings of any kind. It took the Greek revolution of a full alphabet to reveal the fuller potential of phonetic literacy for a society. With their alphabetic literacy, the Greeks were able to encode and leave for posterity the foundation for Western Culture in drama, logic, philosophy, poetry, rhetoric, and the beginnings of science. Carried to Rome, the alphabet became the model to be adopted and adapted by all alphabetic cultures that followed. But even alphabetic writing suffered from a number of limitations.

In terms of sources, the alphabet enabled more people than ever to become writers but literacy remained limited to the few rather than open to the many. Encoding provided opportunities for using the alphabet to write any language, but most languages remained unwritten. Even in literate cultures, writing tended to be limited to official languages (Aramaic, Hebrew, Greek, Latin, et al.). Even after the decline of Rome in the last quarter of the 5th century, Latin continued to be the language of scribal literacy in Europe until the Protestant Reformation of the early 16th century. The transcribing of writing was limited to what one writer could write or copy, limiting the number of written texts and their copies; there was also the added problem that copies were not always faithful to the original, a problem compounded by making copies from copies. The actual media used for even alphabetic writing, primarily papyrus and scraped animals skins (parchment and vellum), were scarce at times and always costly, thus limiting their capacity to store and carry messages. Libraries served as storage systems for writing, but retrieving information was difficult because there were no standardized protocols for identifying and cataloging scrolls or codices. Although written documents did help to extend the limits of time and space by being both storable and transportable, transportation was itself limited to human, animal, and water modes of travel. At the receiving end, written documents could only be read by the literate and could also be read by unintended destinations. Feedback was limited by the same restraints facing the sending of information.

All of these limitations were not enough to stimulate calls for improvements in Greece, Rome, or Western Europe until the 15th century when a confluence of changes in the control of information by the Roman Catholic Church, in the movement from feudalism toward commercial development and nation states, in the growing awareness of the achievements of Ancient Greece and Rome that we call the Renaissance, and in the seminal union of the techniques and technologies needed to bring Johann Gutenberg's printing press sys-

tem into existence in the 1450s combined to create a critical mass that would ignite a revolution in communication we call the Age of Print. The immediate problems that needed attention in the 1440s and the 1450s were centered on the growing demands for more copies of existing books for universities growing with the influx of sons of a rising merchant class. As knowledge and learning moved from sacred subjects controlled by the Roman Catholic Church to secular topics of interest to non-clerical scholars and students, a crisis in communication was developing that would result in other significant changes in human communication with vast effects on the peoples and culture that embraced printing and those who would become the victims of print-empowered cultures.

In seeking to solve one set of problems, the need for more texts produced more efficiently, Gutenberg and his fellow printing revolutionaries created a new system of communication that would have profound consequences far beyond the Church and universities. As we have seen with the evolution–revolution of language itself, speech did not simply create a talking ape but helped to bring about a new species entirely, one that would enhance and use technology to change itself and its culture by imposing human will upon Nature. As writing altered speech but did not eliminate it as the central medium of human communication, printing would also alter but not eliminate writing. Each evolution–revolution can be viewed as an extension of previous evolutions–revolutions. All humans, even highly literate ones, continue to use listening and talking in both our phatic and emphatic communication with our fellow humans. Writing provided significant advantages to those cultures that embraced the new system of communication. That Western Europe, rather than any of the more advanced civilizations of the past or even then-contemporary Asian civilizations (China, Japan, Korea), created the print revolution is a testament to need and not necessarily to creativity.

Perhaps the greatest limitation of writing is not found in techniques and technologies of communication but in the failure to extend literacy to all members of a culture. Scribal literacy was the norm not only in logographic Mesopotamia and Egypt but also in alphabetic Greece, Rome and Medieval Europe. Even the coming of the printing press with its capacity for reproducing exact multiple copies of a text efficiently (in terms of time and cost) was not sufficient to make social literacy a reality. Future changes in culture and social organizations would be required in the quest for universal literacy and its empowering of all people by providing access to information needed for survival.

Today, alphabetic writing systems suffer from the limitations of trying to rep-

resent the different phonemes of different languages with one system of signs, a difficulty even for Indo–European languages. Despite 20th century calls for new systems of writing that would be both exact in representing any and all phonemes of any language and simple enough for a child to learn, there have been few serious attempts to radically change the national alphabets used by existing civilizations.[91]

Writing differs from speech in that it represents a system of techniques and technologies deliberately chosen by specific human beings in specific cultures at specific times to solve specific problems. But it eventually moved beyond its limited uses as a visual storage system for information and became not simply an accessory to speech but a symbiotic partner with orality in shaping language use. In a very fundamental sense, writing provided the paradigm for all future evolutions–revolutions in human communication, making possible all of the benefits and deficits wrought by civilizations during the past 5,000 years of recorded history. As orality failed to solve the quest for full and total human communication, so too did literacy. The quest would continue through the coming evolutions–revolutions and continues today in our Cybernetic Age.

· 4 ·

BECOMING TYPOGRAPHIC

Evolution and Revolution in Printing

Context

Human beings did not create, discover, or invent language. Rather, language helped us to become human beings by providing us with an evolutionary gift necessary for our survival. We did create and develop writing as a cultural device that was central for the invention of civilization. Literacy provided some human cultures with an essential weapon for the survival of their civilizations. Both orality and literacy can be viewed as changes needed by our species at specific times and places to respond to challenges to survival. Typography shares some of these motivations to survive challenges but also introduces a new variable—call it the *technological imperative*, an urge to create new ways to communicate that not only address existing problems but involve creation for creation's sake which can result in new ways to communicate not even conceived by the inventors of the new techniques and technologies. This drive to create what is *possible*, not merely what is *needed*, will become a powerful motivator for new evolutions and revolutions in communication from the Age of Print to the Cybernetic Age and beyond.

The long natural-evolutionary path toward language took some 4 million years from the time our ancestor *Ardipithecus ramidus* separated from our pri-

mate relatives to the emergence of *Homo sapiens*. From orality to the earliest manifestations of true literacy in Sumer and Egypt took some 40,000 to 50,000 years and only existed in a few cultures until the latter half of the 20th century. It then took almost 5,000 years from the beginning of true literacy around 3100 B.C.E. for true typography to be created in the 1450s in Mainz, Germany. The past 550 years have not only brought us the Age of Print but also the Modern World with all of the subsequent developments that have extended communication techniques into graphic, electric–electronic, digital, and cybernetic media. The history of human communication is a continuing journey that began with language itself. All of the later attempts to harness energy and matter to overcome the boundaries of time and space in a never-ending quest to know ourselves and the universe through improved acquisition, storage, retrieval, and sharing of information are extensions of our language instinct. In order to understand any new evolution–revolution in communication, we need to examine how each evolution–revolution is built upon the evolutions–revolutions that preceded it.

One of the puzzles in the history of human communication is why printing did not develop fully and flourish in the cultures with the earliest claims to some of its key elements—paper, ink, and type. China for example, had a number of inventions that made it the most technologically advanced nation in terms of communication and other techniques and technologies. By 105, the Chinese had developed practical systems for the manufacture of paper, and by 175 they were carving the ideograms of their writing system in stone and transferring the images to paper and silk through rubbing. By 200, they were using carved wooden blocks to transfer inked impressions of ideograms onto paper, silk, and other surfaces. Around 700, they were crafting moveable type in wood, metal, clay, and porcelain. Surely, they were poised to take the revolutionary leap to full printing, but that leap never happened. Given the ecological nature of all human activity, guesses as to the reason for this failure are many—from the lack of an alphabet suited to moveable type to the imperial system that kept communication firmly under the command and control of the emperor and his court to the insular and conservative nature of Chinese culture. Similar arguments are also made to explain why Japan and Korea, both cultures that developed early printing based upon the Chinese system, also did not develop full printing. Similarly, the civilizations of India and, later, the Arab world learned papermaking and block-printing techniques from the Chinese and used these techniques to produce printed materials but also failed to move to full printing. In the end, all of these civilizations would use the printing press

system developed in Western Europe in the 1450s for their own typographical revolutions.

In summarizing the evolution of printing from its inception in China to its revolution in Mainz, Thomas F. Carter provides a powerful argument for an ecological view of the history of typography:

> Of all the world's great inventions that of printing is the most cosmopolitan and international. China invented paper and first experimented with block printing and moveable type. Japan produced the earliest block prints that are now extant. Korea first printed with type of metal, cast from a mould. India furnished the language and religion of the earliest block prints. People of the Turkish race were among the most important agents in carrying block printing across Asia, and the earliest extant type are in a Turkish tongue. Persia and Egypt are the two lands of the Near East where block printing is known to have been done before it began in Europe. The Arabs were the agents who prepared the way by carrying the making of paper from China to Europe....Florence and Italy were the first countries in Christendom to manufacture paper....Germany, Italy, and the Netherlands were the earliest centers of the block printing art. Holland and France, as well as Germany, claim to have experimented with type. Germany perfected the invention, and from Germany it spread to all the world.[1]

How do we account for Europe's eventual triumph in perfecting the techniques and technologies of printing that would create a revolution in communication that continues today? A little history is needed to set the stage for the revolution.

With the development of full alphabetic literacy in Greece and its spread to Rome where the letters were adapted for Latin, Roman Europe possessed the possibility of social literacy. Indeed, from the time of the Roman Republic (735 to 31 B.C.E.) and the Roman Empire (27 B.C.E. to 476), Rome was a centralizing power that brought stability and order to most of the lands bordering the Mediterranean Sea and extending outward to Persia in the East and today's England, France, Germany, and Spain in the West. It was a dominant and conquering culture based upon written Latin that provided Roman Law, Roman Order, and Roman Peace, all dependent upon the might of the Roman legions to enforce these values. Despite developments in terms of organization and administration, architecture and engineering, civil and military power, arts and letters, education and science, religion and philosophy, and history and government, both the Republic and the Empire never made any noticeable contributions to the development of printing.

When Octavius accepted the imperial crown from the Roman Senate in 27 B.C.E. (following the assassination of Julius Caesar in 44 B.C.E. and the sub-

sequent civil wars that ended with his defeat of Marc Antony and Cleopatra at the Battle of Actium in 31 B.C.E.), the new Caesar Augustus ruled an empire that encompassed most of the world known to Europeans. While literacy was central to the empire, it was restricted to the elite and to the scribes who kept the written records needed for administering the growing empire. In its 503-year history in the West, the Roman Empire never developed even the foundations for printing. At the time of its demise (476 is the traditional date given for the Fall of Rome when Odovacar banished Emperor Romulus Augustus), the empire was in the process of disintegrating into smaller societies controlled by warlords and tribal leaders capable of controlling local communities with armies of loyal followers.

With this collapse of the central government, local power groups emerged to command and control separate communities. With the loss of central control came the loss of integrated transportation and communication. Latin gave way to local dialects and languages, and writing became a craft practiced by a few monks and scholars. In time, spoken and written Latin became the province of the Roman Catholic Church which preserved literacy in a world that had retreated from literacy to orality, from civilization to a kind of semi-barbarism we call feudalism. Although modern historians object to the rather gross descriptions of what followed in Europe, for a historian of communication these older terms still have usefulness in terms of describing the techniques and technologies of communication used at the time.

The Fall of Rome signified that progress in communication could be eliminated or reversed by the collapse of a civilization. Attacks from barbarian outsiders (Goths, Vandals, and Huns, Angles and Saxons, and Celts) and disintegration from within (too many slaves, increased taxes, civil unrest, and corruption within the legions) combined to destroy Roman civilization. With barbarian invasions, libraries were sacked and burned, scholars killed, and law replaced by armed mobs. The civilized Roman society—a civilization structured on literacy, civic order, a stable economy, and confidence in continued prosperity—could not survive. To many, it signaled the end not only of Rome but of the civilized world itself. The future, if there were to be a future, must have seemed dark indeed. And the Dark Ages is the name historians gave to the years from Rome's fall (476) to the reign of Charlemagne (800–814) and the attempted restoration of the Roman Empire into a Catholic Holy Roman Empire that would reunite all of Christian Europe. Despite all of the subsequent efforts, both diplomatic and martial, the Holy Roman Empire remained more a dream than a reality. In the end, it was eliminated by Napoleon Bonaparte in 1806. Perhaps

its most fitting epitaph is attributed to the French philosopher Voltaire: "It was neither Holy, Roman, nor an Empire."

With centrality of civil government only a dream and knowledge of Latin and writing carried mostly by the Catholic Church, the laws of God and man were preserved and transmitted by the clergy, especially the monks who laboriously copied and recopied the precious manuscripts that held the writings of the sacred texts and a few nonreligious texts from ancient times. These holy scribes copied manuscripts as part of their devotion to God. Working in monasteries, they used pen and ink to inscribe Latin letters onto parchment, an extremely difficult undertaking. In one estimate, "Working six hours a day the scribe produced from two to four pages and required from ten months to a year and a quarter to copy a Bible."[2] With a limited number of manuscripts to copy and with a limited number of literate readers to actually receive the information contained in the texts, literacy in the Dark and Middle Ages had reverted from social to scribal literacy, an information storage-and-retrieval system of the few who used it to command and control the majority of the population. We see here an example of how scribal literacy need not be dependent upon the complexity of the encoding–decoding system but can also be sustained by social and cultural circumstances.

The point here is that techniques and technologies, by themselves, do not cause any major cultural changes but only provide opportunities for change if a culture is open to change. The rulers in Egypt and China obviously saw no reasons for changing their systems of command and control, including their writing systems. And their subjects evidently never rose up to overthrow these centralized powers. Thus, Egyptian hieroglyphs and hieratics lasted some 3,000 years, and the Chinese ideograms continue to be the central writing system after 3,000 years. Given the status of communication in medieval Europe, there were no compelling reasons for change to come from within, despite the presence of the alphabet, a technology that had earlier demonstrated its potential as an agent of change for the Semites, the Greeks, and the Romans.

In the context of Europe during the Middle Ages, additional agents of change would be needed before significant improvements could be made in the communication systems used for the sharing of information. In scribal literacy, orality remains the dominant medium used by the masses of people. In Christian Europe, graphic iconography in the form of sculpture, painting, stained glass images, mosaics, and the architecture of the churches and cathedrals supported the readings of the sacred texts and the sermons by the clergy. The centrality of the mass in Roman Catholic ritual brought all of these media

of communication to one central focus on the need for the faithful to believe in the one true church that provided the only hope for eternal salvation through the forgiveness of sin made possible by the sacrifice of the Son of God, Jesus Christ, who died for the sins of all humans and whose resurrection promised life everlasting for all true believers. Such a centralizing mythos focused everyone on the next life, with this life on Earth viewed as little more than a testing-time for eternal damnation or salvation. With eternity as the ultimate destiny, this short life seemed to be insignificant except for seeking salvation. All in all, this resulted in a cultural, economic, political, and social environment that was not focused on material concerns or changes in this world.

When changes came, they came from outside of the environment but were received by those in the environment who were ready for different ideas and technologies. There are two general ways in which ideas, beliefs, techniques, and technologies are transferred from one culture to another. They can be carried directly, as seems to have been the case with the transfer of the Phoenician letters to Greece and Rome, or they can be carried indirectly as a stimulus, as may have been the case with Sumerian cuneiforms influencing Egyptian hieroglyphs where the idea, but not the form, was transferred. The knowledge available in Ancient Greece was largely lost to the West, partly because of the separation of the Roman Empire into Eastern and Western empires and later by the rise of Islam and its conquest of most of the lands of the Eastern Empire. After Mohammed's death in 632, Islam expanded from Arabia to Persia, Egypt, Mediterranean North Africa, and the Iberian Peninsula. In 732, the Franks halted the Islamic invasion of today's France at the Battle of Poitiers (Tours). Earlier, in 638, Caliph Umar entered Jerusalem as part of the Islamic conquest of the Middle East. The Crusades were attempts by force of arms by Western Christian powers to halt the spread of Islam, restore the Holy Land (Jerusalem), and help the Byzantine Empire to defend itself from Muslim attacks. They began with a call to arms by Pope Urban II in 1095 and continued for most of the Middle Ages. In the end, the Crusaders failed to achieve their central goals, with the Fall of Constantinople to the Ottoman Turks in 1453 signaling the end of the dream of saving the Byzantine Empire from the forces of Islam.[3]

But the Islamic invasion into Europe, although halted by Charles Martel at the Battle of Poitiers (Tours) in 732, left Spain and Portugal under Muslim control and the returning Crusaders brought back to Europe ideas and technological knowledge that would influence the West toward change. For example,

paper, created in China around 105, was carried westward by Muslims after their conquest of Samarkand in 751, reached Muslim Spain in the 10th century, and later Muslim-controlled Sicily and Southern Italy.[4] Although paper has been used for a multitude of purposes in different cultures during the past 2,000 years, it is its central role in the revolution of typography that concerns us most because it provided an ever-expanding supply of surfaces upon which type could be printed.

The contacts with the East, through Muslim invasions and Christian Crusades, although violent, did bring information into the West. Much of this information was not new as it consisted largely of ancient Greek texts on history, philosophy, religion, and sciences that Muslim scholars had preserved in translations into Arabic. Now translated into Latin, these texts provided ideas and information that were "new" to scholars in Europe. What we traditionally call the Dark Ages (476–800) and the Middle Ages (800–1350) would slowly be replaced by a new age, what 19th century historians called the Renaissance, a change in perceptions and conceptions about humans and their place in the world. From Italy, where Petrarch (Francesco Petrarca, 1304–1374), Giovanni Boccaccio (1313–1375), and Dante Alighieri (1265–1321) created literary Italian, this rebirth spread to France, where Francois Rabelais (1494–1553) and Michel de Montaigne (1533–1592) wrote in French, and then to England, where Christopher Marlowe (1564–1593) and William Shakespeare (1564–1616) helped to craft Modern English.

The hallmark of the Renaissance included a revival of interest in antiquity and learning, a focus on humanism's concerns for grammar, rhetoric, poetry, history, and moral philosophy, the secularization of social life and the cultivation of the arts for nonreligious purposes, the cultivation of the arts and creativity for their own sake, the valuing of the individual, an expansion of philosophical and scientific inquiries to gain more knowledge about humans and the world, and a general view of the possibilities of human progress outside of the narrow confines of salvation as the only goal in life. This is, of course, an over-simplified summary of a long and messy cultural process that contained many contradictions and uncertainties. Still, it does give us a general sense of a time in which change was now more possible, in which the limitations of cultural systems could be recognized, criticized, and perhaps altered. The rebirth of ideas in the Renaissance provided a cultural environment that would be open to new techniques and technologies of communication as the written word and the copying of manuscripts would not suffice to meet the growing needs of scholars, secular authorities, and a newly-rising middle class.

A parallel development in the life of the mind involved the creation of the university, that special place for learning where everything is to be studied, where local tribalism is to be replaced with a universalism that treasures learning and new ideas and new information. In Europe, the title of the first university is disputed between Bologna (1158) and Paris (1150–1170). These were followed by Oxford (1200) and Cambridge (1230) in England, and Heidelberg (1386) in Germany. What these, and other, universities required for their growing numbers of scholars and students were increasing numbers of copies of old and new manuscripts to support their studies. Eventually, the demand for more copies of more texts produced more efficiently would exacerbate the need to replace the scribe with a better reproduction system.[5]

Both the Renaissance and the universities stimulated critical debate about the nature of God and the place of human beings in this world. In noting the break that separated the Medieval World from the Modern World, Barbara Tuchman in *A Distant Mirror: The Calamitous 14th Century* summarizes the differences:

> [The Christian religion's] insistent principle that the life of the spirit and of the after world was superior to the here and now, to material life on earth, is one that the modern world does not share....The nature of this principle and its replacement by the belief in the worth of the individual and of an active life not necessarily founded on God is, in fact, what created the modern world and ended the Middle Ages.[6]

Although I am not advocating a Hegelian or Marxist Dialectic of History in which all forces are moving toward some predestined goal, it is possible to see how a confluence of cultural, economic, intellectual, political, and social change helped to create an environment in 15th century Europe that was open to a new way of encoding, storing, and retrieving information.

The long evolution of papermaking and proto-printing would finally come to a critical mass in Mainz, Germany in the 1450s when all of the key elements needed for full printing would be brought together into one system that was itself greater than and different from the sum of its constituent parts. Six key elements were needed:

1. The knowledge and skill to carve the steel punches for the letters, build the molds, and cast the lead-antimony type
2. Moveable metal standardized type face
3. Alphabetic script with a limited number of letters
4. Oil-based ink that would adhere to a page without smearing or sticking

5. Screw-type press to apply pressure evenly and uniformly
6. Paper and parchment upon which to press the inked typeface.

At one time in one place, the 1450s in Mainz, Germany, all of these six ele-
ments would be united by Johann Gutenberg and his assistants to move print-
ing from its long evolution from cylinder seals and wood block prints to a true
revolution. The Age of Typography was dawning.

At the beginning, print seemed to be little more than a more efficient way
to reproduce manuscripts, relieving monks and secular copyists from the bur-
den of copying manuscripts to meet the growing demands from universities and
the rising middle class in the cities that were replacing feudal trading towns with
emerging centers of commerce, finance, and trade. At first, the efficiencies
promised seemed hardly worth the effort it took to actually print something.
First, a skilled metal-worker had to carve a single letter of the alphabet in
Gothic calligraphy onto a steel punch; next, the punch was hammered into a
softer metal to form the matrix for the mold into which a molten alloy of lead
and antinomy was poured; when the alloy cooled, the cast typeface was ready
to be set into a page of type. The setting of the type was itself a difficult and
time-consuming task, with each letter having to be set in its proper place in a
line of type with proper spacing between words, all of this in mirror reverse to
how the type would be read after being imprinted on parchment or paper. The
copyediting of type in reverse was also a laborious process with each page of the
42-line Gutenberg Bible requiring the labor of one man for an entire working
day. When the full page of type was set, copyedited and reset, it was locked in
a frame and ready for inking, with a combination of turpentine and oil (linseed
or walnut) applied with a round pad covered with leather from dog hide
because of its absence of pores that made for even coating. The press itself,
adapted from the common olive or wine presses of the time, had a sliding flatbed
which held the parchment or paper and an upper plate which held the frame
containing the typeface. A quarter turn of the lever would press the inked type-
face down upon the bottom surface. A quick release would separate the top and
bottom sections, and the newly printed page would be rolled out from under
the press and the page hung up to dry while the process was repeated as many
times as copies were required. From the outset, two-color and multicolor print-
ings were produced by Gutenberg and his successors.[7]

The efficiency of printing over hand-copying was demonstrated by the
increased output of copies in shorter times at reduced prices. In the Incunabula
Period (1456–1500), for example, printing produced over 40,000 editions of

various texts for a total of some 15 to 20 million copies, 77 percent in Latin and the rest in vernaculars. Of the total, 45 percent were religious texts, including 95 Bibles in Latin, 15 in German, and 11 in Italian. Of the new books by contemporary authors, two were significant in that they included Hindu–Arabic numerals, in addition to the traditional Roman numerals, that would lead to improvements in mathematics in the future.[8]

Typography produced a genuine revolution in the speed of its spread from Mainz throughout Germany and the rest of Europe. The spread of printing seems to have been based upon an increasing thirst for printed copies of ancient and new texts on the part of a rising reading class and a desire to earn significant profits on the part of those involved in the printing trade, twin motivations that will later account for the rise in graphic, electric–electronic, and digital communication media. Even for those of us living in an age of almost instant changes in communication techniques and technologies, the spread of printing in its first 27 years is impressive. Here is a partial list of cities and dates: Cologne (1464), Basel (1466), Rome (1467), Venice (1469), Paris, Nuremberg, and Utrecht (1470), Milan, Naples and Florence (1471), Augsburg (1472), Lyon, Valencia, and Budapest (1473), Krakow and Bruges (1474), Lubeck and Breslau (1475), Westminster and Rostock (1476), Geneva, Palermo, and Messina (1478), London (1480), Antwerp and Leipzig (1481), Odense (1482), and Stockholm (1483), all secular centers for banking, commerce, and trade.[9] Italy was the first country outside of Germany to embrace printing, with the Roman Papacy using printing to spread its messages of hope and salvation. Printing came to England through the efforts of William Caxton, who learned the trade in Cologne in 1471–72 and set up his first press in Bruges in 1473. In 1476, he returned to England and established a printing shop in Westminster; of the 90 books he printed, 74 were in English, including editions of Geoffrey Chaucer's classic *Canterbury Tales* between 1478 and 1484 and Thomas Malory's *Le Morte D'Arthur* in 1485. After Caxton's death in 1791, his Alsatian assistant Wynken de Worde continued his tradition, publishing a variety of school books and grammar texts (for educating the children of the rising merchant classes) and Bibles in English.[10]

The spread of printing carried two complementary but competing impacts. On the one hand, printing strengthened the Europe Commonwealth of Learning—*Republica Christiana*—by making texts in Greek and Latin (the common languages of scholars) more accessible. At the same time, however, printing also encouraged the spread of vernacular languages by giving them more permanent forms in printed texts, thereby promoting linguistic nation-

alism over Christian universalism. According to S. H. Steinberg's estimates in *Five Hundred Years of Printing*, we can observe this clash of cultures in the proportions of Latin to vernacular texts printed in Europe: "Before 1500, about three-quarters of all printed matter was in Latin, about one-twelfth each in Italian and German. Only in England and Spain did vernacular books outnumber Latin ones from the beginning."[11] Estimates for later times chart the replacement of Latin by vernacular texts: "The proportion of Latin and German titles sold at the Frankfurt and Leipzig book fairs was 71:29 in 1650, 38:62 in 1700, 28:72 in 1740 and 4:96 in 1800."[12]

When printing provided texts on secular topics in local languages, many were focused on how to do certain tasks and on how to speak and write properly (dictionaries and grammar books). From individual printers, printing expanded to publishing companies, which brought together the engraver of type punches, the molder and caster of type, and the actual printers and their presses. These printing companies also commissioned and solicited manuscripts for production and negotiated with paper-making mills and bookbinders to provide a fully-integrated communication company that printed books complete with title pages, colophons (end of book statements by the publishers), and logograms (graphic devices to identify the publishing houses).[13]

In chronicling the history of printing the printing revolution begun by Gutenberg, S. H. Steinberg and John Trevitt identify five distinctive periods:

1. 1450–1550, the creative century which witnessed the invention and beginnings of practically every single feature that characterizes the modern printing press
2. 1550–1800, the era of consolidation which developed and refined the achievement of the preceding period in a predominantly conservative spirit
3. The nineteenth century, the era of mechanization, which began with the invention of lithography and ended with Morris's rediscovery of the Middle Ages
4. 1900–1950, the heyday of the private presses and the inception of paperbacks
5. The post-war world, which has seen typesetting, printing, and publishing turned upside down, with reading surviving the onslaught of television.[14]

During the first century of modern printing, typeface moved from being copies

of Gothic handwriting to the more easily readable Roman and italic typefaces, emulating the round handwriting of Renaissance scribes, producing a script that was more efficient in its encoding, in that it used less space than did Gothic scripts, and in its decoding, in that the letters were easier to write and to read. Printing spread throughout Europe and beyond to Asia, Africa, and the New World of the Americas. Pagination, the sequential numbering of pages in a text, began as an aid for printers in assembling the dried pages to be bound together but quickly became an indispensable technique for readers to keep track of the location of information within a text. In this small but significant step toward standardization that made indexes and tables of contents possible, the shift from Roman numbers to the ten-digit system invented by the Hindus and carried to the West by the Arabs played an important part. Consider the difference between CCCXXXVIII and 338: both contain the same information but the Hindu–Arabic system conveys that information in just three signs while the Roman system requires ten signs. In the first century of print, the reproduction of texts, which had earlier moved from scriptoria manned by monks who labored for the glory of God to the 12th century stationers' shops which employed lay copyists who worked for wages, print proved its value in terms of efficiency in time and costs. For example, in 1483, the Ripoli Press charged 3 florins for each quinterno (5 pages) for typesetting and printing 1,025 copies of Marsilio Ficino's translation of Plato's *Dialogues*. A scribe would have changed only one florin for each quinterno but would have produced only one copy. The difference in scale is staggering and demonstrated the superiority of printing to hand copying for producing multiple and identical copies of a text more efficiently.[15] This edition of Plato's *Dialogues* exceeded the average number of copies for an edition (usually 200 to 1,000 copies). What is remarkable about these figures is that they exist at all, because we have no information about the number of copies per book before print.[16]

The era of consolidation (1550–1800) that followed provided no significant changes in the techniques and technologies of printing achieved in the creative century, but some changes did come with precast type being sold to printers by foundries, booksellers becoming publishers, and authors acting as independent professionals—all contributing to the emergence of new readers, including women and children, not committed to academic and religious texts. The periodical press of magazines and newspapers would soon challenge the book as delivery systems for printed information.[17] The rise of the professional author who wrote for money signaled a change in values. As Steinberg notes, "Until the middle of the 18th century it was considered bad manners to

write for cash remuneration instead of for reputation."[18] That sentiment stands in stark contrast to that of a man who made his living from his writing, the great English dictionary author Samuel Johnson (1709–1784) who is quoted by James Boswell as saying on April 15, 1776, "No man but a blockhead ever wrote except for money."[19] The professional author, a commercially-based press, and an expanding reading public resulting from a rising middle class with more leisure time for reading, and compulsory education all contributed to the spread of literacy and a demand for more reading materials.

The periodical press can trace its beginnings to 1609 with the newspaper *Avisa Relation oder Zeitung* in Germany, followed by "new books" in Holland in 1620, in England in 1621, and in France in 1631. The libraries of the ancient civilizations were priestly or royal collections not open to a general public. None survived the fall of these civilizations, including those of the Roman Empire. During the Dark and Middle Ages, the libraries in Europe were the provinces of monasteries, bishoprics, and the emerging universities. What print did by the sheer duplication of more and more texts was to make possible a growing number of libraries to store and make available the accumulated information, knowledge, and wisdom. Libraries also became symbols of the rising nation-states and their claims to leadership. These national libraries added to the stored treasures found in monasteries and universities and would be augmented by private and public leading libraries in the 17th century.[20]

Against the tendency for information to seek the widest possible circulation stood the all too human fear of those in power who wished to keep the command and control of information from the masses of people. The printing press provided more information to more people, and those in power, both church and state, moved to control print through censorship, beginning with the Vatican Index of Prohibited Books in 1559 and encompassing almost all European states, with the Dutch Republic a notable exception and, therefore, a haven for those seeking the freedom to print what they liked.[21]

Fortunately for the history of ideas, censorship, even under authoritarian or totalitarian regimes, faced resistance from people and from the techniques and technologies of printing itself which make the mass copying of information available to anyone with a printing press.[22] It was a singular achievement of the writers of the Constitution of the United States of America (1787) that they added to the original document a set of ten amendments which constitute the Bill of Rights. For our purposes, the First Amendment is the most significant with regard to communication:

Congress shall make no law respecting an establishment of religion, or prohibiting the free exercise thereof; or abridging the freedom of speech, or of the press; or the right of the people peaceably to assemble, and to petition the Government for a redress of grievances.

There is nowhere a clearer dedication to the fundamental belief in the free marketplace of ideas to expose falsehood and thereby help people to be better informed. It is a testament of belief in modern rational thinking as the foundation for how free people should deal with the communication of information. The world envisioned by the authors of First Amendment would have been exceedingly difficult, if not impossible, to sustain without the printing press that made mass communication a reality.

The 19th century was distinguished in Western Europe and in the United States of America by the confluence of four interconnecting forces: the growth of participatory democratic governments dependent upon the consent of the governed; the rise of literacy encouraged by compulsory education for the young; the centralization of economic and political power in larger cities; and the mechanization of techniques and technologies in communication, beginning with typography. In their symbiotic interactions, these forces would move Western societies further in the direction of change that they perceived as progress. Indeed, one of the most distinguishing features of Western cultures in the 19th century is their almost mythic belief in the idea of progress through scientific thinking and technological innovation.

With typography, the production and operation of the materials needed for printing continued their move from human power to machine power that began with watermills and windmills but now harnessed steam and electric power to provide the energy needed to make paper, cast type, build printing presses, and operate the total process. The mechanized production of paper began in France in 1798 and in England in 1803. Instead of producing 60 to 100 pounds of paper a day by hand, the new mechanical paper mills could easily produce 1,000 pounds a day, with a corresponding lowering of prices by one quarter to one-third. In 1739, William Ged of Edinburgh developed a method for casting completed typeface paper in plaster of Paris molds to facilitate reprinting text without resetting type, but Scottish printers destroyed the molds and it was not until 1805 that Lord Stanhope (1753–1816) in England reinvented the molding technique, now called *stereotype* (literally "hard-type"). In 1829, papier-mâché molds replaced the plaster molds and the age of cheaper reprints was born. In 1814, Friedrich König built a steam-powered press for the London *Times*, replacing the hand-operated press's production of 300

sheets per hour with 1,100 sheets per hour. By1849, the steam-powered rotary press had become the norm for all large printing plants.[23]

The production of typeface also moved from hand to machine. In 1822, a letter-founding machine could produce 12,000 to 20,000 typefaces per day compared to hand-casting averages of 3,000 to 7,000. Similar mechanization replaced hand with machine in the binding and covering of books in leather and cloth, and, in 1833, the dust jacket appeared and would become the norm for most books by 1890. In 1843, German paper mills began to replace some of their rag-based paper mixtures with wood pulp, providing the foundation for inexpensive books, newspapers, posters, and other printed materials. The engraving of images moved from wood to steel, producing both finer details and more lasting engravings, joining with lithography, developed in 1798, to provide the key method for illustrating printed materials until the 1890 invention of the halftone process allowed print to reproduce not only engraved but photographed illustrations.[24] The invention of the first commercially successful typewriting machine in 1867 by Christopher Sholes, Carlos Glidden, and Samuel W. Soule seems to have inspired two hot-metal type-composing machines, Linotype by Ottmar Mergenthaler (1854–1899) in 1886 for the *New York Tribune* and Monotype by Tolbert Lanston (1844–1913) between 1889 and 1897. The age of hand-set type was rapidly being replaced by the age of the machine, a movement that would continue with the word processor and computer in the 20th century.[25]

In terms of the delivery systems for print, no innovations of the 19th century would match those provided by popular magazines and the daily penny newspapers. Both provided the growing reading public that now included working-class people and, in America, new immigrants with information, education, and outlets for their own expression. By the 1830s, König's steam-powered press and the inclusion of expanded advertising notices made it practical and profitable to sell daily newspapers for one penny, rather than the usual six pennies (the price of a pint of whiskey). Although those developments began in London, England, it was New York City that capitalized upon them to create what would become the advertising-supported mass circulation general interest newspaper that dominated the 19th century after 1833 and most of the 20th century. The pioneering Volney B. Palmer moved publicity toward advertising in 1841 by serving as a middleman between newspaper and those wishing to advertise in them. The claim for being the "first advertising agency" is made by both J. Walter Thompson with its 1879 acquisition of an earlier agency founded in 1864 and N.W. Ayer and Sons founded in 1869. Regardless

of which one was first, advertising would continue to develop in the latter part of the century and become a major source of information and promotion in print in the 20th century, reaching audiences through newspapers, magazines, billboards, posters, handbills, etc. By 1900, advertising and advertising agencies would be established in most of the industrialized world, embracing every new medium of communication available. [26]

Palmer and his followers found their outlets in such pioneering newspapers as Benjamin H. Day's *New York Sun*, whose slogan was "The *Sun* shines for you," which debuted on September 3,1833, and James Gordon Bennett's *New York Herald*, which followed on May 6, 1835. Both needed to provide news on a daily basis to attract readers for the advertisements. They found their solution in what can only be called the creation of modern news, with sections on crime, sports, and finances, government, etc. They were joined later by Horace Greeley's *New York Tribune* in 1841 and Henry J. Raymond's *New York Times* in 1851.[27] All benefited from improvements in transportation of information from stage coach, Pony Express, sailing ship, and pigeon to railroad and steam ship. In 1844, Samuel F. B. Morse's electromagnetic telegraph with his binary digital code that represented the Roman alphabet and the Hindu-Arabic numeral system with dots and dashes would move communication from transportation to transmission.[28]

The new journalism would attract newspaper men like Joseph Pulitzer, whose *St. Louis Post-Dispatch* (1878) and *New York World* (1883) added to the circulation wars that pitted newspapers against each other for news, circulation, and advertising by adding new sections, including a woman's page.[29] In the 1890s, the competition for the rights to publish Richard F. Outcault's highly popular comic strip *The Yellow Kid* would give this era of American journalism a label that continues to define a certain kind of scandal-focused newspapers as "The Yellow Press."[30] By the end of the century, social and cultural critics had began to question the role and effects of the popular press upon the citizens of a democracy. Included in their criticism were popular magazines like *Harper's Bazaar* (1867), *Vanity Fair* (1868), *Ladies Home Journal* (1883), and *Cosmopolitan* (1886) which benefited from cheap postal rates for printed materials and the growth of railroads to reach regional and national audiences. All of these expansions of mass journalism were facilitated by the growth of compulsory education and public schools. In 1870, for example, the percentage of children in the United States enrolled in public schools was 57 percent; by 1900, it had risen to 72 percent, with the illiteracy rate falling from 20 percent to under 11 percent.[31] Despite these clear gains in the extending of informa-

tion to more people through more delivery systems at greater efficiency in terms of time and cost, some social and cultural critics began to question the outcomes of mass education and mass literacy, worrying about these new media becoming not agents of communication but of manipulation, a concern that continues with almost every new expansion of information sharing.

This criticism followed in the tradition of both Matthew Arnold's *Culture and Anarchy* (1869) and Gustave Le Bon's *The Crowd* (1895) and was championed by both the right and the left, who saw the rise of social literacy and popular culture as either a threat to the cultivation of excellence or as an instrument of social control and repression. In either case, popular culture was viewed with skepticism and calls for protection from its harmful effects.[32]

The 20th century began with typography at its zenith, having incorporated into its newsgathering and dissemination photography, electric telegraphy (wired and wireless), telephony, and the typewriter. The early experiments with motion pictures in the 1890s were noted by the press, but the world of books, magazines, and newspapers seemed secure and destined to continue to provide the main media that bound modern industrialized societies together and provided the foundation for a continued progressive future. The paperback revolution of the 1930s/1940s and the proliferation of book clubs of all varieties made printed books more available to more people than ever before, despite the attempts at censorship for moral, political, racial, religious, and sexual reasons. Improvements in typography-like phototypesetting (1944) and the use of computers for composing, storing, and typesetting, all seemed to enhance print's position as the dominant communication technology of the modern world. After 1967, the techniques and technologies used for the creation and production of books, magazines, and newspapers would change more radically than they had in the first five hundred years since Gutenberg's Revolution.[33] These changes were all wrought by the Cybernetic Revolution that provided for the binary digitalization of all forms of information coding, storage, and retrieval, including computer composing, typeface selection, desktop publishing, CD-ROM, and, above all, the cybernetic integration of all senders and receivers made possible by the interfacing of main frame and personal computers and the Internet with its global reach and potentially unlimited capacities for information generation, storage, and retrieval.[34]

Why did the Typographic Revolution not occur in the cultures in which paper and early printing developed—China, Japan, India, or even in Arab countries? Why did print evolve in these cultures but not become a revolution? One possible explanation is based on the semiotic codes used for the writing

systems in these cultures. With the Chinese system of thousands of logograms, for example, block printing was actually more efficient than using moveable type for each individual character. Here the Chinese were not being stupid or backward; rather, they were being very practical in using techniques and technologies that helped them to meet their goals efficiently.[35] It is also possible that the conservative ethos of their cultures made them seek stability rather than change in order to ensure their chances for survival. If survival is the ultimate test for any system, then the Chinese, Japanese, Korean, Indian, and Arabic systems were able to meet that goal without the aid of an alphabetic writing system and a full system of printing.

If we consider inadequacies and limitations to be motivations for change, then Western Europe in the mid-15th century was a prime place for the revolution in typography. Simply put, Western Europe needed the printing press to meet its growing deficiencies in communication as it moved from the Medieval to the Modern World. The very chaotic environment in which the closed systems of feudalism and religion were being challenged by new ideas, discoveries, and visions was one ready for new ways to communicate new information. A confluence of factors came together in a culture that fortunately already possessed alphabetic writing, the potential for mass literacy, and the lack of any strong centralized government. The time was ripe and the place fertile for the birth of the Typographic Revolution.

People

The people involved in the evolution–revolution of typography are legion and were spread over both time and place. A conventional starting place could be China in the year 105 when the emperor's chief eunuch T'sa Lun announced the invention of paper. It is probable that the invention was actually the creation of workers under the eunuch but rarely do underlings receive due credit for their achievements. The motivation was simple: to produce a more efficient and cheaper substitute for writing than the expensive silk, clumsy bamboo, stone, slate, clay, and other surfaces being used. Presumably, the emperor was pleased and rewarded T'sa Lun appropriately. In the centuries that followed, Chinese craftsmen experimental with stamping, inked carved seals on paper around 450, with block printing from carved wood, clay, and other materials in the 600s, with the use of folded books, rather than scribal rolls, by 950, and with the earliest binding together of pages by sewing in the early 1100s.

Japanese and Chinese block printers also made significant advancements

in the evolution of printing that included block printing of texts, the binding of pages into books, and the casting of metal type from molds. Other cultures were also involved in these proto-printing experiments, but none of them would lead directly to the Typographic Revolution that would finally move civilizations from handwritten manuscripts to typographic texts. What is significant is that, except for T'sa Lun, we have no information about the people who actually developed paper, block printing, inks, and the other techniques and technologies needed for early proto-printing. They were nameless and faceless functionaries in large bureaucracies, working for rulers who retained total command and control of all writing and printing systems.

The Chinese are rightly given credit for being the first to use inked carved characters to make exact copies of texts and assemble them into a book (the earliest known book is *The Diamond Sutra* created in 868). By the 11th century, the Chinese were using moveable blocks of wood on which were carved ideograms, but they never assembled these individual blocks into a unified frame to produce full pages of print with one pressing. Two key elements were missing from the Chinese system—an alphabet of limited characters to make moveable type practical and an efficient method of pressing the inked characters onto paper with speed and uniformity.[36]

There is rigorous debate as to whether these Chinese developments influenced Western printing directly or indirectly. In either case, the development of typography from evolution to revolution moved from Asia to Europe, with block printing, in the early 15th century, followed by full printing systems using moveable alphabetic type locked in a frame to print inked paper on parchment and paper by the use of a hand-operated screw-type press. Although there are scholarly arguments over who actually invented the world's first true printing press, it is worth quoting Johann Schoeffer, himself a printer and the son of Peter Schoeffer, the assistant to and successor of Gutenberg: "The admirable art of typography was invented by the ingenious Johann Gutenberg in 1450 at Mainz."[37] What Gutenberg, assisted by Peter Schoeffer and financed by Johann Fust, achieved was a synthesis of all of the techniques and technologies needed for typography into one unified system that would produce a revolution in communication. Gutenberg separated history into two parts—before printing and after printing.

Johann Gensfleisch zum Gutenberg was born sometime between 1394 and 1399 to a patrician family in Mainz, Germany. Trained as a goldsmith, his major motivations in life seem to have been his devotion to the Catholic faith and a desire to make money, placing him precisely in the split between the sacred

and the secular worlds. In the 1440s, he began to work in printing, probably using his goldsmith knowledge to carve metal punches containing the individual letters of the alphabet, to strike these into matrices of softer metal that could be fitted into molds, to reproduce typeface from the molds. How he devised a way to lock the assembled typeface into a frame, to ink the typeface, and to use a screw-type press (most likely used for olive or wine pressing) with a roller to print exact copies of texts is something of a mystery, one which he and his early successors tried to keep as secret as possible. In this case, knowledge was both power and money. From civil court records, we know that in 1450 Gutenberg borrowed 800 guiders from Johann Fust, a Mainz lawyer, and in 1452 borrowed another 800 guiders that made them partners in a printing shop. In 1455, Fust foreclosed on Gutenberg and the presses and type were assigned to Gutenberg's assistant Peter Schoeffer, Fust's future son-in-law. We see here how communication had become a mixture of creativity and capitalism, with capitalism usually the stronger partner. Gutenberg died in relative obscurity and poverty on February 3, 1468.

The Gutenberg–Schoeffer press produced two landmarks in the Typographic Revolution: the justly famous 42-line Bible (in Latin) set up in type in 1452 and published in August 1456, and the later 36-line Bible (also in Latin) published between 1458 and 1461.[38] These printed books contain typographic texts that are copies of handwritten letters. Indeed, the intent seems to have been to produce cheaper versions of the manuscript copies available from scribal scriptoria and stationers' shops, a good example of Marshall McLuhan's observation that people usually perceive a new communication technology to be merely a way to improve older technology. In any case, the Gothic script common to Germany was used for Gutenberg's new typeface, making the first printed books with moveable type as difficult to read as handwritten manuscript copies. Gutenberg's *Catholicon*, published in 1460, contains a colophon that summarizes his own view of his achievement:

> With the help of the Most High at whose will the tongues of infants become eloquent and who often reveals to the lowly what he hides from the wise, this noble book *Catholicon* has been printed and accomplished without the help of reed, stylus or pen but by the wondrous agreement, proportion and harmony of punches and types, in the year of the Lord's incarnation 1460 in the noble city of Mainz of the renowned German nation, which God's grace has deigned to prefer and distinguish above all other nations of the earth with so lofty a genius and liberal gifts. Therefore all praise and honour be offered to thee, Holy Father, Son and Holy Spirit, God in three persons; and thou, Catholicon, resound the glory of the church and never cease praising the Holy Virgin. Thanks be to God.[39]

What is remarkable about this colophon is its mixture of piety and pride, its universal Catholicism and German nationalism (at a time when Germany was not a nation but a fragmentation of individual states), and its echo of the Egyptian god Thoth's claims for his invention of writing to Amun-Re as being unique and capable of changing communication. In that sense, Gutenberg was more modest than Thoth, for his printing press would provide the means for alphabetic writing to become a powerful agent of change for the next five centuries by enabling the mass production of information that was open to correction and revision.[40]

The people who played major roles in the history of typography include the printers and their helpers, skilled craftsmen who replaced hand-copying with typeface, their patrons and readers who supported the new technology, the authors—especially the contemporary ones—who provided the copy to be typeset and printed, and the church and secular authorities who attempted to command and control the information made possible by this new system of composing, storing, and sharing through official authorization and censorship. Some of those who played key roles in the techniques and technologies in this evolution–evolution have already been identified in the Context section of this chapter. But there were others who made significant contributions to how the media of this evolution–revolution were used to bring significant changes to their own societies and to Western Civilization in general.

In retrieving knowledge from ancient texts that had long been missing or scarce in Europe, typography helped to make permanent the rebirth of learning stimulated by the Renaissance. One major differences between the storage of information by scribal copyist and by printers was that printed texts tended to have more copies distributed more widely and, thus, had a greater chance for survival over time. It also provided standardized copies that could be corrected, resulting in information that was more accurate, reliable, and valid. All of this helped to move Europe in the 15th and 16th centuries away from closed and toward more open ways of knowing.

Consider what happened with astronomy, an enduring human study of the motions of the heavenly bodies that may well have begun with early humans during the last Ice Age but certainly was a central part of Babylonian writing as early as 432 B.C.E. . In Europe, before print, the dominant cosmology was the geocentric model of the universe first proposed by Claudius Ptolemy, an astronomic and geographer who lived in Greek Alexandria in the 2nd century of the Common Era. Essentially, Ptolemy's system held that all of the heavenly bodies, including the sun and moon, the planets and the stars, revolved around

the earth. Long lost to the West, this Greek manuscript emerged in the 12th century in a Latin translation from an Arabic translation. In 1451, a new Latin translation was rendered from a Greek copy. The first printed edition seems to be from 1476 and was based upon the 12th century translation. Once this text had a wider audience, because more copies were available, scholars noted that Ptolemy's model often failed to describe with precision or to predict with accuracy celestial motions.[41]

In 1543, *De Revolutionibus Orbium Celestium* (*On the Revolution of Heavenly Bodies*) was published. Written by Nicolaus Copernicus (1473–1543), a Polish astronomer born Niklas Koppernigk, it provided a competing theory that held the sun to be the center of the motions of the planets in our solar system, with the stars as suns of their own systems. What Copernicus created was an alternate model that invited comparison with Ptolemy's model for validity and reliability, the very essence of modern scientific thinking.[42] The Danish astronomer Tycho Brahe (1546–1601) later compared the competing models by using his own observations and proposed a third model in which the planets revolved around the sun while the sun still revolved around the earth. In 1609, Johannes Kepler (1521–1630), a German astronomer, published *Laws of Planetary Motion* which held that Copernicus was right, but that the orbits of all heavenly bodies were elliptical rather than the perfect circles imagined by Ptolemy, Copernicus, and Brahe. For upholding Copernicus and Kepler in *The Starry Messenger* in 1609, the Italian Galileo Galilei (1564–1642) incurred the scrutiny of the Roman Catholic Church's Office of the Inquisition. While Galileo officially recanted, his countryman Giodorno Bruno of Nola (1548–1600), who held that the universe was boundless and endless, was less fortunate. Denounced by Rome and by the two major Protestant denominations, Lutherans and Calvinists, as a heretic, Bruno was condemned by the Inquisition and burnt at the stake for his theories.[43] But Bruno's execution and Galileo's recantation did not end scientific thinking, and in time astronomy would replace astrology, and science would replace religion as the tester of theories of how the heavenly bodies moved. In this change, the English scholastic philosopher William of Occam (1285–1349) provided a key principle that all reasoning must be based upon experimental proof and that assumptions and descriptions used to explain phenomena must be tested by their being limited to what is necessary. Thus, Occam's Razor tells us that the less complex explanation is preferable to the more elaborate one. In time, even religious leaders came to accept this position and largely left science to scientists.

But before science was left to the scientists, the nature of God, truth, and

eternity was contested in Western Christianity with the force of words and the force of arms. After the separation of the church into the Eastern Orthodox Byzantine rites and the Western Roman Catholic Papacy, Rome provided the nexus for all Christian belief, thought, and ritual in Western Europe. Those who proposed challenges and alternatives to orthodox beliefs and rites were often ignored or accused of heresy, with execution the likely punishment for those who refused to recant their challenges to the official dogma. The great Schism of the West, which resulted from both Avignon in France and Rome support-ing different popes from 1378 (Clement VII versus Urban VI) to 1417 with the election of Martin V, raised doubts among some Christian scholars about the purity of the Papacy. In England, John Wycliffe (1330–1384), a professor at Oxford University, believed that all Christians should be able to read the Bible and helped to produce the first complete English translation around 1388. For these thoughts and actions, he was expelled from Oxford but permit-ted to die in bed in 1384. Less fortunate was Jan Hus (1369–1418), the Rector of the University of Prague, who echoed Wycliffe's criticisms and was burned at the stake for his ideas.[44] All of these reformers were limited in their ability to have their ideas heard or read by large numbers of people. The very fragmen-tation of society in the feudal system, with limited travel and little contact with people outside of one's immediate environment, with limited literacy and the sparsity of manuscript copies of texts, worked to keep all protests confined in time and space to the now and here.

The Four Pillars of the Christian Commonwealth (*Republica Christiana*) were Scholasticism (a Neo–Aristotelian synthesis of logic and philosophy that upheld Christian beliefs), the authority of the Papacy as Christ's chosen medi-ators between God and humans, the remnants of Roman law as codified by the Church, and the Bible as the repository of the words of God to be interpreted by the Church. The printing press, with its power to spread the words of any-one to everyone, provided the technology to make challenges to the Papacy more effective. These challenges would find their most effective expression in the spoken and written words of an Augustian monk and professor of theolo-gy at Wittenberg in Germany—Martin Luther (1483–1546). Although mod-ern scholars continue to debate the role of the printing press in the Protestant Reformation, with some claiming that "the printing press destroyed the legit-imacy of papal authority"[45] while others hold that such claims are exaggerations and that, at most, the printing press merely provided a vehicle for the sharing of ideas by the reformers and the Papacy.[46] I think that, on balance, the print-ing press provided an advantage to the opposition because it opened a new way

for reformers to challenge the Vatican's command and control of information central to Christian life through church rituals and sermons, and through the interpretation of the Bible (in Latin) to the largely illiterate masses of the faithful.

In one sense, the Reformation reflects the growing conflict between the central power of the Papacy based in Rome (except for the Great Schism from 1378–1417 in which Avignon in France and Rome fought over the Holy See) and Northern European (Germany, Netherlands, and Scandinavia) yearnings for more local control over their own lives. The central issues identified by Luther in his celebrated *Ninety-five Theses* that he nailed to the church door in Wittenberg on October 31, 1517 involved questions of Papal legitimacy, celibacy in the clergy, the selling of indulgences for the remission of sin, and corruption in the Church.

Luther's complaints soon moved beyond the church, when handwritten copies of the *Ninety-five Theses* sent to friends were translated from Latin into German and printed and distributed widely. A local and church argument had now moved to a larger public debate, a shift not possible before typography changed the information environment from a relatively closed to a more open system. Luther's own judgment on the role of print in the Reformation is to the point: "God's highest and extremist act of grace, whereby the business of God is driven forward."[47] But even Luther seemed surprised at the impact of print when his *Ninety-five Theses* were printed. In a letter to Pope Leo X, Luther wrote: "It is a mystery to me how my theses more so than my other writings, indeed, those of other professors were to spread to so many places....They were written in such a language that the common...people could hardly understand."[48]

Whether Luther's dismay at the impact of his theses was genuine or feigned, the German versions of his theses and subsequent writings were printed in Nuremberg, Leipzig, and Basel. As Elizabeth L. Eisenstein notes, "Partly because religious dissent was implemented by print, it could leave a much more indelible and far-reaching impression than dissent had left before."[49] As "typographical fixity" had made possible a permanent revolution in science, it would also make possible a permanent reformation in religion that would split Western Christianity for the next 500 years and beyond.

As it did in science and religion, typography would act as an agent of change in every area of human activity dependent upon the communication of information. In the first century of typography, individuals contested with

local authorities and local authorities contested with centralized authorities (either religious or secular) for command and control of this new system of techniques and technologies that could extend written language over both time and space. The motivations of people were mixed in their individual manifestations in cultural, economic, political, religious, and social realms, but whether they sought continuity or novelty, centralization or fragmentation, one Christian community or national churches, change was the one constant in their quest for survival in material and cultural terms. From individual printers, the impetus for typographical change moved to larger and larger publishing conglomerates, to what we now call vertical integration of all forms of production and distribution of printed materials. Both those who used print to change the system and those who tried to resist change worshipped at the same altar of the power of technology to alter the very nature of communication within an environment.

Those who received the greatest rewards were the individuals who sought the greatest changes in science, religion, economics, and politics. All major changes in the central media of any culture rearrange the command and control of information within that culture. The new media also bring power opportunities to those who invent, develop, and control these media. In the final analysis, it is those who ultimately control the media who reap the greatest rewards, including the survival and supremacy of themselves and all that they hold to be valuable. Thus, the emerging entrepreneurs of printing would be rewarded by profits to be made from the expanding reading classes in Europe. Scientists were rewarded by the opportunity to publish and share their thoughts. Religious reformers, like Martin Luther, John Calvin, and John Knox, founded new Christian churches that would later inspire still more fragmentation of the Christian Commonwealth, with rising capitalism threatening both feudal and papal order.[50]

Printing also rewarded explorers and the mapmakers who facilitated their voyages of discovery. Since maps were first drawn in ancient civilizations, accuracy and reliability were not guaranteed. And as European explorers journeyed to distant lands, their maps proved to be even less accurate and reliable. Ptolemy's *Geography*, translated and printed in local languages, provided a foundation for exploration and, as these expeditions returned with information about the previously undiscovered countries, mapmakers produced corrected charts and maps that contained more information and more valid and reliable information. As John Noble Wilford notes in *The Mapmakers* (1981):

Exploration and cartography were now joined. No longer, after Columbus and Magellan, could mapmaking afford to be a contemplative occupation, the pursuit of cloistered minds. Explorations or planned discovery brought it into the thick of contemporary affairs and geographic thought. The many newly found lands and seas had to be represented on maps, as swiftly, thoroughly, and accurately as possible, for a place is not truly discovered until it has been mapped so that it can be reached again.[51]

By providing multiple copies at the same time, printed charts and maps were distributed to explorers and other chartmakers and mapmakers who were able to provide feedback to correct errors and remove misinformation, thus making the corrected charts and maps more accurate and reliable. These new charts and maps, in turn, helped explorers to plan and execute new voyages of discovery with more confidence in their information about the known world as they explored the unknown.

Obviously, print also was instrumental in increasing the number, fame, and perhaps fortunes of the authors of new texts—first in books and later in newsletters, newspapers, magazines, and other outlets for printed information. Printing preserved the names of ancient authors and provided vehicles for new authors to make their names known to the reading public. The Republic of Letters made possible by printing would be both national in that most people would read books in their native languages and international in that many books would be translated from foreign to native languages, enabling readers to receive information from the widest sources without having to learn other languages to decode the messages.

All human beings with access to typography—whether as authors, editors, type-casters, typesetters, ink makers, inkers, papermakers, binders, printers, publishers, distributors, critics, censors, or readers—were involved in a revolution in communication that made more information from more sources about more subjects available through more outlets to more people than ever before in history. Printing helped to expand the Republic of Letters beyond the intellectual circles of the church and universities to include the rising and increasingly educated middle class. Printing provided the individual reader with access to all that had been printed from the past and present, information that could be used to help each person to think individually. Such power was, and is, a threat to the power elites of any society. It should be no surprise that almost every power, sacred or secular, attempted to command and control information made available by this new invention through censorship, indices of forbidden works, and licensing of presses and printing. But the very techniques and technologies used by printing helped people to resist, if rarely to defeat, the com-

mand and control exercised by the power structures. Alphabetic literacy, empowered by printing, became a driving force for change in Europe and other places to which it spread, encouraging and enabling all people to share knowledge and to think for themselves.

Printing did not cause the Scientific Revolution, the Protestant Reformation, the Age of Discovery, the Rise of Capitalism, the American and French Revolutions, or the Modern World. But it is difficult to see how any of them could have succeeded without the expanded literacy made possible by Gutenberg's Revolution. The promise of mass literacy, inherent in alphabetic writing, needed Gutenberg's printing press with moveable type to make that promise an actuality. Of course, other cultural, social, and historical forces had to play significant roles as well. But from a technique and technology perspective, typography must be seen not simply as one agent of change but as a determining agent of change in terms of communication.

Remembering that our own Cybernetic Age is founded upon the world of print, consider how print continues to affect your life today. How do you use print every day? How is print involved in your daily communication of information? What would you lose if all printed materials were eliminated from your environment? Even if we concede that many delivery systems that used to be dependent upon printing are now being supplemented, even replaced, with electronic formats, what is left of the world of print? We should remember that language did not totally replace pre-language communication, that writing did not totally replace speech, and that typography did not totally replace handwriting. It could be argued that each revolution changed the previous communication system, diminishing it in some ways while enhancing it in others. Just as the language of literate cultures is different from the language of people without literacy, the language and writing of typographic peoples are different from the language and writing of people without printing. But whatever the differences among the impacts of language, writing, and printing on different peoples and cultures, one result seems clear: In the struggle for survival and domination, those who acquired language, literacy, and typography had distinct advantages over those who did not. If knowledge is power, then command and control over the dominant media of communication in an environment help to guarantee access to power.

Messages

At the start of the evolution of typography in China and then in Japan and Korea, the messages carried by early block printing were those needed by the

central authorities headed by emperors and their courts. In all of these early civilizations, the messages were those deemed essential for the continuity of the cultural–social systems. In China, for example, the invention of paper seems to have been spurred by the need of the imperial court to find a medium for distributing its decrees and instructions to the far reaches of the empire that was lighter than bamboo or wood and less costly than silk. These printed messages had more power because they carried identical information from one central source to outer areas.

According to Thomas F. Carter, Chinese printing was born during the T'ang Dynasty (618–906), which not only solidified the reunification of China but expanded its cultural, diplomatic, and material strength. The T'ang emperors encouraged scholarship and the arts, building a library containing over 50,000 scrolls, and opening themselves and their people to the ideas embodied in Taoism, Confucianism, and religious faiths like Buddhism and Christianity. Multiple reproductions of Confucian sayings and images of Buddha carried the messages of their respective philosophies. After the reign of Emperor Ming Huang (712–756) ended in a revolution, non-Chinese philosophies and religions were subjected to persecution and eventual expulsion. An official edict in 845 authorized the destruction of Buddhist temples and forced the secularization of Buddhist monks and nuns.[52]

When print exploded in Western Europe in the 1450s, the messages were both sacred and secular, but they came from the edges of power as well as from the centers. The messages first printed by Gutenberg, Schoeffer, and their followers began with religious texts, especially the Bible, but soon spread to encompass the widest range of areas of interest to the people of the time. The messages called for changes in religion, in sciences, in almost every area of culture and society. Many of them exhorted people to think for themselves, to question accepted authorities, and all received knowledge and wisdom. In religion, the new messages criticized the Papacy and promised a truer path to salvation. In science, the new messages criticized ancient truths and subjected all knowledge to empirical and logical testing.

In the beginning, the messages were overwhelmingly *emphatic*, conveying significant information intended to have specific impacts; in time, the messages carried by print also included *phatic* communication, conveying not specific information but system-sustaining signals. In both cases, the messages carried by print would change the ways that messages were encoded and decoded, in part because print made messages more public and therefore more difficult to conceal. In addition, printed words carried more authority and legitimacy than

spoken words because their very fixity gave them permanence over time, and their multiple copies allowed them to be spread over space more rapidly. In challenging the older messages carried by speech and manuscript, the new messages carried by print themselves became the new orthodoxy, more open to change and correction but still powerful as fixed knowledge.

The form of the messages changed in terms of coding. From Latin, the messages moved toward vernacular languages, and in this movement helped to shape and solidify the languages we associate with specific people and places—German, Italian, French, Spanish, Dutch, English, and other European tongues. The magnitude of this move is signified by the strong resistance it received from both church and state authorities when the Bible was translated into various European languages. The Christian Commonwealth controlled from Rome with Latin as its common language was being challenged and replaced by regional and national states with their own individual languages conveying the words of God and man. Martin Luther's famous aphorism—"Each man his own Bible, each man his own priest"—promised to empower the individual man with the information needed for his own salvation. In time, even Luther saw the danger to authority in this power, and he, joined by other reformers, followed the Pope in trying to restrict interpretations of Holy Scripture to those in authority. The Peasants' War in Germany in 1525, inspired in part by Luther's insistence that the Bible represented the only true authority, was met by condemnation by Luther and brutal suppression by the German nobility.

In time, the messages carried by print would include the significant and the trivial, the eternal and the ephemeral, the profound and the inane, the sacred and the sacrilegious, the informative and the manipulative. Print would provide the first true medium of mass distribution of information that would enhance not only communication but manipulative persuasion. Indeed, the word *propaganda* itself, in its meaning to manipulate masses of people to follow one message, comes to us via the impact of the printing press. In 1622, in response to the Protestant Reformation sparked by Martin Luther in 1517 that was aided so significantly by print, the Vatican established the *Sacra Congretio de Propaganda Fide* (the Sacred Congregation for the Propagation of the Faith), expanding the meaning of *propaganda*—to propagate—from its use in agriculture to its metaphorical use of a medium of communication to plant seeds in the minds of many through the repetition of exact messages. Printing helped to replace the pulpit with the printed text as a system for transmitting one central message to a wide audience.

The propaganda of the Protestant Reformation was met by the counter-

propaganda of the Catholic Counter-Reformation. Both of these propagandas of the word and the image were eventually joined by propaganda of the deed—what we call the Thirty Years War (1618–1648)—in which Protestantism and Nationalism engaged in trial by combat with Roman Catholicism and the Christian Commonwealth. As Philip M. Taylor notes: "If war aims were presented in the disguise of religion, then much of the 'credit' for this must go to the poets, songwriters, pamphleteers, and printers whose work reached just about every class of society."[53] Obviously, the printing press played a major role in providing multiple copies of the words and images that were reproduced through typesetting and graphic engravings and etchings. In its basic ability to reproduce words and images in identical forms, typography provided people with an ideal medium for manipulating people's minds through controlled messages reprinted in simplified language and striking images to masses of people. Both the Protestant Reformers and the Catholic hierarchy benefited from and were hurt by the propaganda carried by print, but, on balance, it would seem that the Vatican got the worse of the exchange, in that its centralized command and control of religious information and knowledge lost some of its power to its critics, resulting in competing universes of discourse on the meanings of God's commandments and ultimate goals for humanity.

Overall, the very nature of print tended to encourage the sending of messages from a few sources to multitudes of receivers, making the flow of information largely one way but with enough feedback to help correct errors in the information. This limited-sources, one-way flow facilitated print's use as a medium for manipulation and propaganda. The very same attributes of print that made it the first medium of communication that extended the flow of information through time and space to more people also made it an ideal system for extending the command and control of information to those who owned or controlled the printing presses. In essence, the *Faustian Bargain* was in effect.

The Media

The central media in this evolution–revolution were all based upon the medium of typography itself—the ability to typeset and reproduce countless copies of a text with greater efficiency that could be possible with scribal copying. As *minding* is what the human brain does when it's operating, *printing* is what the techniques and technologies of typography do when operating as a communication system. Beginning with the Chinese, Japanese, Korean, and Indians, block printing was used to reproduce handwritten texts, but these copies seem

to have been limited in their reach to very specific readers. It was the revolution begun by Gutenberg and those who followed him that made printed copies available to ever-wider audiences of readers and, in that wider distribution, aided and encouraged the spread of literacy to groups previously excluded from the Republic of Letters.

This revolution also went beyond the mere imitating of manuscript scribes by copying in print the types of texts already common in scribal literacy to inspiring new forms and genres. The manuscript newsletter that had been semi-circulated since at least the time of Rome soon evolved into printed newsletters, periodic newspapers, and daily newspapers. What began as a more efficient system for copying books soon evolved into an entirely new way to encode, store, and share information about an expanding number of subjects to an ever-expanding audience. Gutenberg's "wondrous agreement, proportion, and harmony of punches and type" replaced the "reed, stylus, or pen" of the scribe with the techniques and technologies of the printing press as a total system in which tools and machines replaced handwritten letters. Technophiles called it a triumph of human ingenuity while technophobes worried that it was debasing human communication by moving it away from human control and surrendering literacy to technology. Media ecologists would argue that print brought benefits and deficits, and that we have to weigh all the changes in considering its effects on people and cultures.

Certainly, the printing press with its ability to produce multiple copies more efficiently helped to move copying from parchment to paper to meet the demands for more and cheaper copies of books. And this move involved more than merely the surface upon which the lettering was written or printed. As Harold A. Innis noted, "The dominance of parchment in the West involved an exaggeration of the significance of time. A monopoly of knowledge based on parchment invited competition from a new medium such as paper which emphasized the significance of space as reflected in the growth of nationalist monarchies."[54] The very slow and tactile experience of hand-writing manuscripts and the limited number of copies of any text available in chirographic cultures helped to preserve the oral–aural nature of human communication. Because most manuscript information was shared by reading aloud, the information remained largely oral–aural although assisted by literacy. But multiple copies of texts printed on paper and distributed in large numbers encouraged a new kind of individual reading in which sight replaced sound as the dominant sense. To Walter J. Ong, "Manuscript culture is producer-oriented, since every individual copy of a work represents great expenditure of an individual

copyist's time....Print is consumer-oriented, since the individual copies of a work represent a much smaller investment of time."[55] Printed texts on paper enhanced sight at the expense of sound and encouraged not only individual silent reading but, perhaps, individuality itself and its central concern for privacy.

Typography expanded the delivery systems of chirography from books to other formats, but books themselves were always at the center of the printing revolution. The idea of the library as a storage system for writing had existed since the ancient worlds of Sumer and Egypt and had continued through Greece and Rome into medieval times in Europe. But the library as idea and actuality would begin to move from private libraries controlled by monasteries, churches, governments, and universities to private libraries owned by individuals and small groups and to public libraries, either free or subscription, open to all readers. These more open libraries made more information available to more people while also enhancing individual reading with their admonitions for "Silence" posted everywhere. In a very real sense, the mass audience was created by print because it encouraged the widespread sharing of information to a mass of individuals who consumed it in silent reading. Of course, individuals could also share their individual readings and interpretations with other individuals, but this experience was different from group participation in a common reading. The very real communities of information limited to a specific time and place, common to oral–aural cultures, and only slightly altered by chirographic cultures, were being replaced with what we would now call "virtual communities" in which the information was shared by many but at different times and in different places. In cybernetic terms, the contexts had changed and changes in contexts usually mean changes in meaning and effects.

The new formats of distribution—newspapers, magazines, pamphlets, handouts, mailings, etc.—would continue to both widen and narrow the Republic of Letters. While expanded forms of print reached more readers, the language of print moved from the shared Latin of the Middle Ages to the preferred local languages. The Republic of Letters was slowly being replaced by new interpretative communities founded on specific languages connected to rising national states dominated by single powerful language groups. The universality of Latin was replaced by national languages which suppressed local dialects and regional languages, producing fragmentation in the larger realm of Europe but concentration within the areas that would become the modern nations that formed the European Union that now contains 27 countries and is continuing to expand, perhaps forming a 21st century *Republica Europa*.

As with all significant changes in techniques and technologies of communication, the media central to print influenced the sensory balance between sight and sound and the bias balance between time and space, with different results depending upon the specific contexts. Print media not only responded to the limitations of manuscript media but encouraged new forms of print itself, enhancing prose over poetry and verse, standardization over individuality, innovation over tradition, and the new over the old. Without the media made possible by typography, the Modern World of science and technology, of secularization and participatory government, of individuality and mass society might exist but not in its present state. In his 1620 *Novum Organum*, Francis Bacon (1561–1626), the English philosopher, identified three inventions that changed Europe: "We should note the force, effect, and consequences of inventions which are nowhere more conspicuous than those three which were unknown to the ancients, namely printing, gunpowder, and the compass. For these three changed the appearance and state of the whole world."

While none of these inventions originated in Western Europe, each had a profound impact there because people used them in new ways with new and profound consequences. The printing press revolutionized simple block printing to extend information through time and space via new media to new audiences. Gunpowder, which the Chinese used largely for fireworks, was harnessed to provide the explosives for bombs and the propellants for projectiles fired from cannons and guns. The compass was used to extend European exploration to the distant reaches of the Earth, enhancing European knowledge of the world. And it was information, now codified, stored, and communicated via print, that helped Europeans to use all of their techniques and technologies to explore, to conquer, and to rule over less technologically advanced cultures and societies. Never was the concept that knowledge is power more forcefully and brutally demonstrated.

Impacts

Fundamentally, print extended the sense of sight, reinforcing the eye as the dominant source for the reception of information that writing had reinforced earlier. It also extended memory by providing storage systems that surpassed human memory and manuscripts. Even after more than 550 years, it is difficult to catalogue all of the profound effects that typography has had on the world. Let us begin with language itself, that most fundamental human communication system. Printing multiple copies of texts freed people from the need to

memorize vast amounts of information that scribal literacy had not really affected. Rather than the brain, printed books, catalogued and stored in libraries, became the memory storage units of the new age. The very speech of people was affected by typography as printed texts enhanced standardization in vocabulary and syntax and empowered vernacular national and regional languages at the expense of Latin. Printing was an invention and an instrument of the literate, but it helped to spread literacy beyond the limited elites of scribal society. Typographic literacy changed the language of all who had access to this invention and its offspring. In primary oral cultures, knowledge is an integral part of those who hold the knowledge. The knower and the known are one, and there is no question of objectivity because all knowledge in orality is subjective in its essence. Writing provided some detachment between the knower and the knowledge because it could now be stored in an external form that could be transported over time and space to other people, but the very nature of handwriting limited both the output and the copies. Print made it possible to detach knowledge from the knower, to make it more objective by presenting it in a mechanical form that standardized all texts. In preserving language in standardized forms, "Typography arrested linguistic drift, enriched as well as standardized vernaculars, and paved the way for the deliberate purification and codification of all major European languages."[56]

Like writing, printing expanded the vocabulary available to those with access to literacy. Whether thought is dependent upon language is a debatable issue, but there is no question that people who live in literate cultures have larger vocabularies than those who live in oral cultures. And people who live in typographic cultures have larger vocabularies than those who live in chirographic cultures. Typography extended and expanded the benefits of alphabetic literacy, significantly enhancing it with the addition of the Hindu–Arabic numerals that were replacing the old Roman system of using letters to represent numbers. In a famous passage from *Il Saggiatore* (1623), Galileo Galilei wrote these famous words about language and thought: "Philosophy is written in this grand book, the universe, which stands continually open to our gaze. But the book cannot be understood unless one first learns to comprehend the language and read the letters in which it is composed. It is written in the language of mathematics."[57] Here is a clear endorsement of the idea that language is essential to thinking. By expanding the Republic of Letters of Latin scribal literacy to a Commonwealth of Learning of vernacular languages made possible by typographic literacy, the community of scholars was expanded profoundly to include people and classes of people previously excluded by the limitations

prevalent in all scribal cultures.

But this move toward general social literacy did not come quickly or easily. Before the 19th century's commitment to compulsory universal education and participatory democracy, literacy remained limited in Europe and, to a lesser extent, in America to the upper strata of societies. Techniques and technologies of communication do not, in themselves, require cultural and social changes; they merely make them possible. Human beings living in specific cultures do have some choices, and the history of printing provides evidence to support the conclusion that no technique or technology compels people to act in specific ways.[58]

Typography standardized alphabetic–numeric writing in many ways, from spelling and punctuation (upper and lower case letters, capitals, periods, commas, quotation marks, question marks, colons, semi-colons, dashes, ampersands, etc.) to sentence structuring, paragraphing, and beyond. This standardization was especially significant for the many national languages that were enhanced, even made viable, by the printing press and which now encouraged the writing of information by more and more people. And with more people having more access to information and being stimulated to engage in some individual thinking, it was possible to try to answer all questions and to learn to question all answers, two key components of modern critical thinking. By asking themselves and others what constituted "truth" and how "truth" should be evaluated, typographic scientists were freeing themselves from the received wisdom of the past and moving toward a more open system of inquiry. The theories and truths of the past were compared with each other and also compared with the realities of experience in the empirical world, creating "...a modern society that prized the values of individualism, competition, objectivity, and equality...over the closed society values of collectivism, cooperation, subjectivism, and hierarchy."[59]

If the impacts bestowed on science by typography seem to be overwhelmingly positive, its impacts on religion appear to be more mixed. Although Gutenberg was himself a devout Roman Catholic who hoped that his invention would spread the power and the glory of the Church, the printing press, by making more information possible from more sources to more receivers, threatened the empire of knowledge under the command and control of the Vatican. While typography did not cause the breakup of the Western Christian Church, it did facilitate the critics of the Vatican. The Reformation sparked by Martin Luther and carried forth by John Calvin, John Knox, and others benefited profoundly by being able to print its objections and then distribute them

to a wide range of people through both Latin and vernacular languages. Typographical fixity gave a permanence to religious dissent that was extended through time and space, helping the Reformation "to exploit printing's potential as a mass medium" to conduct overt propaganda against the Pope and the entire structure of the Holy Roman Catholic and Apostolic Church.[60] Despite Gutenberg's hope that his invention would be a "peaceful act" benefiting all people, his printing press "probably contributed more to destroying Christian concord and influencing religious warfare than any of the so-called Arts of War ever did."[61] As Elizabeth L. Eisenstein notes, "The long war between the Roman Church and the printing press continued for the next four centuries and has not completely ended."[62] But print's impacts on the Catholic Church were not entirely negative. In addition to helping to standardize church liturgy in forms that would last until the 20th century, typography also benefited the Vatican in its great Counter-Reformation of the 1620s which helped to counter Protestant arguments and to extend the beliefs of the Roman Catholic Church around the world, especially to the new colonies being founded by French, Portuguese, and Spanish explorers.[63]

Printing's impacts on Protestantism were not entirely beneficial despite providing the movement with the ability to print large numbers of Bibles and other religious texts in the local languages of the people, especially in Northern Europe. In challenging Papal authority, the reformers used print to break up the Papacy's empire of knowledge, but they themselves were soon faced with dissent from their own orthodoxies and orthopraxies. The problem with thinking for oneself against some authority is that it encourages others to think for themselves against your authority. The major difference between Catholic and Protestant attempts to command and control typographic information and knowledge was that while the Papacy was centralized, the reformers were fragmented into their own local or national communities. But attempts at command and control of information would become common for both church and state. As Steinberg notes, "A century after Gutenberg's invention, censorship of the printed word had become the universal practice of the lay and church authorities throughout Europe."[64] As printing spread throughout the world, censorship followed. It was not until the American Revolution of 1776 and the French Revolution of 1789 that the idea of a free press would become a hallmark of a free society that continues to spread in the 21st century, although more as an ideal than as a reality.

When Francis Bacon identified printing, gunpowder, and the compass as the three revolutionary techniques that formed the modern world, he over-

looked what some people believe to be the most important invention of all. In *Technics and Civilization*, Lewis Mumford affords it primacy over all: "In sum, the clock was the most influential of machines, mechanically as well as socially....Second to the clock in order if not perhaps in importance was the printing press."[65] Since our beginnings, human beings have attempted to understand and to tame time by finding ways to chart its movements, from the natural cycles recorded in prehistoric art to the calendars of ancient civilizations. In Egypt and China, sundials and water clocks were used to break up the day into smaller units of time. The ancient day–night separation of one day soon yielded more precise measurements. In Rome by 300 B.C.E., the day was separated into four time periods—*Mane* (early morning), *Ante Meridiem* (before noon), *De Meridie* (after noon), and *Suprema* (evening), with night to follow. In medieval Europe hourglasses filled with sand, and candle clocks provided time-keeping for both day and night hours.

The clock in Mumford's reference was the mechanical clock that would standardize what we mean by time. Its origin can be traced to the need for Christian monks to know the time for prayers during the day. An early clock was used by St. Benedict in the 6th century when a weight-driven system struck a bell to summon the monks to prayer seven times each day—*Matins* (dawn), *Hora Prima* (first hour of sunrise), *Hora Tertia* (midmorning), *Hora Sexta/Meridies* (sixth hour/noon), *Hora Nona* (midafternoon), *Hora Vesperalis* (sunset), and *Completorium* (completion, nightfall). Later, an escapement device was used to regulate the escape of the motivating power, allowing for the recording of individual hours and later minutes. By about 1330, the modern hour, based on mean solar time (noon), replaced the seasonal hour in which hours were variable depending upon the changing hours of sunlight in spring, summer, fall, and winter. At first, there were no dials or clock hands, just bells to toll the hours; thus, nine bells signaled nine of the clock—nine o'clock. In 1344, St. Paul's Cathedral in London installed a face clock in its bell tower that displayed the Roman numerals I, II, III, IV, V, VI and a moving hand signaled each number four times each day. Later, an Italian, Giovanni de Dondi (1389), installed a clock with the full 24 hours on its dial.

The problem of deciding when a day began and ended was solved differently at different times by different cultures. In Genesis, it is recorded that "the evening and the morning were the first day," and so the Hebrews, and later the Muslims, used sunset to signal the beginning of the new day. The ancient Babylonians and Hindus signified sunrise as their beginning of the day. Today, the common calendar and definitions of the day and hours developed in the

West are used for pragmatic purposes by all societies involved in global communication. Thus, the year is counted from the calculated date of the birth of Jesus Christ, the day begins at midnight (knowable only with a clock) and consists of 24 hours, divided into 60 minute units of 60 seconds each. What we need to remember is that while day–night, lunar cycles, seasons, and yearly cycles (solar or sidereal) are natural and we merely record their changes within each cycle, seconds, minutes, hours, weeks, non-lunar months, decades, centuries, and millennia are all human inventions, cultural artifacts that help us to understand the great mysteries of time and its passing. [66]

The mechanical clock and the mechanical printing press helped to standardize time and information, providing models for all of the standardizations that would shape the modern world, freeing people from the dominations of the now and here to think about time and space and information in new ways and in new places, like the universities that are dedicated to acquiring, encoding, storing, decoding, and sharing of all information across all cultures.[67]

In his Pulitzer-Prize-winning *The Creation of the Media: Political Origins of Modern Communications*, Paul Starr presents a case for a distinctive American development in communication based upon three interconnected agents of change: "1. the general legal and normative-rules concerning…free expression, access to information, privacy, and intellectual property; 2. the specific design of communication media, structure of networks, and organization of industries; 3. institutions related to the creation of tangible and human capital—that is, education research and innovation."[68] While conceding that no one country or culture created the era of mass media of communication, Starr still singles out the United States for its special role in shaping modern communication, citing four successive areas of change: "1. the American Revolution, which culminated in the Constitution in 1787 with its guarantees of freedom of expression; 2. the technological advances in communication and transportation in the 19th century: 3. the rise of early mass media like the popular press (1830s), the telegraph (1840s), and motion pictures (1890s); and 4. massive public investment in science, technology, and education during World War II (1941–1945) and the Cold War (September 2,1946–December 26,1991)."[69] The people who would become Americans after the Revolution were prepared for these changes in part because of their relatively high literacy rates. For example, male literacy rates in the New England colonies increased from 60 percent in 1660 to 70 percent in 1710 and 85 percent by 1760. Female literacy in New England also increased from 30 to 40 percent in the early 1700s to about 60 percent in the 1760s. In Virginia, white male literacy increased from 46 percent in 1640

to 62 percent in 1710.[70]

Aiding in these increases in literacy were institutions that expanded with the new United States of America—a free press subsidized by lower postal rates, the building of railroads that transported publications more quickly than by horse and stagecoach, the public school movement at local levels, and the federal land grants to states that funded the creation of state universities.[71] By 1850, enrollment in common schools reached 56.2 percent for white people and 47.2 percent for everyone in the United States (including free and enslaved African Americans and new immigrants) with the Northern States having a decided advantage over the Southern States.[72] In summing up the key developments in American communication, Starr takes a cautious stance with regard to technological determinism: "The advances of the postal system, the spread of newspapers, the creation of the modern census, and the rise of common schools—none of them depended on technology. All occurred before railroads and the electric telegraph."[73] What Starr misses is that all of these advances were predicted upon one major technology—Gutenberg's printing press and its 19th century improvements that created the popular newspaper, made possible the wide distribution of census figures, and made the common school practical with common inexpensive books for all children. As media become normal and ubiquitous within a culture, they tend to become so much a part of the culture environment that they seem to be natural and, therefore, invisible. Being normal, ubiquitous, and invisible, such media exert even more power in a culture, and that was the case with typography. Walter J. Ong sums up the impact of literacy on human thought and culture with these words: "The present-day phenomenological sense of existence is richer in its conscious and articulate reflection than anything that preceded it. But it is salutary to recognize that this sense depends on the technologies of writing and print, deeply internalized, made a part of our psychic resources."[74]

In its impacts on culture and communication, typography provided the Matrix of the Modern World, the womb in which modern education, politics, science, and technology evolved and then helped to create even more advanced systems of learning, government, and knowledge. In Marshall McLuhan's terminology, we are all typographic men and women, communicating in *The Gutenberg Galaxy*.[75] Even as the physical forms of printing with moveable type impressed on paper are being replaced with electronic binary digital formats like e-books and Kindle, the impacts of print will continue, for the medium of printing is not bound by any physical forms but represents a way of encoding, storing, and sharing information over time and space through the manipulation of

energy and matter.[76]

Limitations

As profound and as far-writing and far-reaching as the impacts of typography have been, limitations were inherent in printing that would encourage both evolutions to improve printing and a revolution that moved communication from transportation to transmission, replacing matter with energy in the sharing of information among people. While typography had improved the communicative abilities of writing by making it easier to produce more and less expensive copies faster, moving information still required the physical transportation of that information in the form of books, magazines, newspapers, pamphlets, and other printed delivery systems. In terms of time, multiple copies of printed texts tended to guarantee their continuity from one generation to the generations that followed. Typographic fixity and reproducibility provided permanence to information over time as it was stored in archives and libraries. But in terms of space, printed information still faced the same limitations faced by written information in that both needed to be transported from one place to another. Improvements in travel, with better roads for coaches and wagons, the Pony Express, and the expansion of railroads, enabled information to be moved more rapidly over distances, a problem especially acute in the United States with its expanding continental domain.

For over 400 years, typography had defined modern communication of information, with the increased mechanization of paper-making and printing in the 19th century promising and delivering ever-more cutting-edge advances in printing techniques and technologies. It could be argued that most, if not all, of the advancements in science and technology in the 19th century were founded upon the information environments made possible by the printing press. But printing had not addressed the ancient problem of overcoming the time lag present in moving information from one place to another in the shortest possible time lapse. Improvements in transportation certainly helped to alleviate the time problem somewhat, but only a new revolution in communication could change the very nature of information-transfer by replacing physical transportation with electromagnetic transmission.

In the 1830s, with improvements in the techniques and technologies of typography and the beginning of photography, a number of people were experimenting with electricity to replace earlier attempts at telegraphic (far-writing) communication—smoke signals, fires and flares, naval semaphore and flag sig-

nals, heliographic mirrors, and towers that replicated the semaphore system on land with high towers signaling numerical codes to other towers within sight. But all of these systems were limited in the amount and complexity of the information they could transmit and in the distances they could cover over time. Perhaps the most advanced system was designed by Claude Chappe (1763–1805), a French inventor who struggled from 1790 onward to design an optical telegraph to transmit coded messages from high tower to high tower. According to Daniel Headrick:

> Chappe's optical telegraph was made of wood, iron, ropes, and stone....The positions of its arms indicated numbers, which in turn corresponded to words or phrases in a codebook. Of the ninety-eight positions, six were reserved for service instructions, leaving ninety-two for messages. Chappe tried several different codes. His first codebook had 9,999 entries but required four positions for each signal, which made it very slow. In his second code of 1795, each signal consisted of two positions, the first one corresponding to the ninety-two pages in a codebook, the second one to the ninety-two words or phrases on each page. Hence, the device could send any of 8,464 (92×92) words of phrases. In 1799, Chappe added another book for geographic names, bringing the total of signals to 25,392. Yet another code, issued in 1830, contained 45,050 words and phrases.[77]

While Chappe's optical telegraph partly solved the time–space limitations of writing and printing, it was itself limited to days without fog, rain, sleet, or snow. The rate of transmission averaged one signal per minute on long lines, covering the 760 kilometers (about 472 miles) from Toulon to Paris in 1 to 2 minutes. Encoding and decoding the messages took 15 to 30 minutes at each end. Headrick estimates that the system "could handle four to six one-hundred signal telegrams on an average clear day."[78]

Chappe's optical telegraph was a decided improvement in moving information through space over time, reducing the three-day horseback and seven-day stagecoach transportation from Toulon to Paris to one day.[79] Although the amount and complexity of the information were extremely limited, the optical telegraph attracted support from governments, beginning with Revolutionary and Napoleonic France and spreading to Great Britain, Sweden, Spain, Germany, Mohammad Ali's Egypt, and the United States of America.[80] In America, the optical telegraph was used at first to transmit information in harbors like Boston and New York but in 1840 was expanded to send information about stock prices and lottery numbers between two cities—New York and Philadelphia.[81] Faster transportation systems and the optical telegraph certainly brought improvements to the problem of moving information more quick-

ly through space and no doubt future improvements in both transportation and optical telegraphy would have added motorcycles, automobiles, faster trains, and airplanes to transportation and faster encoding–decoding to optical telegraphy, but these improvements would be overshadowed by an entirely new source of energy to transmit information. The Age of Electromagnetic Communication was about to dawn.

But before the Electrographic and Electrophonic Revolution had a major impact on communication, another limitation of typography was being addressed by developments in graphic communication that would see images created by light, lenses, chemicals, and metal, glass, paper, and film compete with hand-crafted images. The Hypergraphic Revolution would eventually join with both typography and electric communication to create modern telecommunication systems that would seek to overcome limitations of time and space by using energy and matter to create new techniques and technologies for the communication of information among greater numbers of people over greater expanses of time and space.

· 5 ·

BECOMING HYPERGRAPHIC

Evolution and Revolution in Graphics, Photography, and Cinematography

Context

In a very real sense, human beings became graphic communicators with the first visible markings they deliberately made to signify something—etchings on bone and ivory, scratches and drawings on cave walls, mutilation of their bodies with scars and tattoos, even clothing and decorations. Certainly by the Upper Paleolithic (some 40,000–10,000 years ago), our ancestors crafted both abstract and representational images, like those found in the Grotte Chauvet (France) dating to 32,400 years ago. Unless we think that beautiful images found in the Grotte Chauvet suddenly sprang full-blown, we need to consider the concept that the Grotte Chauvet images represent one stage in a long evolution in graphic communication that most likely accompanied the evolutionary development of language itself. What makes the images found in Upper Paleolithic art so significant is that we are able to recognize the animals represented and, therefore, the very human minds and hands that crafted them. When we confront Ice Age imagery, we experience the shock of the familiar. While we may never know fully what our ancestors meant by those graphic images, we can recognize their connection to the long history of image-making found in all cultures throughout time. That these Ice Age

images were created and used and reused over many millennia tells us that they were not mere decoration (art for art's sake) but culturally significant coded carriers of information needed for survival by prehistoric human beings.

As students of perception have long noted, we experience the world of objects and processes indirectly through our senses. As Lloyd Kaufman writes in *Perception: The World Transformed* (1979), "…if we start with the notion that mental events such as seeing, hearing, touching, and tasting depend upon information provided to the brain by the sense organs, it is not clear at all that we are in direct touch with the physical world."[1] In other words, we experience the world because of the ways we are in contact with that world, inferring from sensory information the shapes and dynamics of that world. We infer from information taken in by our senses the shape of the physical world. Ideally, we test the validity and reliability of these inferences by how well or badly they help us to survive in our interactions with phenomenological reality. Our inferred world is a construction based upon our limited sensory contacts with the actual world. In human communication, sight, sound, and touch have been the dominant senses in public communication while taste and touch are more common in intimate communication. Sound is fundamental to language and all of its extensions while sight is the foundation of all graphic communication, including writing and printing.

In moving from being receivers of visual information, made possible by light triggering neural signals to different areas of the nervous system to the brain which assembles these signals into images in the mind,[2] to being themselves generators of visual images, human beings demonstrated their abilities to use communication to influence themselves and the world. And the images created by humans were not merely copies of what they perceived in nature but also included graphic representations of beings and objects conceived in the minds of the image makers. Humans not only copied what they beheld but also created what they imagined for other humans to behold.

E. H. Gombrich, in comparing language with graphic communication, begins with Karl Bühler's distinction among three functions of language— *expressive*, if it conveys the state of mind of the source; *arousing*, if it is designed to influence the state of mind of the receiver; and *descriptive*, if it informs the receiver of some information that the source has about the reality of experience. To Gombrich, "…the visual image is supreme in its capacity for arousal, that its expressive purpose is problematic, and that unaided it altogether lacks the possibility of matching the statement function of language."[3] In questioning the Chinese proverb that "One picture is worth more than ten thousand words,"

Gombrich insists that "The chance of a correct reading of the image is governed by three variables: the code, the caption, and the context."[4] In following Gombrich, this text takes the view that visual communication is bound by the same variables found in all human communication—the context, the codes, and the media that carry the messages.

The so-called "universal visual symbols" used in public areas open to global travelers are not universal in their images but become widespread as more people share the contexts and the codes in which these signs and symbols are used. Gombrich is especially critical of the National Aeronautic and Space Agency (NASA) for its use of a plaque affixed to its *Pioneer 10* and *Pioneer 11* space probes launched in the 1970s. Questioning NASA's hope that the graphic information contained on the plaque would tell, what NASA called, "scientifically educated inhabitants of some other star system" the location of the planet of the beings who launched the probes, Gombrich writes that these images would be meaningless to alien beings even if they possessed the sensory system necessary to perceive the images.[5] For a copy of the plaque see Figure 5.1 below.

Figure 5.1

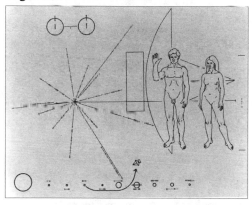

Given that you are a scientifically educated inhabitant of the planet that sent these images into space, what meanings do you make from the information contained on the plaque? What context do you need to understand the messages? What codes do you need to know?[6]

Despite the limitations of using graphic images for communicating some types of information, other types of information are more efficiently communicated by images than by words. Gombrich's examples include diagrams, maps, organization charts, and family trees, all of which communicate complex

relationship information more efficiently than can be accomplished with words alone. But diagrams, maps, charts, and trees are all conventional codes that need to be learned before they can be understood. Gombrich invites us to decode the Great Seal of the United States of America, shown in Figure 5.2.[7]

Figure 5.2, front and reverse

What meanings do you make from the two sides of the seal? Start with the front side: What images can you identify? What meanings do you make of these images? What do the words *Annuit coeptis* and *Novus ordo seclorum* mean? What does *MDCCLXXVI* mean? In what code are these messages written? Why was this code used? Now move to the reverse side: What images can you identify? What meanings can you make of these images? What do the words *E Pluribus Unum* mean? What overall meaning do you make of these images and words?

Gombrich tells us that the design of the Great Seal of the United States

of America was based upon the advice of Sir John Prestwich, an English anti-
quarian, and represented the pyramids of Ancient Egypt and the sacred eye of
the Egyptian god Osiris, whose hieroglyph was composed of "a picture of a
throne (*'usr*) and a picture of an eye (*'iri*) to which was adjoined a picture of
the divine scepter to indicate the name of a god...[T]he design expresses in
words and images the hopes and aspirations of the New World for the dawn of
a new era. *Novus ordo seclorum* alludes to Virgil's prophecy of a return of the
Golden Age, and so does the other Latin tag, *Annuit Coeptis*, 'He [God] favored
the beginnings.'"[8] *E Pluribus Unum*, of course, is Latin for "Out of many, one,"
and *MDCCLXXVI* are Roman numerals for 1776.

These examples make it clear that in order to understand the meanings con-
tained in graphic images and words we need to know both the context and the
codes. We also need to consider that the visual imagery we now label "art" was,
until quite recently, produced not as individual aesthetic expression but as part
of a larger system of communication. This was true of the visual arts in prehis-
tory, as well as in the ancient civilizations of Sumer, Egypt, India, China, and
all of the other cultures and civilizations that created and used images to com-
municate significant social messages.

At this point, it may be useful to consider the explicit condemnations of
the use of visual imagery to convey significant information, both emphatic and
phatic, in a culture. Perhaps in reaction to the extensive and pervasive use of
visual images in civilizations surrounding them, the ancient Hebrews, armed
with their consonant–alphabetic script, banned the use of all images in their
religious art and rituals. In Exodus, the invisible God of Israel explicitly pro-
vides Moses with a prohibition forbidding such graphic communication. The
words of the Second Commandment are clear and categorical: "Thou shalt not
make any graven images, idols, of anything on earth or in heaven."

At other times and in other places, other peoples would follow this rule for-
bidding religious imagery, including early Christians, the followers of Islam, and
some Protestant Reformers. In rejecting images and turning, or returning, to
words, people seem to have conceived of one God as existing in language
alone. In Genesis, the universe comes into being by words alone: "God said, Let
there be light." Thus, all creation came from words. As the Gospel, according
to Saint John, puts it, "In the beginning was the Word, and the Word was with
God, and the Word was God." This relationship between God and words ver-
sus images is explored by Jacques Ellul in *The Humiliation of the Word*: "The word
is related to Truth. The image is related only to reality."[9] While words repre-
sent ideas that can be debated because they invite "the exercise of freedom,"

images represent ideals and visions that can only be accepted or rejected. Although he recognizes that imagery has been present in human communication from the beginning, Ellul cautions us about a growing imbalance between images and words in the modern world: "Images were once the illustrations of the text. Now the text has become the explanation of the image."[10]

The long evolution of graphic communication began with representational imagery over 32,400 years ago in prehistoric sites and continued with the expansion of images in nomadic groups, tribal settlements, early civilizations, classical civilizations, and into the modern world. The 19th century witnessed a Hypergraphic Revolution that contained a number of mini-revolutions that continued into the 20th century, inspiring additional evolutions and mini-revolutions in the early years of the 21st century. As with language itself, graphic communication has been essential to human communication from our beginnings as a symbol-manipulating species. We shape ourselves and are shaped by words and images.

Hand-crafted graphic communication is found in every culture ever studied, and we are able to trace its developments in different locations throughout history. John Ruskin (1819–1900), an English critic of art and architecture, held that "Great Nations write their autobiographies in three manuscripts, the book of their deeds, the book of their words, and the book of their art. Not one of these books can be understood unless we read the two others, but of the three the only trustworthy one is the last."[11] Whatever the validity of any of these books, the history of graphic communication is a journey of images crafted by human hands to images crafted by human hands reproduced by rolling, stamping, or imprinting to images created and reproduced mechanically to images created and reproduced by photo-engraving, cameras, lenses, and film to images created, reproduced, stored, changed, and shared by electronic digital media.

As Alexander Marshack showed us in Chapter Two, Ice Age humans carved, drew, etched, and painted representational images of animals, fishes, and vegetation accompanied by abstract images in the form of notches, crosses, and other geometric shapes to represent the cycles of time related to lunar and seasonal changes.[12] These images functioned as outward mnemonic devices for retaining information vital for the survival of the group. By connecting the past, present, and future in a mythic eternal present, these graphic signs and symbols represented our ancestors' most basic weapons for surviving in a dangerous and hostile world.[13] In *Treasures of Prehistoric Art* (1966), André Leroi-Gourhan lists some 2,188 animal figures found in 66 caves and rock sites. Non-animal figures include six birds, eight fish, and nine unidentifiable

images he calls "monsters" The images of human beings, whether female or male, are always abstract, frequently signified only by sexual representations. The clearest representations of human beings are the many handprints, usually negative outlines with paint sprayed from mouths or tubes.[14]

In trying to provide meanings to these Paleolithic images, scholars have advanced a number of theories based upon magic (hunting and sexual reproduction), religion (gods, goddesses, demons, spirits, and shamanism), and science (times for gathering and hunting of food). John E. Pfeiffer tried to unite all of these theories into one unified communication–education concept in which cave art represented the "first information explosion," requiring *Homo sapiens* to move from signalic communication and observing, imitating, and following elders to more formal and systematic ways of encoding, storing, and retrieving of information crucial to the survival of expanding groups in a world of rapidly changing weather and environments. The images in the caves encoded and stored information needed for group education and indoctrination in three stages: "1) leading the uninitiated through an eerie and difficult route, a kind of obstacle course to soften them up for indoctrination; 2) catching and holding their attention with shocking and frightening displays; and 3) finally, using every trick to imprint information intact and indelibly in memory."[15] To Pfeiffer, "It was in these caves…that the entire contents of the tribal encyclopedia were transferred, installment by installment, to the next generation."[16] His speculation that music and dancing were used to enhance the imprinting of information has received support from some more recent discoveries. In 2009, a *New York Times* article reported that "At least 35,000 years ago, in the depth of the last Ice Age, the sound of music filled a cave in what is now southwestern Europe, the same place and time Early Homo Sapiens were also carving the oldest known example of figurative art in the world."[17]

In the transition from nomadic gatherers and hunters to settled farmers and herders who provided the foundation for permanent settlements and civilization, image-making divided into two branches—pictographic images that evolved into logographic, syllabic, and alphabetic writing and practical images both abstract and representational, that we call "art."[18] But this division was never total and writing and imaging have coexisted in all literate cultures, including the global culture of the Cybernetic Age. In Ancient Egypt, for example, one rarely finds an image without accompanying writing and the hieroglyphic system itself was a mixture of pictograms that represented logographic or phonetic signs. The image of the *ankh* † is both a visual picture of the actual instrument carried by the goddess Isis that signifies "life" and the pho-

netic sound "ankh" that signifies the Egyptian word for "life," "to live," or "living." Thus, the name of the famous pharaoh Tutankhamun is represented by three sets of signs—a single reed signifying a phonogram for *i*, a game board signifying the bi-consonental *mn*, and a water sign reinforcing the sound to produce the sound *imn*, pronounced *imen* or *amon* or *amun* the king of the gods during the New Kingdom; a half-circle signifying *t*, and a chick signifying *w* to produce the sound *tu*, and a cross signifying the tri-consonental *ankh*. Together, they are read as "Tutankhamun" (with the god coming first) within the cartouche of the pharaoh, as shown below:

Where writing evolved from logographic to phonetic signs, the division between image and sound became wider, until those of us who use an alphabetic system are usually unaware of the pictographic foundation of our system. The ancient Semitic word *aleph* (ox) was written by the Canaanites as a pictogram of an ox 𐤀. This evolved into the alphabetic sign 𐤀 used by the Phoenicians and the A adopted by the Greeks and Romans but without any connection to an ox. The sign for house (*beth*) underwent a similar transformation from a sign representing a house ⊏⊐ into the abstract Phoenician 𐤁 which conveys only a phonetic sound. Thus, the *aleph* and the *bet* of the Semites became the first two signs of the Greek phonetic alphabet, *alpha* α and *beta* β, which became the Roman A and B.

All of the civilizations that followed Sumer and Egypt used written words and graven images to encode, store, and transmit their most important messages. The Christian Commonwealth that replaced the Roman Empire in Western Europe relied upon both the spoken word in readings, homilies, and sermons and the graven, painted, sculptured, and stained-glass image to bind the faithful together, with manuscript literacy under the command and control of the religious and secular elites who ruled the commonwealth.

As we saw in Chapter Four, the Typographic Revolution in the 1450s shattered that world of word and image encased in illuminated manuscripts and stained-glass and statues by presenting a new medium for both word and image—the printed book. The printed text threatened not only the handwritten manuscript but the control of the words and images themselves. Except for the anomaly of the Anglo–Episcopal Churches that continued to make extensive use of visual imagery, the majority of the new Protestant churches that came with the Reformation tended to reduce or eliminate most, if not all, graven, painted, sculptured, and stained-glass images, frequently smashing what they regarded as "false idols" whenever possible.

It is important to stress that printing itself did not banish or destroy visual images. The destruction was the work of pious men and women carrying out what they believed were God's commands. Printing actually facilitated something of a revolution in graphic communication, with many printed texts containing illustrations to accompany the words. From woodcuts to lithography and metal engraving, illustrations became part of printed texts in books and later in newspapers and magazines, combining word and image in one unified message system.

Of particular significance were the printed versions of maps that provided people with graphic orientations to the physical world. The origins of mapmaking are a mystery. Maps may even pre-date writing because many nonliterate cultures possess mapmaking skills. In terms of literate cultures, mapmaking may have existed in China as early as the 7th century B.C.E. and in the Middle East even earlier. "One of the earliest…clay maps was found at Nuzi, in Northern Iraq, and dated 2300 B.C.E., the Age of Sargon of Akkad."[19] The Babylonians continued this mapmaking tradition, even attempting a map of the world. Later, the Greeks also attempted to map both the heavens and the earth. Based partly on aesthetics and partly on observation and reason, the Greeks, beginning with Pythagoras (circa 570–490 B.C.E.) and continuing with Plato (439–347 B.C.E.) and Aristotle (384–322 B.C.E.), accepted the concept of a spherical earth, rather than a flat or cylindrical one. But the size was unknown

until a Greek living in Alexandria in Egypt, Eratosthenes (276–196 B.C.E.), observed that that the sun at high noon at Syene (today's Aswan) shone into a well in a straight line and then compared the angle of the sun at noon in Alexandria, both located on the same meridian. Using basic geometry, Eratosthenes measured the shadow cast by an obelisk at high noon in Alexandria on June 21. With the height of the obelisk and the width of the shadow, he had the measurements of two sides of a triangle, which allowed him to calculate the angle, in this case 7 degrees, 12 minutes, almost one-fiftieth of the 360 degrees of a circle. Using an estimated distance of 5,000 stadia (a standard measure), he multiplied 50 by 5,000 for a total of 250,000 stadia (about 46,250 kilometers). Although the calculation was about 6,000 kilometers larger than modern calculations, Eratosthenes's achievement remains a remarkable example of using logic rather than mere observation alone to increase information and knowledge. It was one more demonstration of the ability of the human mind to use language and imagery to not only chart the known but to predict with reasonable accuracy what was then the unknown.[20]

Although many of the key principles of Greek mapmaking were lost to the West during the Dark and Middle Ages, the rediscovery of Ptolemy's Geography in 1410 and its printing in 1472 helped Europeans to explore the entire world. Despite attempts by exploring nations like Spain and Portugal to keep the information in charts and maps state secrets, printing enabled other peoples and nations to gain access to this vital information. The printing of charts and maps to accompany reports by explorers "…brought the discoveries of Columbus, Vespucci, Balboa, and Magellan to the public, transforming the economic arrangements of Europe."[21] The publication of atlases, charts, and maps helped to make the world less an unknown sphere and more a soon to be discovered planet. Today, of course, with satellite imaging, Global Positioning Satellite systems, and images of space captured by radio telescope and the Hubble Telescope we have more and more accurate information about the Earth, our solar system, and the universe than was possible in the past.

Until the emergence of lantern-slide photographic shows and motion-picture projections in the second half of the 19th century, printing provided most people with the visual images they encountered, in books, magazines, and newspapers. Photography (literally light-writing) would provide one of the key components needed for the Graphic Revolution of the 19th century, a change in communication analyzed by Daniel J. Boorstin in his influential The Image: A Guide to Pseudo-Events in America: "Man's ability to make, preserve,

transmit, and disseminate precise images—images of print, of men and land-scapes and events, of the voices of men and mobs—grew at a fantastic pace....Still more revolutionary were the techniques for making direct images from nature."[22]

Although human beings had been making images since the Upper Paleolithic, the 19th century witnessed the critical nexus of scientific theories of light, technical advances in cameras and lenses, and the use of chemical processes to produce permanent images of Nature captured by light itself. Natural light on Earth emanates from our sun and is composed of electromagnetic radiation with a wavelength ranging from 3,900 to 7,700 angstroms (a unit of light measuring one hundred-millionth centimeter in length) that can be perceived by the human eye. The nature of light has long fascinated philosophers and scientists. In 13th century Italy, one practical demonstration of how light worked was the *camera obscura*, a dark room with a small aperture that allowed light to enter and project blurred images of reality on the wall opposite to it. Eventually, a polished glass lens was placed in the aperture to focus the image, although it remained upside-down.

The images of the world focused by the *camera obscura* and later by the *camera lucida* (light room), an apparatus that used a glass prism to project an image on a piece of paper, allowing an artist to try to capture a four-dimensional world of height, width, depth, and time, presented in living color. However, the tracings made possible by both systems were two-dimensional, lacking depth (except for the linear perspective illusion) and motion. Color, of course, could be added by the artist. These early cameras made more exact copying from Nature possible, but the images produced were still dependent upon the skilled hands of an artist. The development of the first true cameras with the ability to capture images by light and chemistry ushered in the Hypergraphic Revolution of the early 19th century, beginning in Western Europe and then traveling to the United States, where it was embraced and extended in photography, graphic printing, and cinematography (motion-writing). From Europe and America, the Revolution spread throughout the developed and colonized world. In some places, new graphic communication systems augmented and complemented existing typographic systems. In other places with lower literacy rates, these new visual systems would provide nonliterate people with information carried by photographs and motion pictures. In either case, the Hypergraphic Revolution would extend sight as the preeminent human sense for communicating information.

People

IMAGE HUNTERS

Although the graphic evolution–revolution began with the first humans who created visual signs and symbols to encode, store, and share information in the Upper Paleolithic, the more immediate contributors were the scientists and inventors whose work led directly to photography, photoengraving, and cinematography. Giambattista della Porta (1535–1615) is worthy of note because his 1589 *Magia Naturalis (Natural Magic)* provided a compilation of theories about and descriptions of how the *camera obscura* and other optical devices provided a more direct connection between Nature and images than was possible with hand-drawn art alone. The great English mathematician and scientist Sir Isaac Newton (1642–1727), in addition to inventing modern calculus and formulating the theory of universal gravitation, described the nature of light and its refraction by lenses and prisms in *Opticks* (1704). During the 18th century, a number of people experimented with "sun prints" by exposing sensitive surfaces partly covered with opaque objects to sunlight, leaving dark images outlined in lighter shades. Experiments with chemicals revealed that silver nitrate would turn black when exposed to light, an effect noted by Johann Schultz in 1727. A century later, in 1827, Joseph Nicéphore Niépce (1765–1833) used a *camera obscura* to produce the first true photograph—an image captured by a lens and camera and preserved chemically on a surface. It was a picture of a courtyard outside of his window, etched on a silver-nitrate coated pewter plate that required an eight-hour exposure time.

The next significant step in the evolution of photography came in 1837 when another Frenchman, Louis Daguerre (1787–1851), a painter, theatrical producer, and partner of Niépce, produced a photograph of improved quality with a 30-minute exposure time. An outdoor still-life with subtle tones of light and shadow, this image was captured on a copier plate coated with silver that was exposed to iodine fumes to produce a thin layer of silver oxide. The daguerreotype became the first practical system for encoding and storing images from nature, quickly becoming a rage in Europe and the United States. Although each picture was reversed and each was an original image, photography was on the verge of being born.

German and French contributions to the evolution of photography were soon joined by those of an Englishman, William Henry Fox Talbot (1800–1877), who while honeymooning at Lake Como in Italy in 1833 used

both a *camera lucida* and a *camera obscura* to make sketches. Expressing disappointment at the impermanence of the images projected by those "cameras," Fox Talbot wrote, "How charming it would be if it were possible to cause these natural images to imprint themselves durably and remain fixed on the paper!" Although Daguerre and Fox Talbot both claimed to have invented photography, it was Fox Talbot who was responsible for the negative and the latent image which made it possible to reproduce exact positive copies of an image from one negative. For this achievement, Fox Talbot can be compared to Gutenberg in that both invented methods to produce multiple copies from reverse images. And it was a friend of Fox Talbot, Sir John Hershel, who coined the common terms we use to describe this revolution in graphic communication— *photography* and *negative* and *positive* images. Fox Talbot also gave us the most vivid metaphor for photography: "A mirror with a memory." His 1844 *The Pencil of Nature* may have been the first book to use photographs as illustrations.[23] Both Daguerre and Fox Talbot could be called the fathers of photography.

In the United States, photography captured the attention of Samuel Finley Breese Morse (1791–1872) a professor of painting and sculpture at the University of the City of New York (now New York University), who learned the techniques and technologies of image-making with light from Daguerre during a trip to Paris. Back in New York City, Morse on September 20, 1839 produced a daguerreotype of his wife and daughter, shot on the roof of the university's main building. One of Morse's colleagues, Dr. William Draper, head of the chemistry department, produced in 1839–1840 what seems to be the first photographic portrait of a human face of which copies are known to exist. Morse's public lectures on photography influenced and inspired some of America's most important early photographers, including Mathew Brady (1822–1896), Alexander Gardner (1826–1882), and Timothy O'Sullivan (1840–1882).

Photographic images, both negative and positive, evolved from wet-plate in 1851 to dry-plate in 1878 to flexible silver-nitrate film in 1888, moving from craft skill by experimenters to social use by ordinary people. The halftone process, invented in 1878 by Frederick Ives (1856–1937), made printed photography possible by encoding a photographic image into a series of dots that could transfer ink to paper. George Eastman's flexible negative film in rolls and his introduction of his Kodak box camera in 1888 allowed anyone to become a photographer, with Kodak developing the film and printing the pictures. Eastman Kodak's advertising for this new camera-film system offered professional results without special knowledge or training: "You push the button, we do

the rest." Other claims actually predicted photography's use by and impact on ordinary people: "Photography is thus brought within reach of every human being who desires to preserve a record of what he sees." Borrowing a metaphor from hunting, photographs become known as "snapshots."

Among those who became professional photographers, some achieved wide audiences and name recognition for their printed photographs. Perhaps the most famous American fashion photographer who captured images of the beautiful people was Richard Avedon (1923–2004). Alfred Stieglitz (1864–1946) helped to make photography an art form. Other photographers attempted to use their image-making to call attention to social concerns. In America, some of the more prominent were Jacob Riis (1849–1914), whose 1890 book *How the Other Half Lives* documented the terrible housing conditions in New York City, Lewis Hine (1874–1940) who documented the exploitation of children in *The History Place—Child Labor in America*, Berenice Abbott (1898–1991) who documented the changing urbanscape of New York City, Weegee (Arthur Fellig, 1899–1968) who documented crime in New York City in works like his 1945 *Naked City*, Ansel Adams (1902–1984) who used photographs to reveal the threats to America's national parks and wilderness, Walker Evans (1903–1975) whose 1941 collaboration with James Agee documented the plight of the victims of the Great Depression of the 1930s on rural farms in *Let Us Now Praise Famous Men*, Robert Capa (1913–1954), one of the most famous of all combat photographers, Joseph "Joe" Rosenthal (1911–2006), whose February 23, 1945 photograph of the second flag-raising by United States Marines on Mount Suribachi (Iwo Jima) may be the most reproduced picture in American history, and David Duncan Douglas (b. 1918), a World War II Marine Corps combat photographer whose 1951 *This Is War!* documented the Korean conflict and whose 1968 *I Protest* and 1970 *War Without Heroes* criticized the Vietnam War.

MOVING IMAGE HUNTERS

Photography would evolve slowly into cinematography, using a series of still images to create the illusion of motion, thus adding changes in time to the still mirror of memory made possible by the photographed image. Beginning in 1873, Eadweard Muybridge (1830–1904) experimented with using multiple pictures to capture motion, achieving a notable success in 1877 when his series of sequential photographs proved that a trotting horse lifted all four feet from the turf at the same time, thereby winning a $25,000 bet for Leland Stanford

(1824–1893), president of the Central Pacific Railroad, governor of California, and founder of Stanford University. Étienne-Jules Marey, a French physician, devised a single camera that could rapidly record a series of still pictures on a single circular photographic plate which, after developing, could be spun and viewed through an opening to create the illusion of motion. While Muybridge seems to have been motivated by both curiosity and a desire to make money, Marey's motivation seems to have been founded upon scientific inquiry into the nature of motion in animals.

The debate over who should be recognized as "the father of cinematography" began with motion pictures and continues today. In actuality, a confluence of ideas, technical developments in lenses, cameras, shutter speeds, and film all contributed to efforts in Europe and the United States to move motion pictures from theory to reality. America's preeminent practical inventor of the 19th century, Thomas Alva Edison (1847–1931), called "The Wizard of Menlo Park," usually gets credit for inventing motion pictures. Unlike Muybridge and Marey, Edison's motivations were primarily profit and acclaim, but it was Edison's assistant William Kennedy-Laurie Dickson (1860–1935) who used Eastman's flexible roll film to develop the *Kinetograph* (1892), a camera for recording moving images, and the *Kinetoscope* (1893) for viewing the images. In 1895, Francis Jenkins and Thomas Armat developed a projection system and Woodville Latham and his colleagues invented the *Latham loop*, which facilitated the use of longer reels of film between reloading of projectors. In Paris in 1895, Auguste and Louis Lumière presented a series of projected motion pictures to paying audiences, using their *cinematograph*, a combination camera-projector. In early 1896, William Paul developed his *animatograph* projector in London. Later, in April, the Edison Company used the *Edison Vitascope* (actually invented by Thomas Armat) to project motion pictures to paying audiences at Koster and Bial's Music Hall on Broadway in New York City.

These technological developments allowed for the capturing of images that simulated motion but cinematography might well have remained the province of inventors and a passing fad for the public. What were needed for motion pictures to become a major mass medium of entertainment and information were the contributions of film-makers who provided content and techniques (shots, angles, editing, etc.) to make film a narrative form of communication. In France, George Méliès awed audiences in 1902 with his *Voyage to the Moon* and other narrative films, but it was Edwin S. Porter's 1903 Edison release of *The Great Train Robbery* that spurred motion picture development in America by creating a growing audience for projected motion pic-

tures. What began as a series of enterprises by inventors and artists began to evolve into a major cultural industry.[24] Among the early artists, no one was more significant than David Wark Griffith, whose epic films like *The Birth of a Nation* (1915), *Intolerance* (1916), *Broken Blossoms* (1919), *Way Down East* (1920), and *Orphans of the Storm* (1921) helped to move films from amusement to serious art, from nickelodeons and vaudeville houses to movie palaces. Among the men who made movies a successful enterprise were William Fox, Adolph Zukor, and Marcus Loew; all began as exhibitors of films in movie theaters in New York City and later founded three major Hollywood motion picture studios—Fox, Paramount, and Metro-Goldwyn-Mayer (in partnership with Samuel L. Goldwyn and Louis B. Mayer). All of these, and later studio founders and executives, were driven largely by the profit motive, and economics would dominate all of Hollywood filmmaking.[25]

While filmmaking would evolve differently in cultures dominated by different economic, political, and social ideologies and values, the developments in techniques and technologies of filmmaking and film projection would be shared by all regardless of cultural differences. Thus, sound film was developed in the United States in 1927–1929 (first by Warner Brothers with *The Jazz Singer*) and quickly became the norm worldwide. In 1935, Herbert Kalmus (1881–1963) perfected his three-strip *Technicolor* process (using Kodak film), first in Walt Disney animated cartoons and some shorts, followed by *Becky Sharp* (1935), the first full-length feature film shot in Technicolor. But it would take the competition threat from television to force the major movie studios to move from black and white to Technicolor in the 1960s and 1970s. Since that time, only an occasional major motion picture has been shot in black and white, like Steven Spielberg's 1993 *Schindler's List* about the Holocaust, a subject Spielberg considered to be too grim and serious for "living color."

Messages

PHOTOGRAPHY AND GRAPHIC COMMUNICATION

While it is possible for photography and cinematography to carry any message that can be filmed, even printed words, the major public media using photographic images—whether printed newspapers, magazines and books, or motion pictures—usually accompanied the images with words. In newspapers, magazines, and books, photographs first augmented, then largely replaced hand-drawn illustrations, until the photographic image became the norm and the

drawing or painting the less usual. As Gombrich notes, the unaided photograph cannot clearly convey informative statements to audiences. Thus, the messages carried in most print media by photographs did not stand alone but were supplementary to the words surrounding the images.

As Ulrich Keller notes in his history of early photojournalism, "More than half a century evolved between Daguerre's epochal invention and the early 1890s when it finally became commercially feasible to reproduce photographs in large newspaper editions."[26] The halftone process, which made the printing of photographs possible, reproduced images of reality which contained their own validity and reliability. As people came to accept, even prefer, photographic images of themselves and their immediate environments, they also accepted as accurate and true the photographs they saw in newspapers, magazines, and books.[27] These images accompanied news stories and carried the same messages of accuracy and truth about war (beginning with the Crimean War of 1854–1856 and the American Civil War of 1861–1865, reaching maturity with the Spanish American War of 1898, and achieving prominence with the First World War of 1914–1918, the Spanish Civil War of 1936–1939, the Second World War of 1939–1945, the Korean War of 1950–1953, the Vietnam War of 1964–1975, and all subsequent wars and conflicts of interest to the reading public), about politics (in America, the presidents were photographed while in office beginning with James Knox Polk by Mathew Brady in 1848 and continuing to the present; all other developed and developing countries followed suit), about sports, about major disasters and about what Daniel J. Boorstin calls "the pseudo-event," those staged photographic opportunities (photo-ops) that constitute so large a share of photojournalism in newspapers and magazines). Whatever the story, the photographic images told the readers that "You are there," as eyewitnesses to history.

In addition to news and public events, printed photographs carried messages for advertising, publicity, public relations, and other persuasive communication. In addition to politicians and public officials, sports figures, stage and screen actors and actresses, and other public personalities became celebrities, known to the public for their accomplishments and for being well known from their images. Printed picture cards also contained images of these personalities, as would flyers and billboards, all carrying the same messages as the images found in newspapers and magazines—recognize me, admire me, trust me, emulate me.[28] To be a public figure required that your photographic image be known to the public. Therefore, the photographs of public people were carefully shot, edited, touched-up, and released to control the images seen by the public. Of

course, non-authorized photographs were also taken and these could be embarrassing to the people pictured, beginning the career of photographers specializing in taking and distributing unauthorized images (the *paparazzi*, named after Paparazzo, a character in Federico Fellini's 1960 film *La Dolce Vita*).

Printed photographs in public media also carried messages of social concern, attempting to stir the consciences of people. But whether assuring the public that the world was all bright and beautiful or warning us about the ills of that world, photography carried or enhanced messages that could entertain, enlighten and inspire, or manipulate and propagandize. In this, photography's messages were similar to those carried by print and by hand-crafted art. What was special about the messages carried by photography were their claims to provide objective images of reality, with photography acting either as a mirror with a memory or a lens to focus on a particular object. Photography extended the old adage "seeing is believing" from the personal observation to a shared public image, making everyone an eyewitness to the reality of the visible world.

This objective eyewitness claim covered all photography, whether emanating from government, institution, business, media, or free-lance sources. Despite cropping, airbrushing, and other types of image manipulation, including those made easier by digital imaging techniques and technologies, the essential message of all photography remains the same: these are images created by Nature and therefore they must be accepted as being true representations of reality because the camera does not lie.

Media

PHOTOGRAPHY AND GRAPHIC COMMUNICATION

In photography, the central medium was photography itself but that medium depended upon a complex of techniques and technologies that found, captured, stored, and reproduced images reflected by light. These included the *camera obscura* and the *camera lucida* which needed lenses to focus the image and shutters to open and close the camera opening. The preservation of the image was a major challenge that had a long evolution from Joseph Niépce's and Louis Daguerre's use of chemically-treated metal surfaces to William Henry Fox Talbot's chemically-treated paper negatives that allowed images to be reproduced as positives. A giant step was taken with George Eastman's revolutionary developments of flexible film that captured images with faster exposures and replaced the glass plates that preceded it. Eastman Kodak's box camera made

photography a reality for common people, a move comparable to how the alphabet (aided by printing) moved literacy from a limited scribal skill to a common system of writing open to the general public. The addition of color to photography helped to make the captured images more life-like, although they still lacked a third dimension of depth and were frozen moments of time. In the 21st century, digital cameras with memory chips are replacing cameras using film, a move from analog to digital that parallels similar movements in all types of human communication.

In graphic communication, the 19th century witnessed the use of photography in books, magazines, and newspaper illustrations made possible by the invention of the *halftone process* that translated the shades in photograph to tiny dots that could carry ink to paper to provide reproductions to accompany texts. The development of faster cylinder presses powered by steam and electricity and the inventions of linotype and monotype machines furthered the mechanization of printing that stimulated the graphic revolution of the 19th century. The replacement of type by computer images moved the revolution from mechanization to the electronic age in which letterpress printing became a charming relic of an earlier age. Now, computerized texts and images use digital encoding, storing, and retrieval in one unified system.

CINEMATOGRAPHY

The limitations of photography in the 19th century—two-dimensionality, lack of color, and lack of motion—would be addressed by attempts to simulate three-dimensionality with stereoscope viewers and magic-lantern projectors, hand-tinting and color film (first invented in 1861 but not used extensively by the public until the Kodak chrome 35mm system in 1936), and cinematography in the 1890s. Cinematography resulted from a confluence of ideas and inventions that provided the techniques and technologies that would create the illusion of motion on film. The core idea was the conception of a phenomenon called "the persistence of vision," whereby the images we receive on our retinas are preserved for a fraction of a second, blending with the next image to create a connected moving image. The Greek astronomer and geographer Ptolemy wrote about this phenomenon in 103, and the idea was later expanded by Peter Mark Roget (1779–1869) in an 1824 paper, "Explanation of an Optical Deception in the Appearance of Spokes of a Wheel When Seen Through Vertical Apertures," presented to the British Royal Society of Medicine. Simple experiments can illustrate this persistence of vision phenom-

enon. If a series of light bulbs are arranged in a row and each one is turned on briefly in sequence in a darkened room, people perceive these individual flashes of light as a movement of one light. Flip cards used by children also provide the illusion of movement if drawings or still photographs are arranged in sequence and flicked through by thumb or machine. Early photography that captured images on dry plates and single-frame silver nitrate film was limited in its ability to provide a sufficient number of images shot in sequence to create the proper illusion.

George Eastman's flexible celluloid film on long rolls solved this problem in 1888–1889, providing an essential technology that made motion pictures practical. Experiments with capturing sequences of images by Eadweard Muybridge and Étienne-Jules Marey had demonstrated the possibility of motion pictures as reality. The debate over who should be credited with the invention of motion picture has a long and fierce history. In a very real sense, the ideas and developments in lenses, cameras, shutter speed, and film stock all made cinematography a reality in Europe and the United States. According to Peter Kobel and the Library of Congress, "Three things were essential to developing projected motion pictures as we know them today: a camera with a sufficiently high shutter speed to freeze motion, a film-strip capable of taking multiple exposures swiftly, and a means of projecting the developed images on a screen."[29] Both the Lumière Brothers in France and the Edison Company in America used the techniques and technologies developed by others to design their motion picture cameras and projectors.

The Lumière Brothers called their system *cinematographe* (motion-writing) while the Edison Company called its 1891 system the *Kinescope* (motion-seeing) which was replaced in 1896 with the *Edison Vitascope* (life-scope) that projected images on a screen. Cinematography requires a camera to take the pictures and a projector to show the pictures. A motion picture camera is itself a complex of techniques and technologies. Light, natural or artificial, enters the camera through a lens that focuses the light and a shutter controls the time that the light enters to form an image on the negative frame of a loop of film held in place by a claw locked into one of the sprocket holes at the side (or sides) of the film. After a suitable exposure time (16 frames per second for silent film and 24 frames per second for sound film), the rotating shutter cuts off the light while the crank raises the claw to move the film to the next frame. In early cinematography, the cameras were cranked by electricity (Edison) and by hand (the Lumière Brothers). Hand-cranking allowed lighter cameras to be used but resulted in slight variation in speed. Spring-wound cameras helped to solve this

problem while electric-driven cameras and projectors would become the norm for studio-produced theatrical films. A motion picture projector is essentially a camera in reverse, in which an artificial light source passes through a frame of film on a loop where a shutter controls its speed before allowing it to pass before a lens which projects images on a screen at either 16 (silent) or 24 (sound) frames per second.

What began as a series of explorations by inventors and artists that were distributed to paying audiences by independent exhibitors became in the first two decades of the 20th century a major culture industry that provided narratives in moving images with dialogue and narrative carried by the titles intermixed with the images. In this beginning, silent films were both national and international because the images carried a major proportion of the stories, and frames carrying title cards could easily be written in the language of any country. The World War of 1914–1918 effectively ended European domination of global film distribution, with Hollywood, the new center of American film production and distribution, becoming the film capital of the world for the rest of the century.

Hollywood moved from silent to sound film from 1927 to 1930 and from black and white to three-strip Technicolor (cyan, magenta, and yellow) film from 1935 to 1970. The size of film moved from the standard 35 mm to wider images in 70 mm with Cinemascope for 20th Century Fox's Bible epic *The Robe* in 1953. Early experiments with trying to simulate three-dimensional (3-D) depth began as early as 1922 with *The Power of Love*, but it was not until the 1950s, in what people call "The Golden Age of 3-D," that major efforts were made to make 3-D films the norm. Some of the key films were *Bwana Devil* (1952), *House of Wax* (1953), *Hondo* (1953) starring John Wayne, and Alfred Hitchcock's *Dial M For Murder* (1954).[30] By 1955, the fad faded but in 2008, 3-D films attracted new audiences. In 2009, *Avatar* became the highest grossing film of all time and a critical success. This 3-D film sparked interest in producing more films using the illusion of depth. Attempts to use *holography* (total-writing) to provide more realistic 3-D moving pictures that could be viewed without the clumsy cardboard eyeglasses with one red (left) and one cyan (right) lens have been unsuccessful.

The move from film to digital imaging has brought new techniques and technologies to capturing, editing, storing, and distributing moving images in wide-screen format accompanied by surround sound to create more realistic simulations of reality. Now, "films" are increasingly not shot or shown using film at all. They are shown not only in movie theaters but via television and com-

puter, and stored on videotape, DVD and Blu-Ray technologies, and in computer memories. Each of these variations of how moving images are shot, stored, and retrieved may alter the condition of attendance (time, place, environment, people present, and control of the actual showing) enough that each could be viewed as a separate medium of communication.

Paralleling the rise and spread of the entertainment movie was that of the newsreel, in both America and Europe, that presented short (10 minute) footage of actual events, usually twice a week, to movie audiences. From 1911 to 1967, newsreels provided American movie-going audiences with information about current events deemed to have wide audience appeal. The rise of television as a more immediate and more convenient medium for providing news hastened the end of the newsreel.[31]

Photography and cinematography attempted to address the problems of authenticity and representing reality directly, something that language, writing, and printing were unable to deliver. They encoded reality, re-creations of reality, and imagined fantasy and reality in visual imagery accompanied frequently by printed texts or audio recordings of words and other sounds. Their messages were stored on metal and glass plates, on paper and film, and in binary digital form. These messages were transmitted via photographs, halftone reproductions, or by movie projectors in theaters or via television or digital transmission. The sense of sight was extended by photography and by early silent cinematography before the addition of sound beginning in 1927. The sense of sound was absent from photography and early cinematography (except for music and occasional sound effects provided live in movie houses). Sound film provided synchronized voices and other sound, including musical scores, but movies tended to convey their messages through images more than through sound.

Command and control of photography, photojournalism, and cinematography were exercised by different groups in different cultures. In many cultures throughout the 20th century, the press (including photojournalism) was either controlled or heavily influenced by governments with limited or no freedom of expression possible. In other cultures, led by the United States and Western Europe, the press was founded upon free enterprise with limited control by governments. But even in the United States, with its strong First Amendment protections of free expression, government pressure based upon national security and commercial pressure based upon economic concerns limited total freedom of the press.

With cinematography, the pattern was similar, with even greater controls

exercised by governments concerned with the possible harmful effects of movies on children and young adults in the areas of sex and violence, and unpatriotic messages. The very nature of the high costs involved in producing and distributing motion pictures of high quality limited the number of people involved in film-making to those employed by large corporations or governments. Freelance independent filmmakers have always found it hard to obtain both financial support and access to distribution outlets. The skills and finances needed to use the techniques and technologies of both photojournalism and cinematography tended to encourage craft use of the media available, with personal photography and home movies shot in 8mm film offering some social uses of these graphic communication media. But the vast majority of people all around the world experienced both public photography (photojournalism) and cinematography as receivers of the messages who paid for the information they received. Except for personal use of photography and home cinematography, most people remained passive receivers of information controlled by the few and distributed to the many.

Even the documentary films intended to serve as counterparts to and warnings about their cultures and societies fit into this frame. Motion pictures began as actualities, moving images that captured and documented real life, but Robert Flaherty (1884–1951) really established the documentary as a valid film genre with his 1922 *Nanook of the North*, an artistic and commercial success that stimulated interest in this use of film as an explorer into the unknown, a reporter of events, a painter of life, an advocate for causes, a bugler to awaken the public, a prosecutor of evil, a poet of feelings, a chronicler of an era, a natural observer without judgments, a catalyst for action and a guerrilla warrior against the power elites. Filmed documentaries tended to be less profitable than commercial feature films, and the genre flourished only with government or other outside support.[32]

Impacts

GRAPHIC COMMUNICATION

Without question, the revolution in graphic typography that began in the 19th century and continued into the 20th century and on into the 21st century brought significant changes in how people received and responded to the altered media (largely newspapers, magazines, books, billboards, signs, and handouts) and the image-enhanced messages they carried. The spread of illus-

trated newspapers and magazines also helped to make advertising more vivid and more accessible to ever-growing audiences. The popular penny press may have succeeded without graphic images, but illustrated newspapers did attract larger circulation than papers with limited use of graphics. It is telling that newspaper cartoon strips beginning with Richard F. Outcault's *The Yellow Kid* in *The New York World* in 1895 had positive impacts on circulation. Although the comic strip had a long history prior to the 19th century, this was only a prelude to the impact comic strips would have on the Hypergraphic Revolution.[33]

The Yellow Kid attracted younger readers to Joseph Pulitzer's *New York World* and inspired William Randolph Hearst to lure Outcault to his own *New York Journal* in 1897, igniting a newspaper war with competing *The Yellow Kid* strips in both papers, providing the label of "yellow journalism" for the penny newspaper wars. Significant strips that followed included *Katzenjammer Kids* (1897), *Little Nemo* (1905), *Mutt and Jeff* (1907), *Krazy Kat* (1913), *Gasoline Alley* (1919), *Little Orphan Annie* (1924), *Buck Rogers* (1929), *Blondie* (1930), *Dick Tracy* (1931), *Li'l Abner, Flash Gordon,* and *Terry and the Pirates* (1934), *Pogo* (1948), *Peanuts* (1950), and *Doonesbury* (1970). Separate note should be made of three newspaper strips that were published as part of special Sunday sections: *Tarzan of the Apes* (1929), *Prince Valiant* (1937), and *The Spirit* (1940), all of which were in full color and printed on a full page.[34]

In 1933–34, reprints of newspaper strips were assembled into separate stand-alone books that sold for ten cents, called *Famous Funnies*. From that small beginning, the comic book industry was born, growing over the 1930s and 1940s into a large publishing sub-section with comic books about animals and children (*Little Lulu, Donald Duck, Mickey Mouse, Mighty Mouse, Archie*), crime (*Crime Does Not Pay, Dick Tracy, Gang Busters*), horror (*The Haunt of Fear, Tales from the Crypt, The Vault of Horror*), romance (*Modern Love, Real Love*), superheroes (*Batman, Fantastic Four, Green Lantern, Spiderman, Superman, Wonder Woman*), war (*Avengers, Black Hawk, Boy Commandoes, Captain America, Daredevil, Devil Dogs, G.I. Joe, Our Fighting Forces, Our Army at War*), and westerns (about real westerners like *Buffalo Bill, Wild Bill Hickok, Jesse James,* and *Annie Oakley*; about western movie stars like *Gene Autry, Tom Mix, Tex Ritter,* and *Roy Rogers*; and about fictional western characters like *The Durango Kid, Hopalong Cassidy, The Lone Ranger,* and *The Two-Gun Kid*). A special series was created by Classics Illustrated Comic Books, which from 1941 to 1971 (with a hiatus in 1962) published 169 classics of literature in comic book form.[35]

The very success of comic books among young readers raised concerns

among adults about their possibly harmful effects, concerns that seem to be raised about any new medium of communication. Censorship of media, which began with typography, continued with graphic communication. The criticism reached a critical mass in 1954 with the publication of Frederick Wertheim's influential *Seduction of the Innocent*, a blistering attack on the content and imagery in comic books, complete with illustrations from the comics. A special subcommittee of the U.S. Senate held hearings in 1954 with Dr. Wertheim as the star witness. To avoid government censorship, the industry countered with self-censorship rules called the Comic Code Authority, which monitored a long list of prohibitions, beginning with sex and violence, criticism of religion, use of slang words, and unconventional behavior.[36] The chief target was EC Comics, but Bill Gaines, who testified against any censorship, and his fellow executives at EC turned their *Mad* comic books into *Mad Magazine* in 1955, thus avoiding the Comics Code Authority while continuing to satirize all of American culture.[37] An entire "underground comics" movement also resisted the Code, offering readers uncensored comic books and graphic novels.[38] In terms of mass circulation, the comic book declined in readership after 1955 and became a carrier of non-controversial content. To some extent, graphic novels continued to provide adult and cult audiences with content and imagery to meet their needs and desires. Both comic books and graphic novels would provide titles, characters, and plots for a number of motion pictures.[39]

Whether in books, magazines, or newspapers, printed graphics will continue to be part of publishing as long as paper continues to be a carrier of print. The changes looming now are those posed by the Digital Revolution that offers new electronic formats for delivering texts and images to people via cybernetic media for the transmitting, storage, and retrieval of information. The challenge to printed graphics by digital systems may result in the lessening, or even elimination, of paper as a carrier of messages, but the fundamental medium of graphic communication will continue to be used by humans to share information. The impacts of graphic imaging in printed media have changed not only how print communicates, moving us from words to pictures in our public communication, but also helped graphic forms like cartoons to become part of popular culture.

Consider your own contacts with graphic communication in print. Have you read comic books, comic strips, and cartoons in print? Did you do so as a child or a teenager? Do you continue to do so? Why? Do you read graphic novels? What impacts have these forms of graphic communication had on your life? Would your life be different without comic books, comic strips, cartoons, and

graphic novels? How and why?

PHOTOGRAPHY

Photography's impact on human life has been profound and widespread. It can be examined in four general areas of culture and communication:

1. Personal photography by and for individuals, families, friends, acquaintances, and small groups
2. Artistic photography by gifted individuals for aesthetic expression to be appreciated by patrons
3. Documentary photography to identify people and record the realities of life.
4. Photojournalism that uses photographs printed in books, magazines, newspapers and other formats to tell stories to public audiences through public media.

George Eastman's Kodak film and box cameras made personal photography possible for masses of people who could afford the relatively low prices charged for renting or buying a camera and for film and processing into prints. Few families in developed countries were without a camera and photography albums, beginning with Kodak's Brownie in 1900 and continuing with today's digital cameras and cell phones with photographic applications. People take pictures of their lives from birth to death and everything in between. We capture images of babies, of weddings (but rarely of divorces), of our first day in school or at other key events, of celebrations, of our travels, and of every moment and event of our lives that we wish to preserve as a visual image of the past, a technological memory that is more real and more vivid than our human memory, literally an eyewitness to our own history. With photography, even the least naturally gifted among us can capture lifelike images of the world and record our lives and our experiences in visual images previously available only to the rich and powerful.

Photography helped to democratize graphic communication by empowering ordinary people with the techniques and technologies needed to compile visual histories of their lives. In *The Pencil of Nature*, William Henry Fox Talbot prophesized that photography would bring to everyone a "*royal road to drawing.*" As he wrote:

Ere long, it will be in all probability frequented by members who, without ever hav-

ing made a pencil sketch in their lives, will find themselves enabled to enter the field of competition with Artists of reputation, and perhaps not infrequently to excel them in the truth and fidelity of their delineations, and even in their pictorial effect; since the photographic process when well executed gives the effects of light and shade which have been compared to Rembrandt himself.[40]

Here the promise of technology will make everyone with a camera an artist of the first order. A 1941 article in *Modern Mechanics* named photography as America's favorite hobby.[41]

Consider how you use photography in your life. What type of camera do you use? What do you photograph? Why? How do you store your photographed images? Who sees your photographs? In what venues? Do you ever destroy or discard photographs? Why? Do you like to be photographed? What benefits do you think photography brings to your life? What would be different in your life if photography did not exist?

In the area of artistic expression, photography actually began as a collaboration between scientists interested in light and chemistry, and artists interested in capturing more realistic images from life than were possible with drawing, painting, and sculpture. Many of the people involved with the evolution–revolution of photography were themselves artists or aspiring artists. For example, Louis Daguerre was a painter, and William Henry Fox Talbot found in photography a remedy for his limited talents as an artist, as he noted in *The Pencil of Nature*: "This is the first work ever published with photographic plates...executed by Light alone, and not requiring for their formation any knowledge of drawing by the Operator."[42] Samuel Morse was a painter of some distinction whose early experiments with photography did not result in his abandoning painting but did inspire other early American photographers, like Mathew Brady, Alexander Gardner, and Timothy O'Sullivan, whose works have been praised for both their artistic and historical value.

Acceptance of photography as an art did not come easily or swiftly, but today more than 30 American colleges and universities have programs, departments, or schools of photography. Worldwide, photography is a skill to be learned and a subject to be studied at schools and universities. Museums have also embraced photography as an art form. France boasts collections at the French Museum of Photography, the Louvre, and the Musée d'Orsay, among others. In the United Kingdom, one can visit the Fox Talbot Museum of Photography in Fox Talbot's home in Wiltshire and the National Museum of Photography, Film, and Television in West Yorkshire. The United States offers a treasure trove of museum experiences from the George Eastman House

International Museum of Photography and Film in Rochester, New York to the International Photography Hall of Fame and Museum in Oklahoma City. In New York City, the Metropolitan Museum of Art has a distinguished photography department and the Museum of Modern Art (MOMA) pioneered photography as art with its collection that began in 1930 and became a full department in 1940; currently, it houses more than 25,000 photographic works of art.

The list of photographers who have been recognized for their artistic achievements is extensive. Even a partial list of names known to American audiences is impressive: Mathew Brady, Julia Cameron, Alexander Gardner, and Timothy O'Sullivan from early photography; Edward Curtis, Eadweard Muybridge, Jacob Riis, and Alfred Stieglitz from its development years; Berenice Abbott, Alfred Eisenstaedt, Dorethea Lange, Lewis Hine, Man Ray, and Alfred Stieglitz from the third wave; Ansel Adams, Diane Arbus, Richard Avedon, Cecil Beaton, Margarget Burke-White, Henri Cartier-Bresson, Robert Capa, Walker Evans, Gordon Parks, and Ben Shahan from the golden age of photography; and Ann Geddes, Annie Leibovitz, and Robert Mapplethorpe from the waning days of filmed photography.[43]

Consider your own contacts with photography as art. Do you own or view artistic photographs? Why? What makes a photograph "artistic"? Subject? Style? Technique? Impacts on people? What impacts has artistic photography had on your life? Would your life be different without artistic photography? How and why?

Photography to document people and events has played vital roles in modern societies. In essence, the very first photographs taken by Daguerre and Fox Talbot documented the realities of their environments with images of courtyards, landscapes, and buildings. Later photographs captured the images of people frozen in time and space for other people and future generations to see if they were given access to the originals or prints made from negatives.

The use of photography to identify people seems to have begun in 1843–44 in Belgium with the photographing of criminals, which by 1870 was common in large cities in Europe and the United States. Birmingham, England was the first city to classify photographs of criminals according to their categories of offenses—the first "Rogues Galleries." But it was the French police official Alphonse Bertillon (1853–1914) who created forensic photography by standardizing the lighting, scale, and angles used for "mug shots" and for documenting scenes of crimes with detailed descriptions and careful photography, as detailed in his *Alphonse Bertillon's Instructions for Taking Descriptions for the*

Identification of Criminals and Others, by Means of Anthropometric Indicators (1889).[44] In a very real sense, Bertillon was the original crime scene investigator, a real-life model for Sherlock Holmes and all the other fictional scientific detectives.

Later, photography was used for improved identification of people on passports that began in the early decades of the 20th century.[45] Driver licenses for automobiles began in America in 1901 in Chicago and New York City, and in 1903 in two states—Massachusetts and Missouri—but photographs were not required until much later. The photograph on other identity cards came even later, although in the 21st century they have become almost mandatory.

Photography helped to document wars, beginning with daguerreotypes in the Mexican–American War of 1846–1848 and Roger Fenton's pictures of actual battles in the Crimean War of 1854–1857 and achieving maturity with the American Civil War (1861–1865) images captured by Mathew Brady, Alexander Gardner, Timothy O'Sullivan, and others. All subsequent wars have been documented by photographs commissioned by governments and news organizations, and by participants and victims. The military used photography to help it wage war more efficiently, especially when the airplane made aerial photography a reality in the First World War (1914–1918). Photography gave faces to war and to those who waged war, providing iconic identification to heroes and leaders by keeping their images in the public eye.

Photography had a profound impact upon politicians and other public personalities, making their images as familiar to the public as those of their neighbors. There is some debate about who was the first president of the United States to be photographed, with some awarding that distinction to John Quincy Adams in 1843 (after he left the White House in 1829) while others insist that James Knox Polk was the first because his 1848 portrait by Mathew Brady was taken while he was the president. In any case, no president following Polk went un-photographed, to the point of losing most of his privacy. Across the world, leaders embraced photography as the newest form of image-making so vital for leaders to be portrayed as *leaders*.

With presidents and politicians leading the way, others followed. Photography soon captured images of actors and actresses (first from the stage and later from motion pictures, radio, and television), baseball and football players, prizefighters, golf and tennis stars, race horses and their jockeys, and other figures from the world of sports. Across the globe, photography captured and preserved images of rulers and notables, of ancient ruins and civilizations of the past, of the glories of China, Egypt, Greece, Japan, Persia, and Rome. Many of

these captured images were turned into slides for illustrated lectures and special stereoscopic collections used for lectures and for home viewing. Stereoscopic entertainment and instruction functioned as the Victorian equivalent of our motion pictures and television programs, bringing the world into the living rooms and parlors of ordinary homes. In 1905, for example, the famous American Egyptologist James Henry Breasted (1865–1935) was enlisted by Elmer and Bert Underwood to write the descriptions to accompany their stereoscopic images of Egypt shot during their trip in 1896. Breasted provided a scholar's knowledge of Egypt in a book to accompany the 100 stereoscopic images in a boxed set of photographs that would be viewed through a stereoscope, creating a three-dimensional illusion of sight. *Egypt Through the Stereoscope* was only one of a number of such books and stereoscope photographs on Greece, Italy, and the Holy Land. Breasted himself provides testimony about the power of these stereoscopic images to instill in the viewer a sense of being in Egypt in his introduction to the 1905 book and image package. In comparing these images with his own on-site viewing of the Nile Valley, Breasted wrote that the images produce "…essentially all the same sensations of having seen the reality; an actual visit to the place can do little more." He also found added value to the stereoscopic images: "Moreover, by the repeated use of the stereograph, the scene can be often reimpressed upon the mind's eye, and herein lies one of the greatest advantages of this system of stay-at-home travel, that the trip may be made as often as one likes."[46]

In bringing the world to people in images, documentary photography extended our sense of sight to overcome limitations of time (with the past captured in solid visual form) and space (by making people eyewitnesses to all of the globe without having to leave home). By documenting the world and the people in it, photography gave masses of people access to information previously available only to those present in time and space to witness the sites, the people, and the events.

The fourth major use of photography, as photojournalism, is the one that had the most impact on people and cultures, if only in the developed societies with literacy, and magazines and newspapers to reach a wide public. It would be difficult to overstate the impacts of photojournalism on American and Western Europe in the last decade of the 19th century and all of the 20th century. The halftone process that made printed photographs possible and the development of high-speed cameras and film that made picture-taking in the real world of events a reality were joined by photographic news agencies that provided photographed images to ever-widening audiences.

From its beginnings with the halftone process in 1880, photojournalism was used in newspapers and magazines to provide images of reality to enhance the impact of their stories and articles. As early as 1912, the Danish Union of Press Photographers was formed, followed later in America by the National Press Photographers Association in 1946 and by the British Press Photographers Association in 1984. The "Golden Age" of photojournalism is usually dated from the 1930s to the 1950s, when such magazines as France's *Paris Match*, Germany's *Arbeiter-Illustrierte-Zeitung* and *Berliner Illustrierte-Zeitung*, and America's *Life*, *Look*, *Sports Illustrated*, among others were created and flourished. Newspapers like London's *Daily Mirror* and New York City's *Daily Mirror* and *Daily News* also brought readers news in words and images. Today, most newspapers use photographs, and magazines on all topics use photographic images, although few continue to practice photojournalism in the 1930s to 1950s style. If we include advertising under photojournalism, a listing possible if you consider advertising to be a form of information sharing, then photography plays an even larger role for images are probably more dominant than words in the world of consumer manipulation. As William Arens notes in *Contemporary Advertising*, "Almost every ad has some kind of a visual image besides typography. And many ads have several pictures."[47] Indeed, it is difficult to conceive of printed advertising existing in its present form without photography to supply most of its images.

From its beginnings in the late 1800s into the 1930s, photojournalism could move images through space only at the speed of transportation in moving the pictures to the publisher and in moving the magazines and newspapers carrying the printed photographs to the public. In the early 1920s, however, the American Telephone and Telegraph Company (AT&T) began to experiment with sending the dots of the halftone process encoded as electromagnetic impulses over telephone lines to be received and recovered as images at the other end. Unfortunately, the early experiments required almost an hour to send and receive each image and that image was quite blurred. Bell Laboratories, the research unit of AT&T, finally succeeded with wire transmissions of photographs on January 1, 1935, sending a clear picture of an airplane crash in the Adirondack Mountains in New York to newspapers from 100 to 3,000 miles away. As the telegraph had freed writing from transportation and the telephone had done the same for speech and other sounds, wire photography now freed the image to move by transmission as well.

During the Second World War, photographs from far-flung theaters of warfare from Africa and Europe to the Far East and the South Pacific were trans-

mitted back to the United States by radiophoto, a electromagnetic system that encoded and decoded the halftone dots into impulses like wire photography but sent through the air as radio waves, using similar technology that gave the world television. While those images moved at the speed of light, they still required time to process, print, and distribute to the magazines and newspapers that would carry them to the public. Even as electromagnetic transmission made communication more efficient, people still depended upon transportation to move information from the source to the destination.[48]

Today, photojournalism, including advertising, continues to shape our communication environments, although the delivery systems seem to be shifting from print to the Internet where news sites, blogs, and advertisements continue to try to communicate their messages to an increasingly growing but fragmented audience.[49]

Consider your own contacts with photojournalism and advertising. In what formats and media do you encounter their messages? How do you receive information about the world carried by photographs? What sources do you trust? Why? Do you think that photographs present images of reality that are valid and reliable? Why? What impacts has photojournalism had on your life? Would your life be different without photojournalism? How and why?

CINEMATOGRAPHY

The impacts of cinematography on communication and culture all around the world were more profound and extensive than the impacts of graphics and photography. In its ability to present moving images that represented reality and imagination, cinematography brought even greater claims for validity and authenticity and more lifelike pictures, complete with sound and color in its full development. Like photography, cinematography served to record people, places, and events with the newsreel and the documentary film. But its greatest impacts came with short and feature films produced primarily for entertainment purposes, with some significant attempts to employ film for propaganda purposes.

The use of film for propaganda purposes began in America during the Spanish American War of 1898 with newsreels that mixed genuine footage with studio fakery to sell the war to America. The First World War (1914–1918) was sold with films, both newsreel and entertainment, by France, Germany, Great Britain, Russia, and the United States. In the 1920s and 1930s, first the Soviet Union and then Nazi Germany used films to propagandize their citizens. The

Second World War (1939–1941) witnessed the extensive use by all involved governments to sell the war to their peoples. The Cold War between the West and the Communist World (1945–1991) inspired a wealth of propaganda films produced by both sides.[50] The post-Cold War world has seen a diminishing interest in political propaganda films designed to sell ideologies and wars. For example, the Global War on Terror declared by President George W. Bush after the attack on September 11, 2001 has not produced any significant contributions to the genre, but it did inspire Michael Moore to create his critically and financially successful *Fahrenheit 9/11* (2004) which challenged President Bush's justifications for invading Iraq.

It was in entertainment that cinematography achieved its most important and lasting impacts on peoples and cultures. As James H. Billington, The Librarian of Congress, notes in an afterword in *Silent Movies*, "For more than a century, motion pictures have documented American life and culture."[51] What was true in America was also true, in somewhat different ways, in all cultures that embraced motion pictures, but because America became the center of the global film industry for most of the 20th century, we can focus on the United States and Hollywood to examine the impacts of cinematography on one people and culture. It is important to keep in mind that Hollywood not only dominated American cinema for a century but also dominated the global market for films.

One of the most cogent arguments for cinematography as an agent for change was made by Robert Sklar in his aptly-titled *Movie-Made America: A Cultural History of American Movies*:

> For the first half of the twentieth century—from 1896 to 1946, to be exact—movies were the most popular and influential medium of culture in the United States. They were the first of the modern mass media, and they rose to the surface of cultural consciousness from the bottom up, receiving their principal support from the lowest and most invisible classes in American society.[52]

While I agree, in general, with Sklar's assessment, I do think it is worth noting that movies were very much a craft skill, exercised by an elite minority to entertain mass public audiences, most of whom were unaware of how to make a film. Command and control of filmmaking were in the hands of those who financed the studios, those who ran the studios, and those who worked to write, design, produce, direct, act in, edit, and distribute films to the paying audiences who had no control over the content and structure of films or the conditions of attendance under which the films were received. Only the coming of video

copies of films and home VCRs gave some control to the viewers. I do agree with Sklar's judgment about the role played by Hollywood films in American life:

> Throughout their history the movies have served as a primary source of information about society and human behavior for masses of people. So significant a medium of communication should naturally reflect dominant ideologies and interests, and the American movies have often done so. But what is remarkable is the way that American movies, through much of their span, have altered or challenged many of the values and doctrines of powerful social and cultural forces in American society, providing alternative ways of understanding the world.[53]

Any extensive study of American films will support Sklar's point that movies both upheld and challenged conventional cultural movies, norms, and values. They actually provided answers to the Four Great Questions of Life—Identity, Creation, Destiny, and Quest. From animated cartoons and other shorts to serials and feature films, movies told the story of America as a heroic struggle to create a civilization out of the wilderness. Nowhere is this saga better told than in the western, a genre that embraces first-class productions and back-lot quickies for children.

The role and impact of western films in America is summarized by Richard Slotkin in *Gunfighter Nation: The Myth of the Frontier in Twentieth Century America*:

> The Myth of the Frontier is our oldest and most characteristic myth, expressed in a body of literature, folklore, ritual, historiography, and polemics produced over a period of three centuries. According to this mythic-historiography, the conquest of the wilderness and the subjugation or displacement of the Native Americans who originally inhabited it have been the means to our achievement of a national identity, a democratic polity, an ever-expanding economy, and a phenomenally dynamic and "progressive" civilization. The original ideological task of the Myth was to explain and justify the establishment of American colonies; but as the colonies expanded and developed, the Myth was called on to account for our rapid economic growth, our emergence as a powerful nation-state, and our distinctly American approach to the socially and culturally disruptive processes of modernization.[54]

This myth of the Frontier was represented by a long tradition of the frontiersman who conquers the chaos of the wilderness, including Native Americans and outlaws, that included real pioneers like Daniel Boone, Davy Crockett, John C. Fremont and Kit Carson and genuine lawmen like James Butler ("Wild Bill") Hickok, Wyatt Earp, and Bat Masterson. All were heroes in fictional nar-

ratives in magazines and dime novels in the 19th century and all would become movie heroes celebrated in a number of films. But a more significant figure was the very real William F. Cody, whose exploits were mythologized as "Buffalo Bill" in pulp fiction and in his own celebrated "Buffalo Bill's Wild West," a live spectacular show that entertained and "educated" American and world audiences from 1883 to 1913. Cody himself was a frontiersman, buffalo hunter, Indian fighter, and Army scout who blended reality with fiction to present the mythic frontier to live audiences, inspiring the western genre in films. [55]

From *The Great Train Robbery* in 1903, western films have provided American and global audiences with mythic images of the American Frontier, complete with binary opposites of good–evil, civilization–wilderness, tame–savage, hero–villain, goddess–seducer, hero–coward, and right–wrong, all in the service of showing, to use a title of one extravagant film, *How the West Was Won*.[56] Gene Autry, the singing cowboy who was the most popular western movie star of the 1930s and 1940s (and the 1950s on television), provided a code of behavior that he called the "Ten Cowboy Commandments" for western films directed at young audiences. The hero:

1. Never takes unfair advantage
2. Never goes back on his word
3. Always tells the truth
4. Is always gentle to old people, children and animals
5. Is never racially or religiously intolerant
6. Always helps people in distress
7. Never smokes or drinks
8. Is always clean in thought, word, deed, and personal grooming
9. Respects women and the nation's laws
10. Is a patriot (above all).[57]

Whether Autry and other western heroes actually influenced the behavior of young people is an open question, but there is no doubt that many serious people thought, even feared, that movies did influence people, especially the young. That, of course, was the crux of the criticisms of film contained in the studies conducted by the Motion Picture Research Council, funded by the Payne Study and Experiment Fund, a private foundation established to study the influence of motion pictures on young people. The eleven studies undertaken were published in eight volumes, with two summaries added in 1933, one popular (Henry James Forman, *Our Movie-Made Children*) and one scholarly

(W. W. Charters, *Motion Pictures and Youth*). Among the most critical conclusions were that children were more influenced by information, attitudes, and beliefs in motion pictures than by family, church school, or neighbors.[58]

Of course, the Payne Fund reports were concerned with other genres in addition to the western. They also found fault with crime and gangster films, social dramas, and films that portrayed any behavior that disturbed or questioned the status quo of accepted and normative values and behaviors. They were not the only ones who would comment upon the impacts of motion pictures on society. Over the years, scholars and writers have examined the portrayals of women, African Americans, Asians, Hispanics, Italians, Jews, and other groups in movies, almost always finding these portrayals lacking in accurate representation. In addition to criticizing portrayals of racial, ethnic, and religious groups, people have analyzed and criticized the portrayals of occupations, professions, social classes, lifestyles, and other groupings. What all of these studies demonstrate is how widespread have been the impacts of cinematography on culture and communication in America and around the world.

During the Golden Age of Hollywood (1930–1960), the movie studios and their stars taught people how to dress, how to groom themselves, how to behave, and how to present themselves in public. *The Image Makers: Sixty Years of Hollywood Glamour* charts Hollywood's concept of beauty in female and male actors from 1910 to 1970, from Mary Pickford and Rudolph Valentino to Raquel Welch and Charlton Heston, providing a chronology of style to be envied and emulated by the public.[59] More recently, Turner Classic Movies published two volumes on *Leading Ladies: The 50 Most Unforgettable Actresses of the Studio Era* and *Leading Men: The 50 Most Unforgettable Actors of the Studio Era* which list those stars who made lasting impressions on American culture.[60] Such lists, of course, tell us more about the judgments of film critics and scholars than about the popular taste of audiences over the years. Lists of actresses and actors whose films earned the most money over the years would yield different names and rankings.

Within the film industry, the Academy Awards given yearly since 1928–1929 by The Academy of Motion Picture Arts and Sciences are the most coveted, with awards for best film, best actor and actress in leading and supporting (beginning in 1936) roles, best director, screenplay (original and adaptation), cinematography, art direction, and a growing number of other categories. What these awards signify is the value the industry places upon itself each year.[61]

The genres of Hollywood films that helped to shape American popular cul-

ture from the 1920s to the present defy easy or definitive classification and listing, but people and organizations continue to attempt the impossible. The American Film Institute (AFI) was established in 1967 with the twin goals of training filmmakers and preserving America's film heritage. It publishes lists of the top 100 names of films, actors, actresses, directors, and other categories. Its 2007 television series *100 Years...100 movies* gave widespread publicity to its endeavors to keep film in the public eye. In that series, AFI identified ten classic genres with ten top films in each genre. Here is their top film in each genre:[62]

Table 5.1 AFI's List of Top Ten Films by Genre

1.	Animation	*Snow White and The Seven Dwarfs*	(1937)
2.	Romantic Comedy	*City Lights*	(1931)
3.	Western	*The Searchers*	(1956)
4.	Sports	*Raging Bull*	(1980)
5.	Mystery	*Vertigo*	(1958)
6.	Fantasy	*The Wizard of Oz*	(1939)
7.	Science Fiction	*2001: A Space Odyssey*	(1968)
8.	Gangster	*The Godfather*	(1972)
9.	Courtroom Drama	*To Kill a Mockingbird*	(1963)
10.	Epic	*Lawrence of Arabia*	(1962)

Source: www.afi.org, 2010.

The AFI lists tell us something about the tastes of film aficionados, but perhaps a better guide to popular taste in films can be found in the 2010 list of All Time Top 100 Box Office Films. Table 5.2 show its top ten films (with revenues adjusted for inflation).[63]

Table 5.2

1.	Gone With the Wind	(1939)
2.	Star Wars, Episode Four	(1977)
3.	The Sound of Music	(1965)
4.	ET	(1982)
5.	The Ten Commandments	(1956)
6.	Titanic	(1997)
7.	Jaws	(1975)
8.	Dr. Zhivago	(1965)
9.	The Exorcist	(1973)
10.	Snow White and the Seven Dwarfs	(1937)

Source: www.filmsite.org, 2010.

In addition to being part of American popular culture and a significant contributor to the Gross National Product (GNP), motion pictures have also become a major subject to be researched, studied, and taught at some of America's leading colleges and universities, with at least 225 departments teaching film production and another 375 teaching the study of film as art, industry, culture, and communication.

By any measurement, whether aesthetic, cultural, economic, political, propagandistic, or social, cinematography as a form of hypergraphic communication has had powerful and lasting effects on America and other nations around the world. Today, as other national cinemas, like China, India, and others, strive to achieve a global reach, the impacts of cinematography may continue even as film itself gives way to digital technologies to encode, store, and retrieve the moving image and sound information needed for the cinematic experience.

Consider your own contacts with cinematography. In what formats and media do you encounter their messages? Which formats do you prefer? Why? When do you go to a theater to see a motion picture? Why? Is watching a film in a theater different from watching a film at home on your television set, computer screen, or other receivers? What impacts have motion pictures had on your life? Are you a creator of films? Are you at the receiving end? Is there a difference? Do you have your own lists of favorite films, actors, actors, and direc-

tors? Do you have your own collection of films? What do they tell you about film in your life? Would your life be different without cinematography? How and why?

Limitations

The Hypergraphic Evolution–Revolution continues today, with newer techniques and technologies providing more efficient ways to enhance images to communicate information to more people. In their customary forms, graphics, photography, and cinematography are limited in terms of both time and space, requiring transportation to move the information from sources to destinations because of the very physical nature of paper, film prints, and motion picture film reels. Simply put, someone has to move the products if they are to travel through space. In terms of time, the limitations are even more pressing, with magazine and newspapers being lost or decaying unless properly catalogued and stored, with photographs facing similar threats and with motion picture film challenged by even more dire fates. As the celebrated film director Martin Scorsese laments in his foreword in *Silent Movies*, "I am still shocked by the fact that 90 percent of the films made during the silent era have disintegrated. That means movies…are now lost to us forever, and there are many others in danger of *being* lost."[64] In the afterword in the same work, James H. Billingham, The Librarian of Congress, writes: "In a 1993 report in the state of film presentation, I alerted the U. S. Congress that motion pictures were disintegrating faster than American archives could save them. Now with the establishment by Congress of the National Film Preservation Foundation, the Library can continue its work to promote and ensure the preservation and public accessibility to the Nation's film heritage."[65]

The energy and matter required for graphic communication, photography, and cinematography involve the physics of light, chemistry, and instruments constructed by people to capture, store, and share information. In terms of public communication, the Hypergraphic Revolution, by its very techniques and technologies of encoding and transmitting of information, provided media that were largely craft-controlled for wider public consumption, resulting in largely one-way media systems. While all of these media did extend the spread of information to ever-widening numbers of people, the receivers of information had limited access to feedback and, thus, little control over the dominant media of this evolution–revolution. Books, of course, were used by people for storage of graphic communication, and institutional, public, and private

libraries provided additional facilities. But, few people bothered to store magazines and newspapers after they had read them and only limited issues were stored in public libraries. Personal photography enabled ordinary people to be both picture-takers and archivists, using family albums and slide carousels to store and share their photographs with family, friends, and acquaintances. Professional photographers provided more formal pictures to commemorate special events that were stored in albums or framed for display in homes, offices, and other places. Motion pictures, except for home movies, were the province of studios, and until the advent of home video recording-playback machines in 1975–1976, few people owned or stored films. Television, itself, played a major role in retrieving and sharing older movies, and cable television channels like American Movie Channel, Fox Movie Channel, and Turner Classic Movies are invaluable outlets for the showing of classic films. But, of course, these outlets required a new and different evolution–revolution before they could perform these services.

Above all, the Hypergraphic Evolution–Revolution enhanced the sense of sight at the expense of sound, although sound films did restore that sense to the communication environment. Despite narration, dialogue, music, and sound effects in films, we still say we "see" movies, signifying the powerful role played by vision in our experiences with graphic media. It is the images that dominate and last, especially in graphics and photography but also in cinematography. All provide us with images that command our attention with their inherent claims to validity and reliability.

Despite the enhancement of the visible brought by the evolution–revolution in hypergraphic communication, the media involved did not completely solve all existing problems in communication. The questions about access continued, as did questions concerning who had command and control of the dominant media, with critics from both the right and the left accusing the popular graphic press, photography, and motion pictures of lowering cultural standards and tastes on the one hand or of contributing to the power of popular culture as a form of social control. The conservative critics worry about the abandoning of our quests to achieve our "better selves" for the panderings to our "ordinary selves" by popular culture. The liberals, including the neo-Marxists, see the Hypergraphic Revolution as an instrument for hegemony by the power elite, and/or as an enforcement for class-based societies. The Post-Modernists insist that language and all media extending from language are constructors of what we perceive as reality and urge us to free ourselves from our illusions.[66]

Given the enhancement of entertainment by this evolution–revolution, the

question can be raised as to whether this abundance of images did not encourage people to spend their time and money on what were ephemeral bits of information that were *phatic*, not *emphatic* and diversionary at the least. As Neil Postman puts it in *Amusing Ourselves to Death*, public discourse that was founded in language and nurtured by typography has become threatened by the graphic revolution that reduced all areas of public communication to the dictates of show business founded upon the Hypergraphic Evolution–Revolution of the late 19th and early 20th century.[67]

At the technical level, the limitations of this evolution–revolution would be addressed by new techniques and technologies that would seek to free hypergraphics from being bound by transportation to overcome space and by deteriorating storage systems to overcome time. The evolution–revolution in electrographic and electrophonic communication would attempt to address these limitations, succeeding quite impressively by providing more efficient ways and means to store and to share information among more people.

But the dream of total communication would still elude people, and by becoming hypergraphic we upset the delicate balance between what James Joyce called the "Ineluctable modality of the visible…(and) the ineluctable modality of the audible."[68] Together, the visible and the audible provide the two senses most central to human communication, and any imbalance between them threatens to limit human communication in its most basic expressions.

· 6 ·

BECOMING ELECTRIC

Evolution and Revolution in Electrographic and Electrophonic Communication

Context

The Typographic Revolution that was enhanced and expanded by the Hypergraphic Revolution would be further enhanced and expanded by the Electrographic–Electrophonic Revolution that also began in the 19th century but found its great impacts in the 20th century. The first three decades of the 19th century saw the birth of photography and the beginnings of the graphic revolutions in typography that would lead to the penny press, popular mass circulation magazines, and the incunabula of modern advertising. The evolution of photography extended the image and augmented hand-crafted images in typography, integrating image and word in a symbiotic relationship that enhanced sight as the primary sense in most public communication. The oral–aural realms of sound were limited to everyday communication and to such public arenas as public lectures, sermons, speeches, and theater, with the human voice and acoustic music reaching only to those ears within range of the sound waves carrying the symbolic messages. In the main, sound continued to be the carrier of dialogue between individuals or among small groups, with public dissemination largely confined to the same roles played in Aristotle's Athens some 2,100 years in the past.

Print had extended written words for almost 500 years since Gutenberg's revolution, with books and libraries providing storage systems for a culture's most memorable information, and popular magazines and newspapers providing extensions in space that were still limited to transportation systems. The optical semaphore telegraph systems developed by Claude Chappe and others in Europe and America in the last decade of the 18th century and the first 3 decades of the 19th century did carry messages more quickly over more distances, but they were extremely limited in both their capacities and in their efficiency in connecting locations not in clear sightlines in clear weather during sunlight hours. Even with improvements in both techniques (encoding–decoding and sending–receiving) and technologies (equipment and materials), the optical semaphore telegraph systems would remain extremely limited in their abilities to transmit large numbers of signals over ever-growing distances in shorter periods of time. In brief, the optical semaphore telegraph had reached the limits of its possibilities. The coming evolutions–revolutions in both sight and sound would seek to extend both the transfer and storage of messages through the harnessing of an energy source that many 19th century scientists and thinkers identified as the central motivating force of Nature itself—electromagnetism.

The idea that electricity could be used for practical purposes became central to many 19th century inventions, but it was only in the 18th century that any serious attempts were made to understand electricity as a force of Nature. In the 17th century, European scientists like Italy's Galileo Galilei (1564–1642) and England's Sir Isaac Newton (1642–1727) had provided scientific explanations for gravity as a central force to explain how the universe operated, but knowledge of how electricity functioned was nearly as limited as it had been for ancient philosophers and proto–scientists in the ancient worlds of China and Greece. In 1743, the American philosopher, scholar, writer, and printer Benjamin Franklin (1706–1790) became intrigued by the demonstrations of static electricity "by a travelling scientific showman from Scotland named Dr. Archibald Spencer."[1] As Franklin's biographer Walter Isaacson notes, "Franklin was the perfect person to turn electricity from a parlor trick into a science. The task demanded not a mathematical or theoretical scholar, but instead a clever and ingenious person who had the curiosity to perform practical experiments, plus enough mechanical talent and time to tinker with a lot of contraptions."[2]

In conducting his experiments over a number of years, Franklin provided the world with a number of key concepts and terms we still use—*positive* and *negative* electrical charges and his discovery "that the generation of a positive

charge was accompanied by the generation of an equal negative charge."[3] He experimented with using Leyden jars to capture and store electrical charges and succeeded in creating what he called "an electrical battery."[4] By 1749, Franklin noted in his journal that electrical sparks and natural lightning possessed some similarities. Using this insight, Franklin designed an experiment that led to his famous invention of the "lightning rod." In 1750, *The Gentleman's Magazine* in London published some of Franklin's speculations in the magazine, and in 1751 as an 86-page booklet. Both were translated into French in 1752 and aroused the interest of King Louis XV who ordered practical experiments to test Franklin's idea, moving Franklin's idea from conjecture to reality.[5]

Meanwhile in America, Franklin devised his own experiment, using the now-celebrated kite with an iron key attached to draw sparks that could be collected as stored electricity in a Leyden jar in June 1752.[6] The lightning rod soon proved its practical value as a protection from fires caused by lightning strikes, and people in Europe and America erected what would become common additions to buildings.[7]

Franklin's achievements demonstrated *how* electricity operated but he never could explain *why* electricity operated as it did. Still, he certainly deserved the title of "New Prometheus" bestowed upon him for stealing the fire of the gods to benefit human beings by the German philosopher Immanuel Kant. For his services to science and to the American Revolution, the French statesman Anne-Robert-Jacques Turgot said of Franklin in 1781: "He snatched lightning from the sky and the scepter from tyrants."[8]

For people involved in communication, the key question was how to use electricity to transmit messages from one place to another with accuracy and reliability. As Daniel J. Czitrom notes in *Media and the American Mind*, "Only after numerous fundamental discoveries in chemistry, magnetism, and electricity could a practical electromagnetic...telegraph take shape"[9] In time, the electromagnetic telegraph would be hailed as the epitome of how science could be used to solve human problems by harnessing Nature through human techniques and technologies. While the contributors to understanding and using electricity stretch from Thales of Miletus in Ancient Greece to William Watson (1715–1787) in England, Benjamin Franklin in America, Luigi Galvani (1737–1798) and Alessandro Volta (1745–1827) in Italy, Hans Christian Øersted (1777–1851) in Denmark, and André Marie Ampère (1775–1836) in France, it was the American Joseph Henry (1797–1878) who in 1831 managed to capture electromagnetism for use in transmitting messages over distances of space. As Czitrom notes, "In the 1820s and 1830s scientists from all over the

world worked to create a viable electric telegraph: Ampère in France; Schilling in Russia; Steinheil in Germany, Davy, Cooke, and Wheatstone in England."[10]

The improvements in transportation and postal systems that accompanied the rise of nation states in Europe, following the Peace of Westphalia in 1648 that ended the Thirty Years War (1618–1648), provided, in part, a restoration and improvement of the transportation–communication systems that had been used to establish and run the Roman Republic and the Roman Empire. "The first postal system that established permanent relays like the old imperial networks, but offered its services to the general public, was founded by Franz von Taxis, postmaster to the Holy Roman Emperor Maximillian I."[11] This 1489 Austrian system was followed by France in 1622 and by England in 1635. Everywhere, these government-controlled postal systems served two functions—to promote commerce and trade and to serve as a way to spy on people's private messages.[12]

Essentially, the postal systems served as common carriers of messages transported over public roads via horseback or stagecoach. Improved roads and coaches, along with frequent changes of horses, increased the speed of moving messages from place to place. Despite these improvements, a telling limitation can be found in the realization that by 1830, "The European postal systems could finally boast speeds comparable to those of the Persians and the Romans."[13] This is a reminder to us that all change is not progress and that progress need not be a continuing phenomenon.

In America, the postal systems established during the Colonial Era were fragmented and rudimentary. During the Revolution (1775–1783), all of these systems deteriorated in terms of efficiency. After the Revolution, Congress in 1792 passed the Post Office Act to help bind the new nation together with an improved communication system that would share information among the citizens of the new states of the union.[14] To Daniel R. Headrick, "The 1880s and 1840 marked the great turning point in postal history, equivalent to the electric telegraph. It had two causes: the railways and the penny postage."[15] While this certainly seems to be true for Europe, especially for Great Britain, it seem to be less true for the United States of America where much larger distances separated people and communities within the growing number of states of the new country. From the original 13 colonies that became states from 1787 to 1790 with the ratification of the Constitution of the United States of America, the country expanded to 26 by 1837.

The expansion of the United States was greatly accelerated by Thomas Jefferson's Louisiana Purchase of 1803 which doubled the size of the country

for a mere $15 million to help Napoleon Bonaparte finance his wars in Europe. The 1804–1806 expedition by Meriwether Lewis and William Clarke established America's claim to all of the lands from the Missouri River to the Pacific Ocean. Later, in 1821, Spain gave possession of Florida to the United States, and, by 1840, the United States stretched from the Atlantic Ocean to the Pacific, from the Canadian border in the North (along the Forty-Ninth Parallel established by the 1814 Treaty of Ghent that ended the War of 1812) to the Mexican territories to the South. America was on track toward achieving what John L. O'Sullivan in an 1845 editorial in *The United States Magazine and Democratic Review* would call the "fulfillment of our manifest destiny to rule the North American continent." The quest to reach that "manifest destiny" would involve political will, war (the Mexican American War of 1846–1848), and improved techniques and technologies of communication to overcome problems of time and space to keep Americans united "in a more perfect union."

In Europe and in the expanding United States of America, there were emerging growing demands for more and more timely information about the availability and movement of goods, including the arrivals and departures of ships and railroads, and risks from war and natural disasters. What was true with the need for writing in Egypt and Sumer in 3100 B.C.E. and with printing in Germany in 1456 would be true in the 1830s–1840s in Europe and America: accurate and timely information that provided more command and control over the environment, bestowing power on those who were best able to overcome limitations of time and space to move and preserve messages. In the context of the times and places where the electric telegraph emerged, the supply of information never met the demand, nor would it do so for the entire history of the electric telegraph and its offspring—the telephone, phonograph, wireless telegraph, radio, and television. Only in the Cybernetic Revolution would the supply of information begin to exceed the demand.

In 1840, the problems that had faced earlier cultures in the gathering, coding, transferring, receiving, and storing of information continued as Europe and America moved through the Industrial Revolution and the political revolutions that provided the foundations for the modern nation-state. The printing press continued to provide the central media for communication messages needed for the survival of these nation states, and improvements in the postal systems aided by improved roads, railroads, and ships—helped to move more information more quickly to more people in more places in shorter periods of time. But information was still largely connected to transportation, limiting the speed of information transfer to the speed of available vehicles of transportation. What

were inconveniences in the limited spaces of Western Europe became major impediments to communication in the vast and expanding spaces of the United States of America.

The optical semaphore telegraph developed in the 1790s and early 1800s tried to solve the key problem of moving information over space in shorter times, but visual telegraphy would prove to be itself quite limited. Daniel R. Headrick thinks that Claude Chappe's optical telegraph was a major advancement in information transmission, and that "The electric telegraph that eventually supplanted Chappe's system represented a less dramatic improvement."[16] In the context of the 1840s, his conclusion is reasonable, but it ignores the reality that the electromagnetic telegraph was not simply an improvement over the optical telegraph. Rather, it was a technology that ushered in a genuine revolution in communication, moving information from transportation to electric transmission and providing the foundation for all of the electric and electronic developments in the Electrographic and Electrophonic Revolutions as well as in the Cybernetic Revolution that followed. The optical telegraph was a technique–technology of communication that reached its zenith and had no further contributions to make to improving communication. In 1840, the optical telegraph had reached maturity with only old age to follow, while the electromagnetic telegraph was being born. And while the electromagnetic telegraph would itself reach the limits of its growth, the concept of electric–electronic communication systems would continue to evolve, grow, and stimulate new revolutions in Communication. In essence, optical telegraphy represented a closed system while electromagnetic telegraphy represented an open system, capable of continuing change and, therefore, survival over time.

At first, with the electromagnetic telegraph in the 1840s, the central problem was one of transmitting messages over ever-expanding distances in the shortest possible time. Later in the 1870s, the telephone solved the problem of the encoding–decoding of telegraphy's Morse Code by carrying the human voice over the wires while the phonograph began to solve the problem of storage for sound. In the 1890s, wireless telegraphy and its offspring, the radio, freed transmission from wires, extending Morse Code and later sound (voice, music, effects) across the airwaves. In the 20th century, television would reunite sight and sound in one medium that would be extended from broadcast to cable transmission. Other evolutions within this revolution would provide the foundations of the Cybernetic Revolution that would follow, notably the electronic computer and the invention of transistors to replace vacuum tubes for electric–electronic signaling.

With speeds that exceeded the speed of typography, all of these manifes-
tations of the Electrographic–Electrophonic Revolution would spread rapidly
throughout the developed industrialized world and throughout the colonies
controlled by these Western societies. By the end of the 20th century, while
wired and wireless telegraphy faded and died, the telephone, phonograph,
radio, and television could be found all across the globe in any area where sig-
nals could be sent and/or received and where electricity, either through current
or stored in electromagnetic batteries, was available. The Electrographic-
Electrophonic Revolution also provided power for motion picture production
and exhibition, adding to the overall array of media that would characterize the
20th century. Few cultures resisted this media wave while most embraced it with
great enthusiasm. While some questioned the costs versus the benefits of each
of these new media, most people and most cultures found the increased infor-
mation flow provided by these media to be worth any cost. To appreciate the
conflict of positions, ask yourself a few questions: What media wrought by this
evolution–revolution are you using? What are their values in your own life?
Could you live without these media? Which ones would you be willing to give
up? Which of these media have been enhanced or replaced by newer media
brought by the Cybernetic Revolution?

Different cultures did embrace these new media somewhat differently,
depending upon their geographic locations and features, upon their cultural,
political, and social histories, and upon their governmental approaches to
communication. In general, the United States dealt with this evolution–rev-
olution with a combination of government encouragement and support with
limited command and control, leaving the ownership and operation of the
media largely to private enterprise, with some government licensing and reg-
ulation. In Europe, governments tended to command and control these media
either directly by making them parts of the overall government system or by
establishing semi-state organizations under government control and supervision.
The financing of these media also tended to follow similar paths, with American
media largely being supported by the users of these media or by advertisers using
these media to promote their goods, products, and services. In Europe, and in
other places, licensing fees paid by users and/or taxation were used to provide
financial support.

As is usual, local circumstances, cultures, events, and environments inter-
acted with the standardizing techniques and technologies of these electro-
graphic–electrophonic media to produce hybrid systems that differed, however
slightly, in different environments. Those who seek universal trends based

upon the universality of the techniques and technologies of these media have had no difficulty in finding in these media evidence of media determinism. Others take comfort in identifying differences, however slight, among cultures inundated with these media. We will encounter this debate again when we examine the impacts of this evolution–revolution later in this chapter.

People

ELECTRIC TELEGRAPHY

The long history of people involved in the evolution–revolution of electrographic and electrophonic communication extends back to Thales of Miletus (624–546 B.C.E.) and continues to all who contributed to the idea that electricity could be somehow tamed, harnessed, and used to help human beings to improve their lives and their communication systems. (It is worth noting that the metaphors used to describe this quest can be connected to how humans used fire, agriculture, and herding of animals to enhance their chances for survival in late Paleolithic and Neolithic times.) The people involved were philosophers and scientists, experimenters and exhibitors, amateur tinkerers and cunning charlatans.

Although a number of people had demonstrated that electricity could be used to carry messages over metal wires, the first practical systems were developed by Charles Wheatstone (1802–1875) and William Fothergill Cooke (1806–1879) in Great Britain, who in 1837 "…obtained a British patent for a needle telegraph that would dominate early development of the medium in that country."[17] This device, which moved a needle like a hand on a dial containing alphanumeric symbols to form words, was an improvement over Chappe's optical telegraph because it could send messages at any time in any weather and because it increased the speed of signaling from 10 to 20 characters per minute possible with the optical telegraph to 25 characters per minute.[18] But the needle telegraph would not prove to be the key invention that sparked the revolution in electric communication.

That distinction would fall upon an American, Samuel Finley Breese Morse, a professor of printing and sculpture at what was then the University of the City of New York (now New York University). From 1832 to 1837, Morse worked on an entirely different approach that used a binary (on/off) series of dots and dashes to send graphic signals to represent his codes for the alphanumeric system used in the Western World.[19] As Daniel J. Czitrom notes about

what stimulated Morse's interest in electric telegraphy, "His original motivation lay in the hope of obtaining an income from his invention that might free him to pursue painting fulltime."[20] By encoding the 26 letters of the Roman alphabet and the 10 numerals of the Hindu–Arabic system into combinations of dots and dashes, Morse was able to use electromagnetism to lower and lift a pen to inscribe the code on a rolled strip of paper pulled along by a clock-like mechanism. Morse's telegraph and code increased the speed of sending messages to 60 characters per minute, more than doubling that of the Wheatstone–Cooke needle telegraph. More importantly, Morse's system laid the foundation for all of the evolutions–revolutions to come in both the Electric Age and the Cybernetic Age.

Whether in Great Britain and the rest of Europe or in America, telegraphy required people who would fund and build the sending–receiving equipment, string the wire on poles, and pay the personnel to operate the systems. Governments provided support in a number of countries, but in Great Britain Wheatstone and Cooke received private financing from private investors and entered into a symbiotic relationship with the Great Western Railway in 1838 to build a 13.5 mile telegraph line. By 1845, they had set up over 550 miles of telegraph lines that used existing railway lines for their rights of way.[21] The railway–telegraph union was a perfect match because the railways provided already existing rights of way and stations to house the telegraph equipment and personnel while the telegraph provided the railways with rapid communication and feedback between stations, helping to avoid accidents and delays. Until 1870, the electric telegraph in Great Britain was funded entirely by the private sector.[22]

On the European continent, governments largely owned and operated telegraph systems for administrative and military uses, with little private interest in setting up or using telegraphy for investment or communication. Part of the explanation for this situation was the fragmentation of Europe into nationalistic states that hindered the growth of long-distance telegraphy between and among separate countries frequently mistrustful of each other. In Germany, for example, the 12 different governments of the individual German states had to approve a telegraph line from Berlin to the border with Belgium. Even after the establishment of an Austro–German Telegraphic Union in 1850 and the use of the Morse system to standardize European telegraphy, the lack of cooperation slowed the expansion of the telegraph.[23]

The United States faced different problems, with the government providing Morse with $30,000 in 1842 to test his telegraph by constructing a line

between Baltimore, Maryland, and Washington, D.C., but leaving future developments to private financing. As in Europe, railroads became the logical partner for the telegraph. Given the single federal government and the vast distances involved, the United States was very responsive to transportation and communication systems that connected people and states. Since many American railroads, especially those that connected distant places, were constructed along single lines of track, with sidelines to allow trains travelling in opposite position to pass each other, head-on collisions were more the rule than the exception. Morse's telegraph united with the railroads to provide the information and feedback needed to enhance the safety of crews, passengers, and freight.

In his early experiments, Morse was aided and assisted by two crucial people—Leonard Gale, a scientist at Morse's university, and Albert Vail, a graduate whose family invested in the invention. When Morse finally obtained a patent for his telegraph in 1840, both men shared in the invention. U.S. Congressman Francis O. J. Smith received one-quarter of the American patent rights for helping to secure the $30,000 appropriation from Congress, a 19th century example of insider profits and influence peddling.[24] The line that Morse and his associates constructed in 1844 began underground but had to be replaced by aboveground wires because of poor insulation. "On May 1, 1844, with the line extending as far as Annapolis Junction, Vail transmitted a message to Washington that the Whig Convention in Baltimore had nominated Henry Clay for president and Theodore Frelinghuysen for vice president."[25] The first "official" telegram did not come until the line was completed on May 25, 1844 and consisted of Morse's famous message, "What hath God wrought?" Although this message is usually reported to be a question, the actual passage from the Book of Numbers in the Old Testament (King James Version) is not a question at all but an exultation of God's omnipotence: "What hath God wrought!" (Numbers 23:19). Whether Morse committed an error in encoding or transmission or Albert Vale did in reception or decoding, scholars have tended to base their analyses of Morse's conception of his achievement on this message being a question. Given Morse's own religious orientation, I doubt that he would have made such an error. Clearly, he saw his invention as a manifestation of God's power and will, as is evident in his many invocations of God in the promotion of electromagnetic telegraphy, for example the use of a question from the Book of Job in which God asks Job, "Canst thou send lightnings, that they may go, and say unto thee, Here we are?" (Job 38:35).[26] Clearly such power is reserved for God, but the use of this quotation by Morse and others indicates

that they saw in the harnessing of electricity for communicating messages the hand of God endowing human beings with powers over Nature.

Among those who helped to move Morse's invention to greater successes were Amos Kendell, a key player in President Andrew Jackson's "Kitchen Cabinet," Francis O. J. Smith, the congressman who enabled Morse to receive government help, and Henry O'Reilly, who extended the telegraph westward. Eventually, the competition from rival systems collapsed, and Western Union, formed in 1856, emerged as the leader in American electromagnetic telegraphy. With this move, Morse and his associates were replaced by businessmen more interested in profits than in communication, a trend that would continue with all subsequent media in this evolution–revolution.[27]

ELECTRIC TELEPHONY

With the telegraph functioning well and expanding to new territories while enhancing its efficiency with improved techniques and technologies for encoding–decoding, sending–receiving, and delivering of messages, many people focused on ways to improve this existing medium. Among the limitations of the telegraph, the most significant were those connected to time and space. First, only one message could be sent at one time; using two wires helped to alleviate this problem, as did methods for sending multiple messages simultaneously. Second, the messages sent were unidirectional from one point to another and then back again, a problem not solved until wireless telegraphy was developed. Third, the rate of sending–receiving was slow (60 characters per minute), but this would be addressed by pre-recording the Morse Code on rolls of paper and then rapidly spinning the tape through the transmitter for rapid writing on the receiving end. Fourth, the encoding–decoding of Morse Code remained a scribal literacy, mastered only by paid telegraphers and a few amateurs who learned the craft; with the encoding–decoding requiring human effort, the time required to complete the movement of the message from source to destination was considerable. Fifth, the wires that carried telegraph messages were connected only to a limited number of locations, like telegraph offices, newspapers, businesses, and government and military offices. Sixth, the storage of messages depended upon older forms of media—writing and printing.

Among the people seeking to address these limitations was Alexander Graham Bell (1847–1922), a Scottish-born teacher of the deaf who came from a family long interested in human speech and hearing. After coming to Boston in 1871 to teach at Sarah Fuller's School for the Deaf, Bell became a professor

of voice and speech at Boston University in 1873. His twin interests in help-
ing the deaf and in improving the telegraph contributed to his most famous
invention—the *telephone* (far-sound). In 1874, he used his knowledge of speech
and hearing to conceive of a machine that could charge an electromagnetic cur-
rent to simulate the vibrations of air waves that carry sound. He also devised
a method for sending a number of telegraphic messages at the same time over
one wire.

Bell's "sound telegraph" used tuned reeds and magnets to create a single unit
sender–receiver. With his assistant, Thomas Watson, Bell experimented for two
years, applying for a patent from the U. S. Patent Office on February 14, 1876.
On that same day, Elisha Gray (1835–1901), a professor at Oberlin College in
Ohio, also filed a *caveat* (an intention to invent) for a sound telegraph (tele-
phone). The patent granted to Bell on March 7, 1876 would set off a battle over
the invention. Gray would be joined by, among others, Amos E. Dolbear and
Daniel Drawbaugh, in a total of 587 lawsuits, with 5 cases reaching the Supreme
Court of the United States. In the end, Bell and his Bell Telephone Company
triumphed, and he won the patent fights. An Italian American inventor,
Antonio Meucci (1808–1889), filed a *caveat* for a voice communication system
in 1871 but neglected to pay the fee to continue it.

Along with Watson, Bell received help from his father-in-law Gardiner
Hubbard (financial) and Theodore N. Vail (organizational) in leading the
Bell Telephone Company to victory over Western Union by 1880, thereby
establishing a virtual monopoly over telephony in America. Again, the moti-
vations of these men were a mix of scientific curiosity and a desire to make large
profits in the emerging world of electrical communication. Eventually, the
Bell Telephone system would control most telephone systems operating in the
United States and would export its techniques and technologies to other coun-
tries. In addition to establishing regional Bell systems throughout the country,
the company also created American Telephone and Telegraph Company
(AT&T) for long-distance telephony in 1884, and in 1925 joined with Western
Electric to form the Bell Laboratories that enhanced communication with
such inventions as the facsimile (fax) machine, radio astronomy, stereo signals,
speech synthesizers, the transistor that made the Cybernetic Age possible, cal-
culators, microwave radio relays, and improvements in personal computers, fiber
optics, digital cellular telephones, and wireless local area network systems, to
list only a few of their contributions to our world.

In identifying the people central to the invention and development of the
telephone, I have focused on the United States, but this does not mean that

other people in other countries were not also involved in its evolution. Still, if we measure the impact of the telephone on communication history, it seem clear that Bell deserves pride of place for reasons similar to our identification of Gutenberg with the printing press: It was Bell's invention and development that revolutionized telephony by moving it from an experimental invention to a practical instrument for human communication. But while Bell's telephone solved the scribal literacy and speed of transmission limitations of Morse's telegraph by replacing Morse Code with electrical simulations of sound waves that carried human speech, these sounds were ephemeral, disappearing as soon as they were spoken and heard. Any storage of the messages continued to rely upon writing, typewriting, and print.[28]

THE PHONOGRAPH

The ability of Bell's telephone to carry sound over wires seems to have encouraged attempts to record the sound of the human voice and music, preserving sound in time as the telephone had extended sound over space. In America, Thomas Alva Edison (1847–1931) would try to solve that problem in 1877 with his *phonograph* (sound-writing). A real-life inspiration for the later exploits of Horatio Alger's fictional boy-makes-good heroes, Edison sold newspapers on railroads at twelve and became a telegrapher for Western Union, where he invented a receiver and transmitter for an automatic telegraph. While perhaps better known for his systems for providing practical electrical lights and for his role in the development and promoting of motion pictures, Edison also provided the foundation for the recording of sound that would not only create an entire industry based upon music recorded on cylinders, records, tapes, and digital formats but would also contribute to the use of recorded sound for radio, film, and television.

At first, Edison seems to have envisioned his phonograph for both entertainment and business uses, but the quality of his early system failed to stimulate public interest. Simply put, there was no immediate demand for what he hoped to supply. But, as would be true of other electric media, its very existence seemed to encourage people to want what they had not known they needed or wanted prior to the invention. It was Bell and his associates who created the "graphophone" in the 1880s that spurred Edison, or his many assistants, to improve his system. This improved phonograph appealed to the public in 1890 with machines that played music when a coin was inserted, a system that Edison would later use with his *Kinetoscope* for motion pictures.

Edison's credit for inventing the phonograph must be shared with Emile Berliner (1851–1929), a Jewish immigrant from Germany who founded the Berliner Gramophone Company in Philadelphia in 1895. Berliner's great contribution was in developing a flat disc record in place of Edison's cylinder. The disc record could be mass produced by stamping and would become the standard system after Edison stopped manufacturing cylinders in 1929. Berliner's flat record also provided the storage system that would later be expanded to hold more information by extending the diameter of records from 10 to 12 inches and by reducing the speed from 78 to 55 revolutions per minute.

Some credit should also be reserved for Peter Goldmark of CBS Laboratories for his 1948 invention of the long-playing (LP) recording system that used 10- or 12-inch records that turned at 33.33 revolutions per minute, thus increasing the storage capacity of each side to 20 minutes, a development that not only facilitated the ease of playing larger musical pieces on fewer records but also opened up possibilities for popular music and song to move from the 3- to 4-minute format to longer times. [29]

In its development, the phonograph would find uses in business and government offices as dictating machines, but its major use would be for playing phonograph records at home on phonograph machines that would later be combined with radios to provide home entertainment for the public. The phonograph would also prove to be invaluable for radio by recording performances and for providing recorded music to the audience, the foundation for most music received over the air or streamed via the Internet.

Edison, himself, was a pragmatic mix of idealistic inventor and shrewd exploiter of his own and his assistants' inventions. As he liked to say "Genius is one percent inspiration and ninety-nine percent perspiration." While his phonograph was an instrument played in individual homes, record companies would make it into a public medium with distribution of multiple copies of records, and the radio would further extend its public reach. Once again, "The Wizard of Menlo Park" played a major role in the evolution–revolution of electric–electronic communication.

WIRELESS TELEGRAPHY

Morse's telegraphy and Bell's telephone can be viewed as media that extended sight and sound through space along wires that connected one place to another. In what Marshall McLuhan called "rear-view mirror thinking," some people, including some inventors, tended to see these revolutionary inventions

as merely improvements in existing systems. Thus, Morse's invention was called the "electric telegraph" to connect it to the optical telegraph, and Bell's telephone was called the "sound telegraph." Such thinking tends to obscure the very revolutionary nature of these electromagnetic contributions to communication. Each represented major breakthroughs not only in techniques and technologies of communication but also in how people conceived of communication afterward. Once it was known that messages could be sent electrically by encoded dots and dashes and by simulated sound waves, the limitations of wired telegraphy and telephony became apparent. The problems of transmitting telegraphy across bodies of water were partly solved by the "submarine cable." Great Britain led the way, connecting its island nation to the European mainland and to its overseas empire in the 1850s and 1860s. France, Germany, and the United States followed by laying underwater cables to connect lands separated by water. A major achievement came in 1866 with the Atlantic Cable that connected the United States to England and another cable that linked England to India and its eastern colonies.[30]

As a number of scholars have noted, Great Britain was the one country that had the most to gain from the development of a medium that could transcend space over water as well as land. It also had the scientific knowledge and technical expertise to free electromagnetic communication from its confining wires. It fell to the young Irish Italian Guglielmo Marconi (1874–1937) to invent a system for transmitting Morse Code signals through the air. But although Marconi got the lion's share of the credit, his work was based upon earlier techniques and technologies used by Heinrich Hertz (1857–1894), Alexander Marshall Lodge (1881–1938), Alexander Stepanovich Popov (1859–1906), and others. What distinguished Marconi's system was that it was the most efficient, providing the best practical transmission of wireless telegraphy. With the backing of his mother (an heiress in the Jameson Irish Whiskey distiller family), Marconi obtained support for his experiments and the capital investment to form the Marconi Telegraph Company in 1897.[31] In providing proof of the practicality of wireless telegraphy, Marconi also demonstrated that great profits could result from improvements in existing communication techniques and technologies.

In America, Western Union officials showed no real desire to develop wireless telegraphy, perhaps because of extensive investment in the existing system. In any case, in 1902 Marconi managed to send a signal (three dashes = s) across the Atlantic Ocean, a feat that demonstrated that the range of signaling could continue to increase. Already, Marconi's wireless was being used by

hundreds of ships, both commercial and naval. With the opening of Marconi Wireless Telegraph Company of America in 1899, wireless telegraph was quickly becoming a global-spanning medium. But wireless telegraph needed "syntony," the ability to focus the signal from the transmitter to one receiver because wireless signals spread outward from the transmitter in a 360-degree radius, presenting problems with privacy of communication and the possible use of wireless telegraphy for military and naval weapons guidance systems.[32] Ironically, it was the very radiating attribute of the wireless that held the promise for an entirely new area of electric communication—radio. But radio would have to wait for the development of what was called "wireless telephony" and "radio telephony."

WIRELESS TELEPHONY

Alexander Graham Bell's telephone proved that electrified wires could carry the human voice and music, and Guglielmo Marconi's wireless signals proved that the airwaves could carry telegraphy. A marriage between these two media would surely produce a viable hybrid offspring. In 1901, while conducting experiments for the U.S. Weather Bureau, Reginald Fessenden (1866–1932), a Canadian-born professor at the present University of Pittsburgh, began work on improving wireless to carry voices as well as clicks (Morse Code) by replacing the spark systems with a continuous wave of electrical current. Fessenden and Ernst Alexanderson of General Electric invented the high-frequency alternator, but two more technical inventions would be needed to move wireless from telegraphy to telephony. The second was the Poulsen arc, invented in Denmark by Valdemar Poulsen (1869–1942) and produced in America by Australian born Cyril Elwell (1884–1963) of Federal Telegraph. The third technology came in 1906 when the American Lee de Forest (1873–1961) added a third element to the vacuum-tube invented by John Ambrose Fleming (1849–1945), a British engineer employed by the Marconi Company. De Forest's vacuum-tube triode, or "audion" as he liked to call it, provided the final technological step for making wireless telephony a reality.[33] De Forest would spend much of his life promoting and defending the title he used for his 1950 autobiography—*Father of Radio*, an honor much disputed by other inventors and by engineers and scholars.[34]

As with all electric media, the development of wireless telephony soon passed from individual inventors to the large staffs devoted to research and development at large corporations, aided by government intervention. Among

these corporations was American Telephone and Telegraph (AT&T), which added to its own research and development in 1913–1914 by buying from de Forest all rights to his audio tube and related technologies, eventually possessing "…all patents and patent rights covering the use of vacuum tubes in wire and wireless telephony."[35] Wireless telephony would continue to develop, especially in ship-to-shore, in military, and in business communication, but it would be its unexpected and unwelcomed ability to radiate signals that would result in its most significant achievement—radio broadcasting from one source/transmitter to multiple receivers/destinations.

RADIO BROADCASTING

Broadcast radio moved radio telephony from point-to-point communication of directed messages to public dissemination of messages over the airwaves. In this movement, radio became the first true mass medium of the Age of Electric Communication. The people who played central roles in this transition from private dialogue to public dissemination included some of the key players in the development of wireless telegraphy and telephony—Marconi (frequently called "The Father of Radio" although he did not actually play a key role), Reginald Fessenden, John Ambrose Fleming, and Lee de Forest. They would be joined by Edwin Howard Armstrong (1890–1954), who improved de Forest's audio tube by adding feedback (regeneration) to amplify the sound in 1912, invented the *heterodyne* (other force) and the *superheterodyne* in 1916–1918, and created the FM (frequency modulation) Revolution in 1933 that brought clearer sound to radio than was possible with AM (amplitude modulation).[36]

The early days of radio were characterized by a gradual shift from independent inventors and amateur radio stations and crystal set receivers to the establishment of broadcast radio as a business enterprise. One amateur who epitomized this shift was Frank Conrad (1874–1941), an employee at Westinghouse and an amateur radio engineer. Following the First World War, Conrad experimented with sending radio signals via continuous wave technology made possible by the radio tubes developed by Fleming, de Forest, and Armstrong. From just talking and playing phonograph music, Conrad moved to scheduling concerts in the evenings over 8XK, his experimental station near Pittsburgh, Pennsylvania, which attracted attention from fellow amateurs and from local newspapers. In September 1920, the Joseph Horn Department Store placed an advertisement in the *Pittsburgh Sun* that promoted Conrad's concerts and informed the public that Horn's carried Westinghouse crystal sets capable

of receiving the broadcasts. Henry P. Davis, a Westinghouse vice president, read the advertisement and realized that radio broadcasting, not radio telephony, held greater promise for the future of radio as a medium for instantaneous mass communication. With Westinghouse backing, Conrad built a more powerful transmitter that began operating at 8:00 P.M. on November 2, 1920 as the first licensed radio station in America, KDKA. Conrad's experiments and corporate backing had provided the spark that moved radio from innovation to mass medium.[37]

Neither an engineer nor an amateur, David Sarnoff (1891–1971) a young immigrant from Russia who began as a Marconi messenger boy and telegrapher, would eventually rule over the development of broadcast radio and television in America as the rising star of the Radio Corporation of America (RCA), beginning with its creation in 1919 and continuing with its offspring, the National Broadcasting Company (NBC), in 1926. Sarnoff was instrumental in pioneering or furthering such techniques as coast-to-coast network broadcasting, commercial sponsors for programs, and genre formats. An early supporter and friend of Armstrong, Sarnoff would eventually betray Armstrong over FM radio, hindering its availability in order to develop an audience for television and preserve RCA's heavy investments in AM technologies and facilities.[38]

In making broadcast radio an electrophonic medium for mass information and popular culture, the people who created radio laid the foundations—in terms of techniques and technologies of broadcasting, advertising support for programs, formats and genres, and the very organizations of stations and networks—also laid the foundations for what would become broadcast television.

TELEVISION BROADCASTING

As radio extended the sense of sound through space, *television* (far-seeing) extended both sound and sight electronically through space. The powerful broadcasting systems, like RCA's NBC (which had two systems—the Red Network and the Blue Network), the Columbia Broadcasting System (CBS), the Mutual Broadcasting System, and the American Broadcasting Company (NBC's former Blue Network that the U.S. Supreme Court ordered NBC to sell in 1943), would provide the technical expertise, capital investment, organization skills, and program content and personnel to make television a reality by 1939.

As with so many developments in communication, the credit for inventing television is hotly debated by scholars and was fiercely contested in lawsuits

by individuals and their corporate backers over many years. In his *Tube of Plenty: The Evolution of American Television*, Erik Barnouw cites two Britons, Charles Francis Jenkins (1867–1934) and John Logie Baird (1888–1946), with a demonstration in 1925 of mechanical televised images based upon Paul Nipkow's perforated rotating disks to transmit rapidly scanned images via electrical waves. But, like optical telegraphy, mechanical television was not a breakthrough but a technological dead end. The future would clearly lie with electronic scanning.[39]

The battle over control of electronic media was fought during the 1920s by AT&T on one side and by General Electric (GE), the Radio Corporation of America (RCA), and the Westinghouse Company on the other side. Facing anti-trust action by the Federal Trade Commission, a deal was struck between the two sides, with AT&T selling its toll radio station WEAF while leasing its long-distance telephone lines to the new National Broadcasting Company (NBC) with RCA owning 50 percent, GE 30 percent, and Westinghouse 20 percent of the new company.[40] While Sarnoff and RCA/NBC sponsored the experiments into electronic scanning by Vladimir Zworykin (1888–1982), a Russian-born immigrant to America, an independent American inventor working largely on his own, Philo T. Farnsworth (1906–1971), succeeded in 1927 in televising still images and bits of film (excerpts from a Jack Dempsey–Gene Tunney heavyweight boxing championship fight and from a Mary Pickford film). In 1930, he received a U.S. patent for his invention. While both Zworykin and Sarnoff dismissed Farnsworth's system as being inconsequential, RCA did agree to pay royalties to Farnsworth for his patents.[41] In the end, it would be Zworykin's work at RCA that would be credited publicly by RCA and by the press for developing television into a reality for millions of Americans. Zworykin's cathode ray tube formed the core of all television receivers, with his iconoscope providing larger and sharper images. The RCA 441-line system in 1939 was improved into a 525-line, 30-frames per second system that was standard for American television until the FCC mandating of high-definition television (HDTV) in 2009.[42]

Although Sarnoff tried to stop Armstrong's development of FM radio with its superior quality, the Federal Communication Commission (FCC) decided in 1940 that FM would provide the audio system for television, giving Armstrong one lasting victory in his battles over broadcasting technologies. While Farnsworth received backing from Philco for further experiments and Allen B. Dumont (1901–1965) worked on a system inspired by Jenkins, RCA and NBC were the most aggressive in pushing for the evolution–revolution of

television.[43] David Sarnoff was the key man behind this push and, with its NBC mobile unit and transmission of signals from atop the Empire State Building, RCA was leading the race to bring television to America. But fear of monopoly based upon the incompatibility of RCA's system with other television systems being developed delayed FCC approval. While Germany and Great Britain moved ahead with their state-controlled broadcasting systems, providing scheduled broadcasting in Berlin in 1935 and in Great Britain by the late 1930s, America lagged behind.[44]

All of the men involved in the evolution–revolution of television in America appear to have been motivated by a mixture of curiosity, a drive to invent something new, a desire to achieve fame and fortune, and a need to survive and thrive in the competitive world of capitalist broadcasting. In the end, Sarnoff and Zworykin claimed the lion's share of the credit, with Farnsworth and Armstrong receiving some belated recognition for their contributions. It is worth noting that in 1950 the Radio and Television Manufacturers Association of America awarded Sarnoff the title of "Father of American Television."[45] Sarnoff was also the man most responsible for the development of color television in the late 1950s.

With competition and resistance from manufacturers of black-and-white television sets and from other television networks, notably ABC and CBS, Sarnoff and NBC waged a lonely struggle that was resolved only with RCA agreeing to make its patents for color television available to its competitors in 1958. By 1960, the conversion to color was moving forward at a slow but steady pace that would end with full color television transmitting and receiving the norm for all broadcasting by 1965. While Sarnoff was the public advocate for color television, it may be more accurate to identify the Radio Corporation of America as the real parent, as mega-corporations with their executives, research and development laboratories, and organization structures came to dominate all broadcasting in America.[46]

CABLE TELEVISION

One area of American television that did not evolve from the major broadcasting companies was that of cable television. Community Antenna Television (CATV) had its origins in the early days of radio in 1923 in Dundee, Michigan. Whether to receive radio or television signals, the community antenna served to capture signals not clearly received because of distance or geography (hills and valleys). For a small fee, the cable operator (frequently the owner of an elec-

tronics store) provided clear pictures and sound to isolated communities. In time, these small systems would grow into the cable television industry that first challenged and then largely took over the older broadcasting systems. By 1964, more than a thousand of these systems were operating, with most of them belonging to the National Community Television Association (later renamed the National Cable Television Association).[47] The people involved in this evolution were largely small entrepreneurs who tended to do little more than provide better television reception for a fee. The later Cybernetic Evolution–Revolution would propel cable television into a central role in the sending–receiving of moving images with synchronous sounds via such techniques/technologies as satellites, microwaves, coaxial cables, optic fibers, and laser beams. But that development is for Chapter 7. What concerns us here is that the people involved in the inception of cable television tended to remain faceless and nameless in histories of communication, rather like those who were involved in the evolution–revolution of writing.

Messages

ELECTRIC TELEGRAPHY

In general, Morse's telegraph was used to send *emphatic* messages that had significant value in terms of time. Business messages included details on shipments of goods, arrivals and departures of ships, prices on commodities, stocks, bonds, and futures markets. For railroads, telegraphed messages provided vital information that literally determined life and death questions by preventing head-on train wrecks. Newspapers were quick to use the telegraph to speed up the timeliness of the news they published from distant places. For the government, including the military, the telegraph provided command and control information that moved closer to real-time communication essential for successful tactical and strategic decision-making. Given the relatively high costs of telegraphy, *phatic* communication played a smaller role at first, with birth and death announcements, birthday and holiday greetings (including singing telegrams), arrival times, destinations reached, marriage proposals and acceptances, and other non-essential messages being rare and exceptional for most people. Still, the electromagnetic telegraph did prove to be a new way to send messages rapidly across the United States and across the oceans to distant lands at increasing speeds of transmission. If not exactly what Tom Standage calls "The Victorian Internet," the telegraph did portend that late 20th cen-

tury innovation by demonstrating that messages could be sent by electricity, beginning the separation of communication from transportation that would be the hallmark of all electrographic–electrophonic media.[48]

As Marshall McLuhan would say, the most significant message sent by the telegraph was the medium itself. Electric telegraphy pointed the way to a future in which the speed with which messages could transcend the limitations of time and space would become more important than the individual messages themselves. While military and some other messages concerned themselves with questions of actual survival, the survival of economic, financial, political, and social institutions came to depend upon the improved flow of two-way information carried by the lightning lines of Morse's invention. And Morse Code itself revolutionized communication by reenforcing the atomic nature of the alphabet by which the phonemes of any language could be represented by electrical dots and dashes signifying letters and numbers. The limitations of the telegraph in terms of the code, access to telegraph stations, costs of transmission, and capacity would provide motivations for a succession of improvements in techniques and technologies of electric communication systems that would create the media of the 20th century and provide the foundations for the media made possible by the Cybernetic Revolution that began in 1948.

ELECTRIC TELEPHONY

By carrying voice rather than on–off electric sparks, the telephone eliminated the need for the scribal encoding–decoding required by the telegraph. In the early years, the telephone, a point-to-point medium connected to a wire, carried messages that were largely *emphatic* in nature, conveying information of value to the government, including the military, to private businesses, to newspapers and news sources, to railroads and other common carriers, and to doctors, hospitals, and pharmacies. Other early adopters of the telephone included liquor stores, livery stables, lawyers, and printers. Municipal police and fire departments, which had earlier adopted the telegraph, now embraced the telephone as another instrument capable of reducing the time–space lag between emergencies and responses.[49]

In time, as telephony expanded from *emphatic* to *phatic* communication with the spread of subscribers from businesses and official organization to private residences, the messages contained both information needed for survival and information needed for maintaining social contacts. And despite some attempts at creating services to bring lectures, music, sermons, and the like to many lis-

teners from one source, the telephone would find its major role as a point-to-point medium. The news messages transmitted over the telephone would reach the wider public only through publication in newspapers and magazines until the coming of radio in the early 20th century.

Improvements in techniques and technologies, including operator and automated switchboards, party lines (perfect for eavesdropping), direct dialing, long distance and overseas connections, and public pay phones, provided telephone services that were cheaper, easier to use, and more convenient. The very presence of the telephone encouraged use that was reinforced by advertisements stressing the value of telephony for vital communication and for just keeping in touch. The 1977–1979 campaign by AT&T to stimulate long distance telephony among its non-business customers achieved great success with its tag line that summarized the appeal: "Reach out and touch someone." Following McLuhan's advice, AT&T encouraged the uses of the telephone as an instrument of personal and social contact to add a metaphorical sense of touch to the telephone's auditory intimacy.[50]

The messages carried by the telephone were shaped by government and business needs at first but later included messages shaped by individual needs and wants. By providing immediate connections between two points, the telephone also encouraged a desire that soon became a need to share both *emphatic* and *phatic* communication to such a degree that regular telephone customers had difficulty understanding how anyone and any society could function properly without telephony, a phenomenon we have encountered earlier with language, writing, and printing. The telephone has been both blessed and cursed for the messages it has carried, from the essential to the trivial, from the sublime to the mundane, from love to hate, from joy to sorrow, from enlightenment to misinformation, and from communication to misinformation. In short, telephony extended the human voice through space via electrical wires.

Regardless of the cultures and the command and control of telephony, the messages transmitted by this medium were essentially of the same types, with some cultures engaging in more official eavesdropping by telephone taps than others. At its core, the telephone served to carry messages at the individual, institutional, and organizational levels but not at the mass communication level except as an aid to news reporting to be disseminated later by other media. As a point-to-point medium, the telephone had built-in limitations that would not be overcome without the advent of new wireless technologies.

THE PHONOGRAPH

Despite Thomas A. Edison's conception of this instrument as a medium for recording business information, the main messages carried by the phonograph were musical. The reproduction of the voices of singers and the playing of instruments brought music to the masses. From the early windup Victrolas to the later automated turntables, from monophonic to stereophonic sound, the phonograph brought musical entertainment to the masses, especially those of the middle class. Early records were single-sided, with both sides added later, doubling the storage capacity of each record with sides A and B. Classical and semi-classical music dominated early records, with singers like Enrico Caruso and John McCormack contributing arias and other brief songs. Given the limitations of time, between two and four minutes, that each side could record at the speed of 78 revolutions per minute, the information carried had to conform to that time restraint.

As phonograph machines became more widespread in use, the musical genres began to expand to ragtime, jazz, country-western, blues, and other forms of musical popular culture. In time, the phonograph and its records would carry musical messages to different groups within the culture. There were also attempts to use the phonograph to store the spoken voice for playing at home, mainly poetry and excerpts from literature, some read by the authors themselves. After the invention of the long-playing record system by Peter Goldmark in 1948 increased the storage–playing time for each side of a record to 20 minutes, classical and popular albums became more practical and the spoken voice was added to music on records. These included Broadway plays and readings of their own works by such literary giants as W. H. Auden, e.e. cummings, T. S. Eliot, William Faulkner, Robert Frost, Ernest Hemingway, Thomas Mann, Sean O'Casey, Gertrude Stein, Eudora Welty, Tennessee Williams, William Carlos Williams, and others by Caedmon and other record companies.

WIRELESS TELEGRAPHY

In general, wireless telegraphy carried messages similar to those previously carried by electric telegraphy itself, with added usage by naval and merchant ships and their onshore installations, by telegraph companies signaling across lakes, seas, and oceans. The sinking of the *Titanic* on April 14, 1912 after hitting an iceberg in the North Atlantic highlighted the survival value of wireless telegraph. Had the Marconi signals from the ship been picked up by the *California*, only 20 miles away but whose sole radio speaker was asleep, the lives of some 1500 passengers and crew might have been saved. The work of the

Marconi wireless in contracting the *Carpathia* did result in saving some 400 peo-
ple in lifeboats. The ship-to-ship messages were also sent ashore to the Marconi
stations in North America, making Marconi a hero to the world. As a result
of this disaster, maritime countries began to require all ships to have wireless
telegraphy systems and to operate them around the clock. In one dramatic
event, wireless telegraphy had proved its essential value as a communicator of
vital information.[51]

Wireless telegraphy also carried more personal and mundane messages
concerning shipping, cargoes, passenger arrival times, birthday and other best
wishes, congratulations, and the like. News became global with the use of the
wireless by news agencies and organizations, eventually being expanded to
include all of the world linked by wire and wireless telegraphy. In America, two
major centers of interest were the U.S. Navy and the United Fruit Company
with its vast fleet of cargo ships carrying tropical fruit from Central and South
America to the mainland. The wireless telegraph, like the electric telegraph,
remained largely an instrument for business, government, institutional, and mil-
itary messages, with private communication playing a minor role.

WIRELESS TELEPHONY

In its infancy, wireless, or radio, telephony tended to carry the same messages
carried by wired telephony, with an emphasis on business, government, insti-
tutional, and military messages because of the costs of using the service. From
1912 to 1919, especially during the First World War (1914–1918), corporate
and military interests dominated the development of proto-radio, restricting
both the techniques–technologies and the messages carried by this emerging
medium. Wireless telephony was capable of sending continuous sound waves
across the waters and in areas without telephone lines. In Europe and America,
the military saw the new medium as a definite force multiplier that could be
used to share vital information between ship and shore, and ship and ship. In
addition, field telephones (called "Walkie-Talkies" in the Second World War)
provided land armies an added way to communicate with forces in field com-
bat situations.

With the war in Europe, radio telephony was slow to develop uses for
individuals and even corporations. In effect, the military assumed control of the
medium and its messages, shaping both to serve its own purposes. After the end
of the war in 1918, radio telephony continued to carry messages similar to those
carried by wire telephony, but the technology would evolve into the new

medium of radio, the broadcasting of sound from one source to multiple receivers and destinations.[52]

RADIO BROADCASTING

With broadcasting, radio found its true technological calling as a medium for disseminating information from the few to the many, creating the foundations for all broadcasting to come. Given the technical limits of radio to sound alone, the messages carried by radio would be those of voice (as narration and dialogue), of music (instrumental and vocal), of effects (natural and created), and of silence. From the early experiments by Lee de Forest and later by Frank Conrad, the format that would dominate radio seemed to have evolved without much planning. The experimenters and the early broadcasters needed content to fill the silence. Human voices (almost exclusively male at first) provided announcements, readings from books, magazines, and newspapers (provoking copyright questions), panel discussions, comedy routines, commentaries, lectures and sermons, and comedy and drama programs and series. Music was represented by classical, semi-classical, and popular music and song. And most of the programming in America would come to be supported by advertisements, radio commercials that used voice, music, and sound effects to sell goods, services, and brand names (which some critics would call "radio's main messages").

The worlds of print and film contributed content to radio, with adaptations of classic novels and plays, and radio dramatizations of motion pictures (*Mr. First-Nighter* and *The Lux Radio Theater*). In fact, fiction, film, and radio would come to form a nexus in which popular culture would find expression across these three media forms with westerns like *The Lone Ranger* (audio to print to film), *Tom Mix* (film to audio to print), *The Cisco Kid* (print to film to radio), *Hopalong Cassidy* (print to radio to film), and *The Gene Autry Show* (radio to film to print), to cite but a few examples of this mixture. Crime characters who also represented this symbiotic relationship include *The Shadow* (radio to film to print) and *Sam Spade* (print to film to radio). Radio also created its own shows with daytime serials (usually called "soap operas" because many were produced by detergent companies) like *Days of Our Lives*, *Ma Perkins*, and *The Romance of Helen Trent*. Evening serials included the famous *Amos'n' Andy*, the most popular radio program of the 1930s that featured two white writers/actors portraying African American comic characters, and *The Rise of the Goldbergs*, which chronicled the lives of an American Jewish family.

Popular comedians (like Fred Allen, Jack Benny, George Burns and Gracie Allen, Eddie Cantor, Bob Hope, the Marx Brothers, and Ed Wynne), singers (like Bing Crosby, Al Jolson, and Rudy Vallee), and musicians (like the Dorsey Brothers, Spike Jones, Guy Lombardo, and Paul Whiteman) helped to fill the airwaves with entertainment for the masses while action-adventure shows like *Captain Midnight, Jack Armstrong, the All American Boy, Sky King,* and *Superman* attracted young audiences.[53]

The serious side of radio messages was represented by the news and public affairs areas of the networks with radio news shows, special reports and commentaries, and panel discussions with contributions by H. V. Kaltenborn, Lowell Thomas, and Walter Winchell, but perhaps the most significant contributions came from CBS News with its rising star, Edward R. Murrow, and his team, Mary Breckinridge, Cecil Brown, Winston Burdett, Charles Collingwood, William Downs, Thomas Grandin, Richard C. Hottelet, Larry LeSueur, Eric Sevareid, William L. Shirer, and Howard K. Smith. Before, during, and following the Second World War (1939–1945), CBS News laid the foundation for both radio and television news.[54]

Programs like *America's Town Hall Meeting of the Air* and *Meet the Press* provided dissemination to the citizens of America concerned with current events. President Franklin Delano Roosevelt's "Fireside Chats," which began on March 12, 1933, reassured Americans concerned about the Great Depression and the state of the Republic. The president's opening words would become his trade-mark opening for all of the subsequent broadcasts: "My friends, I want to talk for a few minutes with the people of the United States about...." Other politicians would also use radio to spread their ideas, including Huey Long of Louisiana with his "spread the wealth" message. Radio would come to play a major role in the delivery of political messages, including propaganda, in the coming decades. In the 1960s, radio as an outlet for political messages was overtaken by television but seems to have carved out a special niche for the expressing of populist, anti-government messages on talk radio shows.

During America's involvement in the Second World War (1941–1945), radio played a major role in delivering messages of continuity and normality, with civilian broadcasters uniting to support the war itself and the Armed Forces Radio Service carrying radio messages to members of the military fighting and serving across the globe. While newspapers and magazines continued to play major roles in keeping the public informed and Hollywood movies provided both information about and propaganda to support the war with newsreels, documentaries, and feature films, radio continued to be the in-the-home commu-

nicator of news and entertainment, a 24 hours a day, 7 days a week constant companion providing both *phatic* and *emphatic* communication to inform and reassure a population that was being united and unified through a limited number of sources of information.

Whether the messages disseminated by radio were news or entertainment, inspirational or propagandistic, a scheduled program or commercial, *phatic* or *emphatic*, they all conveyed a core message: Trust these messages and the medium conveying them. Radio had expanded what communication scholars like to call "the public sphere" beyond the oral–aural forum and the typographic forum provided by newspapers and magazines to a new electric hearth where secondary orality facilitated by broadcasting extended human voices over time and space, creating an electric time–space where everyone is present in the same now and here. The command and control of this new medium for communicating within the electric public sphere would follow different routes in different cultures, from total government ownership or supervision, as in Europe, to the American system of private ownership supported by commercial sponsors with limited government regulation and oversight. In America, the system was, and is, defended with what Susan J. Douglas calls "the myth of audience power," by which the people decide the content of broadcasting with their "votes" as represented by audience ratings. In effect, broadcasters simply give the audiences what the audiences want to hear.[55] This is a much debated issue among students of media. What do you think? Do you feel manipulated by the messages carried by radio, or do you feel you have control over your own listening choices? Are there significant differences in terms of control with different radio delivery systems—broadcast, satellite, Internet streaming?

TELEVISION BROADCASTING

As the child of radio broadcasting, television tended to extend the formats, genres, and messages of radio in the evolution of the new medium. As Marshall McLuhan liked to remind people, the content of the new medium is usually the old medium and its content. Early television messages were mainly the same messages carried by radio with the addition of moving images in black-and-white to accompany the sounds. The news continued to be read by a newsman (women were late and infrequent contributors) with a few still photographs for illustrations. Motion pictures would come later, to be replaced by video pictures when audio-video recording systems became practical in the 1970s.

Music continued to provide a great deal of the content, with such perform-

ers as Bing Crosby and Frank Sinatra carried over from radio while new voic-
es included those of Teresa Brewer, Rosemary Clooney, Nat "King" Cole, Perry
Como, Peggy Lee, and Patti Page. All helped to provide a norming of popular
American music, an arrangement that would last until threatened and then
overwhelmed by the Rock 'n' Roll Revolution in music in the 1950s–1960s.
Perhaps no one program charted this rise and fall of consensus popular music
better than *Your Hit Parade*, which ran on radio from 1935 to 1955 and on tele-
vision from 1950 to 1959 before succumbing to changing tastes in popular
music.

Many narrative television programs were transplanted directly from radio
(*Dragnet, Gangbusters, Mr. District Attorney*), but the live format of early tele-
vision in the 1950s encouraged the production of anthology series that present-
ed different television dramas with different characters, plots, actors, and
writers each week. Although the length was predetermined (one hour, ninety
minutes, or two hours) and the action had to be limited to a few sets, these live
productions offered creative opportunities to new talent. *Philco Television
Playhouse, Goodyear Television Playhouse, Kraft Television Theater, Studio One,
Robert Montgomery Presents, U.S. Steel Hour, Revlon Theater, Medallion Theater,
Motorola Playhouse, The Elgin Hour, Matinee Theater,* and *Playhouse 90* produced
television plays by new writers like Paddy Chayefsky, David Davidson, Reginald
Rose, and Rod Serling. The narrative power of television would challenge
both the stage and Hollywood for audiences, and the live nature of early tele-
vision meant that the audience had to see the production as it was telecast
because repeats were almost nonexistent because the filmed-through-television
copies (*kinescopes*) lacked clarity and were kept mainly for archival purposes.
Only Hollywood films, films produced for television, and, later, video record-
ings would be able to be viewed more than once.[56]

In the Golden Age of Television (1950–1980), the messages were a mix-
ture of news and public affairs and entertainment. A high point for news came
with Edward R. Morrow's *See It Now* series on CBS, with Fred W. Friendly pro-
ducing, in 1951. In 1953, Murrow and Friendly produced a program about Milo
Radulovich, a University of Michigan student and U.S. Air Force Reserve lieu-
tenant, then under attack because his father and sister were suspected of being
radical leftists. The program provoked an attack from U.S. Senator Joseph R.
McCarthy, one of the leaders of the Anti-Communist Crusade at the time. In
1954, *See It Now* presented a report on Senator McCarthy that many commen-
tators and historians credit with helping to curb McCarthy's influence and end
the Red Scare in America. McCarthy's subsequent attack on Murrow, which

CBS broadcast, and the televised Army–McCarthy Hearings of March–June 1954, which led to an official U.S. Senate censoring of McCarthy, ended the senator's power.[57] But the price for Murrow and Friendly would be high, with the cancelling of *See It Now* in 1957 because of corporate pressures from inside and outside the organization. Edward R. Murrow's speech at the Radio–Television News Directors Association (RTNDA) in Chicago on October 15, 1958 was both a lament for the failures of radio and television as media for informing the public and a dire but accurate prediction of what the future would bring to broadcasting. Here are some excerpts:

> Our history will be what we make it. And if there are any historians about fifty or a hundred years from now, and there should be preserved the kinescopes for one week of all three networks, they will find there…evidence of decadence, escapism and insulation from the realities of the world in which we live….One of the basic troubles with radio and television news is that both instruments have grown up as an incompatible combination of show business, advertising and news….The top management of the networks, with few notable exceptions, has been trained in advertising, research, or show business …[and] make the final and crucial decisions having to do with news and public affairs. Frequently they have neither the time nor the competence to do this….[58]

Television news and public affairs did not end despite Murrow's warnings, but they did become subservient to advertising and show business, tailoring their offerings to fit smoothly into a system that Neil Postman criticized for turning all public discourse into entertainment, with television leading the way, in *Amusing Ourselves to Death*.[59] With the bottom line dictating the messages (and shows) carried by broadcast television, the governing maxim for deciding what can be carried may be summed up as "Be profitable or be gone." In the glory days of network-dominated television (say from 1950 to 1980), ABC, CBS, and NBC provided a range of programs from early morning to late night, usually signing off between 12:00 A.M. and 1:00 A.M. and returning about 6:00 A.M. or 7:00 A.M. Morning programs catered to early news, including *The Today Show*, followed by shows for small children and their mothers. Afternoons were devoted to soap operas, game shows, children's programming, and other divertissements. Early evening news shows were followed by prime-time programming (7:00 P.M. to 11:00 P.M.) before the Prime Time Access Rule decreed by the FCC in 1970 which limited the networks to three hours of prime-time broadcasting. Prime time was regarded by the networks and the public as the core of television programming and viewing in America.

A review of the top programs during the Golden Age of Television (as determined by data from the American Research Bureau (ARB) and A.C.

Nielsen and Company) shows us a mosaic of variety shows, crime and medical dramas, situation comedies, westerns, quiz and game shows, and dramatic shows. With some ebbs and flows, these formats had remained reasonably constant, with talent contests continuing, newer "reality" shows replacing older ones, and crime and medicine continuing to attract audiences. The shows and stars change, but the central messages of prime-time programming are the same: Enjoy and find happiness in that escape from reality provided by this powerful medium that unites sight and sound in a simulacrum of reality. Even the news and public affairs messages have become more entertaining, with style substituting for substance and the reluctance to carry messages that challenge or even question the messages reinforced by commercial advertising: The goal of life is happiness, and happiness can be found in the purchasing of products and services that will keep everyone younger, healthier, better looking, and undisturbed by too much reality. It may be that the ultimate message carried by broadcast television is that simulated reality is better than actual reality.

CABLE TELEVISION

In the beginning, cable television merely provided an enhanced means of carrying the messages of broadcast television to locations and people having difficulties receiving the analog signals transmitted over the public airwaves. Before the Cybernetic Revolution, cable television was little more than a service to enhance reception, rather like an antenna providing shared reception for units in an apartment house or complex. Except for a few limited attempts by individual cable operators to provide some added messages to their customers, the messages carried by cable were identical to those carried by broadcast television from 1947 to 1972.

Media

ELECTRIC TELEGRAPHY

Because Samuel F. B. Morse's electromagnetic telegraphy system was the one that sparked the revolution in electrographic and electrophonic communication, it deserves pride of place in the changes that moved message transfer from transportation to transmission. Morse's system used electromagnetic current, stored in batteries, to send signals over metal wires from a telegraph key that sent on–off signals in units of single dots and three-dot dashes that would be inked on a paper tape pulled under a pen or stylus at the receiving end, thus

the name *telegraph* (distant writing). In the beginning, Morse's telegraph extended the sense of sight by providing a device that carried writing by electricity. Later, Alfred Vail developed a simpler receiving device that amplified the sounds of the dots and dashes into "dits" and "dats" that could be heard by the operators and more quickly be written down as letters and numbers.

The techniques and technologies needed for the Morse telegraph involved the control of electricity in terms of supply, power, and maintenance, the construction of telegraph sending and receiving devices, the stringing of wires along rights of way, usually railroad lines between cities and across the open plains, and the organizing and staffing of telegraph offices complete with telegraphers, electricians, messengers, and other required personnel. The messages themselves travelled as on–off signals through the wires that connected the telegraph keys. Perhaps Morse's greatest achievement was his code that reduced all of the letters of the alphabet and the numbers of the Indo–Arabic base ten system into a limited series of dots and dashes. The key idea here was to create the most efficient code possible by assigning the least number of on–off signals to the most used letters and the larger number of signals to the least used letters. Thus, in Morse's American Code, a single dot represents the letter E (one on–off signal) while a dot, a dash, and two dots (six on–off signals, with three quick dots needed for the dash) represent the letter X. The American Morse Code used these signals:

Figure 6.1 American Morse Code Signals

A	B	C	D	E	F
• —	— •••	•• •	— ••	•	• — •
G	H	I	J	K	L
— — •	••••	••	— • — •	— • —	—
M	N	O	P	Q	R
— —	— •	••	•••••	•• — •	• ••
S	T	U	V	W	X
•••	—	•• —	••• —	• — —	• — ••
Y	Z				
•• ••	••• •				

Later, the International Morse Code was altered to represent letters used in non-English Alphabets and some punctuation marks:

Figure 6.2 International Morse Code Signals

A ● –	N – ●	Á ● – – ● –	8 – – – ● ●	
B – ● ● ●	O – – –	Ä ● – ● –	9 – – – – ●	
C – ● – ●	P ● – – ●	É ● ● – ● ●	0 – – – – –	
D – ● ●	Q – – ● –	Ñ – – ● – –	, – – ● ● – –	(comma)
E ●	R ● – ●	Ö – – – ●	. ● – ● – ● –	(period)
F ● ● – ●	S ● ● ●	Ü ● ● – –	? ● ● – – ● ●	(question mark)
G – – ●	T –	1 ● – – – –	; – ● – ● – ●	(semicolon)
H ● ● ● ●	U ● ● –	2 ● ● – – –	: – – – ● ● ●	(colon)
I ● ●	V ● ● ● –	3 ● ● ● – –	/ – ● ● – ●	(slash)
J ● – – –	W ● – –	4 ● ● ● ● –	- ● ● ● ● –	(hyphen)
K – ● –	X – ● ● –	5 ● ● ● ● ●	' ● – – – – ●	(apostrophe)
L ● – ● ●	Y – ● – –	6 – ● ● ● ●	() – ● – – ● –	(parenthesis)
M – –	Z – – ● ●	7 – – ● ● ●	_ ● ● – – ● –	(underline)

Obviously, these codes required skilled operators for both sending and receiving, using touch for encoding–sending and hearing for receiving–decoding. A written message would be encoded in Morse Code, transmitted as electrical signals carried over wires, and decoded back into writing at the receiving end. Although it was not until 1948 that Claude E. Shannon developed his Mathematical Theory of Information, the Cybernetic Model of Communication that resulted from his work describes the electric telegraph as precisely as it does the telephone. While the senses of sight and sound were extended by the telegraph, and the sense of touch was needed to operate the key, the senses of smell and taste were totally ignored. In operation, the telegraph extended the sense of sight more than sound because sound was used only by skilled telegraphers to hear the signals and translate them into letters, numbers, and punctuation symbols. In terms of the actual messages sent and received, it was sight in the form of writing and printing (in newspapers and magazines) that received the biggest boost from the telegraph.

In Europe, the command and control of the telegraph resided firmly with the government, usually as part of the postal systems. In the United States, the telegraph came under the command and control of private companies who operated it as a proprietary carrier for business clients or as a common carrier

open to anyone capable of paying for the service. The Western Union Company eventually owned almost all telegraph systems in the United States. The very form of the medium restricted the quantity and quality of the messages that could be carried. With a relatively slow speed of transmission (60 characters per minute at first, later increased by more efficient sending–receiving technologies) and a charge per word, telegraphic messages were under great technical and financial pressures to be as brief as possible, with Western Union offering a basic 10-word telegram for a set price. In all countries, the telegraph was also controlled and used by the military and would influence how strategies and tactics of warfare were planned and executed, beginning with the Crimean War and the American Civil War and continuing through the Spanish American War, World War I, World War II, and into the Cybernetic Age.[60]

If Marshall McLuhan was even only partially correct in equating the medium with the message, we can say that the medium of telegraphy signaled that time was crucial to information and to the quest to move messages more quickly over ever-greater spaces. Morse's telegraph not only electrified communication; it also electrified peoples and cultures as well, moving them from being oral–aural, chirographic, and typographic communicators toward becoming electrographic and electrophonic beings who could answer God's question to Job—"Canst thou send lightnings, that they may go, and say unto thee, Here we are"—with a hubristic and perhaps sacrilegious, "Yes, we can!" In a very real sense, Morse's electric telegraph was the *ur*-medium that opened the technological gates to all of the electric and electronic, analog and digital, wired and wireless media of the electric and cybernetic revolutions.

ELECTRIC TELEPHONY

At first, Alexander Graham Bell's telephone consisted of one transmitter–receiver that sent analog waves of electrical current transmitted over metal wires. Later the mouthpiece (sender) and the listening device (receiver) were separated either as distinct instruments connected by a wire or as part of the familiar handset still in use today. Electricity was the power source that carried the signals from source to destination. Someone speaks into a microphone where a diaphragm alters the resistance of carbon granules and converts the sound waves into electric impulses. A telephone line carries the signals to a receiving telephone, either directly, through the intervention of an operator, or by direct dialing. The electrical signals are reconverted into sound by electromagnetic codes that vibrate another diaphragm that replicates the original input,

reproducing with astonishing clarity the voices, music, or other sounds captured by the mouthpieces. The simple system designed by Bell evolved into telephones with greater complexity and efficiency over time, using combinations of coaxial wires, fiber-optic cables, and radio signals carried by radio waves, microwave links, and satellite systems. The shift from analog to digital codes allowed for "multiplexing," the ability of one line to carry multiple telephone connections at the same time.

The telephone as a medium had the edge over the telegraph because it carried human speech in its natural form, without the need for special encoding–decoding of messages by the people involved. The telephone restored sound as the primary carrier of human language. People could now talk to each other on the telephone, without the scribal assistance of the telegrapher. The telephone was, as the modern phrase would have it, "user friendly," in that it required little or no training for those using it. Telephony helped to restore the sensual balance between sight and sound that had been tipped toward sight with writing, printing, and the hypergraphic revolution. While the telephone functioned mainly as a medium for personal, business, government, and other one-to-one communication, it did provide a significant feature of the later broadcast radio networks by carrying radio signals by wire between stations and cities. First conceived as an aid to businesses and professions, the telephone eventually became an indispensable medium for communication in the 20th century, providing the foundation for the cellular mobile phones of the Cybernetic Age.

As with the telegraph, the command and control of the telephone varied between Europe and America, with Europeans uniting it with the telegraph under the postal system while Americans developed it as part of a free enterprise commercial system in competition with the telegraph. By the early decades of the 20th century, almost no business of any size was without a telephone, and telephony became the connection for all of the peoples of the United States with the integration of local, regional, and long-distance service. In time, international calls would become reality with the laying of transoceanic cables and radio telephony. In America, the Bell Telephone Company and its AT&T long distance system controlled over 90 percent of telephony for most of the 20th century, until compelled to break up in 1974–1982 by U.S. federal courts.

In the United States, the telephone remained under private ownership with some governmental regulation at local, state, and federal levels. As a common carrier, the telephone carried messages between and among governments, businesses, and private users. Despite its origins as an instrument for business, the

telephone became a social necessity for most Americans, encouraging the exchange of both *phatic* and *emphatic* messages, helping ordinary people to join businesses to "keep in touch" [61]

THE PHONOGRAPH

The *phonograph* (sound writing) was an acoustic medium that stored sound by recording sound waves translated by diaphragm vibrations into modulations carved by a stylus into grooves on metal foil wrapped around a cylinder (Edison's invention) or as lateral modulations carved into a flat zinc disk coated with wax (Berliner's invention). Once recorded, the sound was played back on a phonograph or gramophone by turning the cylinder or disk at 78 revolutions per minute. At first, Edison's cylinder machine and Berliner's record machine were mechanical, with power provided by hand-cranked spring systems. Later, electricity provided the power, and the acoustic phonograph was replaced by electric machines driven by direct power or batteries in 1925. Although Edison stopped producing his cylinder system in 1929 and Berliner's flat disk system became the standard storage and retrieval record for phonography, Edison's *phonograph*, rather than Berliner's *gramophone*, became the common name for the medium in America.

The power of that medium was in its ability to capture, store, and play back sound recordings that could be experienced in Edison's Phonograph Parlor in 1889; in the privacy of one's home; in public places like restaurants, saloons, and amusement parlors in the form of jukeboxes; or played at radio stations to be broadcast to listeners across the world. It was a one-way communication system from one source to many destinations and helped to create, with the evolving home-viewing stereoscope and magic lantern shows, the foundations for the home entertainment systems that are now common for many people. Feedback was only possible by using other media, like letters or telephone calls, and command and control of this medium were firmly in the hands of the record companies and the manufacturers of the phonograph machines, with the listeners limited to expressing control by buying or not buying certain records. In time, the phonograph became another invisible medium in the home entertainment experience. [62]

WIRELESS TELEGRAPHY

The rearview mirror name for Marconi's invention tells us how its inventor and developers regarded the new medium as an extension and improvement over

the existing electric telegraph. That rearview mirror thinking may have kept Marconi and his co-workers from seeing the potential of wireless as broadcast radio. In any event, the medium was used to carry telegraph signals across spaces not covered by wires. In essence, radio signals in the form of the Morse Code dots and dashes were carried by electric sound waves sent through the air from one antenna to another. The system required more than the electric sparks employed by the telegraph, resulting in the improvements in vacuum tubes by Ambrose Fleming, Lee de Forest, and Edwin Howard Armstrong.

As with the telegraph, wireless telegraphy depended upon skilled operators to carry messages that needed to be encoded and decoded using the Morse Code. The only way to save and store messages was by handwriting or typewriting them. Later, tele-typewriting systems allowed the operator to type in the messages which the machine then encoded into Morse which another machine decoded automatically back into alpha–numeric symbols at the receiving end. The senses involved were sight, sound, and touch, exactly the same ones extended by the regular telegraph. As with the telegraph and telephone, wireless telegraphy was controlled by governments in Europe and elsewhere except, as usual, for the United States, where private enterprise would come to own the systems. In America, however, the First World War (1914–1918) interrupted the private development of radio as both the War Department and the Navy Department seized control of radio as a matter of national security and military necessity. The very nature of wireless telegraphy made it an ideal medium for ship-to-shore, ship-to-ship, and mobile field communications. Whether wired or wireless, the telegraph was limited by the constraints of the Morse Code system and the time needed to encode, decode, and deliver the messages to their proper destinations. The wireless also had the added problem of the loss of privacy as wireless companies struggled to find ways to limit their radio signals from one point to another designated point, a problem never totally solved.

The medium itself, because of its complicated systems for sending, encoding–decoding, receiving, and delivering messages, was limited to those who could afford to build and maintain such systems and to those who could afford to use the system. Except for ship-to-shore telegrams from ship passengers, the majority of the use of wireless telegraphy came from the government, including the military, and from businesses, especially those involved in shipping and international trade. During the First World War, the military experimented with ground-to-airplane telegraphy, a development that would bear more fruitful achievements with radio telephony.[63]

WIRELESS TELEPHONY

Wireless telephony extended the telephone just as wireless telegraphy had extended wired telegraphy, freeing voice from wires to travel through space as radio waves. Both media were developed by using similar techniques and technologies to send Morse Code or voice signals from one point to another designated point. With wireless telephony, the same techniques and technologies that carried the human voice and other sounds by wire were used in combination with wireless techniques and technologies capable of carrying sound over airwaves from one point to another. The problem of sound radiating outward in a 360-degree circle was viewed as something to be solved by improved equipment.

As a speaker talks into a microphone, the sound waves are translated by the diaphragm and carbon granules into an electric signal carried by electrical current to an antenna where they are broadcast as modulated radio waves capable of carrying sound waves that are superimposed on the continuous signal coming from the transmitter. In the early days, the sound waves were modulated by having the amplitude of the sound waves vary at the same frequency as the carrier waves, in what is called *amplitude modulation* (AM), the early standard for wireless telephony and later radio broadcasting. The *frequency modulation* (FM) system invented and developed by Edward Howard Armstrong in 1933 would provide an improved sound that was largely free of "noise" (static). The signals themselves were analog in that the electric sound waves emulated the sound waves of actual speech or other sounds.

The wireless (or radio) telephone would prove to be of great service to the military (including land and naval forces, and the coming air corps), to other parts of the government, and to businesses, especially those involved in shipping and international trade. Wireless telephony proved to be more efficient than wireless telegraphy because it carried actual sound, including the human voice in place of the Morse Code, eliminating the need for special operators to encode–decode messages and to send–receive signals. During the First World War, the U.S. military controlled all forms of wireless transmissions, whether telegraphic or telephonic, a situation that lasted until 1919 when the Woodrow Wilson Administration failed to get Congress to pass laws giving the government permanent control of wireless communication.

For the most part, wireless telephony would be used by the government, including the Army and the Navy, by shipping and international businesses, and by news organizations, but its possible use by ordinary people would not become

reality until the advent of citizen broadcast (CB) bands and car and mobile phones in the 1970s during the early years of the Cybernetic Revolution. During all of this time, command and control of wireless telephony remained either directly with the government or with government-regulated private companies. In both cases, wireless telephony remained a sound extension of wireless telegraphy with no storage capacity except for human memory and handwritten or typewritten records.[64]

Radio Broadcasting

In a very real sense, wireless telegraphy and telephony were not so much media in their own right as evolutionary steps toward the revolution of radio as a broadcast medium that would carry messages by sound over airwaves from a limited number of sources–transmitters to vast numbers of receivers–audiences. The techniques and technologies of electromagnetic communication used for the wireless systems were improved to send stronger signals, and those improvements allowed for the development of radio to carry sound waves. The microphone carries the sound waves through the diaphragm and is transformed by the carbon granules into sound signals that simulate sound. The carrier wave is produced by a radio signal with a constant frequency generated by an oscillator and carries the modulated signal containing the voice, music, or sound effects. Early radio (before 1933) operated exclusively by *amplitude modulation* (the up–down movement of the sound wave), producing an electrical wave analogous to the actual sound waves present in the now and here of the experiential world. The signal is transmitted from the sending equipment to an antenna which broadcasts carrier waves at different frequencies to avoid interference. Radio waves, electric and magnetic force fields that vibrate at right angles to one another, vibrating at the same frequency carry the signals at the speed of light (186,000 miles or 300,000 kilometers per second) from transmitter to receiver.

Radio waves come in a number of varieties—surface waves that bend in an arc parallel to the curvature of the earth, reflected waves that are bounced off the ionosphere, and short waves capable of reaching great distances. In the United States, short-wave radio was always extremely limited, and local radio signals were the norm. The development of network radio systems depended upon long-distance telephone wires to carry the signals from city to city for broadcasting. By the Federal Radio Act of 1927 and the Federal Communication Act of 1934, the airwaves belonged to the people of the United States and were

licensed to broadcasters. In the words of the Federal Communications Act of 1934:

> Section 1: For the purposes of regulating interstate and foreign commerce in communication by wire and radio so as to make available, so far as possible, to all the people of the United States, a rapid, efficient, Nation-wide, and worldwide wire and radio service with adequate facilities at reasonable changes, for the purpose of the national defense, for the purpose of promoting safety of life and property through the use of wire and radio communication....

At the receiving end, radio waves are captured by a receiving antenna where they are carried by wires to an amplifier and loudspeaker to reproduce the sounds sent by the transmitter. The listeners hear the sounds by tuning in their receivers to the proper frequencies. Since broadcast radio is a one-way system, receivers in homes are not equipped to send signals back. In operation, broadcast radio became a unidirectional medium, with feedback limited to written or telephoned responses from the listeners.

Radio enhanced the sense of sound over all others, with some touch required for tuning frequencies and sight being needed for the writing/typewriting and reading of scripts by radio performers and for the reading of radio dials by listeners. Human speech and music provided the overwhelming sounds carried by radio. With skilled technicians handling all of the techniques and technologies needed for this medium to communicate messages, all that performers needed to know was how to produce the sounds they produced without radio. All that the listeners needed to know was how to tune in stations and adjust the volume control because human hearing provided the rest of the reception system.

Command and control in America were provided by government regulation and oversight of corporate ownership of stations and networks using the public airwaves to broadcast information to serve the "public interest, convenience, and necessity." Actual command and control were exercised by the corporate and nonprofit organizations that received FCC licenses to operate radio stations and networks. The private enterprise corporations that used radio to serve the "private interest, convenience, and necessity" were involved in commercial advertising of goods and services. Radio news and entertainment programs were the bait used to lure listeners for the commercials that were the most important messages carried by this medium. In terms of who paid for radio in America, the people who purchased goods and services that were advertised on radio paid the money that was used by clients to pay the advertising agencies

and radio stations and networks for creating and airing the commercials that encouraged the listeners to buy the goods and services advertised. In this closed cycle, people paid to be persuaded while thinking that they were receiving free information from radio [65]

Radio was a one-way disseminator of information into a new electric public sphere, what Lee de Forest called "an invisible Empire of the Air" that became the ethical hearth for American homes, a fragmented but communal fire around which people gathered to share in the narratives of the culture. As Arch Obler (1907–1987), a writer of original drama for early radio programs on *Lights Out* and *The Chase and Sanborn Hour*, noted, radio provided a "theater of the mind." Like all media that play significant roles in any culture, radio became invisible in that its presence was so ubiquitous that people stopped noting its novelty and began to regard it as part of the natural environment, like the air itself.

TELEVISION BROADCASTING

In a very fundamental sense, television was radio with moving images in its beginnings. Born in the laboratories of the radio corporations, especially NBC and CBS, television evolved from the same electromagnetic techniques and technologies that made radio a practical reality. After attempts in the 1920s to create a mechanical system based upon Paul Nipkow's rotating disk failed to develop into a viable medium, the electromagnetic systems being worked on by Philo T. Farnsworth and Vladimir Zworykin pointed the way to the future. The improvements in the vacuum tube by Lee de Forest and Edwin Howard Armstrong provided the technologies needed to carry both sounds and images over the airwaves, and Armstrong's FM system would provide the audio. From the experiments to the first licensed stations in the late 1930s, television in America provided black-and-white images on 5-, 9-, and 12-inch screens. Very few people received these early television broadcasts. In 1939, President Franklin D. Roosevelt opened the World's Fair at Flushing Meadows, New York and became the first American President to appear on the new medium. By May 1940, some 23 stations were broadcasting across America on a limited commercial basis. In 1940, television became fully commercial, but technical problems and the uncertainties caused by the war in Europe threatened its development. Most stations stopped broadcasting and those that continued reduced their schedules from 15 hours per week to a mere 4. In all, only some 10,000 television sets had been purchased by the public. America's entry into the Second

World War in December 1941 halted all developments in television while its key personnel, techniques, and technologies were diverted to war needs for communication systems like *radar* (radio detecting and ranging) for locating airplanes and *sonar* (sound navigation and ranging) for locating submarines.

The end of the Second World War in spring–summer 1945 freed the electronic industries to return to television, and by 1946, RCA television sets were being sold to the public. Despite a color system based upon a rotating disk being developed by CBS, RCA's black-and-white system prevailed with the Federal Communication Commission (FCC). Television was on its way to become a defining medium in America, providing both images and sounds to the new electronic hearth. Television would both complement and compete with radio for the home audiences. By 1951, television would begin to draw audiences away from movie theaters by providing at-home alternatives to going out to see a show.

In uniting sight and sound, television brought into people's homes experiences that could not be realized without the techniques and technologies that extended human senses beyond the now and here. In its power to bring information into the home, television became a medium of convenience and familiarity. It was no longer necessary to leave one's home to see and hear what was happening in the world, however selective the information. In the main, television became a medium for *phatic* communication over *emphatic* communication in that the vast majority of its messages did not involve information needed for any kind of survival. As friend, companion, storyteller, babysitter, and teacher, television became more than just a piece of electronic equipment and furniture in American homes.

Beginning with the Democratic and Republican conventions in 1948, television would play a major role in American politics into the 21st century. From limited beginnings, it would provide more and more of the news to more people than any other medium, providing both a mirror of life and a window into the world. As people embraced television, it would come to define the common communication environment shared by most Americans. From the 1950s to the 1990s (and perhaps beyond), American culture and American television were intertwined to produce one mediated culture.

The command control systems for television were almost identical to those for radio, with the FCC overseeing government rules and regulations while private and a few public corporations actually ran the operations. The massive private systems were funded by commercial advertising to such an extent that Marshall McLuhan liked to joke that the only "good news" on television were

the advertisements. Of course, the audiences played their parts by watching and listening to the programming and by buying the products advertised on the tube. Stations, networks, and the National Association of Broadcasters established their own guidelines for content, commercials, and other messages, exercising self-censorship in sensitive areas like politics, religion, sex, and patriotism. Sponsors also exercised some control by the power of their economic support.

As a medium, television moved from black and white to full color imaging in the 1960s–1970s, with improvements in sound from monophonic to stereophonic systems. The screens would become larger, moving to 20-, 30-, and 40-inch screens over time. But it would take the Cybernetic Revolution to replace vacuum tubes with transmitters and cathode ray tubes with flat, wide-angle screens. A combination of corporate control, sponsor preferences, and audience choice (or passivity) would encourage the use of television as a center for amusement and divertissement, except in times of national crises, like the Civil Rights March on Washington and the assassination and funeral of President John F. Kennedy in 1963, the funerals for Martin Luther King and Robert F. Kennedy in 1968, and the 9/11 attacks on the Pentagon and the World Trade Towers in 2001. In time, television would become the greatest medium for the one-way transmission of information, entertainment, and persuasion. [66]

CABLE TELEVISION

Cable television began as an extension of broadcast television, merely enhancing television in signals for improved reception by television sets. In time, however, cable television would morph into a medium in its own right, frequently taking over not only the content of broadcast television but the very corporations that controlled the telecasting stations and systems. But that development would come only later with the Cybernetic Revolution.

In terms of media in the Electrographic and Electrophonic Revolution, it is the proliferation of media and the speed of that proliferation that distinguish these media from those in previous evolutions–revolutions. Morse's electromagnetic telegraph begat the telephone which begat the phonograph which then begat the wireless telegraph and telephone which begat radio which begat television which begat cable television. In one century, from the 1840s to the 1940s, electric communication moved from Morse Code signals carried by wires to moving images accompanied by synchronized sounds carried over the airwaves. Both the variety of media and their evolutions into more sophisticat-

ed carriers of information are remarkable. Some of these media remained as point-to-point two-way transmissions, like wired and wireless telegraphy and telephony, while others functioned as one-way transmissions to mass audiences, like radio and television. The phonograph began as a medium for storing–retrieving music but later became a key provider of content for radio and a storage system for radio programs. It would take developments in cybernetic communication to provide efficient systems for the storing–retrieving of information carried by the other media. While the telegraph eventually became a dead medium, all of the others would continue to operate into the Cybernetic Age, however modified by the move from analog to digital encoding–decoding, storing–retrieving, and sending–receiving.

The core messages carried by all of these media were that electromagnetism held the promise to extend human sight and sound beyond the now and here through time and space by harnessing Nature itself to do the bidding of human beings. Whether these media would help people toward some Golden Age of Communication in which people would come together and conflicts would be resolved with words rather than weapons remained an unanswered question that would be asked again in the Cybernetic Age.[67]

Impacts

The impacts of the Electrographic-Electrophonic Evolution–Revolution were more pronounced in some societies than in others. In general, the more industrialized and technologically advanced the culture, the more it benefitted from electromagnetic communication. All of these media helped to bind America into one nation following the ravages of the Civil War, providing the people with a shared common culture founded upon one common language, the popular press and literature made possible by print, and the advent and spread of motion pictures which accompanied early radio. As a nation composed of many peoples united into one by words and other symbols of common ideas, the United States needed the electromagnetic media to connect all of the people across a vast continent into one culture.

In Great Britain, this evolution–revolution helped the British to command and control its vast global empire from the 1840s to the 1940s, providing surface and maritime communication for government offices, mercantile interests, military and naval units. Belgium, France, Spain, and, to a lesser extent, Germany also used the electric media provided to keep their smaller empires together. Obviously, the colonized peoples in these empires were at a

disadvantage because of this evolution–revolution that helped to keep them bound to the home countries. As always, content played a major role in determining the impacts of any medium on peoples and cultures.

ELECTRIC TELEGRAPHY

The major advantages bestowed by this evolution–revolution came from increased efficiency in transferring information by transmission rather than by transportation. The telegraph began this revolution by connecting far–flung locations by electrical wires carrying Morse Code, promising what its advocates hoped would be a communion of people through improved sharing of messages. But as early as 1854, there were skeptics who questioned whether telegraphy could actually deliver on the promise. In *Walden*, Henry David Thoreau called the telegraph "an improved means to an unimproved end," writing, "We are in great haste to construct a magnetic telegraph from Maine to Texas; but Maine and Texas, it may be, have nothing important to communicate."[68] Thoreau seems to be concerned here with the potential for trivial, rather than substantive, communication with this new medium, but the telegraph actually carried significant information for governments, businesses, new organizations, and the military. And of course, once the telegraph connected Maine and Texas, people did find that they had much to communicate, providing an early example of what is called The Technology Adoption Model, in which innovators (2.5 percent) encourage early adopters (13.5 percent) to try the technology and then influence an early majority (34 percent) who influence a late majority (34 percent) to adopt the technology, leaving behind laggards (16 percent). In this model, people adopt new techniques and technologies not because they are needed for survival but because they have been adopted by others. In this model, form not only precedes but actually shapes function. Once introduced into an environment, new media tend to shape that environment and the people in it by their possibilities. Indeed, the entire history of all evolutions–revolutions in communication has been one of new media stimulating uses not conceived of before their inventions, leading to improvements in these media and the creation of new media not imagined before the coming of the previous media. Thus, without language, no revolution in writing and reading, without literacy, no revolution in printing, without typography, no revolutions in hypergraphy or in electric communication, and without electrographic and electrophonic media, no cybernetic revolution.

There can be no doubt that the benefits bestowed by the telegraph, tele-

phone, phonograph, wireless, radio, and television were significant in extending the senses of sight and sound beyond the now and here and in providing ways for people to communicate from point-to-point or with vast audiences through the harnessing of electricity. As many media historians have argued, by moving communication from transportation to transmission, electromagnetic media not only improved the efficiency of message sending–receiving but also ushered in an expanding host of new media that would inspire still more new media in the future. In distribution of benefits, however, some were more blessed than others. The new electric media allowed some individuals, corporations, and cultures to reap wide rewards while others failed to benefit or were actually harmed by these changes.

ELECTRIC TELEPHONY

Of all electric media, the telephone may have had the most profound and lasting impacts on individual people and their lives. As a personal point-to-point connection, it allowed people to share information, news, gossips, rumor, and any other type of *phatic* and *emphatic* messages they wished. While it allowed news agencies and organizations to speed the flow of information, commercial business to spread the flow of commerce, and government branches to improve message transfers over space, the telephone also empowered ordinary people to "reach out and touch someone," as the AT&T campaign urged its customers to do in 1977–1979. As early as the 1890s, people were worrying about the telephone's effects on social class structures in Great Britain and the United States as its use expanded. In the early 1900s, the telephone was becoming a commonplace, even necessity, for doctors, drugstores, hotels, newspapers, police stations, and businesses in general.[69] By 1950, the telephone had become a norm in most middle-class homes in America; by 2000, the telephone and its cellular phone development would be a medium serving a vast number of people all over the world.

In 2008, 80 percent of American adults had landline telephones, with the remaining 20 percent using cell phones exclusively. Overall, 89 percent owned a wireless or cell phone, and 75 percent used combinations of technologies to make phone calls. Only 9 percent of adults reported using a landline only.[70] What these statistics tell us is that the telephone is very much a vital part of our communication and cultural environment.

In *Understanding Media,* Marshall McLuhan cites a *New York Times* story of September 7, 1949, that demonstrated the invisible power of the telephone

to compel attention:

> On September 6, 1949 a psychotic veteran, Howard B. Unruh, in a mad rampage on
> the streets of Camden, New Jersey, killed thirteen people, and then returned home.
> Emergency crews, bringing up machine guns, shotguns, and tear gas bombs, opened fire.
> At this point an editor on the *Camden Evening Courier* looked up Unruh's name in the
> telephone directory and called him. Unruh stopped firing and answered,
>
> "Hello."
>
> "This Howard?"
>
> "Yes…"
>
> "Why are you killing people?"
>
> "I don't know. I can't answer that yet. I'll have to talk to you later. I'm too busy
> now."[71]

To McLuhan, this behavior shows how even a psychotic man in the midst of
a murder rampage would feel the compulsion to answer the telephone. Are we
different? Do we allow phone calls to interrupt us at significant moments? Do
we fear missing a call? Why? Are the messages we receive vital? To what? Why
do we feel compelled to answer the phone or to feel guilty if we do not?

There can be little doubt that the telephone did bring benefits with its
improved transmission of messages across space and later developments, like the
phone-answering machine, which allowed us to hear playbacks of messages
received while we were unavailable, and the use of two lines on one phone,
which allowed us to put one caller on "hold" while we answered another call.
The telephone changed the pace of emergency responses, news distribution,
business transactions, and social life in general. It helped to speed up commu-
nication and the pace of life itself, moving from a convenience to a necessity
to a point where peoples and cultures with telephony look upon those without
this medium as being backward in terms of communication, technology, and
perhaps culture.

THE PHONOGRAPH

The phonograph brought music, including song, into the home. Invented to
service businesses and as an amusement in arcades, the phonograph found its
major uses as a center for home entertainment. Although the cylinders and
records could be used for recording any sound for replaying, in actuality phono-
graph records were used almost exclusively as a convenient way to listen to
music at home. The coming of radio provided the phonograph with a mass

medium outlet to reach large audiences. The phonograph soon was united with radio to form one home listening system with a combined radio–receiver and a record player capable of holding multiple disks to be changed automatically.

The phonograph also had a significant impact on people who sold records, with companies like RCA Victor, Columbia Records, Decca, and many others providing old and new genres for the buying–listening public. The proliferation of a vast variety of musical categories was primarily due to the records being played on phonograph machines, on radio, and on jukeboxes in public places like candy stores, ice cream parlors, bowling alleys, restaurants, and saloons. People used the phonographs to listen to classical, semi-classical, country–western, jazz, swing, folk, blues, and an expanding variety of music.

Recorded music provided the popular music for most of the 20th century, changing norms, mores, and values while making profits for performers, agents, recording studios, record companies, and manufacturers of equipment. By the 1930s, the phonograph had become another medium fully integrated into American culture, an invisible member of a media mix that entertained on command. While the phonograph was essentially a storage–retrieval system with a one-way flow of information from the producers to the listeners, the people who listened had control over what they listened to, how and where they listened, and with whom they listened.

Although some attempts were made to use the phonograph for educational, inspirational, and instructional purposes, its main function was to provide listening pleasures (mostly musical) to satisfy audience preferences. Music could be controlled by the listener to establish a mood, provide pleasure, expand appreciation, or to serve as background. Teenagers, especially, beginning in the 1920s became avid collectors of records, making stars of their favorite singers and bands. But adults and children also became users of this medium that frequently is not appreciated by media scholars for its impacts on culture and communication.[72] By the 2000s, cassettes, CDs, iPods, and other digital devices would challenge the phonograph as a delivery system for music, but there are some signs that the turntable-playing vinyl records may be having a renaissance with young listeners, although vinyl records sold only 2.1 million copies in 2009, less than 1 percent of total recorded music sales.[73]

WIRELESS TELEGRAPHY

As a British invention, Marconi's wireless telegraph attracted the attention of the British government, anxious to enhance any communication system that

would facilitate the running of the far-flung British Empire and the large mer-chant and naval fleets needed to transport goods and raw materials, bureaucrats and public officials, and military personnel. Because of Marconi's refusal to allow other wireless systems to interact with the Marconi System, some countries saw this as an attempt to exercise British control over all of this new medium. Eventually, agreements were reached to intercommunicate between different systems in order to improve safety at sea, a need made manifest with the *Titanic* disaster in 1912.[74]

In the United States, the wireless telegraph had its first significant impact upon the U.S. Navy as it embraced Captain Alfred Thayer Mahan's 1890 the-sis on *The Influence of Sea Power upon History 1660–1783*, an extension of America's Myth of Manifest Destiny to civilize all of North America and the waters surrounding the nation.[75] The expansion of the Navy into an Atlantic and a Pacific fleet made the wireless a useful and necessary medium for naval communication, although some ship captains resented its interference with their command and control over their vessels.[76] The Army also saw uses of wire-less telegraph not only for field communication but also for control of weapons systems.[77]

In time, the land and naval forces of all technically advanced nations would add the wireless telegraph to their communication systems, but it would be in non-military areas that wireless telegraphy would have its most publicized impacts. It revolutionized the news business not only by making the transmis-sion of information more rapid but also by adding wireless to wired telegraph messages sent by news agencies like the Associated Press (1900), the United Press Associations (1907), and the International News Service (1909) in the United States, Reuters in Great Britain, and Agence France-Presse (formerly Havas) in France.[78] These press associations not only made the news more cur-rent but strove to be as neutral and objective as possible in their reporting, thus enhancing the validity and reliability of information carried by newspapers, helping the press in the 20th century to become less partisan and more professional.

Wireless telegraphy also helped commercial shipping companies, their clients who shipped goods, and the passengers who sailed on their ships. In addi-tion to improving the safety of cargoes and passengers, the wireless telegraph also allowed those on board to keep in touch with people on shore and on other ships. It was the beginning of wireless electric communication and would be the first of a long line of media that would carry messages via sight and sound when-ever human beings travelled across the globe, sailed the seas, submerged under

the seas, and travelled into space.

Wireless telegraphy's primary function was to provide electric bridges between gaps in the wired telegraph system, an improvement of that earlier system. That rear-view mirror thinking of the new medium as an electric telegraph minus the wire kept Marconi and his associates from seeing the greater possibilities for radio transmission of sound as the next major step in the evolution–revolution of electric communication. Although sometimes called "The Father of Radio," Marconi never conceived that radio could be as significant a medium as wireless telegraphy.[79] As Amun–Re would say, the inventor of a technology is not always the best judge of its uses and impacts.

The relatively short life of wireless telegraph between its development and the coming of radio broadcasting limited its impacts on cultures in general because it served mainly as an adjunct to wired telegraphy and as an important military force-multiplier in the field and at sea.

WIRELESS TELEPHONY

As the telephone improved upon the communication capabilities of the telegraph, wireless telephony improved upon wireless telegraphy by using sound to carry human speech rather than Morse Code. Not surprisingly, the U.S. Navy joined with AT&T in conducting "tests of transcontinental wire telephony and transoceanic telephony in 1915," with General Electric developing its own system. The First World War brought new demands for wireless telephony as "European and American armed forces demanded radio units for airplanes, ships, and infantry"[80]

While the people and corporations involved in developing the techniques and technologies of radio telephony thought that its future lay in improving existing systems for long-distance, transoceanic, and maritime communication, the greater impacts of this medium would be in its potential as a new medium entirely. As Daniel J. Czitrom notes, "Virtually no one in the scientific, amateur, military, or corporate communities had expected broadcasting to become the main use of wireless technology. The sending of uncoded messages to an undifferentiated audience transformed wireless into a popular medium of communication."[81] It would require the evolution–revolution of the Cybernetic–Digital Age to realize the hopes for wireless telephony to become a universal medium for keeping people in constant touch all over the world.

RADIO BROADCASTING

From its beginnings with the work of Fleming, Marconi, de Forest, Fessenden,

Armstrong, Conrad, and other pioneers, radio was taken up by innovators who constructed their own sending–receiving systems, but with Conrad's KDKA broadcasts for Westinghouse in 1920, listening–only crystal sets were available for those who became listening audiences. Although technologically capable of serving as a two-way medium, radio in both the United States and the rest of the world evolved into a one-way system for mass dissemination of messages with the potential to influence people in terms of how they received messages, how they evaluated messages, and how they arranged their lives. In America, the connections between commercial broadcasters and their advertising sponsors shaped the programming and the behavior of the listening audience. As a medium for marketing ideas, goods, and services, radio became an essential part of advertising in the 1920s. Even today, with its rich variety of media, radio still plays a key role in what advertisers call "Integrated Marketing Communication." As William F. Arens notes in *Contemporary Advertising* (2006), "In an average week, 95.4 percent of the U.S. population listens to radio; in an average day, over 75 percent. The average American listens to radio more than three hours every workday and over five hours on the weekend. In fact, during the prime shopping hours of 6:00 A.M. to 6:00 P.M., the average U.S. adult spends more time with radio than any other medium."[82]

Radio had different impacts on different cultures at different times depending upon the ways it was owned and regulated. But regardless of whether it was government or privately owned, listener subscribed or commercially sponsored, radio changed the ways that people received information and entertainment. Radio brought information directly to the family, providing an electric voice in the home that connected people to the outside world. Whether the radio provided another expression of the public sphere is a debated question. Some media scholars see in radio a way to extend democracy by the sharing of more information, the ideals of town hall meetings of the air, fireside chats, the questioning of politicians, and the opportunity for listeners to use the telephone to add their voices to the ongoing discussions and debates that constitute the voice of the people. Skeptics, on the other hand, see in radio yet another "opiate of the people" in media form, a source of endless diversion and persuasion that lulls people into acceptance of the status quo rather than rousing them to action. In essence, it is the classic question of whether a medium encouraged active or passive participation in communication. As radio sets became mere receivers requiring no special knowledge or skill to operate, radio invited and encouraged its listeners to become passive receivers of information.[83]

When television replaced radio as the electronic hearth in the 1950s, radio changed from national networks into local stations, with dramatic and narrative genres being replaced by popular music, news, talk shows, and listener call-in formats. FM, with its superior sound quality, tends to broadcast music, while AM focuses on news, talk, and sports programming. A listing of the percentage of radio stations in the most common programming formats tells us something about audience tastes:[84]

Figure 6.3 Percentage of Most Common Radio Programming Formats in the United States

Country	18.9%
News/Talk	11.9%
Religious	9.2%
Oldies (Music)	7.5%
Adult Contemporary (Music)	6.4%
Adult Standards (Music)	6.4%
Classic Rock (Music)	6.3%
Spanish	6.1%
Top 40 (Music)	4.6%
Soft Adult (Music)	3.1%
Easy Listening (Music)	3.1%
Rock (Music)	2.6%
Alternative Rock (Music)	1.5%
Jazz (Music)	0.8%
Classical (Music)	0.3%

Source: Arens, Contemporary Advertising, 2006, 530–531.

This list shows that the radio audiences in America are now fragmented across a wide spectrum of listeners receiving different messages from different sources, the vast majority of which are presentational, not propositional, involving *phatic* rather than *emphatic* communication. The listening now takes place by individuals in separate locations—in bedrooms and dorm rooms, while driving

motor vehicles, or listening to in-ear devices while walking or doing any other activity. From the electric hearth of the 1920s–1950s, radio has changed into an isolating medium that allows the individual to avoid contact with the immediate environment by blocking out unwanted sounds. If radio in its Golden Years helped to unite America and other countries, by providing common narratives, music, and other expressions of popular cultures, it now caters to a fragmentation of subgroups who share few messages in common.

In its prime as a central medium of popular communication, radio provided a powerful megaphone for political leaders of the left, center, and right to try to persuade people to follow them. In Germany, Adolf Hitler used radio to promote Nazi propaganda to great effect from 1933 to 1945. In Great Britain, the British Broadcasting Corporation (BCC) limited political speakers, as did the French systems. In the United States, radio offered more freedom of expression, with Senator Huey P. Long of Louisiana and Father Charles E. Coughlin using radio during the 1930s to challenge the presidency of Franklin D. Roosevelt, himself a skilled exploiter of radio with his speeches and "Fireside Chats."[85] Context does count when it comes to the uses and impacts of any medium in any culture.

What impacts does radio have on your own life? Do you own a radio? When, where, how, and why do you listen to radio? Do you listen to radio over the Internet or via satellite? Do you use earphones or speakers? What would be lost if radio disappeared from your media mix? What would you like radio to do for you?

Whatever your answers, it seems clear that radio no longer has the dominant impact it once had on our lives. But it should not be forgotten that it supplied most of the techniques and technologies that not only gave television to the world but also provided the portal for the later Cybernetic Revolution that continues to shape the communication systems of our lives and our cultures in the 21st century.

TELEVISION BROADCASTING

In general, all of the electric media tended to help those in power to retain that power and to reward the corporation over the individual. The struggles by Edwin Howard Armstrong and Philo T. Farnsworth for control of FM radio and television against the Radio Corporation of America provide sad but telling illustrations. RCA and David Sarnoff, the quintessential corporate bureaucrat, triumphed over the individual inventors, and both radio and television were developed as products of corporate culture. The impacts of television in the

shaping of American culture in the second half of the 20th century can hardly be overstated. As the leading developer of the medium and the nation that most embraced its use, the United States became, in effect, a television culture.

In news and public affairs, television emerged as the dominant medium in America in the 1950s, with the 1952 presidential election and the rise of network news programming. Increasingly, as more American homes became television homes, television became the most used source for news and information, as well as for entertainment. A twenty-year review of how the public perceived television in comparison was published by The Roper Organization in 1979. Covering the years from 1959 to 1978, the report cited a steady climb of television as the source of most news from 51% in 1959 to 67% in 1978, with declines for newspapers (57% to 49%) and radio (34% to 20%).[86] The report also found television to be the most credible medium, rising as most believable from 29% in 1959 to 47% in 1978, with newspapers falling from 32% to 23% and radio from 12% to 9%. During the 1959–1978 period, the average viewing hours per day rose from 2:17 to 3:08.[87] In a comparison of job performances among selected institutions, the report found an interesting pattern in the responses from 1959 to 1978. The comparative percentage for six institutions listed are:[88]

Figure 6.4 Ratings for Six American Institutions

Institution	Excellent or Good (%)		Fair or Poor (%)	
	1959	1978	1959	1978
Television	59	68	32	29
*Churches	–	67	–	18
*Police	–	66	–	29
Newspapers	64	59	30	35
Schools	64	48	26	36
Local Government	44	37	43	52
*Note: 1959 data not given.				

Source: Roper Organization, Inc., Public Perceptions of Television and Other Mass Media: A Twenty-Year Review, 1959–1978, 1979, 3.

Clearly, television had become a trusted messenger as it became the dominant medium in the age of network television, rivaling the churches and the police in the public's perception of excellence.

To the question of how much control the government should exercise over television programs, only 24 percent thought more control was needed while 38 percent said that amount was fine and 30 percent wanted less control, a split that reflected the debate over television and its effects on audiences.[89] To the related question of who should be responsible for what is shown on television, public opinion was overwhelming in naming the individual viewers who decide what they watch. Here are the comparisons in percentages: [90]

Figure 6.5 Responsibility for Watching Television Programs

	News	Entertainment	Commercials	Sex	Violence	All TV
Individual	64	69	49	67	67	71
Television	36	28	25	19	20	26
Advertisers	9	14	35	9	9	12
Federal Govt.	9	4	6	12	15	9
Social Action Groups	6	8	4	15	13	9

Source: Roper Organization, Inc., Public Perceptions of Television and Other Mass Media: A Twenty-Year Review, 1959–1978, *1979, 13.*

In 1978, 48 percent of parents of children between 6 to 18 years of age reported that their children were assigned to watch television programs for homework.[91] Interestingly, 78 percent of people thought that commercials were "a fair price to pay for being able to watch" television, while only 19 percent did not, and the majority of parents supported commercials on children's television by a ratio of 59 percent to 36 percent.[92] An overwhelming 94 percent reported that their children "knew the difference between TV programs and the commercials on them," a refutation of critics who warned that children could not distinguish between the commercials and the programming.[93] (Of course, these are only the perceptions and opinions of the parents, not those of the children.)

In summary, the Roper Report reached three main conclusions:

1. The American public continues to endorse the commercially sponsored system of broadcasting.
2. While criticism exists, critics are in the minority.
3. Most people agree that having commercials is a fair price to pay for getting their programs.... [94]

It is worth noting that the report was commissioned by the Television Information Office, then the publicity and promotion arm of the National Association of Broadcasters which was interested in having television appear in the best light possible.

While television would continue to be a major medium of communication in America for decades to come, the evolution of cable television from an aux-iliary role to a competing medium began in the mid-1970s when the Federal Communications Commission allowed greater control by cable systems, now empowered by the techniques and technologies of satellite communication and the rise of new "super stations" not dependent upon the broadcast network sys-tem to achieve national reach as more television users turned to cable not only for improved reception of over-the-air television but for the greatly expanded number of channels now available. The limitations of the broadcast spectrum would provide the opportunity for new ways to provide ever-increasing sources of information, entertainment, news, and persuasion on television sets.

A 2009 report by the A. C. Nielsen Company, the major source for audi-ence ratings, found that Americans still spend an average of slightly more than 5 hours each day watching television in their homes, a total of 153:27 hours per month. "In addition, the 131 million Americans who watch video on the Internet watch an average about 3 hours per month while time-shifted viewing averages 7:16 per month. The 13.4 million Americans who watch video on mobile phones watch on average about 3:37 hours of mobile video each month."[95] An updated report noted that "Americans are increasing their over-all media consumption, and multitasking is part of the equation, with home watching at 141:03, time shifted at 7:16, Internet viewing at 3:11 and mobile phone use at 3:15 hours per month, for a total of 154:45 hours per month, around 5 hours each day."[96]

In attempting to assess the impacts of television on American culture, crit-ics and scholars have employed a number of approaches taken from earlier stud-ies of print and film media. A number of approaches were taken, some based upon social science models developed by anthropology, psychology, and soci-ology, using statistical methodologies to try to quantify people's responses to questions and to describe people's behaviors according to established theories in these fields. One approach stressed "social learning theory" and viewed television as a significant teacher in the lives of children. A second saw "agen-da setting" as a key function of all media. A third held that people's perceptions of reality are shaped by their media use, what they called "cultivation effect." A fourth found that media tend to be used by people for their own purposes, in a "uses and gratification" model.[97] This last model also had later refinement

by the cultural studies people led by Stuart Hall in Great Britain and Lawrence Grossberg in America.[98] An important study in popular culture that influenced much research in the 1980s and 1990s was Janice Radway's work that demonstrated that women readers of romance novels were not mere recipients of messages that shaped them according to the author's intentions but active makers of meanings in their own interpretations of the texts.[99]

While these debates took place in academia, there were some echoes of them among the public at large, at times reaching to public concern for how television might be affecting the country and its citizens. In 1961, the newly-elected President John Fitzgerald Kennedy spoke before the annual meeting of the National Association of Broadcasters, calling them "...the guardians of the most powerful and effective means of communication ever designed." The president may have been reflecting on the key role that television had played in his 1960 defeat of Richard M. Nixon that was aided by the Nixon–Kennedy debates on national television. But while the president was laudatory toward the NAB attendees, Newton Minnow, his newly-appointed Chairman of the Federal Communication Commission, was severely critical about what he saw as the failures of that medium of communication. After praising the best of television news and public affairs programming and some serious dramatic series, Minnow was blunt:

> But when television is bad, nothing is worse. I invite you to sit down in front of your television set when your station goes on the air and stay there without a book, magazine, newspaper, profit and loss sheet or rating book to distract you—and keep your eyes glued to the set until the station signs off. I can assure you that you will observe a vast wasteland...of games shows, violence, audience participation shows, formula comedies about totally unbelievable families, blood and thunder, mayhem, violence, sadism, murder, western bad men, western good men, private eyes, gangsters, more violence, and cartoons. And endlessly, commercials....[100]

If you accept Minnow's invitation today to watch advertising-supported broadcast and cable television, you may discover that his description is still accurate. What the impacts of watching (and listening to) such offerings have is a topic of fierce debate that continues today.

Perhaps the most encompassing criticism of television was that of Neil Postman whose *Amusing Ourselves to Death: Public Discourse in the Age of Show Business* (1985) insisted that "...television is nothing less than a philosophy of rhetoric."[101] For Postman, the technological revolution in communication that began with the electric telegraph in the 1840s had reached a point in the 1980s where television had become American culture. Basing his argument on the structure and uses of television, Postman claimed that education, news, pol-

itics, religion, and other significant areas of culture had been reduced by television to mere entertainment. Advocating a system of critical thinking founded upon language, literacy, and typography, Postman proposed that students and teachers engage in searches for answers to how people experience any medium of communication in terms of changes in form, volume, speed, and content of information.[102]

While the U.S. Surgeon General and others worried about the effects of television and other media on young people, skeptics questioned the extent of these effects. In a 2003 book, Jonathan L. Freedman, a professor of psychology at the University of Toronto in Canada, concluded that all of the studies on the effects of fictional violence in film and television failed to provide "scientific proof" of any connection between media violence and social behavior.[103] That debate continues.

In the political arena, television played a major role in both elections and in selling wars to America. In *Packaging the Presidency: A History and Criticism of Presidential Campaign Advertising*, Kathleen Hall Jamieson summarizes the impacts of television on presidential elections with these words: "Political advertising is now the major means by which candidates for the presidency communicate their messages to the voters. As a conduit of this advertising, television attracts both more candidate dollars and more audience attention than radio or print."[104] Since the Vietnam conflict, American governments and their critics have used television to try to persuade the people to support their positions. After CBSTV Network news anchor Walter Cronkite concluded that America could not win in Vietnam, President Lyndon B. Johnson said "It's all over."[105] Television played a major role in persuading Americans to support the Persian Gulf War with its Operation Desert Shield and Operation Desert Storm.[106] The attacks of 9/11/01 on the United States provided the motivation for Americans to support a war, but it was the Bush Administration that orchestrated the media, especially television, to back the invasions of Afghanistan and Iraq as parts of a Global War on Terror.[107]

If television's impacts on politics were profound, its role in advertising was more persistent and perhaps more persuasive because it provided nonstop access to people watching television. As William F. Arens notes in *Contemporary Advertising*, "As a way to reach a mass audience, no other medium today has the unique creative abilities of television: the combination of sight, sound, and motion; the opportunity to demonstrate the product; the potential to use special effects; the empathy of the viewer; and the believability of seeing it happen right before your eyes."[108] In a 2003 survey, adults in

America found television to be the most authoritative (49 percent), influential (82 percent), and persuasive (67 percent) medium for advertising.[109]

Television, of course, has had tremendous negative impacts on other media, especially print, radio, and film, in terms of providing information and entertainment, but perhaps its most significant impact has been on communication itself. As Neil Postman noted, television "…has made entertainment itself the national format for the representation of all experience."[110] In a very basic sense, television encourages people to view all areas of their cultures as television genres. The recent "reality television" craze presents anything but reality, but reality can hardly compete with "reality" on television. As Marshall McLuhan noted in *Understanding Media*, new media use old media as content and reconfigure their uses in a society.

Obviously, those who controlled television benefitted from its impacts, including the manufacturers, broadcasters, producers, and all others involved in the medium. Advertisers and their agencies also benefitted, and, if the Roper Poll results can be trusted, the public thought that they benefitted the most. A 2000 Nielsen Media Research reported that 98 percent of all homes in America have at least one television set, with 35 percent owning two sets, and 41 percent owning three or more sets. The debates about whether television helps or harms family life, children, education, a peaceful society, and political discourse continue, with few signs of agreement or resolution in sight. What do you think, and why do you think what you do?

CABLE TELEVISION

The impacts of cable television during the age of broadcast television were limited to bringing regular television into areas with poor reception. Therefore, its impacts would be identical to those of over-the-air television. Even by 1975, only 13 percent of American homes had cable television. By 1995, cable television homes had increased to 60 percent, stimulated by the evolution–revolution in digital techniques and technologies of the Cybernetic Age. When the Telecommunications Act of 1996 brought cable under the jurisdiction of the Federal Communication Commission (FCC), cable had morphed into a medium that was significantly different from its role as a carrier of broadcast signals.

Limitations

The evolution–revolution of electrographic and electrophonic communication continues today, but the techniques and technologies now include contribu-

tions from digital systems that first enhanced the older media but now threaten to replace those media with new ways to encode–decode, store, send, and receive information that moves through space at light speed and can be retrieved over time with no loss of quality or quantity. The search for ways to improve each of the media of this evolution–revolution led not only to improvements but to new media. Telegraphy, the founding electric medium, survived the challenges from the telephone, but finally succumbed to the digital revolution and is now what is called a "dead medium," meaning that it no longer serves as a vehicle for sharing messages. The telephone is still with us, but digital technologies have provided the means to free telephony from its wired connections, although telephone lines continue to carry vast volumes of information. The telephone was an improvement over the telegraph in that it carried voice messages in place of Morse Code. Some of the limitations of wired telegraphy and telephony were addressed by wireless, but those improvements were overshadowed by the morphing of wireless into radio and television.

The limitations of radio in terms of reach and clarity of sound signals were addressed by the invention of improved radio tubes, transmitters and receivers and by Armstrong's revolutionary development of FM transmission–reception. Television enhanced radio by adding sight to sound, but it soon became more than just radio-with-moving-images. It became a new medium that devoured the content of radio and then challenged and surpassed radio as everybody's favorite home medium for news and entertainment. Improvements in television included bringing color and enhancing the sound quality of the audio. The 1941 FCC adoption of a 525-line image electronically scanned at 30 frames per second remained the standard for American television until the 2009 introduction of high-definition digital television (HDTV). Although other countries, including Great Britain and the former Soviet Union, adopted a superior quality image with a 625-line, 30 frames per second standard, the entrenched interests of those who controlled American television slowed any improvements. Some technologies from the digital age were incorporated into standard television sending–receiving technologies, using transistors to replace vacuum tubes, push-button remote controls (wired and wireless) to replace tuning knobs, and automatic adjusting to replace viewer fine-tuning. Transmission and reception antennae were always being improved, but only the coming of full digital television would solve most of the problems with reception.

Cable television's limitations were addressed with improvements in technologies, but it would take the next evolution–revolution of the Cybernetic Age to transform cable television into a new and powerful medium in its own right,

capable of challenging and even controlling its once-dominant partner.

The evolution–revolution sparked by Morse in 1840s with his electric telegraphy opened the way for not only the developments in electrographic and electrophonic media but for the digital evolution–revolution to follow. In seeking to extend human communication in terms of space, the electric media succeeded in sending–receiving written, spoken, and imaged messages through wires and through the air, from point-to-point and from one point to many. While the phonograph provided a storage system for sound, mostly musical, and the teletypewriter provided text messages, radio and television lacked efficient systems for storing information over time. For radio, the flat disk provided one method but recorded a limited number of programs until the victorious American Army captured the German system for storing sound signals on magnetic plastic audiotape, which also made possible editing and multi-track radio mixing that became the standard for the music industry. The audiotape systems were large reel-to-reel devices, but by the 1960s, these were replaced by cassettes and recording-playing machines that were more user-friendly, allowing the audiotape to move from industry professionals to the public at large. The audiocassette mini-revolution was at hand. The new system was perfect for carrying stereophonic sound. (Although stereophonic literally means "hard-sound," most people interpreted it to mean "two-speaker sound" because the two separate tracks of sound were amplified through two speakers, in contrast to the monophonic (one-track) standard system.) In the electric age, all of these sounds were transmitted, recorded, and played in analog form.

Television improvements included color, developed by RCA/NBC in 1954 and standard for the ABC, CBS, and NBC by 1965, and the expansion of VHF (very high frequency) capable of carrying 13 channels with UHF (ultra high frequency) capable of carrying an additional 70 channels. The UHF system was limited, however, in its power and reach, only achieving growth with the digital revolution to come. The audiotape mini-revolution spurred developments in using magnetic tape to record sound and moving images. The 1957 inauguration of President Dwight D. Eisenhower and Vice President Richard M. Nixon was videotaped by an Ampex recorder, a decided advancement over the kinescope film system that used standard film stock to record what the television cameras and microphones captured. By the 1970s, the Sony Corporation introduced a cassette system that used three-quarter-inch wide tape for professional use. In 1975 Sony provided a smaller, half-inch Betamax cassette for home use while JVC, another Japanese company, introduced a competing system, VHS (Video Home System), that would win the consumer wars and

become the international standard for all home viewing recording and viewing. With the VHS, ordinary people could build their own home video libraries, providing them with more command and control over television.

The technical limitations of all electric media would be addressed by continuing improvements in the techniques and technologies needed to make these media operational. What this evolution–revolution stimulated was a thirst for ever-greater speed in overcoming spatial distances between senders and receivers, and more efficient ways to store and retrieve information over time. Wireless and radio and television extended sound and sight over the air (aided in some places by cable wires) while records, audiotapes and videotapes extended sound and sight over time. With these inventions and their improvements, the evolution–revolution in electrographic and electrophonic communication enabled more people to share more information through more media more efficiently over space and time than was ever possible in earlier ages of communication. In the maturity of this evolution–revolution, its very successes would encourage developments that would culminate in the next evolution–revolution of the Cybernetic Age.

As with all of the earlier evolutions–revolutions, this one did not bring about total communication among people. Individual humans beings continued to live their individual lives despite the increases in the number of media and the volume of information now available. Increased speeds and widespread contacts failed to bring improved understanding through improved communication systems. Henry David Thoreau's judgment that the electric telegraph (and presumably its technological descendents) provided only "improved means to an unimproved end" still remains valid. What do people expect their communication media to do for them? What do you expect from your electric media? What do you want the telephone, phonograph, radio, and television to do for you?

Consider how the telephone, the phonograph, radio telephony, radio, and television (including cable television) would be improved by the move from wired to wireless transmission, from analog to digital encoding–decoding, and from separate media to integrated media with the coming evolution–revolution in the Cybernetic Age. How would the improvements in electric media and the introduction of new digital media change how people communicated, what they communicated, with whom they communicated, and how they dealt with the effects of these media on human communication and culture? Would the coming Cybernetic Revolution of Digital Communication address all of the limitations of the Electrographic–Electrophonic Age?

· 7 ·

BECOMING CYBERNETIC

Evolution and Revolution in Digital Communication

Context

Some scholars have identified this evolution–revolution as "The Information Age" and give its birth date as 1992 with the coming of the World Wide Web that provided everyone with the possibility to be connected electronically to everyone else via the Internet. This new Information Superhighway promised to unite all media of communication, from speech, writing, and printing to graphic and hypergraphic imaging to electrographic and electrophonic signals, into one suprasystem that used digitalization to reduce all messages to binary codes. The convergence of audio, video, text, and still and moving images into one system that standardized all information encoding–decoding, sending–receiving, storing–sharing as on–off (1–0) binary digits turning time and space into *cybertime* and *cyberspace*, reducing, if not eliminating, all distinctions between *now* and *then* and between *here* and *there*.[1] While accepting this designation as being helpful for marking a significant moment of change in communication systems, I would also point out that in its most basic meaning, the information age actually began some 13.7 billion years ago with what cosmologists call "The Big Bang," when time–space, energy–matter, and information (the codes that govern the operations of all systems) came into existence. Human communication began with the first hominids who evolved from *Australopithecus afaren-*

sis (4 million years ago) into *Homo habilis* (2.5 to 2 million years ago) and *Homo erectus* (1.5 million to 500,000 years ago), and culminated with *Homo sapiens* some 200,000 years ago. From our beginning as creatures capable of sharing information through signals and symbols that encoded language, we have been active participants in changing ages of communication punctuated by significant evolutions–revolutions in techniques and technologies that structured the central media of these ages.

In the most profound sense, the Cybernetic Revolution is the inheritor and beneficiary of all of the evolutions–revolutions that came before it. And while the earliest changes that gave us language, imaging, writing, and printing were in response to needs for survival in physical, cultural, economic, political, and social environments, some of the later changes were motivated by both survival needs and what we might call technological possibilities by which new electric media stimulate social usage. The Cybernetic Revolution was born as a byproduct of attempts to improve the electrographic–electrophonic media that emerged from Samuel Morse's telegraph in the 1840s and continued with the telephone, phonograph, wireless, radio, and television until the late 1940s. The energy and matter that provided the media to extend sight and sound through electronic transmission formed the foundations for the Cybernetic Revolution of the Information Age that not only further enhanced and extended sight and sound but brought touch back into the sensory mix.

In addition to the techniques and technologies of the electrographic–electrophonic media, the Cybernetic Revolution would also be based upon a profound theory that attempted to describe and explain how all information is communicated by media. The revolution was conceptualized by Claude E. Shannon in his "A Mathematical Theory of Information," first published in the *Bell System Technical Journal* in July and October of 1948. What Shannon proposed was a way for understanding not only how information was transferred from sender to receiver in any system of communication but also a way for seeing information itself as an essential agent in the dynamic interfaces between time–space and energy–matter by connecting order to disorder, probability to uncertainty, and control to chaos.

The roots of Shannon's theory can be traced back to the study of *Thermodynamics* (the movement of heat) in the 19th century. The story begins with a Frenchman, Nicolas Léonard Sadi Carnot (1796–1832), whose *Reflections on the Motive Power of Fire* (1824) claimed that heat can only function as a source of power when it moves "from a higher to a lower temperature."[2] Following the maxim that the amount of matter present in the universe is a con-

stant that can neither be created nor destroyed, physicists studying energy in
the 19th century came to the conclusion that energy also cannot be created or
destroyed, but, like matter, can change its form. Rudolf Clausius (1822–1888)
stated these conclusions in two laws of thermodynamics: "The first law of
thermodynamics states that energy is conserved. It is not created or destroyed.
The second law of thermodynamics says that while energy does not alter its total
quantity, it may lose quality."[3] Clausius called the measure of loss of quality
entropy (from the Greek word for transformation) that could be expressed as a
fraction: entropy = heat ÷ temperature. Given the general tendency of entropy
to increase, the problem was how to employ the loss of quality for useful
purposes.

Building upon the work of the Scottish physicist James Clerk Maxwell
(1831–1879) who proposed in an 1859 paper that some natural phenomena are
best understood not in terms of laws but as statistical probabilities, Ludwig
Boltzmann (1844–1906) proposed that entropy is very difficult and expensive
to overcome. But for life to be possible and for societies and civilizations to con-
tinue, order is essential. And communication of information is the key to
keeping entropy in check.[4] While entropy became the focus of much scientif-
ic and philosophical speculations about the meaning of life and the universe,
it is its connection to communication that concerns us in this book.

Shannon reduced all information to a single unit, called a binary digit (bit),
a yes–no, on–off switch that is able to cut uncertainty in half. A simple demon-
stration with a deck of cards illustrates the principle quite well. With 52 cards
arranged in 4 suits of 13 cards each, the chances of selecting one card is 52:1
if you guess randomly. But by halving the possibilities with binary questions, you
can find the answer with a number of guesses that can be stated in a formula.
Say the card you seek is the ace of spades. You would need five or six bits of
yes–no information to identify the correct card.

1) Black or Red	=	Black	
2) Clubs or Spades	=	Spades	
3) 2 to 8 or 9 to Ace	=	9 to Ace	
4) 9 to Jack or Queen to Ace	=	Queen to Ace	
5) Queen to King or Ace	=	Ace	
or Queen or King to Ace	=	King or Ace	
6) King or Ace	=	Ace	

The key here is that whether the answer is "yes" or "no," the same information is transferred. (Of course, all of this assumes that all information is reducible to binary digits).[5]

A second major contribution made by Shannon was his demonstration that entropy in the form of *noise* (any interference with the transmission of the signal) can be overcome by coding the message properly and by providing redundancy to reduce confusion. As the number of bits of information carried by a communication system increases, redundancy increases and errors are reduced and information is shared.[6] To Jeremy Campbell in *Grammatical Man: Information, Entropy, Language, and Life* (1982), Shannon's theory provides not only the way to understand all human communication from language to computers and other digital information processing systems but also to understand biological, chemical, and physical changes as well:

> Sense and order, the theory says, can prevail against nonsense and chaos. The world need not regress toward the simple, the uniform, and the banal, but may advance in the direction of richer and more complex structures, physical and mental. Life, like language, remains "grammatical." The classic view of entropy implied that structure is the exception and confusion the rule. The theory of information suggests instead that order is entirely natural: grammatical man exists in a grammatical universe.[7]

Shannon's theory of information was expanded in his collaboration with Warren Weaver in *The Mathematical Theory of Communication* (1948) which also provided a more public forum for the spread of these ideas.[8] Although Norbert Wiener never acknowledged that he was influenced by the work of Shannon and Weaver, he did note their connections in the 1954 edition of *The Human Use of Human Beings: Cybernetics and Society*:

> I wrote a more or less technical book entitled *Cybernetics* which was published in 1948. In response to a certain demand for me to make its ideas acceptable to the lay public, I published the first edition of *The Human Use of Human Beings* in 1950. Since then the subject has grown from a few ideas shared by Drs. Claude Shannon, Warren Weaver, and myself, into an established region of research.[9]

In coining the term *cybernetics* (from the Greek *kubernetes*, "steersman"), Wiener defined it as "communication and control" and provided an agenda for the Digital Information Age:

> It is the thesis of this book that society can only be understood through a study of the messages and the communication facilities which belong to it; and that in the future development of these messages and communication facilities, messages between man

and machine, between machines and man, and between machine and machine, are destined to play an ever–increasing part.[10]

Shannon, Weaver, and Wiener provided ways to understand the explosion of electronic media that had characterized the last 100 years of human communication systems, with change becoming not only constant but more rapid. No electronic machine better personifies the coming Digital Age than the electronic digital computer which went beyond the mere calculations provided by manual and electric machines. The computer promised to be a thinking machine, an "electronic brain" that could emulate human thinking. As Joseph Weizenbaum notes, "The arrival of all sorts of electronic machines, especially that of the electronic computer, has changed our image of the machine from that of a transducer and transmitter of *power* to that of a transformer of *information*."[11] The key to the operation of any system is a set of rules that instructs people or machines on what to do in a prescribed sequence, an effective procedure called an *algorithm*.

The evolution of the computer can be traced as far back as simple counting stones or the abacus, but many historians like to begin with Charles Babbage (1791–1871), a mathematics professor at Cambridge University in England whose 1822 mechanical calculator contained all the elements for a computer. Although Babbage's calculator never became a practical reality, its principles formed the basis for Herman Hollerith's (1860–1929) tabulating machine used for the 1890 U.S. Census. Both analog and digital calculations using electricity were employed by military encoders–decoders before the Second World War, and during that war British Intelligence developed *Colossus*, the first fully electronic digital computer, which was used to decipher enemy codes. During the war, an American system for predicting the movements of German aircraft and V-1 rocket missiles, based in part on Wiener's work on statistical probabilities, helped to defend Great Britain from airborne attacks.[12] This war-work to improve the control of cannon fire and missile paths resulted in the development of the world's first general digital electronic computer for the U.S. War Department at the University of Pennsylvania in 1946, *ENIAC* (Electronic Numerical Integrator And Calculator). By 1951, ENIAC was succeeded by *UNIVAC I* (Universal Automatic Computer), the first electronic computer to be used by business and government to manipulate digital data. The rate of change in electronic computing began to move exponentially with great rapidity even before transistors replaced vacuum tubes.[13]

The *transistor* was invented at the Bell Laboratories in 1947 and would play a major role in future development in all electronic communication media by

replacing the relatively large and heat-producing vacuum tubes with tiny transistors that performed the same functions of amplifying and receiving radio signals more efficiently. Transistors would lead to *microprocessors* (miniature circuits to process and store electronic signals) in 1971. In 1965, Gordon E. Moore (b. 1929), who had been the chairman of Intel, then the leading producer of microprocessors, proposed what came to be called "Moore's Law" which noted that the power of computer chips was doubling every 18 months, a rate that would continue for some time to come.[14]

The major problems that motivated this Cybernetic Revolution were those found in the limitations of the previous Electrophonic–Electrographic Revolution, but this new change would eventually embrace all media that extended human communication through sight and sound. The wartime necessities for weapons systems to defeat the enemy drove Great Britain and the United States to develop electronic computers and Nazi Germany to develop long range rockets and their guidance systems. All would play significant parts in the evolution–revolution of the electronic digital media that now define the age in which we live in the 21st century. This evolution–revolution began in these countries but would in just 50 short years spread through the entire technologically developed and developing world, affecting everyone on Earth. If ever an evolution–revolution had the potential to become universal, this was the one, perhaps because it promised to extend the sharing of all audio, textual, and video messages throughout the world through a total interfacing of computer, telephone, radio, television, cable, Internet, and satellite into one system of total communication.

A combination of environmental factors facilitated this evolution–revolution in the United States and other free market countries. The individual inventors and innovators provided the inspirations and inventions needed but these were soon taken over by large corporate interests. Governments also contributed by providing financial support, in terms of grants and tax breaks, and by providing needed regulations of the media developed. Finally, economic competition between and among communication companies led to improvements in media to overcome competing products/services and to stimulate current users to upgrade their hardware and software. In the race for cybernetic excellence, no country could afford to lag behind, and the Cold War between the Communist World and the West that lasted from 1945 to 1991, according to the official Department of Defense calculation, fueled the space race, the nuclear weapons race, the intercontinental ballistic missiles (ICBM) race, the high-speed computer race, and the communication command and

control race—all of which helped to propel communication into the Cybernetic Age. In this evolution–revolution, as was true for all electric media beginning with Morse, war (in this case, Korea and Vietnam) facilitated the developments of the techniques and technologies required for the improved and new media that would emerge. Once more, these new media would lead philosophers and poets, and scientists and supporters to herald the dawn of a new age of total communication. They would also provoke critics into new warnings against the tyranny of technological determinism. As always, the *Faustian Bargain* was in place, with everything costing someone something.

People

In this evolution–revolution, there were no single individuals or groups of individuals responsible for the development of the techniques and technologies that made the media operational. All of the key players in the Electrographic–Electrophonic Revolution were godfathers of the Cybernetic Age. The media industries that developed from telegraphy, telephony, phonography, wireless, radio, television, and cable would play their parts in the coming Media Age. The people who were crucial to the Cybernetic Revolution toiled in a number of key areas of ideas and media.

INFORMATION THEORY

The evolution of Claude E. Shannon's theory of information as a mathematical formulation was a culmination of the ideas of many predecessors, including Nicolas Sadi Carnot, Rudolf Clausius, James Clerk Maxwell, and Ludwig Boltzmann, all of whom were motivated by scientific inquiry into the nature of physics, as were Shannon and Warren Weaver. The extension of Shannon and Weaver's theory of communication into cybernetic theory was supplied by Norbert Wiener, who cited Joshua Willard Gibbs (1839–1903) as his most important influence. Whether French, British, or American, these men were motivated by the spirit of scientific inquiry and none would profit from the explosion of media made possible by their theories. Some were independent seekers of knowledge, some were affiliated with universities, and some worked for media companies. Shannon and Weaver and Wiener wrote books that made their names familiar to the public. And Shannon's theory was central to the Bell Telephone Company's growth in telecommunications in the 20th century.

COMPUTERS

Although the concept of computers is ancient, perhaps extending as far back as prehistoric notations calculating the phases of the moon and yearly cycles and continuing with counting sticks, abaci, and other ways of manipulating numbering symbols, the modern history of the computer usually begins with the *difference engine* created in 1822 by Charles Babbage, a professor of mathematics at Cambridge University in England who was aided and encouraged by Ada Byron, Lady Lovelace (1815–1852), the daughter of George Noel Gordon, Lord Byron (1788–1824), the great Romantic poet. Babbage's machine was hand-cranked and produced mathematical tables. Lack of funding from the British government prevented his building of a larger steam-powered device. George Boole (1815–1864), a British mathematician at Queen's College Cork devised a system for logical thinking that reduced all logical propositions to yes–no binary statements, providing the Boolean search mechanism used for library researches. Boole's work was continued in 1910–1913 by Alfred North Whitehead (1861–1947) and Bertrand Russell (1872–1970), English philosophers and mathematicians, in their influential *Principia Mathematica* (1910–1913) which demonstrated that the roots of mathematics were interconnected to the basic principles of formal logic. As Howard Gardner notes, the connections among these men and their ideas form a progression: "The cluster of ideas represented by Babbage's calculating machines, Boole's laws of thoughts, and Whitehead and Russell's decisive demonstrations were eventually to be integrated by scholars in the 1930s and 1940s. Their work culminated in the first computers and, eventually, the first programs that can be said to display intelligence."[15]

The next significant contributor to computers was Herman Hollerith whose tabulating machine read data from holes punched into cards for the 1890 U.S. Census. Hollerith's machine and cards provided the foundations for the Tabulating Machine Company in 1896 that became the International Business Machine Corporation (IBM) in 1924. The analog and digital calculations made practical by these pioneers were used not only for mathematicians and businessmen but also by the military for intelligence work in coding–decoding and for command and control of weapons systems. One of the key code-breakers for British Military Intelligence during the Second World War was Alan M. Turing (1912–1954), a major figure in Enigma which broke the German Magic Code and helped to win the war. Turing also contributed significantly to the postwar development of codes and computers, especially with his celebrated

"Turing Test" which challenged people to distinguish between responses from humans and from computers. Failure to make any distinction would prove that the machine could think like a human being. [16]

As a graduate student at the Massachusetts Institute of Technology (MIT), Claude Shannon was influenced by Professor Vannevar Bush (1890–1974) to work on the connections between electrical network theory and propositional calculus that resulted in Shannon's master's thesis, "A Symbolic Analysis of Relay and Switching Circuits," called by Howard Gardner "possibly the most important, and most famous master's thesis of the century."[17] In addition to his contributions to Information Theory, Shannon also provided some ideas that would prove to be central to computer development, including *Artificial Intelligence* (AI). A major contributor to thinking about information theory and its applications to computers and Artificial Intelligence was John von Neumann (1903–1957), who developed the idea of storing in a computer a program to command and control all future programs in that computer by using binary logic and arithmetic to create the operating codes. In a sense, he provided computers with the internal structures for the development of all computer languages. Although von Neumann died of cancer at the age of 54, the work in AI was carried on by Herbert Simon and Allen Newell, Marvin Minsky, and John McCarthy, all notable participants at a 1956 conference on computers and intelligence held at Dartmouth College.[18]

Simon and Newell had by 1956 already created a computer program that could prove theorems found in Whitehead and Russell's *Principia Mathematica*. Their program, called *Logical Theorist* (LT), demonstrated that AI was both possible and practical in two key senses: "(1) computers could engage in behavior that, if exhibited by humans, would unambiguously be considered intelligent; (2) the steps through which the programs pass in the course of proving theorems bear a nontrivial resemblance to the steps observed in human problem solving."[19] The *General Problem Solver* (GPS) was a program designed to engage in a wide range of problem solving, from proving theorems to playing chess by following the mental processes used by humans in similar circumstances. In the end, the program was abandoned, but it "can be regarded as the first to simulate a spectrum of human symbolic behavior."[20]

The prophets of the gospel of AI via computers proclaimed the dawn of a new age of technological thinking, in which circuits replace brain cells, computer storage systems function as memory, and electronic transistors, computer chips, and silicon circuits improve on the cerebral cortex. All that would be required was the creation of cybernetic versions of the human mind that would

be freed from biology and physiology. Some enthusiastic supporters of a cyber-netic future suggested that these changes in thinking would constitute the next step in the evolutionary path of humans from hominid toward starchild. Here are a few projections from the early computer age: From Robert Jastrow, Director of the Goddard Institute for Space Studies and professor of astrono-my at Columbia University, "In another fifteen years or so—around 1995, according to current trends—we will see the silicon brain as an emergent form of life, competitive with man." From Edward Fredkin, a professor of electrical engineering and computer science at the Massachusetts Institute of Technology, "Eventually, no matter what we do there'll be artificial intelligences with inde-pendent goals. It's very hard to have a machine that's a million times smarter than you as your slave." And this from Marvin Minsky, an influential profes-sor of computer science, also at MIT, who predicted that "the machine will begin to educate itself...[and] in a few months it will be at genius level....A few months after that its power will be incalculable."[21]

Critics of computers and thinking emerged alongside the prophets, like Amun–Re to Thoth, challenging both the assumptions and the criteria used for testing machine "intelligence." One early and caustic naysayer was Hubert Dreyfus, a professor of philosophy at the University of California at Berkeley whose *What Computers Still Can't Do: A Critique of Artificial Reason* (1972) ques-tioned the basic assumption that computers can think like human beings.[22] A second critic emerged from within the computing laboratories of MIT itself. Joseph Weizenbaum's *Computer Power and Human Reason: From Judgment to Calculation* (1976) laid out an argument against confusing human judgment with computer calculation, using his own highly successful computer program *ELIZA* that emulated the role of a psychotherapist trained in the tradition founded by Carl Rogers. The very "success" of ELIZA in providing "respons-es" to people that could not be distinguished from responses by human thera-pists appalled Weizenbaum because it tended to reduce human communication (sharing) to mere transmission of messages. In his own words:

> Man, in order to become whole, must be forever an explorer of both his inner and his outer realities. His life is full of risks, but risks he has the courage to accept, because, like the explorer he learns to trust his own capacities to overcome. What could it mean to speak of risk, courage, trust, endurance, and overcoming when one speaks of machines?[23]

A third naysayer was John Searle, a professor of the philosophy of language at the University of California at Berkeley, who challenged the validity of the Turing Test for determining intelligence by noting the severe limitations that

the test places on actual human language. For Searle, computers do not "understand" the words of a real language; they only obey programmed protocols for operating in specified sequences that appear to mimic human language but are devoid of real meaning and, therefore, communication.[24]

A balanced view of this debate was taken by Howard Gardner, a MacArthur Prize Fellow at Harvard University, in *The Mind's New Science: A History of the Cognitive Revolution* (1985), where he called for an approach to human thinking and artificial intelligence that rejected either–or positions in favor of a more dialectical approach: "The idea that artificial intelligence must be able to handle all psychological (or all philosophical) issues, or it will be unable to handle any of them must be exorcised. Similarly, there is no more reason for us to think of humans as being completely identical to computers than for us to cling to the notion that there are no useful resemblances or parallels between these two kinds of (potentially) thoughtful entity."[25]

As this debate raged, progress in the areas of techniques and technologies continued. In 1947, John Bardeen (1908–1991) and Walter Brattain (1902–1987) built the first point-contact transistor at Bell Laboratories under the direction of William Shockley (1910–1989), who resented not being involved in the actual invention. Shockley soon invented his own improved and more stable junction (or sandwich) transistor. Although the trio had a falling-out and Bardeen left Bell Laboratories in 1951, in 1956 they were all awarded the Nobel Prize in Physics for inventing the transistor, a key technology for not only computers but for all telecommunication media in the future.[26]

In 1951, John P. Eckert and John W. Mauchly invented *UNIAC*, and in 1954 John Bachus at IBM invented the *Fortran* computing program language. In 1958, Jack Kilhy and Robert Noyce invented the *Integrated Circuit* ("chip"), followed in 1964 by Douglas Engelbart's *computer mouse*. The changes in the 1970s and 1980s came at increasing speeds with competing companies like Dell, IBM, Intel, Microsoft, and Apple developing improved technologies and operating systems. In 1981, IBM introduced the IBM PC, the first home computer, and Microsoft offered its MS–DOS operating system. By 1983, the personal computer had become *Time* magazine's "machine of the year," the first nonhuman winner, and in 1984, Apple introduced its Macintosh, the personal computer that revolutionized both computers and television advertising with its debut commercial on that year's Super Bowl telecast. While some individuals, like Bill Gates of Microsoft and Steve Jobs of Apple and Pixar, became public figures, the people who advanced computer techniques and technologies remain largely anonymous. The 1990s witnessed continued evolutions in software

programs and hardware technologies, punctuated by IBM's Deep Blue computer defeating the world chess champion Garry Kasparov in their second 6-game contest. In this version of the Turing Test, the machine defeated the man in a restricted zero-sum game, and the debates over human versus machine intelligence continued. The 1997 Apple–Microsoft agreement partially united two powerful computer companies, rewarding their owners and investors with ever-greater profits. Corporations, not people, would control the future of the computer.

From 2000 through 2009, the only people whose names appear in the history of computers are those who owned and managed the corporations that manufacture and sell machines and programs, except for the obituary notices for Claude E. Shannon (2001) and other pioneers of the Cybernetic Age. Some were rewarded with fame and fortune but most lived in relative obscurity and modest circumstances, a fate not unlike that of the inventors and innovators of writing, printing, hypergraphy, and electric media. What is most lasting in their legacies are the improved media of communication they helped to shape realities for generations to come.[27]

COMMUNICATION SATELLITES

The idea of using artificial satellites to transmit signals from Earth and back again was first advanced by Arthur C. Clarke (1917–2008) in 1945. Later, Clarke became a renowned science fiction writer, but in 1945 he was a British Royal Air Force (RAF) electronics officer and member of the British Interplanetary Society. In an article in *Wireless World*, he proposed a system of manned satellites to relay television signals around the world, but his proposal had little or no impact, even after he repeated it in *The Exploration of Space* (1951). Although John R. Pierce of AT&T's Bell Laboratories speculated on the possibility of such a system for telephony, it was the 1957 launch of *Sputnik I* (Fellow Traveler) by the Soviet Union during the American–Soviet Space Race, a part of the Cold War competition in missiles and nuclear weapons that sparked interest in satellite communication. Clarke's motivation seems to have been genuine intellectual curiosity while Pierce seems to have been motivated by a combination of technological problem-solving and corporate financial concerns.[28] During this period, the Soviet Union and the United States seem to have been motivated primarily by ideological and military competition and by fear.

But before communication satellites could be lifted into orbit, rockets were needed to propel them into space. Ancient China seems to have been the

first culture to develop and employ rockets for uses as ceremonial fireworks and as weapons of war, beginning in 1232 with fire arrows against a Mongol invasion. From that small beginning to the 18th century, rockets were used by various peoples. After local forces in India used rockets against British troops, the British experimented with rocketry, and Sir William Congreve (1772–1828) developed a war rocket with a range of about 3,000 yards that was used against American forces in the War of 1812, most notably in the 1814 Siege of Fort McHenry in Baltimore Harbor. Francis Scott Key's poem noting "the rockets' red glare, the bombs bursting in air" would become the official national anthem of the United States by an act of Congress in 1931. Rockets were a minor weapon system throughout the 19th century, but the work of Konstantin Tsiolkovsky (1857–1935) in Russia and Robert Goddard (1882–1945) in America inspired Germany rocket scientists to develop their rocket program in the 1920s.

The German Rocket Society, founded in 1927, experimented with liquid-propellant missiles. After Adolf Hitler and the National Socialist (Nazi) Party came to power in 1933, rocket scientists received extensive funding for their experiments. Toward the end of the Second World War, they produced the V–1 (*Vergeltungswaffe*: Retaliation Weapon), a subsonic pulse-jet rocket that had limited effect on the war. The much larger supersonic V–2 had greater range and delivered more explosives, carrying 1,000 pounds of high explosives over some 200 miles. The V–2 was propelled to an altitude of 80 miles with just 62 seconds of thrust, achieving a speed of over 3,000 miles per hour. Its impact on the targets was devastating, but its aim was not very precise.[29] These German advances in rocketry were largely due to the work of two men—Walter Dornberger (1895–1980), a Wehrmacht gunnery officer, and Werner von Braun (1912–1977), a technological professional interested in space travel. Together, they were in charge of the development of both the V–1 and V–2 rockets. At the war's end in May 1945, they had designed specifications for a third rocket that would use the V–2 for a second stage thrust and have a range of 2,800 miles. Fortunately for the enemies of Nazi Germany, these intercontinental missiles never became a reality.[30]

Both the Soviet Union and the United States used captured German personnel, plans, and technologies to build their own rocket and missile programs in the postwar years. In the United States, Werner von Braun became the key man in the American space program. The 1957 Soviet launch of *Sputnik I* was answered in 1958 by the American launches of *Explorer I*, its first satellite, and *Atlas–B*, its first Intercontinental Ballistic Missile (ICBM). This

race into space for military and technological dominance continued through the 1960s with manned orbits of Earth by Yuri Gargarin in 1961 and by John Glenn in 1962. In 1966, the Soviet Union achieved a soft landing of an unmanned vehicle on the moon with *Luna 9*, but the crown jewel of the space race went to the Americans with the *Apollo 11* landing on the moon by Neil Armstrong and Edwin "Buzz" Aldrin, Jr. with Michael Collins orbiting in the command ship on July 20, 1969, thus fulfilling President John F. Kennedy's challenge to the U.S. Congress on May 25, 1961: "I believe that this nation should commit itself to achieving the goal, before this decade is out, of landing a man on the moon and returning him safely to the Earth."

The space race benefited communication by facilitating the development and operation of satellites to carry signals all across the world. While NASA (National Aeronautics and Space Agency) experimented with passive satellites that reflected signals, the Department of Defense (DOD) concentrated on active repeater satellites that amplified signals. In 1960, AT&T entered the field with a proposal for an operational system, once again joining together the government, military, and private enterprise in the development of communication media. In 1965, the Communication Satellite Corporation (COMSAT) launched *Early Bird*, a 24-hour orbit (geosynchronous) satellite built by the Hughes Aircraft Company, heralding the dawn of efficient satellite communication. Prior negotiations had resulted in earth stations being set up not only in the United States but also in Brazil, France, Germany, Italy, Japan, and the United Kingdom. Additional international negotiations resulted in an international organization to control all of the global satellite system; the International Telecommunications Satellite Organization (INTELSAT) came into being on August 20, 1964. By 1988, six companies provided fixed satellite service in the United States—GE Americom, Alascom, AT&T, COMSAT, GTE, and Hughes Communications. Other countries also offered satellite uplinks, including Canada (1972), Indonesia (1976), Japan (1978), India (1982), Australia (1985), Brazil (1985), Mexico (1985), and many others. Thus, the people involved came from government, military, business, communication, financial, and related fields, not as individuals but as members of corporations and organizations. Their rewards have been satisfaction in achieving technological breakthroughs, increased senses of security and superiority, and significant financial rewards for individuals and corporations.[31]

THE INTERNET

A fourth part of the Cybernetic Revolution was the development of the

Internet, which employed information theory to unite computers and communication satellites with earlier media of telecommunications like telegraphy, telephony, phonography, motion pictures, radio, television, teletext, cable, lasers, fiber optics, and others, into one new unified system for sending–receiving audio and video messages via digital signals throughout the world. The Internet's birth and development can be followed by using the Technology Adoption Model: first, inventors and innovators attempted to solve some specific problems in communication; second, supporters tried to make the new technology practical; and third, a growing number of people found uses for the new technology that exceeded those envisioned by its inventors.

The Internet began as a proposal to address the problem of maintaining telecommunications in the event of a nuclear attack on the United States during the Cold War. In 1964, Paul Baran, a computer scientist at the Rand Corporation, was the principal author of a report to the Department of Defense "On Distributed Communications Networks." The report noted that centralized telecommunication networks were vulnerable to nuclear attacks because they were all connected to single centers; even decentralized networks were vulnerable because their multiple centers are limited in number. Only a distributed network in which every connection is both a sender and receiver of information would be able to survive a nuclear attack.[32] By 1966, Larry Roberts of MIT was hired to manage the ARPAnet (Advanced Research Projects Agency) project for the Department of Defense, directing the research that provided a network of minicomputers acting as gateways for interfacing of information exchanges for what is now called DARPAnet (Defense Advanced Research Projects Agency). A group of university and independent researchers developed packet switches called "interface message processors" (IMPs) in 1968, which went into trial runs in 1969 by researchers at four sites: Leonard Kleinrock at the Network Measurement Center at the University of California at Los Angeles; Douglas Englebart at Stanford University; Dave Evars and Ivan Sutherland at the University of Utah; and Glen Culler at the University of California at Santa Barbara. In 1972, Robert Kahn of Bolt Beranek and Newman, Inc. (BBN) organized the first public demonstration of the new system at the International Conference on Computer Communications in Washington, D.C. That same year, Ray Tomlinson, also at BBN, wrote the first email program to send messages via the ARPAnet/DARPAnet, using the @ symbol for the first time in his email address.

After continuing improvements in both protocols and technologies, including the 1980 Defense Department adoption of the TCP/IP (transmission con-

trol protocol/internet protocol) standard, in 1985, ARPAnet and all intercon-
nected networks officially adopted the TCP/IP protocols and the integrated net-
works become known collectively as "the Internet." In 1984, Paul Mockapetris
and Craig Partridge developed Domain Name Service to provide unique inter-
net protocols numerical addresses to names with suffixes such as .mil, .com, .org,
and .edu. The people working on these developments continued to be from uni-
versities and research organizations working largely for the Department of
Defense, but some non-Americans were also working in this new area of com-
munication research and development. Perhaps the most important contribu-
tion came from Tim Berners-Lee, an Englishman working at the CERN particle
physics laboratory in Switzerland, whose *hypertext* linked all Internet commu-
nication in nonlinear connections. Thus, the *World Wide Web* was born, com-
plete with *URI* (Universal Resource Identifier), *HTTP* (Hypertext Transfer
Protocol) and *HTML* (Hypertext Markup Language). Significantly, Berners-
Lee refused to copyright or patent his creation, inviting everyone to become a
member of the Internet global community.[33]

The people involved in the majority growth of the Internet after the
Internet expanded from those who worked in military–university research
centers to people working for both older and newer companies involved in com-
puters and telecommunications committed to financial gain. A Nielsen Net
View list of the top ten global and American Internet parent companies in 2009
is revealing:

Global	United States
1. Google	1. Google
2. Microsoft	2. Microsoft
3. Yahoo!	3. Yahoo!
4. Facebook	4. Facebook
5. eBay	5. AOL, LLC
6. Wikimedia Foundation	6. News Corp. Online
7. AOL, LLC	7. InterActiveCorp
8. News Corp. Online	8. Amazon
9. Amazon	9. eBay
10. InterActiveCorp	10. Apple Computer

The lists are nearly identical, indicating both the global reach of satellites and American domination, which is likely to lessen in the future.

Messages

In the beginning, the Cybernetic Revolution served to extend in time and space the messages carried by earlier evolutions–revolutions in communication: spoken and written language, visual images and graphics, typographic words and images, telegraphy, telephony, phonography, photography and cinematography, radio, television, and cable. In time, Information Theory would lead to ways to integrate the messages carried by computers, satellites, and Internet into one digital system capable of transmitting, storing and sharing aural and visual information, and the ability to extend the sense of touch through robotics.

COMPUTERS

At first, computers functioned as electronic calculators, crunching numerical data translated into on–off signals. In 1890, computers were used to handle census data, but it was not until the late 1940s with ENIAC and 1951's UNIVAC I that electronic digital computers became common technologies for business and government uses. Early computers required that users type in information using such language codes as BASIC, COBOL, FORTRAN, LOGO, PASCAL, and others, which required the user to behave somewhat like a telegraph operator who needed to translate alphanumeric symbols into Morse Code. With these early computing programs, users had to learn the special codes that fed information into the machine, usually via punch cards with holes or rolls of tape, which then encoded the information into on–off bits to be stored, transmitted, and decoded back into the original forms of the information. It was a slow and costly system that tended to restrict the messages to *emphatic communication*, except for the non-significant messages carried to test the systems. The large main-frame computers carried messages of significance for businesses and governments. It was not until the evolution of the personal computer that allowed word processing to replace electric typewriters and, later, typesetting machines that computers could be used to encode, store, and retrieve typed alphanumeric information without the knowledge of special codes. The use of computers in graphics enabled visual artists to create, manipulate, and store images electronically.

Even with these moves toward more user-friendly computers, the mes-

sages were not significantly different from those carried earlier by other public media, remaining largely in the form of words, numbers, and still images. Advances in microprocessors that allowed miniaturization of components increased the storage (memory) capacity and the processing (encoding–decoding) capacity, providing sound and moving images to the message systems. McLuhan's principle that the contents of new media were the older media still applied. The computer itself tended to shape the kinds of messages that it could encode–decode and it depended upon earlier media to carry its messages. Words, numbers, and images were printed (by typewriter, dot matrix, or laser) on paper, as were images. Some were printed onto books, magazines, newspapers, and other forms of typographic media. The computer-generated copy could be read over radio and television to reach mass audiences. And manuscripts moved from typewriter to word processor, making alterations, corrections, and other changes much more efficient.

The messages carried by ELIZA seemed to involve communication between a human and a thinking machine, but Joseph Weizenbaum, its inventor, thought that the users were only communicating with themselves by using ELIZA as a channel, but the deeper message was that human communication tended to be reduced only to communication that the machine and program could process, a form of reification in which the symbols become the reality.[34] A more positive view of the messages structured by the computer is that they help to expand human consciousness and thought in a cognitive revolution in which people who study philosophy, psychology, artificial intelligence, linguistics, anthropology, and neuroscience unite to try to explain how the mind works.[35]

Computers allowed the development of games that could be played on the computers or on portable play stations. Among the most popular genres and titles for console games are: Action–Adventure—*Grand Theft Auto: San Andreas*; Fighting—*Super Smash Bros Brawl*; First-Person Shooter—*Halo 3*; Music—*Guitar Hero II*; Party—*Wii Play*; Platform—*Super Mario Bros.*; Puzzle—*Tetris*; Racing—*Mario Kart Wii*; Role-playing—*Pokémon Red, Blue,* and *Green*; Simulation—*Nintendogs*; Sports—*Wii Sports*; Stealth—*Metal Gear Solid 2: Sons of Liberty*; Survival horror—*Resident Evil 2*. The six top sellers of personal computer games by genre are: Adventure—*Myst*; Computer role-playing—*Diablo II*; First-person shooter—*Half–Life*; Real-time strategy—*StarCraft*; Simulation—*The Sims*; Third-person shooter—*Mafia: The City of Lost Heaven*. The top ten bestselling video game franchises are: *Mario; Pokémon; Tetris; The Sims; Need for Speed; Final Fantasy; Madden; Grand Theft Auto; FIFA,* and *The*

Legend of Zelda.[36] Whatever the specific messages contained in these games, most, if not all, of them promote competition of the zero-sum type and frequently involve the use of force or guile to overcome adversaries and opponents. Some involve explicit and extensive simulated violence that some critics think will encourage aggression in their players, a charge leveled earlier against motion pictures, comic books, television, and cable.

What is clear is that the computer did more than carry messages previously carried by older media; it also changed the shape and the content of the messages it carried. But its greatest impact on messages would be in its role as an integral component of the new digital conversion of all information into digital binary bits that could be coded, stored, transmitted, decoded, and shared by anyone with access to a computer linked to the Internet by telephone or cable line, microwave carrier, fiber optic cable, and satellite. Perhaps the most important message carried by computers was that they represented only the first stages of this new Cybernetic Revolution and that the future would bring new opportunities for more messages being shared with more people in more places more quickly, with greater storage of information over time. Although we are only some 60 years into the history of the digital computer, we can already bear witness to the power of its messages for individuals and cultures. How would your own messages be different if you did not have a computer? Would the Internet be possible without the computer? How would your own life be different if computers did not exist?

COMMUNICATION SATELLITES

Like computers, communication satellites tended to be viewed as no more than new channels for transmitting messages already carried by older media like the telephone, radio, television, and cable. And that is exactly what the satellites did carry for most of their first 40 years. For example, in 1965 the *Early Bird* satellite carried telephone messages and over 80 hours of television service. In 1969, satellites carried moving images and sound messages from the *Apollo 11* moon landing to an estimated half billion people across the globe. Beginning with TELESAT CANADA in 1972, Western Union's WESTAR I in 1974, RCA's RCASATcom F-1 in 1975, and AT&T's and COMSAT's COMSTAR in 1976, satellites began to provide domestic television signals and domestic and international telephone services.

The military proved to be major users of communication satellites for sending–receiving messages not only on Earth but for the command and control of satellites and missiles. Spy satellites allowed the military, the Central

Intelligence Agency (CIA), and the National Security Agency (NSA) to acquire and distribute information concerning possible threats to American National Security by foreign nations and terrorist organizations. Such satellite information, augmented by Predator Drone airplanes, was part of American intelligence and military operations in the Persian Gulf War (1991), the invasions of Afghanistan (2001) and Iraq (2003), and the subsequent efforts to control both of these countries after the invasions, including surveillance of the Afghanistan–Pakistan border areas. Spy satellites also allowed American oversight of other countries deemed to be potential threats to American interests and security, including China, Cuba, Iraq, North Korea, and others. NASA, of course, used satellites for the space missions to the moon and beyond, including the International Space Station. In time, the satellites carried messages for businesses, for radio and television programming, and all of the *emphatic* and *phatic* messages carried by the Internet. Educational institutions used satellites for Distance Learning and for reaching isolated communities and schools in large nations across the globe.

The number of nations involved in commercial satellite communication has grown from a handful in the 1970s to 40 in January 2010. Both the spread and the range of communication satellite countries are impressive. In addition to two international systems, Horizons 1 and 2, that serve North America, and RASCON (Regional African Satellite Communication Organization), here are the countries grouped by geographic area: In Africa, Egypt and Nigeria; in Asia and Oceana, Australia, China (People's Republic), Hong Kong, India, Indonesia, Iran, Israel, Japan, Kazakhstan, South Korea, Malaysia, Pakistan, Philippines, Saudi Arabia, Singapore, Taiwan, Thailand, Tonga, United Arab Emirates, and Vietnam; in Europe, France, Germany, Greece, Luxembourg, Netherlands, Norway, Russia, Spain, Sweden, Turkey, and the United Kingdom; in North America, Bermuda, Canada, Mexico, and the United States; in South America; Argentina, Brazil, and Venezuela. As one might expect, the United States leads with 20 commercial satellite companies, followed by Russia and China (including Hong Kong) with 5, France with 4, and India, Indonesia, and Japan with 3 each. All of the rest have one or two commercial companies operating satellites for communication.[37]

In addition to the Internet carrying messages from various sources, it also provides websites for governments, businesses, educational institutions, private and non-government organizations, associations, unions, advocacy groups, political parties, and other individuals and groups seeking to inform and/or influence anyone searching the web. Advertising messages are very prevalent

on the Internet, which promises to be the growing advertising medium for the present and near future. From websites to buttons and banners, sponsorships and added-value packages, and search engine marketing to classified advertisements and email advertising, the Internet carries messages of persuasion to all web users. It is an ideal medium for facilitating dialogue between companies and their customers and stakeholders (employees, stockholders, the news media, and other people of influence), a major component of what advertisers call *Integrated Marketing Communication* (IMC).[38]

To paraphrase and update Henry David Thoreau's question about Morse's electric telegraph, "What do these countries have to say to each other?" From the volume of personal telephone (including cell phone), radio, television, business, and other messages exchanged daily, the answer seems to be quite a lot. Whether these messages constitute attempts at genuine dialogue or consist mainly of dissemination of information intended to persuade the receivers is open to research and debate. What is clear is that by conveying digital signals from across the globe and redistributing them across the same globe, communication satellites have facilitated the integration of all audible and visual messages into binary digits and the sharing of these digitalized messages across space at the speed of light, with all time and space becoming *cybertime* and *cyberspace*, abstractions that are freed from any particular geographic now and here.

The real news of the Cybernetic Revolution is the integration of all media into user-friendly technologies that have the potential to connect every human being with every other human being and to every source of information encoded in digital form and available to all. Satellites, along with old-fashioned twisted copper wires, newer fiber-optic cable strands, microwave relays, and wireless connections, play an ever-more significant role in connecting people with people, people with machines, machines with machines, and machines with people in a cybernetic version of McLuhan's Global Village. Today, satellites provide people with direct radio and television broadcasting, and with the *Global Positioning System* (GPS) that provides humans with the information to locate themselves in time and space, whether on land, at sea, or in the air. While many of messages carried from cable, radio, telephone, and television tend to be nonessential except in emergencies, GPS messages provide real-time *emphatic* information that enhance people's chances for survival by showing and telling them where they are and how they can safely reach their destinations by the most efficient routes. Think of GPS messages as cybernetic updates of the messages our Paleolithic ancestors needed to survive the Ice Age.

Media

The single most important point to make about the media central to the Cybernetic Evolution–Revolution is that they are all digital electronic extensions of the audible and visible media made possible by our language instinct as manifested in sound and sight. Rather than using analog waves of electricity to carry sounds or images, digital encoding reduces all information to a series of binary on–off switches that can be decoded back into sounds or images at the receiving end of the transmission. In essence, the phonetic alphabet was digital encoding in which an arbitrary symbol represented a phoneme of a language in contrast to the pictographic or ideographic systems that used representational symbols to signify the referent, as with Egyptian hieroglyphs. Morse Code was the first binary digital system of the electric era of communication. Although it was superceded by the analog coding of the telephone, phonograph, radio, and television, Morse's Code was reborn in a more efficient manifestation that is the foundation for all electronic communication in the Cybernetic Age.

SOUND

As speech enabled humans to extend language beyond one person's thoughts, the new media of the Cybernetic Age further extended the human voice and all other communicative sounds across the entire world. The electric–electronic extension of sound through space made possible with Bell's telephone and the Marconi–de Forest–Fessenden–Armstrong radio was further extended by the transistor and other digital technologies into the mobile cellular phones that have challenged traditional wired telephony using either coaxial copper wires or fiber optic wires carrying digital signals via laser beams of light. The latest versions of the mobile phone, including the iPhone, not only provide wireless telephone connections across the globe but also can be used to send and receive email, to use Twitter, to browse the Internet, to take and store still and moving images, to record information via voice or typed text, to play video games, to calculate mathematical equations, to access maps and global positions, and to use for whatever other applications (apps) made possible by the electronic digitalizing of information. The race to provide more and more attractive applications (apps) for cellphones continues to be a battle among a number of cellphone companies, including Apple, Research in Motion, Samsung, Google, Microsoft, Nokia, and the smaller Palm.[39]

Sound was extended through time by Edison's phonograph and Berliner's gramophone which allowed sounds to be stored for later listening on cylinders

and flat discs (records) that would be augmented by tape recorders (reel-to-reel and cassette). Later, the Sony Walkman in 1978, digital Compact Discs (CDs), in 1982, and the iPod in 2001 provided greater storage capacity, fidelity of sound, and transportability. In 2010, a Best Buy circular advertised three such devices: Apple's iPod Nano 5th Generation, with "Built-in video camera, speaker, microphone and FM radio with Live Pause feature"; a Sony Walkman, with "Built-in stereo speakers, FM radio tuner/recorder and voice recorder"; and a Zune HD, which "Features HD Radio Technology, Internet browsing, multi-touch OLED touch screen, music and games." The same page also offers a Sansa 8GB Fuze MP3 Player, whose "FM tuner and MicroSD card slot let you listen to music or watch videos."[40]

The interfacing of computers, cable and telephone connections, fiber optics, and the Internet now allows people to receive radio as recorded sounds via downloading or streaming of digitalized information which can be stored in computer hard drives (memory), on compact discs (CDs), on flash memories, and in Cloud computing, where you can access information from "cyber-storage" memory banks maintained by computer service companies. Through wired or wireless connections, many digital media can be interfaced with your computer to form one integrated and interactive system that not only allows you to acquire and store audio information but to share that information by sending it to other people in the form of digital signals over the Internet or "burnt" into CDs for later listening, thereby challenging the protocols for copyrighted information established to deal with phonograph recordings and radio broadcasts of the previous evolution–revolution. This follows the usual practice of rules and regulations struggling to catch up with changes brought by new techniques and technologies of communication.

High definition radio (HDR) carries Armstrong's FM signals in digital form over the air, via the Internet, through cable, or directly from satellites to be played on radios, home audio centers, or wireless HD audio systems, iPods, and other receiving–storing–playing devices. What digitalization in all of its manifestations has made possible is greater freedom for the individual to both send and receive information via sound wherever one can be connected by wire or by wireless technologies to the global–local ("glocal" in advertising parlance) cyberworld of total information.

SIGHT

In the beginning, humans communicated visually through facial expressions (grins, smiles, grimaces, etc.) and conventional gestures (waves, arm and hand

signals, etc.) that had both general and cultural significance. In moving beyond what Nature provided to the creation of human-crafted visual signs and symbols, human beings began our long journey from carved and painted images on stone and cave walls to statues and temples and tombs, a journey from oral prehistory to literate civilization. The visualization of language, and later speech, with logographic and alphabetic writing extended words through both space and time since clay tablets, papyrus, silk, and later paper allowed messages to be transported from one place to another while parchment and stone preserved messages over time. Print further extended writing through both space and time in the form of newspapers, magazines, and books that could be both transported and stored.

Morse's electric telegraph extended words and numbers encoded in binary digits through space at the speed of light during their transmission over wires. Marconi's wireless freed the telegraph from its wired connections, opening the doorway to radio and television (accompanied by radio sound). Early teletypewriting reduced dependence upon the scribal limitations of Morse Code, and the mid-1970s *videotext* (displays of text and graphics on television screens) and *teletext* (continuous streams of information broadcast to television receivers) provided pathways to future extensions of text and graphics via electronic media. Early computers were entirely text driven and required users to learn various "computer languages" that now seem as strange and old-fashioned as ancient writing systems.

Accompanying the evolution of writing becoming electrified, graphic images in the 19th century moved from human crafted to Nature crafted through light, lenses, and chemistry. As photography evolved into cinematography, these visual media were almost always accompanied in their public viewings by text in the form of titles, captions, and accompanying text in print publications and as titles, subtitles, and other textual information in motion pictures. What the digital revolution provided was a simple way of reducing all visual information to its simplest form of binary on–off signals. With digitalization of visual media, most distinctions between film and video became insignificant, and both media became one new medium in which moving images, synchronized sounds, and accompanying graphics and text are part of a unified whole. While people still go to theaters to see and hear motion pictures (whether on film or digitally delivered), home entertainment centers equipped with large high definition screens and high definition multi-channel speaker systems are providing serious competition. Even the distinctions between television sets and computers are lessening, although most television

sets are receivers only while computers continue to be senders and receivers, with growing numbers of younger people using their computers as their main devices for receiving and sending visual information.

Digitalization has now overtaken film in the recording, storing, and sharing of photographs. Although still written by light, pictures are now stored and retrieved as digital bits of information that have no material form until printed on special paper by a wireless multifunction printer. Of course, digitalization allows pictures to be stored and displayed on a screen with devices like Insignia's Digital Picture Frame with 800×450 digital resolution, a one gigabyte (1GB) internal memory, and automatic rotation of images, or Brookstone's Digital Photo Keychain which can store and display 100 photographs on a high-resolution one-inch square (2.5 centimeter) screen. Both, of course, are totally compatible with other digital systems.

High definition television (HDTV) finally became the standard system in 2009 with the conversion of American television from analog to digital, a lag attributable to cultural, economic, and political concerns rather than caused by lack of technological expertise. Here is a good case to illustrate the frequent phenomenon of a society that once led in a technological innovation lagging behind when new technologies overtake and replace the older ones. A similar situation happened to the typewriter, which employed the standard QWERTY order of the keys to keep keys from entangling on manual typewriters by separating letters that frequently accompany each other in American English. Despite attempts at replacing this now-obsolete order with more efficient arrangements, like the familiar ABCD or the supposedly faster for English DVORAK, QWERTY continues to dominate keyboards for even the most advanced digital information processors and transmitters–receivers. Once again, culture limits the development of technology.

Another extension of sight relates to the evolution of electronic delivery systems for reading texts not simply on computer or television screens but on hand-held readers generally called *eReaders* like these that were available in 2009: Amazon's Kindle and Kindle DX; Barnes & Noble's Nook; and Sony's Reader Touch PRS–600 and Daily Reader. Three additions in 2010 were Disney Digital Books, an online e-book portal for children; IREX DR 800SG, with wireless access through Verizon; and Plastic Logic's Que, a wireless reader with an 8×10 inch screen.[41] Whether these electronic digital readers will complement, supplement, or replace printed paper pages for books, magazines, and newspapers remains to be determined, but at the least they are already challenging traditional printed media for authors, content, and readers. Still, in

whatever encoding and delivery system, the reading of words as text will continue for the foreseeable future.

TOUCH

The sense of touch has been part of human communication from the beginning and continues its key role in interpersonal face-to-face communication. But graphic imaging and writing only required touch in the crafting of the signs and symbols used to create the images and the scripts. Looking and reading required only the visual sense (unless the reader read the text aloud). Typography further excluded touch except in the manufacturing and handling of the printed texts. All of the media involved in graphic, hypergraphic, and electrographic communication extended sight, with sound added to film, television, and cellphones, while neglecting touch. The Cybernetic Evolution–Revolution revived hopes for creating *robots*, machines that could think and act like human beings, an aspiration that dates as far back as ancient China and Greece. In *Sailing to Byzantium*, the Irish poet William Butler Yeats wrote of robotic birds

> *Of hammered gold and gold-enamelling*
> *To keep a drowsy emperor awake;*
> *Or set upon a golden bough to sing*
> *To lords and ladies of Byzantium*
> *Of what is past, or passing, or to come.*

Both Leonardo da Vinci (1452–1519) and René Descartes (1596–1650) are reported to have designed and built robotic machines to perform functions like people. The 18th century witnessed a proliferation of mechanical musicians, clocks, and other toys that amused rather than performed needed work. In 1923, the Czech writer Karel Capek (1890–1938) in *R. U. R.* (Rossum's Universal Robots) gave us the Czech word for serf, *robot*, to label all artificial duplications of life forms. At the 1939 New York World's Fair, the Westinghouse Corporation's exhibit featured *Electro*, a robotic man, and *Sparko*, his robotic dog. Until artificial intelligence was combined with computing and other technologies, robots were largely relegated to toys and science fiction, although theme parks like Disneyland, Disney World, and Expo featured robotic people, animals, and monsters in their exhibits and rides.

Cybernetic technologies have moved robots from games and future dreams to realities in a wide range of human activities. Robotics has revolutionized industrial production from the gathering and refining of raw materials to the design and manufacture–robofacture of products across a wide spectrum of

human needs and wants.[42] Robots have also played significant roles in medicine not only for educating medical personnel and students and for administration and dispensing of medications but also for surgery and improvements in prosthetic devices of all types. Robotic technologies have also extended the reach of doctors and researchers to enable them to touch instruments, people, and devices not actually present in the same place. Robots also allow medical personnel to handle dangerous biological, chemical, and nuclear substances with greater safety.[43] Even with these more serious uses, robots have not disappeared from the world of games and toys, where they play an ever-increasing role in enjoyment for young and old alike.[44] While robots have been invaluable for explorations on the moon and Mars, perhaps the most interesting and significant cases of robots has been in the areas of military intelligence and operations and in local and national security where they are employed to detect and neutralize dangerous people and weapons. Using digital command and control systems, the military is able to deploy distance-piloted air, ground, on the sea, and under the sea vehicles to gather visual intelligence, locate targets, and direct gunfire, rockets, smart bombs, and other missiles on hostile forces. Despite resistance from some key military personnel, especially in the U.S. Air Force, unmanned aerial vehicles (UAVs) became a key new weapon in Afghanistan and Iraq, used by both the military to combat terrorists in war zones and surrounding territories (like Pakistan) and by the Central Intelligence Agency (CIA) to combat terrorists all around the world.[45] There has been one unforeseen downside to the collection of information by drones. As a headline in the *New York Times* noted, "Drone Flights leave Military Awash in Data," causing the Pentagon to seek help from the television industry, especially its analyzing and reporting of sporting events, to sort all of the video data collected in order to identify the information needed for survival from less emphatic information and mere "noise."[46]

The sense of touch plays a part in robotics and in virtual reality, in which people interact with computer-simulated environments, either modeled on reality or based upon fantasy. In addition to visual data on screens or through stereoscopic goggles and auditory data through headphones or speakers, some advanced systems also offer tactile feedback through wired gloves, clothing, and footwear. In *The Metaphysics of Virtual Reality*, Michael Heim lists seven types of Virtual Reality experiences: simulation, interaction, artificiality, immersion, telepresence, full-body immersion, and network communication. [47] While useful in military and police simulation training and enjoyable in home computer game applications (like those supplied by Nintendo's Wii), it may be that

future applications of simulated environments will allow humans to extend all of their senses in cyberspace and cybertime.

CONVERGENCE

The digitalization of all information wrought by the evolution–revolution of the Cybernetic Age has made it possible to integrate all of the media that extend language through sound and sight and, now, touch. The older distractions between those media that extended one sense or the other have little meaning in the Brave New Cyberworld of Today and Tomorrow. Smartphones and their cybernetic cousins are devices that can be carried anywhere, that are capable of connecting anywhere with any other device, and that can function as a telephone, teletypewriter, audio player and recorder, still and moving image recorder, computer, and transmitter–receiver of information available digitally. These new metamedia will unite the senses electronically as they are united in reality by extending sound, sight, and touch from beyond the here and now to cyberspace and cybertime. That, of course, is the vision of the technophiles but not that of the technophobes who question all claims for technological solutions to human communication questions. Ecologists of media will take a more dialectic approach, waiting to see what costs this *Faustian Bargain* will bring. But one change already is clear: Changes in media in the Cybernetic Age have moved, are moving, and will likely continue to move at an ever-increasing pace, in a kind of cybernetic hyperdrive.

Impacts

The impacts of the Cybernetic Evolution–Revolution on individual societies and global interactions have been profound. Perhaps no earlier evolution–revolution, except language itself, has had such profound consequences for all of the peoples and cultures of the world because of the totality of the changes in communication wrought by cybernetics and by the rapid spread of the techniques and technologies across the globe in an extremely short period of time. Even if we date the Cybernetic Age to the late 1940s with the Shannon–Weaver–Wiener Cybernetic Theory of Communication and the invention of the digital electronic computer, it has been only 60 years since the transition from the Electrographic–Electrophonic Age to this new digital age of integrated media and total communication.

If change has been the one constant in human life and communication

since we became human, the rates of change have changed. It took millions of years of evolution for us to become fully human, with language developing some 200,000 to 50,000 years ago. The earliest true writing appeared only some 5,000 years ago only in two places—Sumer and Egypt—and it took until the 20th century for literacy to even become moderately available across the globe. It took almost 4,500 years from early writing to be extended by full printing in the 1450s. Another 400 years passed before photography began the Hypergraphic Revolution and Morses's telegraph began the Electrograph–Electrophonic Revolution of the 1830s–1840s. Electricity freed communication from transportation and carried the technological seeds of the digital electronic transformations to come. The Electric Communication Age lasted from the 1840s to the late 1940s, after which it shared the stage with the emerging digital techniques and technologies that first complemented and later replaced the analog systems that gave us the telegraph, telephone, phonograph, radio, television, and cable.

Changes in communication media that marked each of these evolutions–revolutions tempt us to focus on the latest change as defining an age, as though the earlier ages no longer existed. But language did not entirely separate us from our pre-linguistic communication systems involving touch, smell, gestures, signalic grunts, and other ways we share with our primate relatives and, indeed, with all other animals. As some recent research has shown, baboons, chimpanzees, monkeys, and other primates employ sophisticated systems of oral signals to communicate information needed for survival and social organization.[48] Humans incorporated language into their communication capacities, allowing them to extend thinking in time and space through speech and visual symbolic imagery. Just as we retained our pre-language communication systems after we learned to speak, we retained speech and visual imagery even after we learned to write. (It is worth remembering that while speech and visual image-making seem to be the result of evolutionary changes, writing and all other systems of human communication are the results of cultural and technological changes.) When printing was developed, speech, imagery, and writing did not disappear; their roles in communication changed but were not eliminated. The evolutions–revolutions in graphics and electric media did not eliminate print or any of the other systems that preceded typography. And the Cybernetic Revolution did not eliminate any of the earlier evolutions–revolutions; it only changed how they would function in the new age of total integrated media of communication. While the camera using lenses and film may become rare or obsolete in the digital age, the taking, storing, and sharing of

visual images captured by light will remain for both still and moving pictures. While Morse's telegraph may be a discontinued technique–technology, the electric–electronic transmission of signals carrying information will continue, and the latest metamedia, incorporating sound and sight encoded in computers and smartphones sending messages over coaxial cables, fiber-optic lines, microwave relays, and communication satellites to wired and wireless computers, smartphones, broadcast and cable radio and television receivers, can be thought of as a cybernetic extension of Morse's binary digital system that began the Age of Electrified Communication.

The Cybernetic Evolution–Revolution is the latest stage in the long series of evolutions–revolutions that began with language. It has had its greatest impacts on the cultures and nations that first developed or employed digitalization to improve the gathering, encoding, storing and transferring of messages. In 1989, Thomas Shannon proposed a three-zone model for categorizing nations according to their economic, labor, and technological capacities to embrace and use the new media of the Cybernetic Age—core nations that facilitate modernization; semi-peripheral nations that aspire to join the core, and peripheral nations that are least developed in terms of economics and technology. The core nations include the United States, the members of the growing European Union of 25 nations, Australia, Canada, Israel, Japan, and New Zealand, with China emerging in 2010. The semi-peripheral nations include Austria, Brazil, Denmark, Finland, Hungary, Poland, Russia, Sweden, Switzerland, Singapore, South Korea, Egypt, India, Argentina, Chile, Mexico, Malta, Slovenia, and Venezuela. The peripheral nations are largely those usually labeled the Third World of developing (or underdeveloped) countries, including most of Africa, large parts of South America and Asia, and the lesser-developed nations in Eastern Europe.[49] A key point to remember about this triad classification is that it is not permanent. Since 1989, China has moved from semi-peripheral to core status, and other nations may make similar moves as digitalization spreads across the globe. Unless there is some catastrophic event, like nuclear war, famine, revolution, etc., the trend should continue to be toward greater modernization for all nations. Just as the Typographic Revolution made the Renaissance permanent, the Cybernetic Revolution has made the Information Revolution a permanent reality.

With mobile phones, the top ten countries in the world in 2010 in terms of number of cellphones per population were:

1. Taiwan (106.45%);

2. Luxembourg (101.34%);

3. Hong Kong (92.98%);

4. Italy (92.65%);

5. Iceland (92.65%);

6. Sweden (88.5%);

7. Czech Republic (84.88%);

8. Finland (84.5%);

9. United Kingdom (84.49%);

10. Norway (84.33%).

The United States is number 29 with 48.81%, perhaps attributable to its excellent landline telephone system. The bottom five nations are: 39. Indonesia (5.52%); 40. Vietnam (2.34%); 41. Cambodia (1.66%); 42. Laos (1%); and 43. Burma (.03%). The overall global average is 59.3%, a figure that is certain to increase in coming years.[50] In terms of overall numbers, by September 2006, the number of global cellphone subscribers had grown to 2.5 billion of the then 6-plus billion people on Earth, an increase in half a billion since a year before. By 2007, the number had grown to more than 3 billion, with continued growth expected.[51]

Figures on television in terms of hours per person per week show a similar pattern across the top thirteen countries: 1. United Kingdom and United States (28); 3. Italy (27); 4. Ireland, France, and Germany (23); 7. Australia (22); 8. Denmark and Netherlands (20); 10. Belgium (19); 11. Finland, Norway; and Sweden (18), for an average of 22.1 hours per week for each person in these countries.[52]

Radio, by the very nature of its limitation to sound, tends toward local and regional use according to language, with some global networks carried by short-wave and the Internet.

The Internet, that most central component of the new cybernetic metamedia convergence, also has had a substantial growth. According to Internet World Stats, Internet use for seven geographic areas grew substantially from 2000 to 2009:[53]

Table 7.1 Internet Usage for Seven Geographic Areas

World Regions	Internet %	Growth 2000–2009 %
Africa	6.8	1,392.4
Asia	19.4	545.9
Europe	52.0	297.8
Middle East	28.3	1,648.2
North America	74.2	134.0
Latin America/Caribbean	30.5	890.8
Oceania/Australia	60.4	175.2
World Average	25.6	380.3

Source: www.internetworldstats.com

However we analyze those statistics, they tell us that the Internet is a growing global force in media that will continue to define and structure information for some time to come. The Internet has given people access to global databases and to the most extensive and efficient system of two-way communication ever known, one that allows voice, music, data, text, and still and moving images to be shared with everyone everywhere. Email alone has become a major service used by Internet subscribers. According to a 2008 study by The Radicati Group, the number of people worldwide using email totaled some 1.3 billion, about one-fifth of the estimated 6,767,805,208 world population that year.[54]

Of course, the impacts have not been totally beneficial for everyone. Older media have been changed by the newer media, with printed books being challenged by e-books, magazines by webzines, and newspapers by online news services. Conventional television broadcasting has been declining in audience numbers for some time, first affected by cable and then faced with competition from digital alternatives. Motion picture audiences in theaters are being replaced by audiences for home theater, video streaming, DVDs, Blu-ray, and other methods of experiencing movies. Conventional photography, using cameras with lenses and shutters that record images on film, may well become an art form for specialists, rather than a popular medium for the masses. The same fate seems to face conventional motion pictures that use film to record and project moving images with synchronized sound.

An unexpected impact on all areas of information and knowledge has been the tremendous amount of new and old information now available on

every subject in every field of inquiry, interest, scholarship, and study, from the trivial to the significant. In January 2007, Jim Gray, a database software engineer at Microsoft, proposed that computing was forcing science into a new, fourth paradigm approach that added to experimental, theoretical, and computational science the need for new computing systems to manage what he called the "exaflood" of data now threatening to overload researchers.[55] The information overload that earlier challenged human beings is now challenging the programs and machines that are computing this tidal wave of data made possible by the Cybernetic Revolution, not only in science but in every area of human life where information is needed for physiological, cultural, economic, political, or social survival.

While information overload is a challenge to everyone, other challenges concern disparities in command and control of media and information. These include the New World Information and Communication Order (NWICO), Electronic Colonialism Theory (ECT), and the World Systems Theory (WST); all concern themselves with questions about the fairness of present communication systems and possible solutions to those questions.[56] At present, these concerns and debates are more theoretical than practical, since they have little or no impact on the reality of communication in the world.

In addition to these concerns about the negative impacts of Cybernetic technologies are more general reservations about technology and its impacts on culture and society. The French social theorist Jacques Ellul, in *The Technological Society* (1964), *Propaganda* (1965), and *The Technological Bluff* (1990), warned of the dangers to individual freedom and human culture of "technological civilization."[57] Following in Ellul's path, the American cultural and media critic Neil Postman warned against both *Technophiles*, "one-eyed prophets who see only what new technologies can do and are incapable of imagining what they will *undo*" and *Technophobes*, "one-eyed prophets…inclined to speak only of burdens…[but] silent about the opportunities that new technologies make possible."[58] Both Ellul and Postman advise us to be cautiously critical about new techniques and technologies (what Ellul calls "*la technique*") and their impacts upon people and cultures. As Postman put it, "New technologies alter the structure of our interests: the things we think *about*. They alter the character of our symbols: the things we think *with*. And they alter the nature of community: the arena in which thoughts develop."[59] Ellul and Postman, along with Socrates, Harold Innis, and Marshall McLuhan, are inviting us to engage in some serious critical thinking about the impacts of changes in media on individuals and cultures.

How have the new media of the Cybernetic Age changed the ways you

think, communicate, and live? Have their altered your concepts of time and space? Which senses have they extended? What benefits have you received from these new media? What disadvantages have you experienced with these new media? What unexpected consequences came with these new media? On balance, do you find the changes wrought by these new media to be worth the costs? Is the *Faustian Bargain* fair?

Limitations

Identifying the limitations of the five earlier evolutions–revolutions was relatively easy because we had the benefit of hindsight afforded by later eras in communication history. We now find ourselves in the incunabula of the Cybernetic Age, and we need to engage in some critical analyses of our current techniques and technologies of communication.

INFORMATION

Some critics have claimed that Information Theory does not address questions about the quality of information while others have said that it is limited in describing the dynamics of human communication in different cultures.[60] These are fair criticisms that need to be addressed. At the outset, I must acknowledge that all theories and models are fallible because all human beings are fallible. But what gives Information Theory its power is its very openness to change. It is a dynamic theory that describes a dynamic universe. As Jeremy Campbell notes, "Information theory did not regard a message as a separate, independent object, but as part of an organized system, related to the other parts even if those existed only as possibilities."[61]

What Information Theory does is to recognize that any system of human communication, however mediated, is highly complex, never entirely describable, and, therefore, not fully predictable. Humans survived by becoming generalists, and language allowed us to extend our ability to be even more general in how we extended our communication of information across space and through time. The structural codes of language and all of their extensions in media, from speech and graphic imagery to typography, photography, and cinematography, to electrography and electrophony, to the electronic digitalizing of all media, have provided humans and human cultures with ever-expanding choices of how to acquire, encode–decode, store, and share information from multiple sources to multiple destinations. All of the new and revised media that constitute the Cybernetic Age of Communication are outward physical manifestations of the ideas central to the Shannon–Weaver–Wiener Cybernetic

Model. These new metamedia not only provide us with more choices and a wider variety of choices in how to communicate but also invite us to ask ourselves some questions. How much variety is too much? Is too much information as threatening to our survival as too little information? How much change can an individual or a society handle before suffering culture shock? Should we, as individuals or as members of a society, place any limits or restrictions on the command and control of information and information systems? What are the limits of Information Theory itself? What does it fail to explain about cybernetic media and communicating in the Cybernetic Age? Can Information Theory help us to learn how to improve human communication by lessening misunderstandings? Can it help us to find ways to distribute communication systems more equitably among peoples and cultures? What do you want to understand about media, culture, and communication? Why? Can Information Theory help you toward this understanding? How?

METAMEDIA

The limitations of today's computer and programs are readily apparent to the people and companies involved in these areas. Almost daily, new or improved products and services are announced by producers of cellphones, digital cameras, radios, television sets, audio–video recorder–editor–players, computers, fiber-optic cables, microwave transmitters, satellites and their uplink and downlink connections, cable systems, and Internet servers and access systems. The technological imperative will compel us to seek greater efficiency in how these systems operate. How can we make them smaller, with greater capacities and lower costs, using less energy, and more capable of overcoming limitations of time and space? How can we further integrate all of these systems into one metasystem? How can we make them simpler to understand and easier to use? How many applications do you want for your communication media?

At the 2010 Consumer Electronics Show in Las Vegas, Nevada, the messages, for the most part, echoed themes of improvements in existing media: "Big, bright, thin flat TV screens. Eco-conscious design. Reduced power consumption. Download services (Vudu, Netflix, Amazon) built into more TV sets and Blu-ray players. Incrementally improved cameras, camcorders, printers, laptops, Blu-ray players, accessories, audio gear, home theater stuff, phones, car electronics."[62] Among the all-new offerings were more e-book readers to compete with the Kindle, Nook, and Sony Reader devices now on the market. But the headline-grabbing news was the promise of three-dimensional television (3-D TV) in the future from LG, Panasonic, Sony, Samsung, and Toshiba, although

the technologies are still in development, with special glasses needed to see images that have less definition than regular high definition television (HDTV) provides now.[63] The 3-D TV effort seems to have been propelled by the success of *Avatar*, the critically-acclaimed and highly-profitable film that did much to revive interest in the 1950s Hollywood experiment with three-dimensional motion pictures. But whether *Avatar* will be the catalyst for a revolution in 3-D film is still an open question, with financial reality likely to play a major role in determining its future. Simply put, the question is whether the heavy investment in time and money will be worth the financial rewards. James Cameron, the director, and Vince Pace, an effects specialist, developed a special camera that allowed "a director to view actors within a computer-generated virtual environment" that has little relationship to the actual sets in which the scenes are shot.[64] The future of 3-D films will depend upon how quickly the technologies involved become more efficient (in terms of time, effort, costs, etc.). For example, if the 15-year production time and the production and marketing costs (about $460 million) can be reduced to two years and the costs cut significantly, the 3-D motion pictures may become the accepted, even preferred, norm, as was the case with the moves from silent to sound films and from black and white to color films.[65]

The 2010 Consumer Electronics Show introduced a number of new electronic reading devices to compete with Amazon.com's Kindle and the Sony Reader, including an Apple tablet computer and other touch-screen devices that will enable people to read for longer periods of time without eye strain or depleting battery power. Other devices will enable users to "surf the Web, watch video and play casual games, without being tethered to a bulky laptop and its traditional keyboard."[66] The show also promised digital media that would return control of these media from keyboards, remote controls, and other devices to the human hand from major PC (personal computer) companies. This "gesture revolution" will become a reality in 2010 when Microsoft's new video game *Project Natal* attempts to improve upon the technology offered by Nintendo's *Wii.*[67]

The need for ever-expanding memories for storing the flood of information made possible by the Cybernetic Revolution is being met by NAS (Network-assisted storage) units, like those provided by the Iomega Hume Media Network Hard Drive, My Book World Edition II, the Netgear MS2110, and the Apple Time Capsule. Each "provides a central hard drive in which you can store, share, and back up all files from multiple computers in the household. Unlike an external hard drive, an NAS device has a processor and uses its own operating sys-

tem for storing and sharing photos, music, video and personal files."[68] The newer drives allow users to access the stored data from iPhones, BlackBerrys, and iPod Touches, providing one to two terabytes of memory.[69]

A single edition of the *New York Times* Business Day on January 4, 2010 provided stories on the new Apple tablet (later named the iPad) that promises to help book publishers to survive; on a plan to make digital movie files as portable as DVDs; on enhanced applications for non-smart "feature phones"; on technology to allow people to watch television shows at the same time in different locations; on how the mobile phone is replacing the landline telephone, the digital camera, the MP3 player, and the wristwatch; one new multitouch screens in consumer electronics; and on venture capital flowing to the development of more mobile computers that will erase the differences between mobile phones and computers, making a keyboard and mouse as archaic as the punched cards for old main frame computers are now.[70]

A report by the Pew Research Center for People and the Press (December 21, 2009) found that Americans continued to have largely positive views of the new and evolving technologies of the Cybernetic Age.[71]

Technology	Positive Change	No Difference	Don't Know	Negative Change
Cell phone	69%	11%	5%	14%
Internet	65%	11%	8%	16%
BlackBerrys/ iPhones	56%	12%	7%	25%

On the uses of these technologies, the results were more mixed:

Use	Positive Change	No Difference	Don't Know	Negative Change
Email	65%	19%	9%	7%
Online Shopping	54%	24%	8%	15%
News and Entertainment Choices	54%	27%	3%	16%
Social networking Sites	35%	31%	12%	21%
Cable news talk & opinion shows	34%	31%	5%	30%
Internet blogs	29%	22%	7%	63%
Reality TV	8%	45%	8%	40%

What do you think about these survey results? Where do you find yourself among those answering the questions? Are you a Technophile, a Technophobe, or an Ecologist? Who will benefit from increased convergence of media with increased efficiency in their uses? Do you foresee a continuing evolution in efficiency for cybernetic media for the next 5, 10, 20, or 50 years? Can you conceive of the next evolution–revolution in communication? Will it come with changes in quality of communication brought by massive changes in quantity of media encoding, storing, and transmitting of messages?

Three areas of concern raise serious questions about the limitations of digital communication that are both technological and cultural: censorship and cyberwar; piracy and privacy; and the individual versus the collective. The first set of concerns was highlighted in the 2009–2010 clash between Google and China over Chinese control of access to websites and alleged Chinese cyberattacks on private Gmail accounts.[72] Despite concerns about the trading of human rights and freedom of expression for profits, many digital companies continued to do business as usual in China, including Microsoft and Apple. The double attraction of increased profits for digital communication companies and the U.S. government's attempts to improve relations with China seemed to have limited the American responses to these threats to free expression and to the security of the Internet.[73] The second set of concerns also involved Google because of its "disregarding the rights of individual authors as it builds an immense digital library and bookstore" and for its own violations of individual privacy.[74] But piracy and privacy are not issues restricted to corporations and governments. Individual cybernetic communicators are also involved. A 2005 national survey conducted for the Business Software Alliance reported that two-thirds of college and university students had "no ethical reservations about illegally downloading digital copyrighted files from the Internet for free—swapping them electronically with other people."[75] The third set of concerns is one that has echoed through the ages since Socrates raised questions about the relative worth of speech versus writing in promoting true communication. What is the role of individual critical thinking in an environment that values groupthink, the idea that the collective is superior to the individual in deciding what is true and worthwhile? In his 2010 *You Are Not a Gadget: A Manifesto*, Jaron Lanier, an artist and computer scientist, argues that the collectivist ethos, what he calls "cybernetic totalitarianism," threatens to replace individual thinking with digital conformity, reducing people to mere units like drone bees in a beehive.[76] Here, Lanier is following in a long line of critics that stretches from Socrates

to Innis and McLuhan, and to Ellul and Postman, all asking us to think for ourselves about the limitations of technology to solve problems of human thought and communication.

Where do you find yourself in this dialogue? What are your own thoughts about these three areas of concern? Are ethical questions framed by changing techniques and technologies of communication? Do we need new ethical guidelines for the Cybernetic Age? Are censorship and cyberwar inevitable in global digital media? Are protections from piracy and expectations of privacy outdated values left over from the Typographic Age? Are questions about the individual versus the group irrelevant in a time of massive interconnections between and among people, cultures, and nations? Are group security and solidarity worth the price of individual free will and choice?

Will human beings need to become *cyborgs* (cybernetic organisms) for the next evolution–revolution in communication to become a reality? Will we need to integrate media technologies into our bodies, brains, and nervous systems in order to extend our capabilities to overcome the limitations of time–space and energy–matter present with our current media techniques and technologies? Are improved techniques and technologies of media the answer to the problems of human communication? Will these new and improved media help us to survive as individuals, as groups, as cultures and societies?

Consider how far we have traveled since 1948 with the introduction of Information Theory and the realization of the digital electronic computer. One binary digit (*bit*) of information represented one single on–off switch in a computer. In 1956, the term *byte* to represent eight bits of information came into use. With the expanding power of computers, people were forced to provide ever-expanding terms to represent greater number of bytes: *kilobyte* (one thousand bytes), *megabyte* (one million bytes), and *gigabyte* (one billion bytes). Newer terms include *terabyte* (fortieth power), *petrabyte* (fiftieth power), *exabyte* (sixtieth power), *zettabyte* (seventieth power), *yottabyte* (eightieth power). These numbers alone indicate that we are now awash in a sea of information, in danger of drowning in an environment with too many sources providing too many messages encoded digitally and carried by too many media, creating problems of separating information from noise and *emphatic* communication from *phatic* communication.

The techniques and technologies of the Cybernetic Age hold great promise to improve the communication of messages among a wider range of people across the world than was ever possible in the earlier evolutions–revolutions.

What do these changes portend for the future of human communication? Will the Cybernetic Age close or widen the gaps between the have and have-not peoples and cultures of the world? How will command and control of information and information systems be exercised? Will technology itself shape how we communicate? How will human beings use these communication techniques and technologies? How will these techniques and technologies shape how human beings think and feel, and how we express our thoughts and feelings with other human beings? Will we become more comfortable in "communicating" with machines, with "living" in digital environments, and with "experiencing" virtual reality?

Is total Human Communication possible or is it simply a fantasy that distracts people from some very real possibilities for improving our abilities to obtain valid and reliable information that will enhance our chances of survival not only for the core technologically advanced cultures and nations but for everyone on the planet? Before we make more advances in Artificial Intelligence, perhaps we need to put some serious effort and resources into improving human intelligence for all of the peoples of the Earth. The new media of the Cybernetic Age do hold the promise of providing more choices for more people to create, acquire, share, and use more information than was ever possible before this evolution–revolution. As always with questions involving changes in human communication, there will be the technophilic boosters of the new media and technophobic naysayers warning of doom. Perhaps the best way to think about the Cybernetic Age is to take an ecological view that is critical of all claims, whether technophilic or technophobic, and expect all human communication systems to be imperfect, with limitations always present. The future will favor those who are able to identify and enhance the positive attributes of these systems while working to improve or overcome their limitations.

Whatever directions the evolution–revolution of communication may take in the Cybernetic Age and beyond, they will still involve the desire to use energy and matter to overcome the limitations of time and space in order to share information needed for human survival. The journey that began with the Big Bang some 13.7 billion years ago and continued with the evolution of *Homo sapiens* some 200,000 years ago did not end with speech and imaging, with writing, with printing, with hypergraphics, or with electrographics and electrophonics. It will not end with cybernetic communication, unless we cease to exist as human beings in technological civilizations. Whatever the future holds, it is

well to remember that we are now living in a Cybernetic Age that has just passed from infancy through childhood to the beginnings of adulthood. Maturity is yet to come, and all of us living in the core cultures of this age can contribute to shaping the future of human communication.

· 8 ·

BECOMING CRITICAL THINKERS ABOUT EVOLUTIONS AND REVOLUTIONS IN HUMAN COMMUNICATION

Our long journey in human communication history began at the beginning of everything when The Big Bang some 13.7 billion years ago created all space and time, all energy and matter, and the information needed to keep all systems operating. We are creatures who evolved on a small planet in a minor solar system where life began some 4 billion years ago. Our own Primate Order evolved only some 50 million years ago, and our hominid ancestors separated from their primate relatives only some 7 million years ago. Some findings published in *The Proceedings of the National Academy of Sciences* (January 19, 2010) estimated that all modern human beings have descended from a population of 18,500 breeding hominids in a population of some 55,000 about 1.2 million years ago, what we call *Homo ergaster* in Africa and *Homo erectus* in East Asia. In comparing the estimated populations at that time for chimpanzees (21,000) and gorillas (25,000), it would seem that, in terms of survival, hominids were not a very successful species for a long time, and the physical investment in larger brains and retarded maturity would not result in population sizes sufficient to ensure survival of the human species until the coming of agriculture some 10,000 years ago.[1] As this book has argued, the command and control over the natural environment that distinguish *Homo sapiens* from our fellow creatures were the results of the evolution–revolution in commu-

nication that gave us language, that uniquely human ability to symbolize our inner thoughts and express them outwardly in audible and visible signs and symbols.

Human language shaped human culture and made possible all of the changes in techniques and technologies that form the history of human communication. Nature equipped us with five senses with which to experience the world—sight, sound, touch, smell, and taste. In our social and cultural communication, we have used sight and sound as our primary senses to extend our messages over space and time, with touch providing significant messages in intimate and small group exchanges of information until the digitalization of information, robotics, and virtual reality also extended human touch from the here and now. Our communication systems are limited not only by our physiological sensory limitations but also by the limitations of the universe itself. How do we use energy and matter to overcome the limitations of space and time that restrict our actual lives to the here and the now? While we have not been able to be physically in more than one place at one time or to move backward and forward in time at will, we have used communication media to symbolically be present everywhere at the same time and to receive messages from the past and send messages to the future. Our systems of communication, from speech to imaging and writing, to typography and hypergraphy, to electrography and electrophony, to cybernetic communicating, have become so much a part of our lives and our cultures that we fail to see their profound influences on how we perceive the world, on how and what we think, on how we share information with other human beings.

Language, expressed outwardly as speech and visual symbols, helped to create in early humans a shared narrative that aided the preservation of tribal memory for a culture. Using mnemonic devices and visual signs and symbols, the group narratives preserved selected memories of the past deemed valuable for survival in the present and future, whether that survival was physiological or cultural, real or imagined. In Greek mythology, this looking backward is personified by *Epimetheus* (afterthought), the brother of *Prometheus* (forethought) who stole fire from the gods to benefit human beings. Although it is relatively easier to recall the past than it is to predict the future, even "history," whether oral or written, is open to selective memory, selective recording, selective editing, and selective interpretation. Limitations in terms of sources, encoding, storage, retrieval, sharing, and interpretation shape the messages we call "history," even without deliberate manipulations and propagandizing by those charged with keeping the information intact for generations to come. The

oral cultures that existed from the time that we became fully human some 200,000 to 50,000 years ago are still the norm today for many of the 6.7 billion humans inhabiting the Earth. Speech still remains our primary and most central medium for the exchanging of information, and much of our created media can be viewed as ways to extend speech. Imaging, that other outward manifestation of the language instinct, provides the basis for most of the other mediated extensions of human communication.

Oral memory, even when augmented and enhanced with mnemonic devices, visual aids, and group narratives, is usually unreliable, more responsive to the needs of the present rather than true to actual events. The invention of writing some 5,000 years ago in Egypt and Sumer provided a system of recording the present for preservation in the future, but most of our narratives about ancient Egypt and Sumer came from sources that were written long after the events being related. For example, *Gilgamesh*, an epic Babylonian poem describing events that supposedly occurred around 2,000 B.C.E., survived only on clay tablets found in the library of King Assur-bani-pal (668–626 B.C.E.). Similarly two accounts of the Greek–Trojan War that occurred in the beginning of the 12th century B.C.E. were not committed to writing until the 8th century B.C.E. with *The Iliad* and *The Odyssey* (both attributed to but not actually written down by Homer, the Ionian singer of epic poems). Even the chronicle of the Egyptian pharaohs that begins with the unification of the two kingdoms of Upper and Lower Egypt about 3100 B.C.E. was compiled long after by a Greco–Egyptian priest named Manetho during the reign of Plotemy I, Greek governor of Egypt from 323 to 305 B.C.E. and pharaoh from 305 to 282 B.C.E. . Manetho's *Egyptian History*, which divided that history into a series of 30 dynasties from the unification by Narmer to the last native-Egyptian pharaoh, Nectanebo II, in 343 B.C.E., was based on documents and records preserved over some 2,800 years, a longevity made possible by the invention and continuity of the Egyptian writing system of hieroglyphs and hieratics.[2]

Writing is the great preserver of information, and our knowledge of ancient civilizations and their peoples is made possible by the deciphering and translating of texts carved on the walls of temples and tombs, written on papyrus sheets and scrolls, impressed into clay tablets and envelopes, and inked onto sheets of parchment, silk, and paper. Writing allowed human beings to record information outside of human memory, extending both memory and information beyond the limitations of the here and now. With writing, messages could be carried across space from here to everywhere that a written message could be sent and received. With writing, messages could also be carried across time

from now to the future but not to the past. But writing was limited in that it could only carry a unidirectional message that required a response to be sent back in space, with time lags for both sending–receiving and for feedback. With time, the direction of the flow of information is always toward the future, with no return messages possible.

Each of the five evolutions–revolutions in human communication after language itself, with its speech and visual imagery manifestations, can be viewed as progressions by which people in specific times and places attempted to use energy and matter to extend their messages and message systems beyond the limitations of space and time imposed on language by Nature. If the ultimate goal is some mystical and mythical quest for immediate and total communication and understanding, some kind of true communion of meaning, then all of our created systems, from writing and graphics to typography, hypergraphy, electrography, and electrophony, and cybernetics, have failed to reach that goal. That, of course, was Thoreau's point about Morse's electric telegraphy—that it was only "an improved means to an unimproved end." For Thoreau, improvements in achieving genuine human communication had to come from improving human language as expressed in thinking, in speaking–listening, and in writing–reading. But if the goal of new techniques and technologies is a more modest one that seeks to improve language and its outward manifestations by providing them with improved systems to reach more people across space and time than would be possible in the natural environment, then we can view the history of these evolutions–revolutions as part of the technological nature of *Homo sapiens* as a species.

Whatever else distinguishes human beings from our primate cousins and all other living creatures, it is language and its manifestations in verbal and visual systems of communication, in culture, and in the techniques and technologies of tool-conceiving, tool-designing and redesigning, and tool-using that have changed us the most. Before human beings learned how to build permanent settlements, to use herding of animals and agriculture to provide steady supplies of food, and to organize large social systems not bound by family, clan, or tribal loyalties, we were not profoundly different from our primate cousins in how we lived. And despite some differences in our physiology and culture, we were quite close to our last fellow hominids—the *Neanderthals*. In the time between our becoming human some 200,000 to 50,000 years ago and early civilizations some 5,100 years ago, we moved from the world of Nature in which humans lived as best they could to a world of Nature as modified by human culture and technology in which humans began to play a growing role in actively chang-

ing themselves and their natural environments.

Communication is the core of what makes us different because language itself is an instinct that evolved in our primate and hominid ancestors and enabled our species to survive, to thrive, and to prevail over other species and, to some extent, over Nature itself. And to understand any of the techniques and technologies that humans have invented to improve our communication systems, we need to understand the simple fact that all human communication is based upon our instinct for language. Language is not merely one of the many changes that made us human; it is the catalytic change that allowed us to use our larger brains, our bipedal locomotion and upright posture, our opposable thumbs, and our other biological inheritances to create human culture. That is why this text has argued for an approach to understanding all human communication as a series of evolutions and revolutions that extended language through our sense of sight, sound, and touch in order to enhance our chances for survival in both the world of Nature and the world of Nature plus human culture and society. Change is the key concept in assessing these evolutions and revolutions. When the changes are gradual or do not involve a significant shift in techniques and technologies or in the paradigms that describe them, we call these changes evolutionary. When the changes are abrupt or involve new ways to communicate or to describe communication, we call these changes revolutionary.

It is possible to see the Big Bang as the only true revolutionary change in the cosmos because that was the instant in which all time and space, and all energy and matter came into being. With the Big Bang, whatever came before is unknown and possibly unknowable, and we can only gain knowledge about time since the Big Bang. In *A Brief History of Time: From the Big Bang to Black Holes*, Stephen W. Hawking reminds us of the oneness of all existence and of the human search for meaning in the cosmos: "…ever since the dawn of civilization, people have not been content to see events as unconnected and inexplicable. They have craved an understanding of the underlying order of the world. Today we still yearn to know why we are here and where we came from."[3] While Professor Hawking's interests lie in the nature of the cosmos and mine are restricted to human communication, I would nevertheless stress that communication is part of the interconnectivity of the physical cosmos that began with the Big Bang and continues today with the expanding universe that seems to be governed by laws knowable to human reason.

As a theoretical physicist following in the paths of Sir Isaac Newton and Albert Einstein, Hawking rightly insists that any theory in science has to sat-

isfy two criteria: "It must accurately describe a large class of observations on the basis of a model that contains only a few arbitrary elements, and it must make definite predictions about the results of future observations."[4] In this text, I have tried to adhere faithfully to the first criterion in order to describe human communication as a series of evolutions and revolutions that are marked by significant changes in how people acquire–create, encode–decode, store, transmit, and share information in order to enhance their chances for survival. That history has carried us from the evolution of human beings and the language instinct to the dawn of the Cybernetic Age. Whatever changes, both evolutionary and revolutionary, came in human communication, however unexpected and unpredictable by many people, all conformed to the basic laws of the nature of the universe, involving time and space, energy and matter, and information, and how they relate to each other and to the whole. Where this text lacks scientific credibility is in its inability to predict with accuracy and reliability future evolutions and revolutions in human communication. The reason that this is true is because human communication is not entirely a natural system obeying laws of Nature but a hybrid system that evolves both *processes* of Nature and *practices* of human beings. To the extent that human communication systems involve natural *processes*, they are subject to laws that govern biology, chemistry, and physics. In this area, we can make some reasonable predictions about what specific techniques and technologies of communication media might achieve in the future. But to the extent that human communication systems involve human *practices*, they are open to influences that involve human choices based on individual and/or group needs and desires, hopes and fears, events and circumstances, and historical changes in general. In order to think critically about the history and future of human communication one must keep the distinction between *processes* and *practices* clearly in mind.

Context

In order to understand how human communication changed slowly (evolution) and rapidly or profoundly (revolution) in terms of both the techniques and technologies of media and the paradigms people used to conceive and perceive these media systems, we need to consider the significant roles played by both natural *processes* and human *practices*. We need to begin our examinations with the *context* in which significant changes occurred. The time, place, and circumstances within which the changes took place form both the physical and communication environments that provided the motivations for the change and the

techniques–technologies and the mindsets that made the change possible. In terms of *processes* of Nature, the environment needs to contain the energy and matter required to construct the media central to the evolutionary or revolutionary change. In terms of human *practices*, the culture needs to possess some understanding of how to use and alter these natural *processes* for communication purposes.

While language was a biological and physiological gift from human evolution, the ability to express that gift outwardly in visual images, clothing, tools, myths, rituals, and other manifestations of culture required both the ability to conceptualize these activities as symbolic structures and the availability of natural resources that provided the energy and matter needed for these human activities. No amount of ingenuity in knowing how to adapt, improvise, and overcome will be of much use unless we are in environments that contain the natural resources needed to make such ingenuity a reality. In *Guns, Germs, and Steel: The Fates of Human Societies*, Jared Diamond makes a strong case for context as the determining variable in explaining why some cultures and peoples developed differently in terms of technology and wealth. In the afterword to the 2005 edition of the book, Diamond reiterates his central conclusion:

> My main conclusion was that societies developed differently on different continents because of differences in continental environments, not in human biology. Advanced technology, centralized political organization, and other features of complex societies could emerge only in dense sedentary populations capable of accumulating food surpluses—populations that depended for their food on the rise of agriculture that began around 8,500 B. C. But the domestication of wild plants and animal species essential for that rise of agriculture were distributed unevenly over the continents.[5]

In this perspective, Diamond comes close to echoing the words from *Ecclesiastes*: "I returned and saw under the sun, that the race is not to the swift, nor the battle to the strong, neither yet bread to the wise, nor yet riches to men of understanding, nor yet favor to men of skill; but time and chance happeneth to them all." What Diamond and the writer of *Ecclesiastes* are telling us is that life is unfair and that rewards are not commensurate with innate gifts and endeavors alone. Time and place and circumstances play major roles in influencing changes in all human techniques and technologies, including those used in changing human communication systems. If nothing else, these caveats should make us cautious about reaching overly-bold conclusions about why some peoples and cultures developed more advanced systems of communication while others did not.

Still, we must note that the survival of *Homo sapiens* and the extinction of *Homo neanderthalis* seem to have depended more upon innate abilities than upon environmental factors since both species shared and competed for the same environments. It may well have been our more advanced symbolic language instinct that gave us the edge in the struggle for survival. Certainly the ability and willingness to adapt, improvise, and overcome in the face of new challenges provide not only species but peoples and cultures with ways to overcome these challenges by being able to change cultural beliefs and behaviors. With communication, problems of acquiring–generating, coding–decoding, storing–transmitting, and sharing of information provided challenges to many emerging societies in the time between the end of the last Ice Age and the dawn of civilization, but only two societies—Sumer and Egypt—overcame these challenges by developing full writing systems that helped them to structure large, complex nation–states unified by fortified cities, common languages, centralized governments, powerful armies, efficient bureaucracies, organized state religions, and shared cultures. The natural environments of Sumer and Egypt differed, with Sumer forming along the valleys between the Tigris and Euphrates rivers that were open to invasion and Egypt forming along the two sides of the Nile River with vast deserts protecting the sides and invasion possible only from narrow stretches of land to the North and South. While Sumer was invaded and controlled by a number of peoples and cultures speaking different languages while still retaining cuneiform as the writing system, Egypt was able to maintain a continuing culture for almost 3,000 years, despite internal revolts and external invasions. The center held, helped in large part by the centralizing forces of the pharaoh and the state religion and organizations he controlled, with that control resting on the Egyptian language and its hieroglyphic–hieratic writing system.

The very slow spread of writing as a foundation for civilization tells us that other environments may have not been as hospitable to domestication of animals and crops, but as literate cultures expanded they were able to incorporate nonliterate peoples and societies into their growing civilizations. As would be true with future techniques and technologies, including those needed for communication, some peoples and cultures would invent or be born into them, some would achieve them through adoption, and some would have them thrust upon them by other peoples and cultures. In any case, time and chance happened to them all, except for those peoples and cultures that managed to escape the spread of technological expansion, those we generally label as "tribal," "pre-technological," "underdeveloped," or "undeveloped," all pejorative

terms that assume that certain levels of technological development ("the latest") are not only the norm but also the ideal for all peoples and cultures. Still, history shows us that even advanced civilizations can be overtaken by other forces, frequently from lesser-developed cultures. Thus, Sumer fell to invaders, and Egypt succumbed to nonliterate Hyksos and Nubian invaders and to Persian, Greek, Roman, and Arab conquerors who were literate but lacked Egypt's 3,000-year history.

In the 2nd century of the Common Era, China was the most technologically-advanced civilization on Earth and would continue to lead all others in innovations until the end of the Middle Ages (800–1400). In communication, the Chinese possessed a logographic writing system that they still use today, silk and paper to store their written information, and the beginnings of printing. Any communication scholar in 1400 would have concluded that the next revolution in communication would surely come in China, possibly with the full development of printing with type, ink, press, paper, and binding. But, as we know from hindsight, that fulfillment did not come from the Chinese or from the Arab conquerors of Samarkand who appropriated Chinese techniques and technologies for ink-making, papermaking, and printing. Instead, the Typographic Revolution would come from the small city of Mainz in a very non-unified Germany where human *practices* provided the insight and ingenuity to assemble all of the techniques and technologies developed in other places by other peoples to create a communication system that would change the world forever.

Printing spread throughout the world and stabilized communication from the 1450s to the 1830s and 1840s when photography and electrography–electrophony brought new evolutionary–revolutionary changes. Although these changes had been long envisioned, only the advances in science and the theoretical understanding of how light, chemistry, and electromagnetism worked provided the technical and conceptual environment conducive for turning these dreams and theories into realities. While the early experiments in photography and electromagnetic communication began in Western Europe, the focus for development quickly moved across the Atlantic Ocean to the United States of America, a nation only founded in 1787. America emerged as the leading nation in the evolutions–revolutions of hypergraphics–photography–cinematography, and electrography–electrophony, expanding its role during and after the two world wars of the 20th century (1914–1918 and 1939–1945), emerging in 1945 as the preeminent technological civilization on Earth. Despite Soviet challenges to that supremacy during the Cold War, America continued

its domination in most fields of science and technology, including communication. The Cybernetic Revolution began in the United States in 1948 but has spread globally since that birth, now encompassing all technologically developed societies.

What evolutionary changes that have come with cybernetic media and what revolutionary changes in communication that may or will come in the future will depend upon both the possibilities and limitations of the *processes* of Nature inherent in the media technologies involved and the possibilities and limitations of the *practices* that human beings are able to employ in conceiving, inventing, and using these media. If history is any guide, the people and cultures that are open to new ideas and inventions from within and from outside their societies will be most able to cope with the changes needed to overcome the new challenges. With our biological evolution now at a steady state, changes in *Homo sapiens* will only come with some technological modifications to our natural *processes*, enhancements of bodies, brains, and sensory abilities made possible by technology. From the first crafting of a visible sign or symbol by a human being, we have been involved in extending our natural endowments with human inventions to extend ourselves, our thoughts, and our senses from the now and here of experience through time and space to other people in other times and locations. What is needed for successful cultural mutation to overcome biological determinism is a balance between innovation and tradition, between change-for-change sake and inertia, between blindly embracing the future and blindly clinging to past practices. In short, what is needed is a socio-cultural environment that values the balancing of information and entropy in order to move forward with the arrow of history that travels with increased communication that reduces ignorance and uncertainty by half with each bit of information. In my judgment, the Cybernetic Model of Communication developed by Claude E. Shannon, Warren Werner, and Norbert Wiener and "The Open Society" construct developed by Karl Popper provide us with sound foundations for our explorations into the contexts within which human communication has evolved, is now evolving, and is likely to evolve in the future.

What do you think are some significant problems and limitations in the acquiring–generating, coding–decoding, storing–retrieving, and sharing of information in language, speech, visual imaging, writing, typography, photography, cinematography, graphics, electromagnetic communication, and cybernetic digital communication that need to be addressed in the near future? What *processes* of Nature will facilitate or hinder attempts at solving these prob-

lems and limitations? What *practices* by human beings and cultures will facilitate or hinder attempts of solving these problems and limitations? What types of cultural environments will be more responsive to change? What types of cultural environments will be less responsive to change? What do you think will be the future centers for change in communication? Why do you think as you do?

People

The central people involved in each and all of the evolutions–revolutions we have studied were people very much like most human beings. That is, they were very much people of their own times and places who responded to challenges to improve communication by extending language through the senses of sight, sound, and touch through time and space. All *Homo sapiens* were involved in the evolution of the language instinct which different groups of humans fashioned into the wealth of different language families and languages that have been the norm from the very beginning of language. That no language or language family is inherently superior or inferior to another is a fundamental principle of all language study. Each language is shaped by its speakers in specific environments to communicate information vital to those speakers in those environments. Power in language comes from other forces—cultural, economic, historical, military, political, social, etc.—that empower languages used by power elites formed by individuals or nations.

The extension of language in symbolic writing and imaging brought power to the cultures that developed and spread writing and to the people who commanded and controlled these symbolic systems of communication. These were peoples and cultures that were able to recognize the possibilities of progress in the development of new ways to extend human communication. When people and cultures achieved a stable society and communication system, they tended to be more conservative, preserving what worked in the past into the present and the future. Thus, the peoples of Mesopotamia and Egypt clung to their ideographic–logographic writing systems long after the phonetic alphabet was first formulated about 1500 B.C.E., even though both cuneiform and hieroglyphs–hieratics contained phonetic signs. Similarly, the Chinese saw little significant gains in developing full typography despite inventing ink, paper, typeface, and ways of imprinting characters on surfaces. The very conservative culture of Ancient China found reinforcement in its complex writing system and social organization that valued secrecy above all when it came

to communication of information among a wide audience. Simply put, no one in Mesopotamia, Egypt, China, or any of the other literate societies of the Ancient World was encouraged, or even allowed, to introduce a new system of phonetic–phonemic signs to represent speech more efficiently with fewer symbols that could be learned by children.

The West Semites developed the consonant alphabet that was carried by the Phoenicians across the Mediterranean Sea to the Greeks, who added vowels and then passed it on to the Etruscans and Romans in what is today's Italy. In each case, the development, adoption, and change were made in response to the needs and wants of the people involved, who used this more efficient writing system for commerce and trade, for recording the sacred scriptures of their beliefs, for preserving the myths and legends of their cultures, and for organizing and administrating their far-flung empires over time and space. But the Greeks and the Romans, even in their later manifestations in the Eastern (Byzantine) Empire and Western (Roman) Empire, failed to see the need for moving alphabet literacy from handwriting to printing. That revolution would come in a city that once was on the northeastern edge of the Western Roman Empire. What Gutenberg accomplished was to unite the techniques and technologies of metal carving, metallurgy, typecasting, ink-making, papermaking, and the screwtype press into one unified system for efficiently producing multiple copies of texts in shorter periods of time, with less labor, fewer errors, and lower costs.

These changes from the periphery would continue with the evolutions–revolutions wrought by hypergraphics, electromagnetics, and digital electronics, with outside voices and inventions proposing and providing new techniques and technologies of communication that the centers of command and control did not think were needed or wanted. During the evolution–revolution in electrographic–electrophonic communication, something changed in how change came in communication, with research and development moving from the edges to the centers, although we still witnessed some centers missing the technology adoption curve as IBM did with the personal computer (PC) before Apple's mini-revolution of 1984. The Cybernetic Revolution, as we have seen, sprang from people involved in large-scale corporate communication industries and from people involved in the defense systems of NATO (North Atlantic Treaty Organization) nations and the Warsaw Pact Nations (the Soviet Union and its client states), what is usually labeled "the Military–Industrial Complex." Today, the people involved in conceiving the theoretical approaches and in designing the techniques and technologies required to turn theory and design

into usable technologies tend to work in large organizations.

Who are the people you identify as being at the cutting-edge of the new techniques and technologies of media that will continue the Cybernetic Revolution or plant the theoretical and technical seeds for the next evolution–revolution in human communication? What dreams, hopes, and ideas do you have to improve human communication? What kinds of people will be needed for future evolutions–revolutions? What kinds of education and training will they need? How can you tell a visionary from a charlatan? What techniques of critical thinking are helpful to you in answering these questions?

In *Teaching as a Subversive Activity* (1969), Neil Postman and Charles Weingartner attempted to provide some strategies for survival in an age of rapid change: "…survival in a rapidly changing environment depends almost entirely upon being able to identify which of the old concepts are relevant to the demands imposed by the new threats to survival, and which are not."[6] Which concepts about communication and media do you think are relevant to the demands for information imposed by today's threats to our communication systems? How can people learn to distinguish between concepts that are relevant to survival and concepts that are no longer relevant? Obviously, the author of this text thinks that a critical examination of communication history divided into six evolutions–revolutions is one way toward critical thinking about media, culture, and communication. What do you think? Why do you think as you do?

Messages

How did the *processes* of Nature enable and/or limit the quality and quantity of the messages made possible by each of the six evolutions–revolutions in human communication? What limitations of time and space were involved? What types of energy and matter were used by the media in each evolution–revolution? What types of energy–matter transformation were employed in shaping the messages central to each evolution–revolution? How did cultural *practices* enable and/or limit the quality and quantity of the messages made possible by each of the six evolutions–revolutions in human communication? How were cultural *practices* changed or shaped by the quality and quantity of the messages central to each evolution–revolution? How did the central media of each evolution–revolution shape the messages they carried?

It is clear that the evolutionary *processes* that endowed *Homo sapiens* with

the ability to use speaking and hearing to externalize the language instinct enabled humans to share information more efficiently between and among other humans. Only human memory, augmented by visible markings, provided information storage and retrieval needed for survival. Messages could be carried from one place to another by people with reliable memories and from one time to another by people responsible for preserving the cultural memories of the family, clan, and tribe. With space, the time required for the sending and receiving of messages depended upon transportation until Morse's electric telegraph partially moved the sending of electric signals from transportation to transmission.

Writing helped to ensure that the messages sent over both space and time would contain the same information at both ends, employing the *processes* of Nature in terms of human energy and the alterations of matter to provide brushes, pens, pencils, reeds and other writing implements, inks and paints to record the symbols, and monuments and walls, clay tablets, stone flakes and walls, papyri, silk, parchment, paper, and other surfaces on which the symbols were pressed, carved, drawn, etched, painted, inscribed, or inked. Writing also required human *practices* that provided the actual writing systems used, including the signs and their order, the direction of the writing, and the arrangements of texts according to some standardized systems of organization. The time and knowledge needed to master a specific system limited the messages that could be carried by writing, as did limitations in the types of writing implements, recording ingredients, and materials carrying the writing.

The history of communication can be interpreted as a movement that allowed messages to be sent and received by a growing and widening number of cultures and of peoples in those cultures. Writing in all of the Ancient World, whether in Sumer and Egypt, in India and China, or later in Pre-Columbian America, was a highly skilled craft that required long and intensive training. Such scribal literacy lasted even into the alphabetic age in the Middle East, in Greece, in Rome, and in medieval Europe. And despite the help from printing and the electromagnetic media, enhanced by the Enlightenment and participatory governments committed to widespread social literacy, full literacy remains a goal in even the most technologically advanced societies today.

How many messages do you record and/or send by writing in an average day? Do you take notes by hand in classes or at meetings? Do you write notes and letters to acquaintances, family members, and friends? Do you write in a diary or personal notebook? What kinds of messages do you encode in writing?

What limitations do you find with writing? Are these limitations in thinking, encoding, storing, or sending? Why has writing not disappeared in the age of digital communication? Do you Text? Is Twitter a kind of digitalized writing?

Printing extended writing but imposed its own influences on the quality and quality of messages carried by books, magazines, newspapers, and other genres of print. The messages carried by print had tremendous consequences for science, religion, literature, history, exploration, government, business and commerce, and for information in general. Print enabled information to become more standardized and, therefore, more valid and reliable as subsequent printings corrected the information in earlier editions and publications. Printed messages provided the information foundations for the modern world of rationality in science and in life in general. After Gutenberg, societies with printing were populated by typographic people who relied upon information encoded, stored, and retrieved in printed formats that provided a fixity to what was worth knowing. In essence, printed messages contained and carried the information deemed most valuable by all cultures that embraced the Typographic Revolution.

How many messages do you send and receive by printing in an average day? Given the structure of print, most of its messages are received by most people, with few involved in sending and storage. How much of your message-receiving comes in printed books, magazines, newspapers, brochures, pamphlets, posters, and other forms of typography? What is the shape of these messages? What limitations do you find with printed messages? Are they too unidirectional and impersonal? Do you feel frustrated by your inability to ask for and receive clarification from the text? What messages do you receive in print that are more valuable than those from other media? Do you think that e-books will provide improvements in the messages carried by print? Should electronic print be made interactive? Why? Does print have a future in the Cybernetic Age?

The emergence of hypergraphics in the 18th century helped restore the visual to the media mix, enhancing the illustrations that frequently accompanied printed texts. Images again competed with words as carriers of significant messages in a culture, even if the images threatened to become the major messages, encouraging people to respond to the surface messages of images without considering the more subtle, and perhaps more significant, information contained in the text. Rather than being used to illustrate the meanings of words, images became messages themselves, with words added to explain the illustrations. Once exposed to widespread hypergraphic messages, people found

it difficult to read texts, especially in magazines and newspapers but in books as well, without graphic illustrations to accompany the words.

How many messages do you send and receive via printed hypergraphics in an average day? In general, hypergraphic messages are mainly received by the majority of people, with only a minority engaged in capturing, producing, and sending them. What roles do hypergraphic messages play in your information flow? What are the benefits and drawbacks of hypergraphic messages? Do you wish that they were more open to interactivity? Do hypergraphic messages encourage passivity in information processing? Do you think that hypergraphic messages will be carried by interactive systems? Will these interactive systems change the quality and quantity of the messages carried by hypergraphics? What would be gained and lost if we move graphic messages into the Cybernetic Age?

The evolution–revolution in electromagnetic communication involved both words and images, resulting not only in media, like the telegraph, telephone, and wireless, that were designed to carry *emphatic* messages, but also in media, like the phonograph, radio, and television, that carried both *emphatic* and *phatic* messages, with the latter dominating media devoted to entertainment. The telegraph extended alphabetic writing and restricted its messages because of the costs and time needed to send and receive messages. The telephone extended the human voice and expanded the quality and quantity of the messages that could be carried, but, of course, restricted those messages to sound alone. Wireless extended the telegraph but was limited to sound to encode–decode alphanumeric and punctuation symbols. When the wireless morphed into radio, it was able to broadcast messages, both *emphatic* and *phatic*, from a few sources and transmitters to a multitude of receivers and listening audiences. Television added moving images to broadcast sound in delivering messages to masses of people. The messages were shaped by these media and included both the significant and the trivial, with the trivial dominating in what would be called "the mass media."

How many messages do you send and receive each day via the landline telephone, the wireless telegraph, radio, and television? The telephone continues to be a carrier of *emphatic* and *phatic* messages by individuals, corporations, governments, institutions, organizations, et al. Wireless today is largely a carrier of *emphatic* messages of significance, but it has little impact on society at large. The phonograph, radio, and television carry messages that concern themselves with musical enjoyment with the phonograph and a mixture of news, entertainment, and advertising with radio and television (including cable as a simple car-

rier of television signals). How do you use these media for receiving information each day? Are the messages you receive *emphatic* or *phatic*? How do they enhance your chances of survival? Do the *phatic* messages bring something of value to your life? What would your life be like without the messages carried by these media? What alternative media have you employed to receive the messages previously carried by the telephone, phonograph, wireless, radio, and television? As all of these electromagnetic media move from analog to digital encodings and transmissions in the Cybernetic Age, what will be gained and lost? How will the messages carried by these media be reshaped by digitalization?

The Cybernetic Evolution–Revolution carries the promise to encompass all messages carried by earlier media into one unified digital cybermedium that will make the acquiring–gathering, encoding–decoding, storing–retrieving, and sharing of messages more efficient in terms of spanning time and space, using less energy and matter, and in carrying more messages to more people in an interactive system that extends human senses (sight, sound, and touch) through digital electronic techniques and technologies. This new age provides a reintegration of the senses that had been fragmented by earlier evolutions–revolutions and promises to provide a bright future for continued progress in improving the quality and the quantity of all messages in human communication.

We now live in this Cybernetic Age, with the cell phone–computer –Internet–satellite nexus providing a series of integrated techniques and technologies to carry messages. How do you send and receive messages today? Which of these subsystems do you use daily for your message exchanges? How do these subsystems shape and limit the quality and quantity of the messages you send and receive? How are these messages shaped by you, by other people, by your culture, and by the techniques and technologies of these subsystems? What would you like to be able to do in sending and receiving messages that you are unable to do now? Why?

Media

In identifying the media that were central to each of the six evolutions–revolutions in human communication covered in this text, we have been examining how these media have shaped and were shaped by the contexts in which they developed, the people involved, and the messages they carried. All of these media were shaped by the *processes* of Nature and by the *practices* of people in the environments in which they developed and spread. While many scholars

find Marshall McLuhan's aphorism "The medium is the message" to be an over-statement, I think that it does contain a core principle that all media tend to shape the messages they carry and the cultures within which they function. The medium of language, for example, was instrumental in helping to make us human. Whether different language families tend to encourage us to think differently continues to be debated, but there can be little debate that the language instinct did provide human being with a communication system that differs significantly from the communication systems used by our primate cousins among the bonobos, chimpanzees, gorillas, and orangutans.

How do you use language today? Do you talk and listen? How do you remember what you say and what others say to you? Is your memory efficient in remembering what you need to recall? How much of what you say and hear every day consists of *emphatic* communication and how much of *phatic* communication? How are both significant for your physical survival? For your emotional and psychological survival? For your cultural and social survival? For your intellectual survival? For your personal happiness? How much command and control do you have with language? What kinds of messages are facilitated and hampered by language? What are the limits of your language? Has the Cybernetic Evolution–Revolution helped or hindered your use of language to communicate with other human beings?

The medium of writing, in all of its manifestations, changed human languages and cultures wherever it became a dominant medium. Literate people think, talk, and act differently from nonliterate people. Literate cultures are organized and operate differently from oral cultures because writing extended human communication through space and time, facilitating the emergence of civilizations and empires with spatial reach and temporal continuity. In terms of sensory bias, writing extended sight, and the movement from pictographic to alphabetic writing enhanced abstract thinking over concrete thinking. Historically, writing divided history from pre-history and provided enormous advantages to the individuals, groups, cultures, and civilizations that mastered this medium. All of the foundations for scientific thought began with writing, as did history and all systematic record-keeping. Writing extended human thought and speech beyond the immediate environment through both space and time, further enabling human beings to learn from other human beings even when separated by space and time.

How do you use writing in your own life? What natural *processes* and what human *practices* are involved in writing? What senses are involved when you write? Do you feel you have command and control of your own writing, or do

you feel intimidated by grammarians and these textbooks, by language and writing teachers in school, by other writers? Do you feel more comfortable writing with a pen or pencil, with a typewriter or word processor, with a computer? Is your writing different when you use these different techniques and technologies? Where will writing and reading fit into the Cybernetic Age? Will they be enhanced or marginalized by new cybernetic megamedia? Will new systems allow us to enter information into computers by handwriting? Would it be better to stick to typing? Would direct speaking be better? Should all three methods be used? Why?

At its core, printing was invented to provide more efficient systems for producing multiple copies and more reliable storing of texts, but it soon proved to be a catalyst for changes in culture and communication that extended far beyond printing shops and libraries. The world after Gutenberg's Revolution was a different world in which centralized authorities were challenged by people with ideas and information that contradicted the accepted truths of peoples and cultures. If language helped to define us as human beings and writing helped us to create civilization, then printing assisted us in becoming rational, secular and scientific-minded people living in a modern world that encouraged and rewarded new ideas, new inventions, and new cultural, economic, political, and social systems. After 560-plus years, Gutenberg's invention is still very much with us in the form of books, magazines, newspapers, and other genres of print. What its future will be in the cyberworld of e-books, e-zines, news-online, and other formats is an open question that will only be answered in full in the future, but we can discern some movements now. There is little doubt that traditional printed-on-paper media forms will be challenged, changed, and perhaps replaced by the new cybernetic metamedia that encompass all previous media. Print enhanced the sense of sight and made it preeminent for communication, a position it continued to hold even with the latter evolutions–revolutions in electrophonic media.

What roles does print play in your life today? How do you use it in your communication mixture? Do you generate and send information by traditional printing? Do you receive and store printed information? Do you find printed information to be outdated in comparison with Internet information? Do you read print in traditional paper forms, or have you moved to electronic formats? Are there differences between the two delivery systems in terms of the sources, encoding–decoding, messages, delivery systems, reading, and sharing of information? What do you think will be the future of print in the Cybernetic Age?

Hypergraphics enhanced the visual–image in the age of printed texts, fur-

thering sight as the primary sense for human communication of messages. The media brought by this evolution–revolution were photography, mass graphic reproduction, and cinematography. The image (still, mass reproduced, and moving) challenged the word for carrying information to masses of people, threatening to replace sequential propositional thinking based upon language, writing, and printing with gestalt presentational thinking based upon the image. While photography invited masses of people to become producers of images for personal consumption, photography in graphic communication was commanded and controlled by centralized sources that produced reproductions of images in books, magazines, and newspapers, and on calendars, posters, and signs. Similarly, cinematography, despite some amateur users, became the province of large motion picture corporations that produced the vast majority of films shown throughout the world, a situation that still prevails today. Both the *processes* of Nature and the *practices* of people shaped how these hypergraphic media gathered, encoded, stored, and shared their messages with people. Despite the addition of synchronous sound to motion pictures, we still say we "see" a movie, just as we "watch" television, indicating the dominance of sight in the sensory mix we use with these media. Although individual people do exercise some command and control through choosing what images they will see, most of the power tends to reside with those who finance and produce the images to be consumed by the public. The Cybernetic Age has challenged and transformed photography, graphics, and cinematography, replacing lens and film with photoelectric cells and digital memories. The visual images captured from life by light, reproduced through graphic manipulation, and presented as moving images accompanied by synchronous sound will continue to be part of our media mix, but the encoding–storing–delivering system is likely to be quite different in the Cybernetic Age.

What roles do image-based media play in your communication? Do you still use a film camera to take pictures or have you gone digital? Do you receive graphic images printed on paper or in digital form? Is there a difference between the two systems? Do they represent different media? How much command and control do you have with traditional photography, graphics, and cinematography? Do you have more or less command and control when these media are transformed into digital data, captured and presented on your own computer?

The electromagnetic media that began with the telegraph, telephone, phonograph, and wireless provided the foundations for radio and television, two quintessential electric media that extended sound and sight and sound across the airwaves to mass audiences. In doing so, they helped to create the matrix

of ideas and theories, and techniques and technologies that would give birth to the Cybernetic Age. The telegraph and the telephone made information more accessible to ordinary people and changed how people thought about how messages were carried by different media. While the telegraph enhanced sight and the telephone enhanced sound, both worked to extend language as our primary system of communication. The phonograph enhanced sound and enabled people to store and play recordings of their favorite music and musicians. The wireless extended the telegraph in space but served a more significant role by being the precursor to radio and television. Radio and television need to be treated as one hybrid medium that extended first sound and then sound-plus-sight over the airwaves to multitudes of listeners and listening viewers.

What roles do these electrographic–electrophonic media play in your life today? How do you use them to obtain, store, and share information? As these media move from their traditional forms to newer digitalized forms, what is gained and lost? Is digital radio and television via the Internet or direct satellite transmission the same as broadcast radio and television? Are there any differences in terms of generation, encoding, storing, and sharing of information? Are there any differences in terms of command and control of the media? What do you foresee for the future of the telephone, phonograph, radio, television, and cable in the Cybernetic Age? Will they eventually all became digitalized and unified into one total cybernetic metamedium? What will be gained and lost by the move to digital systems?

The Cybernetic Evolution–Revolution not only altered older media, like the telephone, phonograph, wireless, radio, television, and cable; it also heralded the birth of new media like the computer, Internet, and satellites, all made possible by the Cybernetic Model of Communication and the digitalization of all information and the media that carry messages among people. In the most basic sense, all of the older and the newer media have become both the content and the media for the metamedia megasystems of the Cybernetic Age. These new metamedia now provide ways to communicate with cell phones, computers, Internet connections and sites, communication satellites, fiber-optic cables using laser beams, and all of the other media of the digital revolution.

Obviously, you are involved in this evolution–revolution, and these new metamedia are very much parts of your life. What roles do they play in your communication? Have they supplemented or replaced older media in your own acquiring–generating, encoding–decoding, storing–retrieving, and transmitting–sharing of information? How would your life be changed if you did not

have access to cybernetic media? Can you identify the major benefits you have received from using these new cybernetic media? Can you identify any drawbacks you have noted? Are you pleased to be living in the Age of Cybernetic Communication? Do you have pity or sympathy for those who are unable or unwilling to make full use of the new cybernetic media?

Impacts

In inquiring into the impacts that these six evolutions–revolutions in human communication have had on peoples and cultures, we have examined how communication media have played key roles in moving us from primate to human being, from nomadic tribal members to civilized citizens, from medieval to modern people, from transporters to transmitters of information, from analog to digital communicators. The history of human communication is the history of how we became who and what we are today. It is also a way of imagining who and what we might become tomorrow. The impacts of each of these evolutions–revolutions have been profound for all of the peoples and cultures involved in or affected by these changes in communication. Clearly, the impacts were different for different peoples and cultures at different times and places. Still, we can manage to reach a few tentative and possibly valid conclusions. *First*, those people and cultures able to exercise command and control over each evolution–revolution as it occurred tended to benefit more than those peoples and cultures unable to grasp the significance of the change. *Second*, these evolutions–revolutions brought both benefits and disadvantages within and among cultures. *Third*, these evolutions–revolutions also brought unexpected impacts that were both welcomed and unwanted. *Fourth*, the inventors and early developers of these evolutions–revolutions often failed to recognize the power and potential of their inventions and developments. *Fifth*, natural *processes* and human *practices* shaped how these evolutions–revolutions will have an impact on people and cultures, limiting any expectation of certainty in predicting future changes in communication techniques and technologies. *Sixth*, while technologies must conform to the possibilities and limitations of Nature, in terms of time–space, energy–matter, gravity and other forces, human beings have some freedom in deciding how to use the media provided by evolutionary or revolutionary change to improve communication and their own lives and cultures.

What do you think should be done, if anything, to provide more equitable distributions of media and their impacts on people in your own culture and society? Should you be concerned with yourself, with your family, with your own

country, with your region, or with the world in general? Why? What ethical questions concerning the nature of what is true, what is beautiful, what is good, what is worthwhile, and what is worth knowing do you think are worth asking? How would you go about seeking answers to these questions? From yourself? From your family or tribe? From your nation? From all peoples? From wise people? From written and printed texts? From messages over the air, via cable, on the Internet, or from other digital sources? What do you want the cybernetic media to do for human communication? How can your goals be achieved?

Limitations

All evolutions–revolutions in human communication will have limitations precisely because they involve human beings. We are fallible and limited creatures whose *practices* contain flaws that limit our reach, but we are also limited by natural *processes* we must use to construct our techniques and technologies. Thus, we are limited by our very biological inheritance as a species. We are able to think in symbolic structures, but there are limitations to our thinking patterns. We are able to communicate these symbolic structures of thinking with other humans through semantic, syntactic, and delivery (speaking and hearing) codes. Our outward manifestations of our language instinct are limited in time and space by our limited sensory organs that allow us to speak words in meaningful structures that can be understood by those who share our particular language codes. Orality allows us to share information, but it limits us to the here and now, with fallible human memories as the storage system we use to carry that information to other places and later times.

The limitations of orality, even when augmented by mnemonic devices like narrative structures (myth, repetition, rhyme and rhythm, alliteration and assonance, etc.), rituals, and visual markings, tend to shape the quality and quantity of information that can be shared and stored by individuals and groups of people. But we should never forget that our language instinct expressed as speech has served us well since we became fully human some 200,000 to 50,000 years ago. Despite efforts to "improve" language by inventing artificial languages and by trying to enforce vocabulary, syntactic, and pronunciation rules, normal human language continues to serve the needs of human beings even in the Cybernetic Age.

What limitations do you find with your own uses of language? With the language used by other people? Do you think that the existence of many different languages is a limitation to human communication? As the number of languages

spoken becomes fewer and a limited number of super-languages dominate com-munication, will that help or hinder human communication? Are different lan-guages merely surface manifestations of the language instinct with no significant differences in terms of sharing information, or do different languages encode the reality of experiences differently? Do people who speak different languages perceive the world differently? Think differently? Act differently? As the Cybernetic Age promotes some languages through the use of the Internet, will this be beneficial or harmful for peoples and cultures?

The limitations of time and space that bound orality to the here and now were partially overcome with the use of human energy and natural materials (modified for special uses) and the employment of our natural ability to use vis-ible signs and symbols as codes to communicate concepts, ideas, words, and eventually phonemes. Literacy partially freed us from the tyranny of the eter-nal becoming in which the present becomes the past with no precise demar-cation indicators. Each writing system, beginning with cuneiform in Sumer, hieroglyphs–hieratics in Egypt, characters in China, and script in India–Pakistan, and continuing with the birth and spread of the alphabet, contained limitations. Even the alphabet, that universal system capable of encoding every language efficiently with some 20 to 60 signs for phonemes, has not led to total understanding in the sharing of information. But writing did bring significant improvements in communication for those peoples and cul-tures fortunate enough to invent or adopt this new system of visual communication.

What limitations do you find with literacy in your life? What limitations of copying and storing led to the next evolution–revolution of typography? How is literacy as limited as orality in transcending space and time? How is literacy better than orality in transcending time and space? What limits writing as a medium for sharing of information? What problems of communication were not addressed by writing? How do you think writing could be improved? What lim-itations of writing have been addressed by the Cybernetic Evolution–Revolution? What limitations of writing still exist?

The Typographic Evolution–Revolution addressed some of the limitations of writing, especially with more efficiency in reproducing copies of texts and in providing multiple copies (redundancy) for memory storage and retrieval. But printed texts still needed to be transported to move information over space, rely-ing upon available means of transportation. The explosion in information and knowledge sparked and spread by the printing press created greater demands for more information delivered to more places more quickly. The expansions of

communities of knowledge facilitated by the European discoveries of new and old lands and improvements in transportation stimulated the globalization of information and of the techniques and technologies that encoded, stored, and retrieved that information. Human *practices* harnessed natural *processes* to provide power to propel machines with water and wind and to modify natural materials to produce glue, thread, and leather for bindings and paper and parchment for receiving the imprinted letters on pages. But energy for transportation still came from humans, animals, water currents, and wind captured by sails. Information transfer remained dependent upon transportation.

What limitations do you find with your own uses of typography? Does its one-way flow of information limit your ability to access and use this information? Would you like to be able to question the writer of a text? Would you like to be able to correct errors in the text? Is information found in printed texts different from information found in electronic digital formats? How will electronic books, magazines, and newspapers change your communication environment? Do you see any role for print in the Cybernetic Age?

The evolution–revolution in hypergraphic communication added photographic images to our visual systems of signs and symbols, bringing a kind of valid and reliable realism to the ancient arts and crafts of drawing, etching, and painting. The reproduction of photographic images in books, magazines, and newspapers allowed information to be spread to larger numbers of people. And cinematography created an entirely new media industry that brought moving images with synchronized sound to millions of moviegoers around the world. Still, these media remained dependent upon transportation to move information from one place to another, and the preservation of the information carried by film was endangered by deterioration of the film stock itself.

What limitations do you find in your uses of photography, graphics, and cinematography? Does their one-way flow of information trouble you? Do you wish they were interactive in some way? What limitations do you find with access to information carried by these media? Is information carried in photographs, graphic reproductions, and cinematography different from information carried by orality, literacy, or typography? What would you like these media to do differently to meet your own information needs?

The Electrographic–Electrophonic Evolution–Revolution solved some of the specific limitations of all of the media of the four earlier evolutions–revolutions by shifting the moving of information from transportation to transmission, but these solutions were only partial at best and, at first, did little to solve the problem of storing information over time. Although the gramophone–

phonograph did provide limited storage for sound, it was not until after the end of the Second World War (1939–1945) that practical ways to record audio and video information became available. The telephone improved the telegraph by providing sound to the wires, and radio improved wireless telegraph by adding sound to the airways. Similarly, television improved radio by adding moving images to the broadcast sounds, and cable improved television by providing clearer signals to people in areas with poor reception. But it would take the movement from analog to digital signaling to allow these media to become more efficient in moving information across vast distances in space and in preserving information through time.

What limitations do you find in your uses of the telephone, radio, television, and cable? What would you like them to do that they do now? Are these media only early versions of the cybernetic media now emerging? Will landline telephones become obsolete? Will radio and television cease to be effective as broadcast media? What is the future of cable television as a separate entity? Can any of these media survive without becoming part of the digital revolution?

Although we are only in the early days of the Cybernetic Evolution–Revolution, the advances and improvements in the techniques and technologies that are used to acquire–generate, encode–decode, store–transmit, and share information seem nothing less than spectacular, with changes coming not in centuries or decades or even years but in months. What is cutting-edge technology today will be obsolete tomorrow, as new instruments with greater efficiency and more applications replace older versions. The Cybernetic Age not only brought new techniques and technologies of communication but also a new way to think about communication, information, media, and messages.

While it is difficult to see the limitations of the communication age in which one lives, do you find any limitations with all of the media of the Cybernetic Age? What improvements would you like for your cell phone, computer, and Internet service? Would you like to see an integration of all forms of communication into one cybernetic suprasystem that is always accessible, always operating efficiently, always capable of sending information across the globe and storing it in unlimited quantities for unlimited time periods? Which of your cybernetic media would you find it difficult to live without? Are users of cybernetic media always going to be limited to the privileged elite in selected technologically advanced civilizations? What are the limitations of being a cybernetic human being?

A Critical Thinking Model

In our explorations into the history of human communication, we have focused on six major evolutions–revolutions that made significant changes in the ways that information was acquired–generated, encoded–decoded, stored–retrieved, and shared by human beings as they attempted to use energy–matter to overcome time–space limitations in order to enhance their chances for survival in the natural and cultural environments in which they lived. The key to using this model is to recognize and understand change as the key dynamic in all existence. To adapt, improvise, and overcome, we must first understand the possibilities and limitations of ourselves and our techniques and technologies of communication media. We need to be knowledgeable about the natural *processes* involved in human communication. What do the *processes* that control energy and matter allow us to do? What limitations are inherent in these energy and material *processes*? How can we use human *practices* to alter these *processes* for human uses? As our survey of communication has shown us, humans have used different *practices* to create new forms of both energy and matter. But while we can change the quality of both energy and matter, we can neither create nor destroy the total quantity of energy and matter present in the universe. Sound critical thinking rests upon knowing what is possible and impossible within the laws of nature. It also rests upon knowing what forces are likely to encourage or improve changes in human thinking and behaving. In other words, we need to understand the forces of nature and culture that influence what can be changed by human intervention.

From our examination of six evolutions–revolutions in human communication, it seems clear that the more open a society is, the more it is likely to be able to adapt, improvise, and overcome. Conversely, the more closed the society, the more likely it is to be resistant to the positive possibilities of change. This was true for our evolution from primates to hominids to *Homo sapiens* in our development of symbolic language and all of its outward manifestations in speech, visual imagery, tools, weapons, clothing, decoration, building and architecture, art, magic, religion, government, and other symbolic structures. The hominids who changed most by developing language survived; those who changed least became extinct. Similarly, the cultures that developed or adopted writing tended to survive and to dominate cultures that failed to develop or adopt literacy. The same dynamic was present with typography, with hypergraphics, and with electromagnetic communication. We are now in the mid-

dle of the first century of the Cybernetic Age, but already we can see evidence that more open societies have tended to benefit from these new digital media systems while less open societies have lagged behind not only in communication but in overall lifestyle as well. China provides an excellent test case for this proposition. Time will determine whether the rulers of China will be able to use the new digital media for social and economic growth while continuing to restrict access to information and media they deem harmful to their core interests. The 2009–2010 clashes between China and Google over censorship and cyberwar attacks on Google and other American computer networks and systems resulted in heated clashes between China and the United States over freedom of access to information, freedom of expression, and freedom from cyberattacks on national and international communication systems.[7] In all human affairs, natural *processes* and human *practices* interact in a dynamic dialectic that involves changes in the quality of energy and matter and in how humans use natural *processes* in structuring their human *practices* involved in the techniques and technologies of communication media.

In each of the six evolutionary–revolutionary changes in communication we have examined, human beings have attempted to overcome limitations of the quality and quantity of information gathering, storing, and sharing, as well as the limitations of time and space imposed by the now and here of natural existence. To a surprising degree, we have succeeded, with each evolution–revolution, extending human reach across time and space to provide ever-greater control over information and media systems and their impacts upon people and cultures. But, as Henry David Thoreau asked in *Walden* in 1854, what is the purpose of human communication? He questioned whether improvements in the means of communication (media) would improve human communication at its core. We face the same questions in the Cybernetic Age. Has human communication in terms of mutual understanding and survival been improved by such digital technologies as broadband, cell phone, computer, digital camera, iPod/MP3 player, Internet, radio, television, and all of the other gadgets now available? Are these merely "improved means to unimproved ends," as Thoreau claimed? Or have they made significant and substantial improvements not in only the media you use to communicate but also in the messages you communicate?

Would we benefit from improvements in the existing systems of communication made possible by the six evolutions–revolutions in human communication? What improvements would you most expect to see in the next 50 years? What improvements would you most *want to* see in the next 50 years?

What do you think might be the foundations of the next evolution–revolution in human communication? Do you think it might come from new ways to improve human thought and language through human interventions in DNA, the brain, the body, the senses, etc.? Will human thought and language be improved through the union of human thinking with computer-generated Artificial Intelligence in one *cyborg* (cybernetic organism)? Will we develop some type of *telepathic* (distant-feeling) communication made possible by improvements in the power of the human brain/mind by human *practices* and/or by implanted digital transmitters–receivers?

Will all new systems of human communication be limited by the physical limitations of time–space and energy–matter? Given that information, unlike time–space and energy–matter, can be created and destroyed by human and natural forces and events, will the exponential increases in the quantity of cybernetic information available to masses of people lead to changes in the quality of that information? What new sources of energy can we develop and use for human communication? How can these sources help us to overcome the limits of time and space we have faced from our beginnings as human beings? Is the movement of energy–matter limited to the speed of light? Can that speed be exceeded, or is that merely science fiction fantasy?

In each age of the six changes in human communication we have examined thus far, we have seen that some people thought that their particular age was the ultimate achievement possible while other people envisioned new techniques and technologies to improve the generation, storage, and sharing of information. The ancient dialectic between determinism and free will operates in human communication and the media systems we use to facilitate the exchange of information. To what extent is human communication determined by natural *processes* (time–space, energy–matter), by the techniques and technologies we have inherited and crafted, by the encoding–decoding of language (speech and visual imagery), writing, hypergraphics, electromagnetic media, and digital electronic media? To paraphrase Ludwig Wittgenstein, "Are the limits of our media the limits of our world?" How much freedom of choice do we have within natural and cultural environments that limit choice? Total determinism would dictate all future events, limiting human beings to whatever fates decreed by supernatural powers, by culture, by history, by economics, by politics, by technology, by the Big Bang, or by other forces. Total free will, on the other hand, would lead to chaos as each individual attempted to exercise her or his own will without regard to natural and cultural limitations. Some middle ground within this dialectic may provide a critical

perspective from which we can judge the relative roles played by determinism and free will in the history of human communication.

The Cybernetic Evolution–Revolution encourages us to trust technology to solve all problems, including those in human communication. In promising salvation through technology, the Cybernetic Age continues a long tradition of Technology as a mythic hero capable of providing answers to the great questions of identity, creation, destiny, and quest by accepting that improved techniques and technologies will improve human communication and, therefore, human life. This technological hero reinforces the goals of life proclaimed by all of the evolutions–revolutions beginning with hypergraphics and continuing with electrics, electronics, and cybernetics—that the purpose of life is limited to the pursuit of personal happiness based upon appearance, health, and youth founded upon material goods, products, and services. This regeneration and salvation through technology finds a responsive chord in the networks of communication made possible by the cybernetic media.

As noted in Chapter One, we are all voyagers in time and space, being both time-travelers in terms of history and planning for the future and space-travelers in terms of sharing information across distances of space at the same time. In the Cybernetic Age, all time has become *cybertime* and all space *cyberspace*, but it is yet to be determined whether these new, virtual time and space realities will provide humans with the information they need in order to adapt, improvise, and overcome in the face of future challenges to our physical, and cultural survival as a species apart from all others.

A passage from what the ancient Egyptians called "Spells of Emerging by Daylight" (what is usually called *The Book of the Dead* in more recent times because the scrolls containing the spells were discovered in coffins and tombs) contains a poignant reminder of the realities of life and death: "Mine is yesterday, I know tomorrow."[8] This advice from the dawn of literacy tells us that only the dead know the future. Those of us living in the present as it becomes the past can recall the past by storing in our natural and human-created memory systems information we think we need for surviving the changes that the future will bring. While only the dead can truly know tomorrow, we need to envision and plan for possible and probable tomorrows in order to improve our chances for survival. Language provided us with the gift of being able to conceive and even to help fashion tomorrows we want and to help prepare us for tomorrows we fear. Whatever forms new media will take, these forms will most likely be extensions of the ineluctable modalities of the audible and the visible, with perhaps touch being extended by technology. The past and present

are not always accurate guides to the future, but by knowing how human communication has changed through evolution and revolution from language to cybernetics we can arm ourselves with some weapons for critical thinking about changes in media, culture, and communication.

This book attempts to provide an historical overview and theoretical explanation of how human communication has changed through gradual evolution and rapid revolution in six ages of concepts and media used to share information through time and space among growing numbers of people and cultures. Each of the six major evolutions–revolutions examined in the book deserves deeper and broader studies if we are to understand how each developed and changed. You are invited to explore how we became human by studying human evolution, language development and diversity, the nature and development of visual imagery and musical expression, and the roles these information systems continue to play in today's communication. You are further invited to explore how we became civilized by studying the various writing systems and how ideographic, logographic, syllabic, and alphabetic writing systems developed and the roles they continue to play in today's communication. You are invited to make similar explorations into typographic, hypergraphic, electrographic and electrophonic, and cybernetic communication. All of these evolutions–revolutions continue to play significant roles in contemporary communication, even if some particular techniques and technologies cease to be part of the current media mix. Humans still rely upon sight and sound, and some touch, to expand their communication of messages through time and space. Humans still are bound by the limits of natural *processes* in using and transforming energy and matter to construct our message systems. Above all, humans still need to use our communication systems to help us to adapt, improvise, and overcome in the face of challenges brought by the future. Therefore, we need to explore the possibilities and limitations of the digital metamedia of the Cybernetic Age and their impacts on people and cultures.

In past ages, the major problems in human communication were caused by there being too few sources of information, two few systems for encoding–decoding information, too few systems for sending information, and too few receivers–destinations for information. In the Cybernetic Age, the major problems in human communications may be caused by our having too many sources of information, too many systems for encoding–decoding, storing, sending–receiving information, and too many destinations for sharing information. We face a crisis caused by information-overload and media-overload. Clearly, we need both improved technical *processes* and improved human *prac-*

tices to deal with these communication overloads. And if survival is dependent upon the sharing of accurate, timely, and vital information, then we need to echo Thoreau and ask: "What are our purposes in communicating information? What's worth knowing? Who should command and control our messages and message systems? How can we ensure that our new systems provide improved means to improved ends?" In attempting to answer these questions, we will continue the journey that began with ancestors when they became "human" some 200,000 to 50,000 years ago, a journey that continued with each evolution–revolution to the Cybernetic Age and will continue beyond to the next evolution–revolution. Let our journey continue. Good luck and good thinking.

NOTES

Chapter 1

1. Claude E. Shannon, "A Mathematical Theory of Information," *Bell System Technical Journal* 27 (1948).
2. Claude E. Shannon and Warren Weaver, *The Mathematical Theory of Communication* (Urbana, IL: University of Illinois Press, 1948).
3. Norbert Wiener, *Cybernetics, or Control and Communication in the Animal and the Machine* (Cambridge, MA: MIT Press, 1948).
4. Stephen W. Hawking, *A Brief History of Time: From the Big Bang to Black Holes* (New York: Bantam Books, 1988), 8.
5. Ibid., 23.
6. Kenneth Chang, "Gauging Age of Universe Becomes More Precise," *New York Times* (December 18, 2008).
7. Hawking, *A Brief History of Time*, 117.
8. Ibid., 172–173.
9. Ibid., 10.
10. Ibid., 37.
11. Ibid., 45.
12. Edward Burnett Tylor, *Primitive Culture* (New York: Henry Holt and Co., 1889), 1.
13. Bronislaw Malinowski, *Magic, Science and Religion, and Other Essays* (Garden City, NY: Doubleday Anchor Books, 1948).

14. Edward T. Hall, *The Silent Language* (New York: A Premier Book, Fawcett World Library, 1965), 69–70.

15. Ibid., 70–71.

16. Ibid., 71–72.

17. Shannon, "A Mathematical Theory of Information."

18. Shannon and Weaver, *The Mathematical Theory of Communication*.

19. Norbert Wiener, *The Human Use of Human Beings: Cybernetics and Society* (New York: Avon Books, 1967), 23.

20. Ibid., 24–25.

21. Ibid., 56.

22. Ibid., 27.

23. Ibid., 84.

24. This idea is explored in John Durham Peters, *Speaking into the Air: A History of the Idea of Communication* (Chicago and London: University of Chicago Press, 1999).

25. Jeremy Campbell, *Grammatical Man: Information, Entropy, Language, and Life* (New York: Touchstone Books, Simon & Schuster, Inc., 1982), 12.

26. Ibid., 67–74.

27. Wiener, *The Human Use of Human Beings*, 59.

28. This approach to learning is highly influenced by the works of Karl Popper, especially *The Open Society and Its Enemies*, vol.1: *The Spell of Plato* (Princeton, NJ: Princeton University Press, 1971), and *The Open Society and Its Enemies*, vol. 2: *The High Tide of Prophecy: Hegel, Marx and the Aftermath* (Princeton, NJ: Princeton University Press, 1971).

Chapter 2

1. See Steven Pinker, *The Language Instinct: How the Mind Creates Language* (New York: William Morrison and Company, Inc., 1994), 352–357.

2. Randall White, *Prehistoric Art: The Symbolic Journey of Humankind* (New York: Harry N. Abrams, Inc., 2003), 10–11.

3. David Crystal, *The Cambridge Encyclopedia of Language*, 2nd ed.(Cambridge and New York: Cambridge University Press, 1998), 6–7.

4. See Robert O'Connell, *Of Arms and Men: A History of War, Weapons, and Aggression* (New York and Oxford: Oxford University Press, 1989); Harry Holbert Turney-High, *Primitive War: Its Practice and Concepts*, 2nd ed. (Columbia, SC: University of South Carolina Press, 1971).

5. Arthur Ferrill, *The Origins of War: From the Stone Age to Alexander the Great* (London: Thames and Hudson, 1985), 13.

6. For an examination of this problem, see John Durham Peters, *Speaking into the Air: A History of the Idea of Communication* (Chicago and London: The University of Chicago Press, 1999).

7. Alexander Marshack, *The Roots of Civilisation: The Cognitive Beginnings of Man's First Art, Symbol and Notation* (London: Weidenfeld and Nicolson, 1992).

8. Ibid., 35.

9. Richard Leakey and Roger Lewin, *Origins Reconsidered: In Search of What Makes Us*

Human (New York: Doubleday, 1992), 250–251.

10. Crystal, *The Cambridge Encyclopedia of Language*, 287.

11. David Crystal, *How Language Works: How Babies Babble, Words Change Meaning, and Languages Live or Die* (Woodstock and New York: The Overlook Press, 2005), 336.

12. Crystal, *The Cambridge Encyclopedia of Language*, 289

13. Ibid., 359.

14. Ibid., 360.

15. George Steiner, *After Babel: Aspects of Language and Translation* (New York and London: Oxford University Press, 1975), 73.

16. Ibid., 74.

17. Noam Chomsky, *Aspects of the Theory of Syntax* (Cambridge, MA: Harvard University Press, 1965), 121–122.

18. Pinker, *The Language Instinct*, 23.

19. Ibid., 74.

20. Steiner, *After Babel*, 74.

21. Ibid., 81.

22. Ludwig Wittgenstein, *Philosophical Investigations* (London: Basil and Blackwell, 1953), 329.

23. Gerd Brand, *The Essential Wittgenstein*. Translated and with an Introduction by Robert E. Innis (New York: Basic Books, 1979).

24. John B. Carroll, Ed., *Language, Thought, and Reality: The Selected Writings of Benjamin Lee Whorf* (Cambridge, MA: The M.I.T. Press, 1956).

25. Crystal, *How Language Works*, 204.

26. Helen Keller, *The Story of My Life* (1903) (New York: Lancer Books, 1968), 36–37.

27. Crystal, *The Cambridge Encyclopedia of Language*, 91.

28. Ibid., 85.

29. Joseph Campbell, *The Hero with a Thousand Faces* (New York: Pantheon Books, 1949) and *The Masks of God*, vol. 1: *Primitive Mythology*; vol. 2: *Oriental Mythology*; vol. 3: *Occidental Mythology*; vol. 4: *Creative Mythology* (New York: Viking Press, 1954–1968), Siegfried Gideon, *The Eternal Present: The Beginnings of Art* (New York: Bolligen Foundation, Pantheon Books, 1957); Claude Levi-Strauss, *Introduction to a Science of Mythology*, vol. 1: *The Raw and the Cooked* (1969); vol. 2: *From Honey to Ashes* (1973); vol. 3: *The Origin of Table Manners* (1978); vol. 4: *The Naked Man* (1981) (Chicago: The University of Chicago Press) and *Structural Anthology*, vol. 1 (1963) and vol. 2 (1976) (Chicago: University of Chicago Press).

30. Karl Popper, *The Open Society and Its Enemies*, vol. 2: *The High Tide of Prophecy: Hegel, Marx, and the Aftermath* (Princeton, NJ: Princeton University Press, 1962, 1966), 12.

31. Ibid., 13.

32. Ferrill, 20–21.

33. Ibid., 31.

34. Gideon, *The Eternal Present*, 119.

35. Ibid., 538.

36. Ibid., 4.

37. André Leroi-Gourhan, *Treasures of Prehistoric Art* (New York: Henry N. Abrams, Inc., Publishers, 1966), 111.

38. Ibid.

39. Ibid.
40. Ibid., 113.
41. Ibid., 123.
42. Ibid., 130
43. Ibid., 148.
44. John E. Pfeiffer, *The Creative Explosion: An Inquiry into the Origins of Art and Religion* (New York: Harper and Row, Publishers, 1982), 124.
45. White, *Prehistoric Art*, 79.
46. Judith Thurman, "First Impressions: What Does the World's Oldest Art Say About Us?" *New Yorker* (June 23, 2008), 59.
47. White, *Prehistoric Art*, 50.
48. Ibid., 51.
49. Nicholas Wade, "Neanderthal Genome Hints at Language Potential, but Little Human Interbreeding," *New York Times* (February 13, 2009), A12.
50. Colin McEvedy and Richard Jones, "Atlas of World Population History," (New York: Facts on File, 1978; and Ralph Thominson, *Demographic Problems: Controversy over Population Control*, 2nd ed. (Encino, CA: Dickenson Publishing Company, 1975).
51. Population Reference Bureau http://www.prb.org/Publications/Datasheets/2009/2009 wpds.aspx.
52. Malinowski, *Magic, Science and Religion*, 19.
53. Ibid.
54. Anne Baring and Jules Cashford, *The Myth of the Goddess: Evolution of an Image* (New York: Viking, 1991).
55. Jared Diamond, *Guns, Germs, and Steel: The Fates of Human Societies* (New York: W.W. Norton and Company, Inc., 2005), 268–269.

Chapter 3

1. UNESCO, *World Illiteracy at Mid-Century*, UNESCO Statistical Division, 1957.
2. Edgar Rice Burroughs, *Tarzan of the Apes* (New York: Avenel Books, 1988), 45.
3. Albertine Gaur, *A History of Writing* (New York: Charles Scribner's Sons, 1984), 14.
4. I.J. Gelb, *A Study of Writing*, rev. ed. (Chicago and London: The University of Chicago Press, 1963), 7.
5. Ibid., 12.
6. Ibid., 27.
7. Ibid., 60.
8. Gaur, *A History of Writing*, 14.
9. Ibid., 15.
10. Neil Postman, *Technopoly: The Surrender of Culture to Technology* (New York: Alfred A. Knopf, 1992), 7.
11. Harold A. Innis, *Empire and Communication* (Toronto: University of Toronto Press, 1971), 10.
12. Marshall McLuhan and Robert K. Logan, "Alphabet, Mother of Invention," *Et Cetera* (December 1977), 374.

13. Plato, *Phaedrus*, Translated with Introduction, Notes, and Interpretive Essay by James H. Nichols, Jr. (Ithaca and London: Cornell University Press, 1998), 85.

14. Ibid.

15. Quoted in Gelb, *A Study of Writing*, 13.

16. James Henry Breasted, *The Conquest of Civilization*, New Edition (New York and London: Harper and Brothers Publishers, 1938), 61.

17. Ibid., 222.

18. Andrew Robinson, *The Story of Writing: Alphabets, Hieroglyphs and Pictograms* (London: Thames and Hudson, Ltd., 1995), 7.

19. Gelb, *A Study of Writing*, 205.

20. See Gaur and Robinson, for example.

21. See Denise Schmandt-Besserat, *Before Writing: From Counting to Cuneiform* (Austin: University of Texas Press, 1992).

22. Robinson, *The Story of Writing*, 71; William W. Hallo and William Kelly Simpson, *The Ancient Near East, A History*, 2nd ed. (New York: Harcourt Brace College Publishers, 1997), 251; Michael Roaf, *Cultural Atlas of Mesopotamia and the Ancient Near East* (Oxfordshire, England: Andromedea Books, 1996), 70–73.

23. Hallo and Simpson, *The Ancient Near East*, 25–29.

24. Robinson, *The Story of Writing*, 72–81.

25. Ibid., 82–83.

26. Ibid., 86–87.

27. Hallo and Simpson, *The Ancient Near East*, 151; for a fuller story of Ur, see Sir Leonard Woolley, *Ur of the Chaldees* (London: The Herbert Press, 1982).

28. Jared Diamond, *Guns, Germs, and Steel: The Fates of Human Societies* (New York and London: W.W. Norton & Company, 2005), 224.

29. Joan Oates, *Babylon*, rev. ed. (London and New York: Thames and Hudson, 1986), 15.

30. Ibid., 18.

31. Michael A. Hoffman, *Egypt Before the Pharaohs: The Prehistoric Foundations of Egyptian Civilization* (New York: Dorset Press, 1979), 48.

32. Ibid., 59.

33. Ibid., 290.

34. Ibid., 291.

35. John Wilson, *The Culture of Ancient Egypt* (Chicago: University of Chicago Press, 1971), 38.

36. Hoffman, *Egypt Before the Pharaohs*, 289.

37. Peter A. Clayton, *Chronicle of the Pharaohs: The Reign-by-Reign Record of the Rulers and Dynasties of Ancient Egypt* (London: Thames and Hudson, 1994), 9.

38. Hoffman, *Egypt Before the Pharaohs*, 313.

39. The Narmer Palette is displayed inside the entrance of the Cairo Museum. See Alice Cartocci and Gloria Rosati, *Egyptian Art: Masterpieces in Painting, Sculpture and Architecture* (New York: Barnes and Noble, 2007), 25–27; Clayton, *Chronicle of the Pharaohs*, 16–18; Hoffman, *Egypt Before the Pharaohs*, 129–130; Robinson, *The Story of Writing*, 92–93; and B.G. Trigger, B.J. Kemp, D. O'Connor and A.B. Lloyd, *Ancient Egypt, A Social History* (Cambridge: Cambridge University Press, 1983), 50–59.

40. Robinson, *The Story of Writing*, 24–33.

41. See Cyril Aldred, *The Egyptians*, rev. ed. (London: Thames and Hudson, 1987); Clayton, *Chronicle of the Pharaohs*; Bill Marley, *The Penguin Historical Atlas of Ancient Egypt* (New York: Penguin Books, 1996); Trigger et al., *Ancient Egypt*.

42. Gelb, *A Study of Writing*, 62.

43. Ibid., 65.

44. Ibid., 68.

45. Quoted in William Kelly Simpson, "The Gift of Writing," in National Geographic Society, *Ancient Egypt: Discovering Its Splendors* (Washington, DC: National Geographic Society, 1978), 140.

46. Hallo and Simpson, *The Ancient Near East*, 29–30.

47. Ibid., 31.

48. Joseph Campbell, *The Hero with a Thousand Faces* (Princeton, NJ: Princeton University Press, 1963), 284.

49. Hallo and Simpson, *The Ancient Near East*, 52-53; Roaf, *Cultural Atlas of Mesopotamia and The Ancient Near East*, 78.

50. Robinson, *The Story of Writing*, 161.

51. Ibid., 164–165.

52. Ibid., 166–167.

53. Ibid., 167.

54. Eric A. Havelock, *Origins of Western Literacy* (Toronto: Ontario Institute for Studies in Education, 1976), 22–23.

55. Ibid., 21.

56. Ibid., 27.

57. Ibid., 44.

58. Ibid., 61.

59. R. H. Barrow, *The Romans* (London: Penguin Books, 1958).

60. For rigorous defenses of medieval technology, see Frances and Joseph Gies, *Cathedral, Forge, and Waterwheel: Technology and Invention in the Middle Ages* (New York: Harper Collins Publishers, 1994); Jean Gimpel, *The Medieval Machine: The Industrial Revolution of the Middle Ages* (New York: Holt, Rinehart and Winston, 1976); and Lynn White, Jr., *Medieval Technology and Social Change* (London: Oxford University Press, 1962). For a strong argument on how literacy was preserved in Europe after the collapse of the Roman Empire, see Thomas Cahill, *How the Irish Saved Civilization: The Untold Story of Ireland's Heroic Role from the Fall of Rome to the Rise of Medieval Europe* (New York: Nan A. Talese/Doubleday, 1995).

61. Gaur, *A History of Writing*, 190–191.

62. David Crystal, *The Cambridge Encyclopedia of Language*, 2nd ed. (Cambridge and New York: Cambridge University Press, 1998), 196–207.

63. Gaur, *A History of Writing*, 35–36.

64. Innis, *Empire and Communication*, 7.

65. Gaur, *A History of Writing*, 37–44.

66. Ibid., 45; see also Thomas Carter, *The Invention of Printing in China and Its Spread Westward* (New York: Ronald Press, 1953), 3.

67. Gaur, *A History of Writing*, 45–47.

68. Innis, *Empire and Communication*, 108–109,

69. Gaur, A History of Writing, 46–47.

70. Diamond, Guns, Germs, and Steel, 234–235.

71. Ibid., 236–237.

72. Havelock, Origins of Western Literacy, 28–30

73. Ibid., 34–35.

74. Henry J. Perkinson, How Things Got Better: Speech, Writing, Printing, and Cultural Change (Westport, CT: Bergin and Garvey, 1995), 37.

75. Ibid., 39.

76. Clayton, Chronicle of the Pharaohs, 12–13.

77. Hoffman, Egypt Before the Pyramids, 12–15.

78. John Noble Wilford, The Mapmakers: The Story of the Great Pioneers in Cartography from Antiquity to the Space Age (New York: Vintage Books, 1982), 7.

79. Ibid., 8.

80. Ibid., 10.

81. Walter J. Ong, Orality and Literacy: The Technologizing of the Word (London and New York: Methuen, 1982), 82.

82. Ibid., 83.

83. Ibid., 31–57.

84. Ibid., 89.

85. See Trevor N. Dupuy, The Evolution of Weapons and Warfare (London: Jane's Publishing Company, 1980); Gwynne Dyer, War (New York: Crown Publishers, 1985); Arthur Ferrill, The Origins of War: From the Stone Age to Alexander The Great (London: Thames and Hudson, 1985); John Keegan, A History of Warfare (New York: Alfred A. Knopf, 1993); and Robert L. O'Connell, Of Arms and Men: A History of War, Weapons, and Aggression (New York and Oxford: Oxford University Press, 1989).

86. Clayton, Chronicle of the Pharaohs, 217.

87. Robinson, The Story of Writing, 145.

88. Ibid., 146.

89. Ibid., 183.

90. Ibid., 184–185.

91. Gelb, A Study of Writing, 236–247.

Chapter 4

1. Thomas F. Carter, The Invention of Printing in China and Its Spread Westward (New York: Columbia University Press, 1931).

2. Harold A. Innis, Empire and Communication (Toronto: University of Toronto Press, 1972), 138; for a fuller description of the contributions of the Christian scribes to European civilization, see Thomas Cahill, How The Irish Saved Civilization: The Untold Story of Ireland's Heroic Role from the Fall of Rome to the Rise of Medieval Europe (New York: Nan A. Talese/Doubleday, 1995).

3. See Christopher Tyerman, God's War: A New History of the Crusades (Cambridge, MA: The Belknap Press of Harvard University Press, 2006).

4. Frances and Joseph Gies, Cathedral, Forge, and Waterwheel: Technology and Invention in the

Middle Ages (New York: Harper Collins Publishers, 1994), 97.

5. Innis, *Empire and Communication*, 138.

6. Barbara Tuchman, *A Distant Mirror: The Calamitous 14th Century* (New York: Ballantine Books, 1978), xix.

7. Gies, *Cathedral, Forge, and Waterwheel*, 243–244.

8. Ibid., 246.

9. S. H. Steinberg, *Five Hundred Years of Printing*, New Edition Revised by John Trevitt (The British Library and the Oak Knoll Press, 2001), 17–18.

10. Ibid., 47–48 .

11. Ibid., 54.

12. Ibid., 54–55.

13. Ibid., 58–61.

14. Ibid., 1.

15. Elizabeth L. Eisenstein, *The Printing Revolution in Early Modern Europe* (London and New York: Cambridge University Press, 1985), 16.

16. Ibid., 9.

17. Steinberg, *Five Hundred Years of Printing*, 74.

18. Ibid., 108.

19. James Boswell, *Life of Samuel Johnson* (1791) (New York: Penguin Classics, 2008).

20. Steinberg, *Five Hundred Years of Printing*, 126–129.

21. Ibid., 131–132.

22. Ibid., 135.

23. Ibid., 138–139.

24. Ibid., 140–145.

25. Ibid., 17.

26. See Jib Fowles, *Advertising and Popular Culture* (Thousand Oaks, CA: Sage Publications, 1977); Daniel Pope, *The Making of Modern Advertising* (New York: Basic Books, 1983); and Michael Schudson, *Advertising, The Uneasy Persuasion: Its Dubious Impact on American Society* (New York: Basic Books, 1984).

27. Michael Emery and Edwin Emery, *The Press and America: An Interpretative History of the Mass Media*, 6th ed. (Englewood Cliffs, NJ: Prentice Hall, 1988), 117–127.

28. Ibid., 135–136.

29. Ibid., 204.

30. Ibid.

31. Ibid., 189.

32. Kenneth Dyson, "Revisiting *Culture and Anarchy*: Media Studies," in Kenneth Dyson and Walter Homolka, editors, *Culture First! Promoting Standards in the New Media Age* (New York: Cassell, 1996).

33. Steinberg, *Five Hundred Years of Printing*, 218.

34. Ibid., 220–249.

35. Gies, *Cathedral, Forge, and Waterwheel*, 98.

36. David Crystal, *How Language Works* (Woodstock and New York: The Overlook Press, 2005), 103.

37. Quoted in Gies, *Cathedral, Forge, and Waterwheel*, 241.

38. Steinberg, *Five Hundred Years of Printing*, 4–5.

39. English translation quoted in ibid., 5.

40. Ibid., 5–6.

41. Ibid., 6.

42. Henry J. Perkinson, *How Things Got Better: Speech, Writing, Printing, and Cultural Change* (Westport, CT: Bergin and Garvey, 1995), 77–79.

43. Ibid., 80–85.

44. Tyerman, *God's War*, 902.

45. Perkinson, *How Things Got Better*, 94.

46. Harvey J. Graff, *Legacies of Literacy: Continuities and Contradictions in Western Culture and Society* (Bloomington: Indiana University Press, 1991).

47. Quoted in Eisenstein, *The Printing Revolution in Early Modern Europe*, 147.

48. Quoted in ibid., 148.

49. Ibid., 151.

50. See A.G. Dickens, *Reformation and Society in Sixteenth Century Europe* (New York: Harcourt Brace & World, 1966).

51. John Noble Wilford, *The Mapmakers: The Story of the Great Pioneers in Cartography from Antiquity to the Space Age* (New York: Vintage Books, 1981), 72.

52. See Carter, *The Invention of Printing in China and Its Spread Westward*.

53. Philip M. Taylor, *Munitions of the Mind: War Propaganda from the Ancient World to the Nuclear Age* (Wellingborough, UK: Patrick Stephens Limited, 1990), 95.

54. Innis, *Empire and Communication*, 137.

55. Walter J. Ong, *Orality and Literacy: The Technologizing of the Word* (London and New York: Methuen, 1982), 122–123.

56. Eisenstein, *The Printing Revolution in Early Modern Europe*, 81.

57. Quoted in ibid., 235.

58. Steinberg, *Five Hundred Years of Printing*, 119.

59. Perkinson, *How Things Got Better*, 88.

60. Eisenstein, *The Printing Revolution in Early Modern Europe*, 145, 151.

61. Ibid., 155.

62. Ibid., 157.

63. See ibid., 153.

64. Steinberg, *Five Hundred Years of Printing*, 130.

65. Lewis Mumford, *Technics and Civilization* (New York: Harcourt, Brace and Company, 1934), 134.

66. David Landes, *Revolution in Time: Clocks and the Making of the Modern World*, Revised and Enlarged Edition (Cambridge, MA: Belknap Press of Harvard University Press, 2000).

67. Mumford, *Technics and Civilization*, 135–137.

68. Paul Starr, *The Creation of the Media: Political Origins of Modern Communications* (New York: Basic Books, 2004), 5.

69. Ibid., 12–13.

70. Ibid., 52–53.

71. Ibid., 89.

72. Ibid., 105–108.

73. Ibid., 109.

74. Ong, *Orality and Literacy*, 155.

75. Marshall McLuhan, *The Gutenberg Galaxy: The Making of Typographic Man* (Toronto: University of Toronto Press, 1962).

76. See Geoffrey Nunberg, ed., *The Future of the Book* (Berkeley/Los Angeles: University of California Press, 1996).

77. Daniel Headrick, *When Information Came of Age: Technologies of Knowledge in the Age of Reason and Revolution, 1700–1850* (New York: Oxford University Press, Inc., 2000), 195–196, 39.

78. Ibid., 197.

79. Ibid., 197–199.

80. Ibid., 202–203.

81. Ibid., 203.

Chapter 5

1. Lloyd Kaufman, *Perception: The World Transformed* (New York: Oxford University Press, 1979), 4.

2. Ibid.

3. E. H. Gombrich, "The Visual Image," *Scientific American* (September, 1972), 82.

4. Ibid., 86.

5. Ibid., 91–92.

6. If you become frustrated, you could use reference sources for help.

7. Gombrich, "The Visual Image," 93.

8. Ibid.

9. Jacques Ellul, *The Humiliation of the Word* (Grand Rapids, MI: William B. Eerdmans Publishing Company, 1985), 27.

10. Ibid., 117.

11. Quoted in Kenneth Clark, *Civilization: A Personal View* (New York: Harper & Row, Publishers, 1969), 1.

12. Alexander Marshack, *The Roots of Civilisation: The Cognitive Beginnings of Man's First Art, Symbol, and Notation* (London: Weidenfeld and Nicolson, 1992).

13. Siegfried Gideon, *The Eternal Present: The Beginnings of Art* (New York: Bolligen Foundation, Pantheon Books 1957), 4.

14. André Leroi-Gourhan, *Treasures of Prehistoric Art* (New York: Henry N. Abrams, Inc., Publishers, 1966), 111, 113, 123, 130, 148.

15. John E. Pfeiffer, "Was Europe's Fabulous Cave Art the Start of the Information Age?" *Smithsonian* (April 1983), 39.

16. Ibid., 41.

17. John Noble Wilford, "Flutes Offer Clues to Stone-Age Music," *New York Times* (June 25, 2009).

18. I.J. Gelb, *A Study of Writing*, rev. ed.(Chicago and London: The University of Chicago Press, 1963), 4.

19. John Noble Wilford, *The Mapmakers: The Story of the Great Pioneers in Cartography from Antiquity to the Space Age* (New York: Vintage Books, 1982), 8.

20. Ibid., 15–20.

21. Henry J. Perkinson, *How Things Got Better: Speech, Writing, Printing, and Cultural Change* (Westport, CT: and London: Bergin and Garvey. 1995), 122–125.

22. Daniel J. Boorstin, *The Image: A Guide to Pseudo-Events in America*, 25th Anniversary Edition (New York: Atheneum, 1987), 13.

23. Robert Leggat, *A History of Photography*. http://www.rleggat.com/photohistory/history/talbot.htm/

24. Charles Musser, *The Emergence of Cinema: The American Screen to 1907* (Berkeley: University of California Press, 1994).

25. Paul Starr, *The Creation of the Media: Political Origins of Modern Communications* (New York: Basic Books, 2004), 304.

26. Ulrich Keller, "Early Photojournalism," in David Crowley and Paul Heyer, Eds., *Communication in History: Technology, Culture, Society*, 5th ed. (New York: Pearson, 2007), 161.

27. Ibid., 163.

28. See Jib Fowles, *Starstruck: Celebrity Performers and the American Public* (Washington and London: Smithsonian Institution Press, 1992).

29. Peter Kobel and The Library of Congress, *Silent Movies: The Birth of Film and the Triumph of Movie Culture* (New York: Little, Brown and Company, 2007), 1.

30. The History of American Cinema published by the University of California Press provides comprehensive studies of film from its inception to 1970. In sequence they are: Charles Musser, *The Emergence of Cinema: The American Screen to 1907* (1994); Eileen Bowser, *The Transformation of Cinema, 1907–1915* (1994); Richard Koszarski, *An Evening's Entertainment: The Age of the Silent Feature Film, 1915–1928* (1994); Donald Crafton, *The Talkies: American Cinema's Transition to Sound, 1926–1931* (1994); Tino Balio, *Grand Design: Hollywood as a Modern Business Enterprise, 1930–1939* (1999); Thomas Schatz, *Boom and Bust: American Cinema in the 1940s* (1999); Peter Lev, *The Fifties: Transforming the Screen, 1950–1959* (2006); and Paul Monaco, *The Sixties: 1960–1969* (2003). See also Douglas Gomery, *The Hollywood Studio System, 1930–1949* (New York: St. Martin's, 1986).

31. See Raymond Fielding, *The American Newsreel, 1911–1967* (Norman, OK: University of Oklahoma Press, 1972).

32. See Erik Barnouw, *Documentary: A History of the Non-Fiction Film*, 2nd rev. ed. (New York: Oxford University Press, 1993).

33. David Kunzle, *The History of the Comic Strip*, vol.1: *The Early Comic Strip: Narrative Strips and Picture Stories in European Broadsheets from c. 1450 to 1825* (Berkeley: University of California Press, 1973).

34. David Kunzle, *The History of the Comic Strip, vol. II: The Nineteenth Century* (Berkeley: University of California Press, 1990).

35. See Shirrel Rhodes, *A Complete History of American Comic Books* (New York: Peter Lang, 2008) and Bradford W. Wright, *Comic Book Nation: The Transformation of Youth Culture in America* (Baltimore: The Johns Hopkins University Press, 2003).

36. See Amy Kiste Nyberg, *Seal of Approval: The History of the Comics Code* (Jackson: University Press of Mississippi, 1988).

37. Maria Reidelbach, *Completely Mad: A History of the Comic Book and Magazine* (New York: Little, Brown, 1991).

38. Mark James Estren, A History of Underground Comics (California: Ronin Publishers, 1992).

39. Paul Gravett, Graphic Novels: Stories to Change Your Life (United Kingdom: Aurum Press, Ltd., 2005); and Stephen Weiner and Chris Couch, eds.,: The Rise of the Graphic Novel: Faster than a Speeding Bullet (New York: Nantier-Beall-Minoustching Publishing, 2004).

40. Quoted in Daniel J. Boorstin, The Creators: A History of Heroes of the Imagination (New York: Random House, Inc., 1992), 525; see also William Henry Fox Talbot, Michael Gray, Arthur Ollman and Carol McCusker, First Photographs: William Henry Fox Talbot and the Birth of Photography (powerHouse Books, 2003).

41. Edwin Teale, "America's Five Favorite Hobbies," http://blog.modernmechanix.com /2008/11/04/americas-five-favorite-hobbies/

42. Boorstin, The Creators, 525.

43. See Beaumont Newhall, The History of Photography: From 1839 to the Present Day, rev. ed. (New York: Bulfinch, 1982); John Szarkowski, Photography until Now (New York: Museum of Modern Art, 1960) and Mirrors and Windows: American Photography Since 1960 (New York: Museum of Modern Art, 1984).

44. Alphonse Bertillon and Gallus Muller (trans.), Alphonse Bertillon's Instructions for Taking Descriptions for the Identification of Criminals and Others, by Means of Anthropometric Indications (Whitefish, MT: Kessinger Publishing, LLC, 2009); see also Henry T. F. Rhodes, Alphonse Bertillon, Father of Scientific Detection (George C. Harrap, 1957).

45. Martin Lloyd, The Passport: The History of Man's Most Travelled Document (Charleston, SC: The History Press, 2003).

46. James Henry Breasted, Egypt Through the Stereoscope: A Journey Through the Land of the Pharaohs, with the Stereographs of Underwood & Underwood (New York: Camera/Graphic Press Ltd., 1978), 8.

47. William F. Arens, Contemporary Advertising, 10th ed. (Boston: McGraw-Hill Irwin, 2006), 448.

48. For histories of photojournalism, see Bonnie Brennen and Hanno Hardt, eds., Picturing the Past: Media, History, and Photography (Champaign Urbana: University of Illinois Press, 1999); Howard Chapnick, Truth Needs No Ally: Inside Photojournalism (Columbia, MO: University of Missouri Press, 1994); and Bodo von Dewitz, Robert Lebeck, and Cordelia Lebeck, Kiosk: A History of Photojournalism (Cologne: Steidl Publications, 2002).

49. For a report on recent developments in photojournalism in the Cybernetic Age, see Loup Langston, Photojournalism and Today's News: Creating Visual Reality (Hoboken, NJ: Wiley-Blackwell, 2009).

50. Eugene Secunda and Terence P. Moran, Selling War to America: From the Spanish American War to the Global War on Terror (Westport, CT and London: Praeger Security International, 2007); see also Barnouw, Documentary; and Fielding, The American Newsreel, 1911–1967.

51. Kobel, Silent Movies, 283.

52. Robert Sklar, Movie-Made America: A Cultural History of American Movies (New York: Random House, 1975).

53. Ibid., 316.

54. Richard Slotkin, Gunfighter Nation: The Myth of the Frontier in Twentieth Century America (New York: Atheneum, 1992), 10.

55. See Joy S. Kasson, Buffalo Bill's Wild West: Celebrity, Memory, and Popular History (New

York: Hill and Wang, 2000); Louis S. Warren, *Buffalo Bill's America: William Cody and the Wild West Show* (New York: Alfred A. Knopf, 2005); and Nellie Snyder Yost, *Buffalo Bill: His Family, Friends, Fame, Failures and Fortunes* (Chicago: Sage Books/The Swallow Press, Inc., 1979).

56. For histories of western films, see William K. Everson, *A Pictorial History of the Western Film* (Secaucus, NJ: The Citadel Press, 1969); and George N. Fenton and William K. Everson, *The Western: From Silents to the Seventies* (New York: Grossman Publishers, 1973); see also Edward Buscombe, ed., *The BFI Companion to the Western* (New York: Atheneum, 1988) and Thomas W. Knowles and Joe R. Lansdale, *Wild West Show! How the Myth of the West Was Made, from Buffalo Bill to Lonesome Dove* (New York/Avenel, NJ: Wings Books, 1994).

57. Buscombe, *The BFI Companion to the Western*, 35–36.

58. Sklar, *Movie-Made America*, 134–139.

59. Paul Trent and Richard Lawton, *The Image Makers: Sixty Years of Hollywood Glamour* (New York: Crescent Books, 1972).

60. Turner Classic Movies, *Leading Ladies: The 50 Most Unforgettable Actresses of the Studio Era* (San Francisco, CA: Chronicle Books, 2006) and *Leading Men: The 50 Most Unforgettable Actors of the Studio Era* (San Francisco, CA: Chronicle Books, 2006).

61. See The Academy of Motion Picture Arts and Sciences website at www.oscars.org.

62. To see all of the categories and films, as well as other lists, go to the American Film Institute website at www.afi.com.

63. www.filmsite.org.

64. Kobel, *Silent Movies*, ix.

65. Ibid., 285; to view some of the Library's collection, go to www.loc.gov/rr/mopic.

66. See Kenneth Dyson, "Revisiting *Culture and Anarchy*: Media Studies," in Kenneth Dyson and Walter Homolka, Eds., *Culture First! Promoting Standards in the New Media Age* (New York: Cassell, 1996).

67. Neil Postman, *Amusing Ourselves to Death: Public Discourse in the Age of Show Business* (New York: Elisabeth Sifton Books, Viking, 1985), Chapter 5.

68. James Joyce, *Ulysses* (New York: The Modern Library, 1934), 38.

Chapter 6

1. Walter Isaacson, *Benjamin Franklin: An American Life* (New York: Simon & Schuster Paperbacks, 2004), 133.

2. Ibid., 134.

3. Ibid., 134–135.

4. Ibid., 136.

5. Ibid., 138–139.

6. Ibid., 140.

7. Ibid., 143–144.

8. Ibid., 145.

9. Daniel J. Czitrom, *Media and the American Mind: From Morse to McLuhan* (Chapel Hill, NC: University of North Carolina Press, 1982), 4.

10. Ibid.

11. Daniel R. Headrick, *When Information Came of Age: Technologies of Knowledge in the Age of Reason and Revolution, 1700–1850* (New York: Oxford University Press, 2000), 184.

12. Ibid., 184–185.

13. Ibid., 188.

14. Ibid., 190.

15. Ibid., 191–192.

16. Ibid., 197.

17. Paul Starr, *The Creation of the Media: Political Origins of Modern Communications* (New York: Basic Books, 2004), 158.

18. Headrick, *When Information Came of Age*, 204–205.

19. Ibid.; Starr, *The Creation of the Media*, 158; Czitrom, *Media and the American Mind*, 4–5; Thomas J. Frusciano and Marilyn H. Pettit, *New York University and the City: An Illustrated History* (New Brunswick, NJ: Rutgers University Press, 1997), 21.

20. Czitrom, *Media and the American Mind*, 5.

21. Starr, *The Creation of the Media*, 158.

22. Ibid., 159.

23. Ibid.,

24. Ibid., 160–161.

25. Ibid., 162.

26. Czitrom, *Media and the American Mind*, 9.

27. Starr, *The Creation of the Media*, 172–173. For biographies of Morse, see Carleton Mabee, *The American Leonardo: A Life of Samuel F. B. Morse* (New York: Alfred A. Knopf, 1944); and Kenneth Silverman, *Lightning Man: The Accursed Life of Samuel F. B. Morse* (New York: Alfred A. Knopf, 2003). For studies of the telegraph, see Tom Standage, *The Victorian Internet: The Remarkable Story of the Telegraph and the Nineteenth Century's On-Line Pioneers* (New York: Walker & Company, 1999); and Lewis Coe, *Telegraph: A History of Morse's Invention and Its Predecessors in the United States* (Jefferson, NC: McFarland & Company, Inc., 2003).

28. For biographies of Bell, see Edwin S. Grosvenor and Morgan Wesson, *Alexander Graham Bell: The Life and Times of the Man Who Invented the Telephone* (New York: Harry N. Abrams Publishers, 1997) and Charlotte Gray, *Reluctant Genius: Alexander Graham Bell and the Passion for Invention* (New York: Arcade Publishing, 2006). For a history of the telephone, see Claude S. Fischer, *America Calling: A Social History of the Telephone to 1940* (Berkeley: University of California Press, 1992); and Lewis Coe, *The Telephone and Its Several Inventors* (Jefferson, NC: McFarland & Company, Inc., 2006).

29. Starr, *The Creation of the Media*, 298–299. For Edison's biography, see Paul Israel, *Edison: A Life of Invention* (New York: John Wiley and Sons, 1998). For Berliner's biography, see Frederic W. Wile, *Emile Berliner: Maker of the Microphone* (Indianapolis, IN: Bobbs-Merrill, 1974). For Goldmark's autobiography, see Peter Goldmark, *The Maverick Inventor: My Turbulent Years at CBS* (New York: Saturday Review Press, 1973).

30. See John Steele Gordon, *A Thread Across the Ocean: The Heroic Story of the Transatlantic Cable* (New York: Walker & Company, 2002).

31. Czitrom, *Media and the American Mind*, 62–63.

32. Ibid., 66–67.

33. Starr, *The Creation of the Media*, 219–220; Czitrom, *Media and the American Mind*, 66–69.

34. See Tom Lewis, *Empire of the Air: The Men Who Made Radio* (New York: Edward Burlingame Books, An Imprint of Harper Collins Publishers, 1991).

35. Czitrom, *Media and the American Mind*, 69; see also David F. Noble, *America by Design: Science, Technology, and the Rise of Corporate Capitalism* (New York: Alfred A. Knopf. 1997), 91–101.

36. See Don Erikson, *Armstrong's Fight for FM Broadcasting* (Montgomery: University of Alabama Press, 1973); Lawrence Lessing, *Man of High Fidelity: Edwin Howard Armstrong*, rev ed. (New York: Bantam Books, 1969); and Lewis, *Empire of the Air*.

37. Susan J. Douglas, *Inventing American Broadcasting 1899–1922* (Baltimore and London: The Johns Hopkins University Press, 1987), 296–303; Czitrom, *Media and the American Mind*, 71–73; Lewis, *Empire of the Air*, 151–153; and Erik Barnouw, *Tube of Plenty: The Evolution of American Television* (New York: Oxford University Press, 1975), 36–37, 52–53, 68–72.

38. See Lewis, *Empire of the Air* for an excellent overview of the struggles to develop broadcasting in America. For biographies of Sarnoff, see Kenneth Bilby, *The General: David Sarnoff and the Rise of the Communications Industry* (New York: Harper & Row, 1986); Carl Dreher, *Sarnoff: An American Success* (New York: Quadrangle/New York Times Book Co., 1977); and Eugene Lyons, *David Sarnoff* (New York: Harper & Row, 1966).

39. Barnouw, *Tube of Plenty*, 48–49.

40. Ibid., 49–54.

41. Ibid., 77–78; and Lewis, *Empire of the Air*, 310–311.

42. Michael Emery and Edwin Emery, *The Press and America: An Interpretive History of the Mass Media*, 6th ed (Englewood Cliffs, NJ: Prentice Hall, 1988), 384–385; and Starr, *The Creation of the Media*, 383–384.

43. Barnouw, *Tube of Plenty*, 83–84.

44. Starr, *The Creation of the Media*, 383–384.

45. Lewis, *Empire of the Air*, 312.

46. Ibid., 343–346.

47. Barnouw, *Tube of Plenty*, 351–353.

48. See James Carey, *Communication as Culture: Essays on Media and Society* (New York: Routledge, Inc., 1989); Starr, *The Creation of the Media*, chap. 5; and Standage, *The Victorian Internet*.

49. See Fischer, *America Calling*.

50. See Michael J. Arlen, *Thirty Seconds* (New York: Penguin, 1981).

51. Douglas, *Inventing American Broadcasting*, 226–239; and Lewis, *Empire of the Air*, 105–109.

52. Douglas, *Inventing American Broadcasting*, chap. 8.

53. For the rise of radio broadcasting, see Eric Barnouw, *A History of Broadcasting in the United States: A Tower in Babel; The Golden Web* (New York: Oxford University Press, 1966, 1968).

54. On Murrow and the evolution of radio news, see Stanley Cloud and Lynne Olson, *The Murrow Boys: Pioneers on the Front Lines of Broadcast Journalism* (Boston and New York: Houghton Mifflin Company, 1996); Alexander Kendrick, *Prime Time: The Life of Edward R. Murrow* (Boston: Little, Brown and Company. 1969), 138–334; and A. M. Sperber, *Murrow: His Life and Times* (New York: Freundlich Books, 1986), 79–261.

55. Douglas, *Inventing American Broadcasting*, 321–322; see also Starr, *The Creation of the Media*, 370–376.

56. Barnouw, *Tube of Plenty*, 154–167.

57. Ibid., 172–184.

58. See Sperber, *Murrow*, xix–xxv, 538–542.

59. Neil Postman, *Amusing Ourselves to Death: Public Discourse in the Age of Show Business* (New York: Elisabeth Sifton Books, Viking, 1985), 86–113.

60. Starr, *The Creation of the Media*, 159–165.

61. Ibid., 191–200.

62. Ibid., 298–299.

63. Ibid., 215–225.

64. Ibid., 212–220.

65. Ibid., 212–230; Douglas, *Inventing American Broadcasting*, 240–291; Czitrom, *Media and the American Mind*, 60–61, 71–74; and Lewis, *Empire of the Air*, 141–159.

66. Barnouw, *Tube of Plenty*, chaps. 3 and 4.

67. Ibid., 350–353.

68. Henry David Thoreau, *Walden* (1854) (Boston: Houghton Mifflin Co., 1957), 36; for commentaries on Thoreau's criticism, see Czitrom, *Media and the American Mind*, 11; and Neil Postman, *Technopoly: The Surrender of Culture to Technology* (New York: Alfred A. Knopf, 1992), 3, 6, 45, 48.

69. Carolyn Marvin, *When Old Technologies Were New: Thinking about Electric Communication in the Late Nineteenth Century* (New York: Oxford University Press, 1988), 102–108.

70. ICT Statistics Newslog–Cell Phone Usage Continues to Increase in the USA http://www.itu.int/ITU-D/ict/newslog/Cell+Phone+Usage+Continues+To +Increase+In+The+USA.aspx.

71. Marshall McLuhan, *Understanding Media: The Extensions of Man* (1964), Critical Edition edited by W. Terrence Gordon (Corte Madera, CA: Gingko Press Inc., 2003), 366.

72. William Howard Kenney, *Recorded Music in American Life: The Phonograph and Popular Memory, 1890–1945* (New York: Oxford University Press, 2003); and Daniel Marty, *Illustrated History of Phonographs* (Rockleigh, NJ: Marboro Books, 1990).

73. Patrick McGeehan, "Beyond Nostalgia, Vinyl Albums and Turntables Are Returning," *New York Times* (December 7, 2009), A 23.

74. Starr, *The Creation of the Media*, 216–217.

75. See Eugene Secunda and Terence P. Moran, *Selling War to America: From the Spanish American War to the Global War on Terror* (Westport, CT: Praeger Security International, 2007), 15.

76. Starr, *The Creation of the Media*, 217–218.

77. Czitrom, *Media and the American Mind*, 67.

78. Emery and Emery, *The Press in America*, 282–289.

79. Czitrom, *Media and the American Mind*, 209.

80. Ibid., 69.

81. Ibid., 71.

82. William F. Arens, *Contemporary Advertising*, 10th ed. (Boston: McGraw-Hill Irwin, 2006), 528.

83. Czitrom, *Media and the American Mind*, 72–79.

84. Arens, *Contemporary Advertising*, 530–531.

85. Starr, *The Creation of the Media*, 370–376.

86. Roper Organization Inc. *Public Perceptions of Television and Other Mass Media: A Twenty-Year Review, 1959–1978* (New York: Television Information Office, 1979), 3.

87. Ibid., 4.

88. Ibid., 9–10.

89. Ibid., 11–12

90. Ibid., 13.

91. Ibid., 14.

92. Ibid., 15–16.

93. Ibid., 20.

94. Ibid., 21.

95. Nielsenwire, "Americans Watching More TV Than Ever; Web and Mobile Video Up Too" *http://blog.nielsen.com/nielsenwire/online_mobile/americans-watching-more-tv-than-ever/*. (Accessed on May 20, 2009.)

96. Nielsenwire, "Three Screen Report: Media Consumption and Multi-tasking Continue to Increase Across TV, Internet, and Mobile" *//http://blog. nielsen.com/nielsenwire/ media_entertainment/three-screen-report-media-consumption-and-multi-tasking-continue-to-increase/*. (Accessed on September 2, 2009.)

97. For social learning theory, see Albert Bandura, *Social Learning Theory* (Englewood Cliffs, NJ: Prentice Hall, 1976) and Wilbur Schramm, Jack Lyle, and Edwin Parker, *Television in the Lives of Our Children* (Stanford, CA: Stanford University Press, 1961); for agenda setting, see Maxwell McCombs and Donald Shaw, "The Agenda Setting Function of the Mass Media," *Public Opinion Quarterly* 36, no. 2 (1972), 176–187; for cultivation effects, see Nancy Signorielli and Michael Morgan, eds., *Cultivation Analysis: New Directions in Media Effects Research* (Newbury Park, CA: Sage, 1990); for the uses and gratifications model, see Jay Blumer and Elihu Katz, *The Uses of Mass Communication* (Beverly Hills, CA: Sage, 1974).

98. Stuart Hall et al., *Policing the Crisis: Mugging, the State, and Law and Order* (London: Macmillan, 1978); and Lawrence Grossberg et al., *It's a Sin: Essays on Postmodernism, Politics and Culture* (Malibu, CA: Power Publications, 1989).

99. Janice Radway, *Reading the Romance: Women, Patrimony, and Popular Literature* (Chapel Hill, NC: University of North Carolina Press, 1984). Students of literary criticism will note in Radway's work echoes of approaches taken earlier with regard to the reading of all literature by I.A. Richards in *Practical Criticism: A Study of Literary Judgment* (New York: Harcourt, Brace and Company, 1929) and by Louise M. Rosenblatt in *Literature as Exploration* (1938) 5th ed. (New York: Modern Language Association, 1996).

100. Barnouw, *Tube of Plenty*, 299–300; for an amusing and revealing report from a journalist who accepted Minnow's challenge, see Charles Sopkin, *Seven Glorious Days, Seven Fun-Filled Nights* (New York: Simon & Schuster, 1968).

101. Postman, *Amusing Ourselves to Death*, 17.

102. Ibid., 160–163.

103. Jonathan L. Freedman, *Media Violence and Its Effect on Aggression: Assessing the Scientific Evidence* (Toronto: University of Toronto Press, 2003).

104. Kathleen Hall Jamieson, *Packaging the Presidency: A History and Criticism of Presidential Campaign Advertising*, 3rd ed. (New York: Oxford University Press, 1996), 517.

105. Austin Ranney, *Channels of Power: The Impact of Television on American Politics* (New York:

Basic Books, 1983), 5.

106. Secunda, and Moran, *Selling War to America*, 132–138.

107. Ibid., 144–179.

108. Arens, *Contemporary Advertising*, 512.

109. Ibid.

110. Postman, *Amusing Ourselves to Death*, 87.

Chapter 7

1. See Walter Wriston, *The Twilight of Sovereignty: How the Information Revolution Is Transforming Our World* (New York: Charles Scribner's Sons, 1992); and Michael Riordan and Lillian Hoddeson, *Crystal Fire: The Invention of the Transistor and The Birth of the Information Age* (New York: W. W. Norton and Company, Inc., 1997).

2. Jeremy Campbell, *Grammatical Man: Information, Entropy, Language, and Life* (New York: A Touchstone Book Published by Simon & Schuster, Inc., 1982), 35.

3. Ibid., 36–37.

4. Ibid., 38–42.

5. Ibid., 75–77.

6. Ibid., 77–80.

7. Ibid., 12.

8. Claude E. Shannon, and Warren Weaver, *The Mathematical Theory of Communication* (Urbana, IL: University of Illinois Press, 1948).

9. Norbert Wiener, *The Human Use of Human Beings: Cybernetics and Society*, 2nd rev. ed., (Garden City, NY: Doubleday Anchor Books, 1954), 15–16.

10. Ibid., 16.

11. Joseph Weizenbaum, *Computer Power and Human Reason: From Judgment to Calculation* (San Francisco: W. H. Freeman and Company, 1976), 41.

12. Christopher R. Evans, *The Making of the Micro: A History of the Computer* (New York: Van Nostrand Reinhold, 1981); Kenneth Flamm, *Creating the Computer: Government, Industry and High Technology* (Washington, DC: Brookings Institute, 1988); and Campbell, *Grammatical Man*, 30–31.

13. Ruth Schwartz Cohen, *Social History of American Technology* (New York: Oxford University Press, 1997).

14. Charles C. Mann, "The End of Moore's Law," *Technology Review* http://www.technologyreview.com/computing/12090/. (Accessed in May/June 2000)

15. Howard Gardner, *The Mind's New Science: A History of the Cognitive Revolution* (New York: Basic Books, Inc., Publishers, 1985), 143.

16. Ibid., 16–17. Turing's ideas can be found in Alan M. Turing, *The Essential Turing: Seminal Writings in Computing, Logic, Philosophy, Artificial Intelligence, and Artificial Life, plus the Secrets of Enigma* (New York: Oxford University Press, 2004). For biographies of Turing, see Alan Hodges, *Alan Turing: The Enigma* (New York: Simon & Schuster, 1983); and David Leavitt, *The Man Who Knew Too Much: Alan Turing and the Invention of the Computer* (New York: W. W. Norton and Company, Inc., 2006). For Turing's significance to culture, see Jay David Bolter, *Turing's Man: Western Culture in the Computer Age*

(Chapel Hill, NC: University of North Carolina Press, 1984).

17. Gardner, *The Mind's New Science*, 144; see Claude E. Shannon, "A Symbolic Analysis of Relay and Switching Circuits." Master's thesis, Massachusetts Institute of Technology; published in *Transactions of the American Institute of Electrical Engineering* (57, 1938), 1–11.

18. Gardner, *The Mind's New Science*, 145.

19. Ibid., 148.

20. Ibid., 149.

21. Morton Hunt, *The Universe Within: A New Science Explores the Mind* (New York: Simon & Schuster, 1982), 318. For early studies of computers and Artificial Intelligence, see Margaret Boden, *Artificial Intelligence and Natural Man* (New York: Basic Books, 1977); E. A. Feigenbaum and J. Feldman, editors, *Computers and Thought* (New York: McGraw-Hill, 1963); Tracy Kidder, *The Soul of a New Machine* (Boston: Little, Brown and Company, 1981); Pamela McCorduck, *Machines Who Think* (San Francisco, CA: W. H. Freeman, 1979); Seymour Papert, *Mindstorms: Children, Computers, and Powerful Ideas* (New York: Harper Colophon Books, 1980); Sherry Turkle, *The Second Self: Computers and the Human Spirit* (New York: Simon & Schuster, 1984); and Patrick Henry Winston, *Artificial Intelligence* (Reading, MA: Addison–Wesley, 1977).

22. Hubert Dreyfus, *What Computers Still Can't Do: A Critique of Artificial Reason* (New York: Harper & Row, Publishers, 1972; revised 1979).

23. Weizenbaum, *Computer Power and Human Reason*, 280.

24. John Searle, "Minds, Brains, and Computers," *The Behavioral and Brain Sciences* (1980, vol. 3), 417–459.

25. Gardner, *The Mind's New Science*, 180.

26. For a biography of John Bardeen, see Lillian Hoddeson and Vicki Daitch, *True Genius: The Life and Science of John Bardeen* (Washington, DC: National Academy Press, 2002). For Walter Brattain, see *Britannica Online*. http://www.britannica.com/EBchecked/topic /77971/Walter-Houser-Brattain. For William Shockley, see Michael Riordan and Lillian Hoddeson, *Crystal Fire: The Invention of the Transistor and the Birth of the Information Age* (New York: W. W. Norton and Company, 1997); and Joel N. Shurkin, *Broken Genius: The Rise and Fall of William Shockley, Creator of the Electronic Age* (New York: Palgrave Macmillan, 2006).

27. See Paul Freiberger and Michael Swaine, *Fire in the Valley: The Making of the Personal Computer* (Berkeley, CA: Osborne/McGraw–Hill, 1984). A timetable for the history of computers from the *abacus* (the Latin form of the Greek *abax* or *abakon*, meaning table or tablet), first used in Mesopotamia around 2700 B.C.E., to the latest devices introduced in 2009 is available at http://www.computerhope.com/history

28. David J. Whalen, "Communications Satellites: Making the Global Village Possible," National Aeronautics and Space Agency http://history.nasa.gov/satcomhistory.html. (Accessed on July 27, 2007)

29. Trevor N. Dupuy, *The Evolution of Weapons and Warfare* (London and New York: Jane's, 1982), 238–240.

30. John Keegan *The Second World War* (New York: Viking Penguin, 1989), 580–582; for a skeptical biography of Werner von Braun, see Wayne Biddle, *Dark Side of the Moon: Werner von Braun, The Third Reich, and the Space Race* (New York: W. W. Norton and

Company, 2009).

31. Whalen, "Communication Satellites."

32. Katie Hefner and Matthew Lyon, *Where Wizards Stay Up Late: The Origins of the Internet* (New York: Simon & Schuster, 1996), 55.

33. Alexander, R. Galloway, *Protocol: How Control Exists After Decentralization* (Cambridge and London: The MIT Press, 2004), 137–140; see also Tim Berners-Lee, *Weaving the Web: The Original Design and Ultimate Destiny of the World Wide Web by Its Inventor* (New York: Harper Collins, 1999); and Nichols Negroponte, *Being Digital* (New York: Alfred A. Knopf, 1995). For a timeline of the Internet, see Greatest Engineering Achievements of the 20th century: Internet Timeline, 2010, http:/www.greatestachievements.org/?id=3736.

34. Weizenbaum, *Computer Power and Human Reasoning*, chap. 3; see also Turkle, *The Second Self: Computers and the Human Spirit*, especially chap. 8.

35. See Gardner, *The Mind's New Science*, chap. 14.

36. http://en.wikipedia.org; see also Steven Poole, *Trigger Happy: Video Games and the Entertainment Revolution* (New York: Arcade Publishing, 2000).

37. Data taken from List of Communication Satellite Companies, Wikipedia. *http://en.wikipedia.org/wiki/*.

38. William F. Arens, *Contemporary Advertising*, 10th Edition (Boston: McGraw-Hill Irwin, 2006), 540–564.

39. Saul Hansell, "Underdog Palm Takes on Giants in Smart Phones," *New York Times* (November 16, 2009), B5.

40. Best Buy, January 10–16, 2010.

41. Danielle Belopotosky, "Something to Read; Wider Choices for E–Book Readers," *New York Times* (December 3, 2009), F1, F6; Brad Stone and Nick Bilton, "A Deluge of Devices for Reading and Surfing," *New York Times* (January 9, 2010), B1, B2.

42. See Shimon Y. Nof, ed., *Handbook of Industrial Robotics*, 2nd ed. (New York: John Wiley & Sons, 1999); and Lars Westerlund, *The Extended Arm of Man: A History of the Industrial Robot* (Stockholm: Informationsförlat, 2000).

43. See L. Fabry, "Twelve Amazing Robots That Are Revolutionizing Medicine" http://www.mritechnicianschools.org/twelve-amazing-robots-that-are-revolutionizing-medicine/.

44. See Deborah Jaffe, *The History of Toys: From Spinning Tops to Robots* (Charleston, SC: The History Press, 2006).

45. See Charles Duhigg, "The Pilotless Plane That Only Looks like Child's Play," *New York Times* (April 15, 2007); Jane Mayer, "The Predator War: What Are the Risks of the C. I. A.'s Covert Drone Program?" *The New Yorker* (October 26, 2009); Shane Armstrong, "C. I. A. Drone Use Is Set to Expand inside Pakistan," *New York Times* (December 4, 2009); and Robotics of Space and Naval Warfare Systems Center.*www.spawar.navy.mil/robots*.

46. Christopher Drew, "Military Is Awash in Data from Drones," *New York Times* (January 11, 2010), A1, A3.

47. See Michael Heim, *The Metaphysics of Virtual Reality* (New York: Oxford University Press, 1998); D. Kanecki. *The Metaphysics of Virtual Reality and Cyberspace*, Kindle Edition (Kenosha, WI: Kanecki Associates Inc., 2008); Galloway, *Protocol*, 107–110; and Margaret Morse, *Virtualities: Television, Media Art, and Cyberculture* (Bloomington and Indianapolis: Indiana University Press, 1998), chap. 7.

48. Nicholas Wade, "Chimps and Monkeys Could Talk. Why Don't They?' *New York Times* (January 12, 2010), D1, D4.

49. Thomas Shannon, *An Introduction to the World-System Perspective* (Boulder, CO: Westview Press, 1989), 29; also see Thomas L. McPhail, *Global Communication: Theories, Stakeholders, and Trends* (Boston: Allyn and Bacon, 2002), 15–21.

50. Media Statistics Mobile phones (most recent) by country. *http://www.nationmaster .com/graph/med_mob_pho-media-mobile-phones/*.

51. Facts About Cell Phones. http://www.wirefly.org/news/cell-phone-facts.php.

52. Media Statistics Television Viewing (most recent) by country. http://www .nationmaster.com/graph/med_tel_vie-media-television-viewing /graph/med_mob_pho-media-mobile-phones/.

53. Internet Usage Statistics: The Internet Big Picture; World Internet Users and Population Stats. http://www.internetworldstats.com/stats.htm.

54. http://www.radicati.com/.

55. John Markoff, "A Deluge of Data Shapes a New Era in Computing, "*New York Times* (December 15, 2009), D2; also see Tony Hey, Stewart Tansley, and Kristin Tolle, *The Fourth Paradigm: Data-Intensive Scientific Discovery*, vol. 1 (Redmond, WA: Microsoft Research, 2009).

56. McPhail, *Global Communication*, 8–21; see also Benjamin R. Barber, *Jihad vs. McWorld: How Globalism and Tribalism Are Reshaping the World* (New York: Ballantine Books/Random House, 1996).

57. Jacques Ellul, *The Technological Society* (New York: Alfred A. Knopf, 1964); *Propaganda: The Formation of Men's Attitudes* (New York: Alfred A. Knopf, 1965); and *The Technological Bluff* (Grand Rapids, MI: Eerdmans Publishing Company, 1990).

58. Neil Postman, *Technopoly: The Surrender of Culture to Technology* (New York: Alfred A. Knopf, 1992), 5.

59. Ibid., 20.

60. See James Carey, *Communication as Culture* (New York: Routledge, Inc., 1989); for an overview of theories of mass communication, see Denis McQuail, *Mass Communication Theory, An Introduction*, 6th ed. (Thousand Oaks, CA: Sage Publications, 2010).

61. Campbell, *Grammatical Man*, 255–256.

62. Davis Pogue, "Want It or Not, TV Goes 3-D," *New York Times* (January 14, 2010), B1, B12.

63. Ibid., B12; Brian Stelter and Brad Stone, "Television Begins a Push into the 3rd Dimension," *New York Times* (January 6, 2010), A1, B3.

64. Michael Cieply, "For All Its Success, Will 'Avatar' Change the Industry?" *New York Times* (January 13, 2010), C1, C5.

65. Ibid.

66. Brad Stone and Nick Bilton, "A Deluge of Devices for Reading and Surfing," *New York Times* (January 9, 2010), B1.

67. Ashlee Vance, "Using a Little Body English to Give Electronic Commands," *New York Times* (January 12, 2010), A1, A3.

68. Rik Fairlie, "Expanding Universe, Expanding Storage," *New York Times* (January 14, 2010), B10.

69. Ibid.

70. David Carr, "A Savior in the Form of a Tablet," B1, B4; Brad Stone, "Trying to Add Portability to Movie Files," B1, B6; Jenna Wortham, "Giving Your Phone More Oomph," B1, B4; Ashlee Vance "Watching TV Together, Miles Apart," B1, B6; Robert Cyran, Rob Cox, and Margaret Doyle, "The Smartphone Makes and Breaks," B2; and Claire Cain Miller, "Following Venture Capital for Signs of Tech to Come," B6, *New York Times* (January 4, 2010).

71. Pew Research Center for the People & the Press, "Current Decade Rates as Worst in 50 Years: Internet, Cell Phones Are Changes for the Better." http://peoplepress.org/report/573/

72. Miguel Helft and John Markoff, "In Rebuke of China, Focus Falls on Cybersecurity," *New York Times* (January 14, 2010), A1, A12; David E. Sanger, "After Google's Stand on China, U.S. Treads Lightly," *New York Times* (January 15, 2010), A1, A10.

73. Michael Wines, "FA–Ranging Support for Google's Rebuff to China," *New York Times* (January 15, 2010), A10.

74. Miguel Helft, "Small Effect on Revenue, and Windfall in Publicity," *New York Times* (January 15, 2010), A10.

75. Brad Wong, "Illegal Downloads Don't Pose Ethical Problems for College Students," *Seattle Post-Intelligencer Reporter* http://www.seattlepi.com/business/230702_downloads30. html. (Accessed on June 30, 2005.).

76. Jaron Lanier, *You Are Not a Gadget: A Manifesto* (New York: Alfred A. Knopf, 2010).

Chapter 8

1. Nicholas Wade, "Genome Study Provides a Census of Early Humans," *New York Times* (January 19, 2010), D4.

2. Peter A. Clayton, *Chronicle of the Pharaohs: The Reign-by-Reign Record of the Rulers and Dynasties of Ancient Egypt* (London: Thames and Hudson, 1994), 9–10.

3. Stephen W. Hawking, *A Brief History of Time: From the Big Bang to Black Holes* (New York: Bantam Books, 1988), 13.

4. Ibid., 9.

5. Jared Diamond, *Guns, Germs, and Steel: The Fates of Human Societies* (New York: W.W. Norton & Company, 2005), 450.

6. Neil Postman and Charles Weingartner, *Teaching as a Subversive Activity* (New York: Delacorte Press, 1969), 208.

7. See John Markoff, David E. Sanger, and Thom Shanker, "In Digital Combat, U.S. Finds No Easy Deterrent," *New York Times* (January 26, 2010), A1,6; and Michael Wines, "China Issues Sharp Rebuke to U.S. Calls for an Investigation on Google Attacks," *New York Times* (January 26, 2010), A6.

8. See James Henry Breasted, *The Conquest of Civilization*, (New York and London: Harper and Brothers Publishers, 1938); for all of the spells, see Raymond O. Faulkner, *Ancient Egyptian Book of the Dead*, with an Introduction by James P. Allen (New York: Barnes & Noble, 2005).

BIBLIOGRAPHY

Academy of Motion Picture Arts and Sciences. http://www.oscars.org/.

American Film Institute. http://www.afi.com/.

Arens, William F. *Contemporary Advertising*. 10th ed. Boston: McGraw-Hill Irwin, 2006.

Arlen, Michael J. *Thirty Seconds*. New York: Penguin, 1981.

Balio, Tino. *Grand Design: Hollywood as a Modern Business Enterprise, 1930–1939*. Berkeley: University of California Press, 1999.

Bandura, Albert. *Social Learning Theory*. Englewood Cliffs, NJ: Prentice Hall, 1976.

Barber, Benjamin. *Jihad vs. McWorld: How Globalization and Tribalism Are Reshaping the World*. New York: Ballantine Books/Random House, 1996.

Baring, Anne, and Jules Cashford. *The Myth of the Goddess: Evolution of an Image*. New York: Viking, 1991.

Barnouw, Erik. *Documentary: A History of the Non-Fiction Film*, 2nd rev. ed. New York: Oxford University Press, 1993.

———. *A History of Broadcasting in the United States*, vol. 1: *A Tower in Babel*. New York: Oxford University Press, 1966

———. *A History of Broadcasting in the United States*, vol. 2: *The Golden Web*. New York: Oxford University Press, 1968.

———. *A History of Broadcasting in the United States*, vol. 3: *The Image Empire*. New York: Oxford University Press, 1970.

———. *Tube of Plenty: The Evolution of American Television*. New York: Oxford University Press, 1975.

Barrow, R. H. *The Romans*. London: Penguin Books, 1958.

Belopotosky, Danielle. "Something to Read: Wider Choices for E-Book Readers." *New York Times* (December 3, 2009).

Berners-Lee, Tim. *Weaving the Web: The Original Design and Ultimate Destiny of the World Wide Web by Its Inventor*. New York: Harper Collins, 1999.

Bertillon, Alphonse, and Gallus Muller (Trans.). *Alphonse Bertillon's Instructions for Taking Descriptions for the Identification of Criminals and Others, by Means of Anthropometric Indications*. Whitefish, MT: Kessinger Publishing, LLC, 2009.

Biddle, Wayne. *Dark Side of the Moon: Werner von Braun, the Third Reich, and the Space Race*. New York: W.W. Norton and Company, 2009.

Bilby, Kenneth. *The General: David Sarnoff and the Rise of the Communication Industry*. New York: Harper & Row, 1986.

Blumer, Jay, and Elihu Katz. *The Uses of Mass Communication*. Beverly Hills, CA: Sage Publications, 1974.

Boden, Margaret. *Artificial Intelligence and Natural Man*. New York: Basic Books, 1977.

Bolter, Jay David. *Turing's Man: Western Culture in the Computer Age*. Chapel Hill, NC: University of North Carolina Press, 1984.

Boorstin, Daniel J. *The Creators: A History of Heroes of the Imagination*. New York: Random House, Inc., 1992.

———. *The Discoverers: A History of Man's Search to Know His World and Himself*. New York: Random House, Inc., 1983.

———. *The Image: A Guide to Pseudo-Events in America*. 25th Anniversary Edition. New York: Antheneum, 1987.

Boswell, James, *Life of Samuel Johnson (1791)*. New York: Penguin Classics, 2008.

Bowser, Eileen. *The Transformation of Cinema, 1907–1915*. Berkeley: University of California Press, 1994.

Brand, Gerd. *The Essential Wittgenstein*. Trans. Robert E. Innis. New York: Basic Books, 1979.

Breasted, James Henry. *The Conquest of Civilization*, New Edition. New York and London: Harper and Brothers Publishers, 1938.

———. *Egypt Through the Stereoscope: A Journey Through the Land of the Pharaohs*. New York: Camera/Graphic Press Ltd., 1978.

Brennen, Bonnie, and Hanno Hardt, eds. *Picturing the Past: Media, History, and Photography*. Champaign Urbana: University of Illinois Press, 1999.

Burroughs, Edgar Rice. *Tarzan of the Apes (1914)*. New York: Avenel Books, 1988.

Buscombe, Edward, ed. *The BFI Companion to the Western*. New York: Atheneum, 1988.

Cahill, Thomas. *How the Irish Saved Civilization: The Untold Story of Ireland's Heroic Role from the Fall of Rome to the Rise of Medieval Europe*. New York: Nan A. Talese/Doubleday, 1995.

Campbell, Jeremy. *Grammatical Man: Information, Entropy, Language, and Life*. New York: Touchtone Books, Simon and Schuster, Inc., 1982.

Campbell, Joseph. *The Hero with a Thousand Faces*. New York: Pantheon Books, 1949.

———. *The Masks of God*, vol. 1: *Primitive Mythology*. New York: Viking Press, 1959.

————. *The Masks of God*, vol. 2: *Oriental Mythology*. New York: Viking Press, 1962.

————. *The Masks of God*, vol. 3: *Occidental Mythology*. New York: Viking Press, 1964.

————. *The Masks of God*, vol. 4: *Creative Mythology*. New York: Viking Press, 1968.

Carey, James. *Communication as Culture: Essays on Media and Society*. New York: Routledge, Inc., 1989.

Carr, David. "A Savior in the Form of a Tablet." *New York Times* (January 4, 2010).

Carroll, John B., ed. *Language, Thought, and Reality: The Selected Writings of Benjamin Lee W Whorf*. Cambridge, MA: The MIT Press, 1956.

Carter, Thomas. *The Invention of Printing in China and Its Spread Westward*. New York: Ronald Press, 1953.

Cartocci, Alice, and Gloria Rosati. *Egyptian Art: Masterpieces in Painting, Sculpture and Architecture*. New York: Barnes and Noble, 2007.

Chang, Kenneth. "Gauging Age of Universe Becomes More Precise." *New York Times* (December 18, 2008).

Chapnick, Howard. *Truth Needs No Ally: Inside Photojournalism*. Columbia: University of Missouri Press, 1994.

Chomsky, Noam. *Aspects of the Theory of Syntax*. Cambridge, MA: Harvard University Press, 1965.

Cieply, Michael. "For All Its Success Will 'Avatar' Change the Industry?" *New York Times* (January 13, 2010).

Clark, Kenneth. *Civilization: A Personal View*. New York: Harper & Row, Publishers, 1969.

Clayton, Peter A. *Chronicle of the Pharaohs: The Reign-by-Reign Record of the Rulers and Dynasties of Ancient Egypt*. London: Thames and Hudson, 1994.

Cloud, Stanley, and Lynne Olson. *The Murrow Boys: Pioneers on the Front Lines of Broadcast Journalism*. Boston and New York: Houghton Mifflin Company, 1996.

Coe, Lewis. *Telegraph: A History of Morse's Invention and Its Predecessors in the United States*. Jefferson City, NC: McFarland & Company, Inc., 2003.

————. *The Telephone and Its Several Inventors*. Jefferson City, NC: McFarland & Company, Inc., 2006.

Cowan, Ruth Schwartz. *A Social History of American Technology*. New York: Oxford University Press, 1997.

Crafton, Donald. *The Talkies: American Cinema's Transition to Sound, 1926–1931*. Berkeley: University of California Press, 1994.

Crowley, David, and Paul Heyer, eds. *Communication in History: Technology, Culture, Society*. 5th ed. New York: Pearson, 2007.

Crystal, David. *The Cambridge Encyclopedia of Language*. 2nd ed. Cambridge and New York: Cambridge University Press, 1998.

————. *How Language Works: How Babies Babble, Words Change Meaning, and Languages Live or Die*. Woodstock and New York: The Overlook Press, 2005.

Cyran, Robert, Rob Cox, and Margaret Doyle. "The Smartphone Makes and Breaks." *New York Times* (January 4, 2010).

Czitrom, Daniel J. *Media and the American Mind: From Morse to McLuhan*. Chapel Hill: University of North Carolina Press, 1982.

Dewitz, Bodo von, Robert Lebeck, and Cordelia Lebeck. *Kiosk: A History of Photojournalism*. Cologne: Steidl Publications, 2002.

Diamond, Jared. *Guns, Germs, and Steel: The Fates of Human Societies*. New York: W. W. Norton and Company, Inc., 2005.

Dickens, A. G. *Reformation and Society in Sixteenth Century Europe*. New York: Harcourt Brace & World, 1966.

Douglas, Susan. *Inventing American Broadcasting 1899–1922*. Baltimore and London: The Johns Hopkins University Press, 1987.

Dreher, Carl. *Sarnoff: An American Success*. New York: Quadrangle/New York Times Book Co., 1977.

Drew, Christopher. "Military Is Awash in Data from Drones." *New York Times* (January 11, 2010).

Dreyfus, Hubert. *What Computers Still Can't Do: A Critique of Artificial Reason*. New York: Harper & Row, Publishers, 1972.

Duhigg, Charles. "The Pilotless Plane That Only Looks like Child's Play." *New York Times* (April 15, 2007).

Dupuy, Trevor N. *The Evolution of Weapons and Warfare*. London: Jane's Publishing Company, 1980.

Dyer, Gwynne. *War*. New York: Crown Publishers, 1985.

Dyson, Kenneth, "Revisiting *Culture and Anarchy*: Media Studies." In Dyson, Kenneth and Walter Homolka, eds. *Culture First! Promoting Standards in the New Media Age*. New York: Cassell, 1996.

Eisenstein, Elizabeth L. *The Printing Press as an Agent of Change*. London and New York: Cambridge University Press, 1970.

———. *The Printing Revolution in Early Modern Europe*. London and New York: Cambridge University Press, 1985.

Ellul, Jacques. *The Humiliation of the Word*. Grand Rapids, MI: William B. Eerdmans Publishing Company, 1985.

———. *Propaganda: The Formation of Men's Attitudes*. New York: A. Knopf, 1965.

———. *The Technological Bluff*. Grand Rapids, MI: Eerdmans Publishing Company, 1990.

———. *The Technological Society*. New York: Alfred A. Knopf, 1964.

Emery, Michael, and Edwin Emery. *The Press and America: An Interpretative History of the Mass Media*. 6th ed. Englewood Cliffs, NJ: Prentice Hall, 1988.

Erikson, Don. *Armstrong's Fight for FM Broadcasting*. Montgomery: University of Alabama Press, 1973.

Estren, Mark James. *A History of Underground Comics*. California: Ronin Publishers, 1992.

Evans, Christopher R. *The Making of the Micro: A History of the Computer*. New York: Van Nostrand Rheinhold, 1981.

Everson, William K. *A Pictorial History of the Western Film*. Secaucus, NJ: The Citadel Press, 1969.

Fabry, L. "Twelve Amazing Robots That Are Revolutionizing Medicine." http://www.mritech-nicianschools.org/twelve-amazing-robots-that-are-revolutionizing-medicine/.

Facts about Cell Phones. http://www.wirefly.org/news/cell-phone-facts.php/.

Fairlie, Rik. "Expanding Universe, Expanding Storage." *New York Times* (January 14, 2010).

Faulkner, Raymond O. *Ancient Egyptian Book of the Dead*. New York: Barnes & Noble, 2005.

Feigenbaum, A., and J. Feldman, eds. *Computers and Thought*. New York: McGraw-Hill, 1963.

Fenton, George N., and William K. Everson. *The Western: From Silents to the Seventies*. New York: Grossman Publishers, 1973.

Ferrill, Arthur. *The Origins of War: From the Stone Age to Alexander the Great*. London: Thames and Hudson, 1985.

Fielding, Raymond. *The American Newsreel, 1911–1967*. Norman, OK: University of Oklahoma Press, 1972.

Fischer, Claude S. *America Calling: A Social History of the Telephone to 1940*. Berkeley: University of California Press, 1992.

Flamm, Kenneth. *Creating the Computer: Government, Industry and High Technology*. Washington, DC: Brookings Institute, 1988.

Fowles, Jib. *Advertising and Popular Culture*. Thousand Oaks, CA: Sage Publications, 1977.

———. *Starstruck: Celebrity Performers and the American Public*. Washington and London: Smithsonian Institution Press, 1992.

Freedman, Jonathan L. *Media Violence and Its Effect on Aggression: Assessing the Scientific Evidence*. Toronto: University of Toronto Press, 2003.

Freiberger, Paul, and Michael Swaine. *Fire in the Valley: The Making of the Personal Computer*. Berkeley, CA: Osborne/McGraw-Hill, 1984.

Frusciano, Thomas J., and Marilyn H. Pettit. *New York University and the City: An Illustrated History*. New Brunswick, NJ: Rutgers University Press, 1997.

Galloway, Alexander R. *Protocol: How Control Exists After Decentralization*. Cambridge and London: The MIT Press, 2004.

Gardner, Howard. *The Mind's New Science: A History of the Cognitive Revolution*. New York: Basic Books, Inc., 1985.

Gaur, Albertine. *A History of Writing*. New York: Charles Scribner's Sons, 1984.

Gelb, I. J. *A Study of Writing*, Rev. ed. Chicago and London: The University of Chicago Press, 1963.

Gideon, Siegfried. *The Eternal Present: The Beginnings of Art*. New York: Bolligen Foundation, Pantheon Books, 1957.

Gies, Frances, and Joseph Gies. *Cathedral, Forge, and Waterwheel: Technology and Invention in the Middle Ages*. New York: Harper Collins Publishers, 1994.

Gimpel, Jean. *The Medieval Machine: The Industrial Revolution of the Middle Ages*. New York: Holt, Rinehart and Winston, 1976.

Goldmark, Peter. *Maverick Inventor: My Turbulent Years at CBS*. New York: Saturday Review Press, 1973.

Gombrich, E. H. "The Visual Image." *Scientific American* (September 1972).

Gomery, Douglas. *The Hollywood Studio System, 1930–1949*. New York: St. Martin's, 1986.

Gordon, John Steel. *A Thread Across the Ocean: The Heroic Story of the Transatlantic Cable*. New York: Walker & Company, 2002.

Graff, Harvey J. *Legacies of Literacy: Continuities and Contradictions in Western Culture and Society*. Bloomington: Indiana University Press, 1991.

Gravett, Paul. *Graphic Novels: Stories to Change Your Life*. United Kingdom: Aurum Press, Ltd., 2005.

Grossberg, Lawrence, Tony Fry, Ann Curthoys, and Paul Patton. *It's a Sin: Essays on Postmodernism, Politics and Culture*. Malibu, CA: Power Publications, 1989.

Grosvenor, Edwin S., and Morgan Wesson. *Alexander Graham Bell: The Life and Times of the Man Who Invented the Telephone*. New York: Harry N. Abrams Publishers, 1997.

Hall, Stuart, Chas Critcher, Tony Jefferson, John N. Clarke, and Brian Roberts. *Policing the Crisis: Mugging, the State, and Law and Order*. London: Macmillan, 1978.

Hallo, William W., and William Kelly Simpson. *The Ancient Near East, A History*. 2nd ed. New York: Harcourt Brace College Publishers, 1977.

Hansell, Saul. "Underdog Palm Takes on Giants in Smartphones." *New York Times* (November 16, 2009).

Havelock, Eric A. *Origins of Western Literacy*. Toronto: Ontario Institute for Studies in Education, 1976.

Hawking, Stephen W. *A Brief History of Time: From the Big Bang to Black Holes*. New York: Bantam Books, 1988.

Headrick, Daniel. *When Information Came of Age: Technologies of Knowledge in the Age of Reason and Revolution 1700–1850*. New York: Oxford University Press, 2000.

Hefner, Katie, and Matthew Lyon. *Where Wizards Stay Up Late: The Origins of the Internet*. New York: Simon & Schuster, 1996.

Heim, Michael. *The Metaphysics of Virtual Reality*. New York: Oxford University Press, 1998.

Helft, Miguel. "Small Effect on Revenue, and Windfall in Publicity." *New York Times* (January 15, 2010.

Helft, Miguel, and John Markoff. "In Rebuke of China, Focus Falls on Cybersecurity." *New York Times* (January 14, 2010).

Hey, Tony, Stewart Tansley, and Kristin Tolle. *The Fourth Paradigm*, vol 1: *Data-Intensive Scientific Discovery*. Redmond, WA: Microsoft Research, 2009.

Hoddeson, Lillian, and Vicki Daitch. *True Genius: The Life and Science of John Bardeen*. Washington, DC: National Academy Press, 2002.

Hodges, Andrew. *Alan Turing: The Enigma*. New York: Simon & Schuster, 1983.

Hoffman, Michael A. *Egypt Before the Pharaohs: The Prehistoric Foundations of Egyptian Civilization*. New York: Dorset Press, 1979.

Hunt, Morton. *The Universe Within: A New Science Explores the Mind*. New York: Simon & Schuster, 1982.

ICT Statistics Newslog—Cell Phone Usage Continues to Increase in the USA.

http://www.itu.int/ITUD/ict/newslog/Cell+Phone+Usage+Continues+To+
Increase+In+The+USA.aspxInternet Usage Statistics: The Internet Big Picture; World
Internet Users and Population Stats. http://www.internetworldstats.com/stats.htm

Innis, Harold A. *Empire and Communication*. Toronto: University of Toronto Press, 1971.

Isaacson, Walter. *Benjamin Franklin: An American Life*. New York: Simon & Schuster Paperback,
2004.

Israel, Paul. *Edison: A Life of Invention*. New York: John Wiley and Sons, 1998.

Jamieson, Kathleen Hall. *Packaging the Presidency: A History and Criticism of Presidential Campaign
Advertising*. 3rd ed. New York: Oxford University Press, 1996.

Joyce, James. *Ulysses*. New York: The Modern Library 1934.

Kanecki, D. *The Metaphysics of Virtual Reality and Cyberspace*. Kenosha, WI: Kanecki Associates,
Inc., 2008.

Kasson, Joy S. *Buffalo Bill's Wild West: Celebrity, Memory, and Popular Culture*. New York: Hill
and Wang, 2000.

Kaufman, Lloyd. *Perception: The World Transformed*. New York: Oxford University Press, 1979.

Keegan, John. *A History of Warfare*. New York: Alfred A. Knopf, 1993.

———. *The Second World War*. New York: Viking Penguin, 1989.

Keller, Helen. *The Story of My Life (1903)*. New York: Lancer Books, 1968.

Keller, Ulrich, "Early Photojournalism." Crowley, David, and Paul Heyer, eds. *Communication
in History: Technology, Culture, Society*. 5th ed. New York: Pearson, 2007.

Kendrick, Alexander. *Prime Time: The Life of Edward R. Murrow*. Boston: Little, Brown and
Company, 1969.

Kenney, William Howard. *Recorded Music in American Life: The Phonograph and Popular Memory,
1890–1945*. New York: Oxford University Press, 2003.

Kidder, Tracy. *The Soul of a New Machine*. Boston: Little, Brown and Company, 1981.

Knowles, Thomas W., and Joe R. Lansdale. *Wild West Show! How the Myth of the West Was Made,
from Buffalo Bill to Lonesome Dove*. New York/Avenel, NJ: Wings Books, 1994.

Kobel, Peter, and The Library of Congress. *Silent Movies: The Birth of Film and the Triumph of Movie
Culture*. New York: Little, Brown and Company, 2007.

Koszarski, Richard. *An Evening's Entertainment: The Age of the Silent Feature Film, 1915–1928*.
Berkeley: University of California Press, 1994.

Kunzle, David. *The History of the Comic Strip*, vol.1: *The Early Comic Strip: Narrative Strips and
Picture Stories in European Broadsheets from c. 1450 to 1825*. Berkeley: University of California
Press, 1973.

———. *The History of the Comic Strip*, vol. 2: *The Nineteenth Century*. Berkeley: University of
California Press, 1990.

Langston, Loup. *Photojournalism and Today's News: Creating Visual Reality*. Hoboken, NJ: Wiley-
Blackwell, 2009.

Lanier, Jaron. *You Are Not a Gadget: A Manifesto*. New York: Alfred A. Knopf, 2010.

Leakey, Richard, and Roger Lewin. *Origins Reconsidered: In Search of What Makes Us Human*. New
York: Doubleday, 1992.

Leavitt, David. *The Man Who Knew Too Much: Alan Turing and the Invention of the Computer*. New York: W.W. Norton and Company, 2006.

Leggat, Robert. A History of Photography. http://www.rleggat.com/photohistory/history/talbot.htm/ .

Leroi-Gourhan, André. *Treasures of Prehistoric Art*. New York: Henry N. Abrams, Inc., Publishers, 1966.

Lessing, Lawrence. *Man of High Fidelity: Edwin Howard Armstrong*. Rev. ed. New York: Bantam Books, 1969.

Lev, Peter. *The Fifties: Transforming the Screen, 1950–1959*. Berkeley: University of California Press, 2006.

Levi-Strauss, Claude. *Introduction to a Science of Mythology*, vol. 1: *The Raw and the Cooked*. Chicago: University of Chicago Press, 1969.

———. *Introduction to a Science of Mythology*, vol. 2: *From Honey to Ashes*. Chicago: University of Chicago Press, 1973.

———. *Introduction to a Science of Mythology*, vol. 3: *The Origin of Table Manners*. Chicago: University of Chicago Press, 1978.

———. *Introduction to a Science of Mythology*, vol. 4: *The Naked Man*. Chicago: University of Chicago Press, 1981.

———. *Structural Anthropology*, vol. 1. Chicago: University of Chicago Press, 1963.

———. *Structural Anthropology*, vol. 2. Chicago: University of Chicago Press, 1976.

Lewis, Tom. *Empire of the Air: The Men Who Made Radio*. New York: Edward Burlingame Books, An Imprint of Harper Collins Publishers, 1991.

Library of Congress. www.loc.gov/rr/mopic/.

List of Communication Satellite Companies. http://en.wikipedia.org/wiki/List_of_communication_satellite_companies.

Lloyd, Martin. *The Passport: The History of Man's Most Travelled Document*. Charleston, SC: The History Press, 2003.

Lohr, Steve. "The Lock That Says 'Pick Me'; Google Case Highlights Growing Holes in Security of Computers." *New York Times* (January 18, 2010).

Lyons, Eugene. *David Sarnoff*. New York: Harper and Row, 1966.

Mabee, Carleton. *The American Leonardo: A Life of Samuel F. B. Morse*. New York: Alfred A. Knopf, 1944.

Malinowski, Bronislaw. *Magic, Science and Religion, and Other Essays*. Garden City, NY: Doubleday Anchor Books, 1948.

Markoff, John. "A Deluge of Data Shapes a New Era in Computing." *New York Times* (December 15, 2009).

Markoff, John, David E. Sanger, and Thom Shanker. "In Digital Combat, U.S. Finds No Easy Deterrent." *New York Times* (January 26, 2010).

Marshack, Alexander. *The Roots of Civilisation: The Cognitive Beginnings of Man's First Art, Symbol and Notation*. London: Weidenfeld and Nicolson, 1992.

Marty, Daniel. *Illustrated History of Photography*. Rockleigh, NJ: Marboro Books, 1990.

Marvin, Carolyn. *When Old Technologies Were New: Thinking about Electric Communication in the*

Late Nineteenth Century. New York: Oxford University Press, 1988.

Mayer, Jane. "The Predator War: What Are the Risks of the C.I.A.'s Covert Drone Program?" *The New Yorker* (October 2009).

McCombs, Maxwell, and Donald Shaw. "The Agenda Setting Function of the Mass Media." *Public Opinion Quarterly*, vol. 36, No. 2, 1972.

McCorduck, Pamela. *Machines Who Think*. San Francisco, CA: W.H. Freeman, 1979.

McEvedy, Colin and Richard Jones, 1978. "Atlas of World Population History." New York: Facts on File.

McGeehan, Patrick. "Beyond Nostalgia, Vinyl Albums and Turntables are Returning." *New York Times* (December 7, 2009).

McLuhan, Marshall. *The Gutenberg Galaxy: The Making of Typographic Man*. Toronto: University of Toronto Press, 1962.

———. *Understanding Media: The Extensions of Man*. Corte Madera, CA: Gingko Press Inc., 2003.

McLuhan, Marshall, and Robert. K. Logan. "Alphabet, Mother of Invention." *Et Cetera* (December 1977).

McPhail, Thomas L. *Global Communication: Theories, Stakeholders, and Trends*. Boston: Allyn and Bacon, 2002.

McQuail, Denis. *Mass Communication Theory, An Introduction*. 6th ed. Thousand Oaks, CA: Sage Publications, 2010.

Media Statistics. Mobile phones (most recent) by country. http://www.nationmaster.com/graph/med_mob_pho-media-mobile-phones/.

———. Television Viewing (most recent) by country. http://www.nationmaster.com/graph/med_tel_vie-media-television-viewing/graph/med_mob_pho-media-mobile-phones/.

Miller, Claire Cain. "Following Venture Capital for Signs of Tech to Come." *New York Times* (January 4, 2010).

Monaco, Paul. *The Sixties: 1960–1969*. Berkeley: University of California Press, 2003.

Moran, James. *Printing Presses: History and Development from the Fifteenth Century to Modern Times*. Berkeley and Los Angeles: University of California Press, 1973.

Morse, Margaret. *Virtualities: Television, Media Art, and Cyberculture*. Bloomington and Indianapolis: Indiana University Press, 1998.

Mumford, Lewis, *Technics and Civilization*. New York: Harcourt, Brace and Company, 1934.

Musser, Charles. *The Emergence of Cinema: The American Screen to 1907*. Berkeley: University of California Press, 1994.

Negroponte, Nicholas. *Being Digital*. New York: Alfred A. Knopf, 1995.

Newhall, Beaumont. *The History of Photography: From 1839 to the Present Day*. Rev. ed. New York: Bullfinch, 1982.

Nielsenwire. "Americans Watching More TV Than Ever; Web and Mobile Video Up Too." http:/blog.nielsen.com/nielsenwire/online_mobile/americans-watching-more-tv-than-ever/. (Accessed on May 20, 2009.)

———. "Three Screen Report: Media Consumption and Multi-tasking Continue to Increase Across TV, Internet, and Mobile." http:/blog.nielsen.com/nielsenwire/media_entertainment-

/three-screen-report-media-consumption-and-multi-tasking-continue-to-increase/. (Accessed on September 2, 2009.)

Noble, David F. *America By Design: Science, Technology, and the Rise of Corporate Capitalism*. New York: Alfred A. Knopf, 1997.

Nof, Shimon Y., ed. *Handbook of Industrial Robotics*. 2nd ed. New York: John Wiley & Sons, 1999.

Nunberg, Geoffrey, ed. *The Future of the Book*. Berkeley/Los Angeles: University of California Press, 1996.

Nyberg, Amy Kiste. *Seal of Approval: The History of the Comics Code*. Jackson: University Press of Mississippi. 1988.

Oates, Joan. *Babylon*. Rev. ed. London and New York: Thames and Hudson, 1986.

O'Connell, Robert. *Of Arms and Men: A History of War, Weapons, and Aggression*. New York and Oxford: Oxford University Press, 1989.

Ong, Walter J. *Orality and Literacy: The Technologizing of the Word*. London and New York: Methuen, 1982.

Papert, Seymour. *Mindstorms: Children, Computers, and Powerful Ideas*. New York: Harper Colophon Books, 1980.

Perkinson, Henry J. *How Things Got Better: Speech, Writing, Printing, and Cultural Change*. Westport, CT: Bergin and Garvey, 1995.

Peters, John Durham. *Speaking into the Air: A History of the Idea of Communication*. Chicago and London: University of Chicago Press, 1999.

Pew Research Center for the People & The Press. "Current Decade Rates as Worst in 50 Years: Internet, Cell Phones Are Changes for the Better." http://people-press.org/report/573/.

Pfeiffer, John. *The Creative Explosion: An Inquiry into the Origins of Art and Religion*. New York: Harper and Row, Publishers, 1982.

———. "Was Europe's Fabulous Cave Art the Start of the Information Age?" *Smithsonian* (April 1983).

Pinker, Steven. *The Language Instinct: How the Mind Creates Language*. New York: William Morrison and Company, Inc., 1994.

Plato. *Phaedrus*. Trans. James H. Nichols Jr. Ithaca and London: Cornell University Press, 1998.

Pogue, David. "Want It or Not, TV Goes 3-D." *New York Times* (January 14, 2010).

Poole, Steven. *Trigger Happy: Videogames and the Entertainment Revolution*. New York: Arcade Publishing, 2000.

Pope, Daniel. *The Making of Modern Advertising*. New York: Basic Books, 1983.

Popper, Karl. *The Open Society and Its Enemies*, vol. 1: *The Spell of Plato*. Princeton, NJ: Princeton University Press, 1971.

———. *The Open Society and Its Enemies*, vol. 2: *The High Tide of Prophecy: Hegel, Marx and the Aftermath*. Princeton, NJ: Princeton University Press, 1971.

Population Reference Bureau. http://www.prb.org/Publications/Datasheets/2009/2009wpds.aspx

Postman, Neil. *Amusing Ourselves to Death: Public Discourse in the Age of Show Business*. Elisabeth Sifton Books, Viking, 1985.

———. *Technopoly: The Surrender of Culture to Technology*. New York: Alfred A. Knopf, 1992.

Postman, Neil, and Charles Weingartner. *Teaching as a Subversive Activity.* New York: Delacorte Press, 1969.

Radway, Janice. *Reading the Romance: Women, Patrimony, and Popular Literature.* Chapel Hill, NC: University of North Carolina Press, 1984.

Ranney, Austin. *Channels of Power: The Impact of Television on American Politics.* New York: Basic Books, 1983.

Reidelbach, Maria. *Completely Mad: A History of the Comic Book and Magazine.* New York: Little, Brown, 1991

Rhodes, Henry T. F. *Alphonse Bertillon, Father of Scientific Detection.* Bel Air, CA: George C. Harrap, 1957.

Rhodes, Shirrel. *A Complete History of American Comic Books.* New York: Peter Lang, 2008.

Richards, I. A. *Practical Criticism: A Study of Literary Judgment.* New York: Harcourt, Brace and Company, 1929.

Riordan, Michael, and Lillian Hoddeson. *Crystal Fire: The Invention of the Transistor and the Birth of the Information Age.* New York: W.W. Norton and Company, 1997.

Roaf, Michael. *Cultural Atlas of Mesopotamia and the Ancient Near East.* Oxfordshire, England: Andromeda Books, 1996.

Robinson, Andrew. *The Story of Writing: Alphabets, Hieroglyphs and Pictograms.* London: Thames and Hudson, Ltd., 1995.

Robotics of Space and Naval Warfare Systems Center. http://www.spawar.navy.mil/robots/.

Roper Organization, Inc. *Public Perceptions of Television and Other Mass Media: A Twenty-Year Review, 1959–1978.* New York: Television Information Office, 1979.

Rosenblatt, Louise M. *Literature as Exploration.* 5th ed. New York: Modern Language Association, 1996.

Sanger, David E. "After Google's Stand on China, U.S. Treads Lightly." *New York Times* (January 15, 2010).

Schatz, Thomas. *Boom and Bust: American Cinema in the 1940s.* Berkeley: University of California Press, 1999.

Schmandt-Besserat, Denise. *Before Writing: From Counting to Cuneiform.* Austin: University of Texas Press, 1992.

Schramm, Wilbur, Jack Lyle, and Edwin Parker. *Television in the Lives of Our Children.* Stanford, CA: Stanford University Press, 1961.

Schudson, Michael. *Advertising, The Uneasy Persuasion: Its Dubious Impact on American Society.* New York: Basic Books, 1984.

Searle, John. "Minds, Brains, and Computers." *The Behavioral and Brain Sciences* 3. Cambridge, UK: Cambridge University Press, 1980

Secunda, Eugene, and Terence P. Moran *Selling War to America: From the Spanish American War to the Global War on Terror.* Westport, CT and London: Praeger Security International, 2007.

Shannon, Claude E. "A Mathematical Theory of Information." *Bell System Technical Journal* 27 (1948).

———. "A Symbolic Analysis of Relay and Switching Circuits." *Transactions of the American*

Institute of Electrical Engineering 57 (1938).

Shannon, Claude E., and Warren Weaver. *The Mathematical Theory of Communication*. Urbana, IL: University of Illinois Press, 1948.

Shannon, Thomas. *An Introduction to the World-System Perspective*. Boulder, CO: Westview Press, 1989.

Shurkin, Joel N. *Broken Genius: The Rise and Fall of William Shockley, Creator of the Electronic Age*. New York: Palgrave Macmillan, 2006.

Signorielli, Nancy, and Michael Morgan. *Cultivation Analysis: New Directions in Media Effects Research*. Newbury Park, CA: Sage Publications, 1990.

Silverman, Kenneth. *Lightning Man: The Accursed Life of Samuel F. B. Morse*. New York: Alfred A. Knopf, 2003.

Simpson, William Kelly. "The Gift of Writing." *Ancient Egypt: Discovering Its Splendors*. Washington, DC: National Geographic Society, 1978.

Sklar, Robert. *Movie-Made America: A Cultural History of American Movies*. New York: Random House, 1975.

Slotkin, Richard. *Gunfighter Nation: The Myth of the Frontier in Twentieth Century America*. New York: Atheneum, 1992.

Sopkin, Charles. *Seven Glorious Days, Seven Fun-Filled Nights*. New York: Simon & Schuster, 1968

Sperber, A. M. *Murrow: His Life and Times*. New York: Freundlich Books, 1986.

Standage, Tom. *The Victorian Internet: The Remarkable Story of the Telegraph and the Nineteenth Century's On-Line Pioneers*. New York: Walker and Company, 1999.

Starr, Paul. *The Creation of the Media: Political Origins of Modern Communications*. New York: Basic Books, 2004.

Steinberg, S. H. New Edition Revised by John Trevitt. *Five Hundred Years of Printing*. The British Library and Oak Knoll Press, 2001.

Steiner, George. *After Babel: Aspects of Language and Translation*. New York and London: Oxford University Press, 1975.

Stelter, Brian, and Brad Stone. "Television Begins a Push into the 3rd Dimension." *New York Times* (January 6, 2010).

Stone, Brad. "Trying to Add Portability to Movie Files." *New York Times* (January 4, 2010).

Stone, Brad, and Nick Bilton. "A Deluge of Devices for Reading and Surfing." *New York Times* (January 9, 2010).

Szarkowski, John. *Photography Until Now*. New York: Museum of Modern Art, 1960.

———. *Mirrors and Windows: American Photography Since 1960*. New York: Museum of Modern Art, 1984.

Taylor, Philip M. *Munitions of the Mind: War Propaganda from the Ancient World to the Nuclear Age*. Wellingborough, UK: Patrick Stephens Ltd., 1990.

Teale, Edwin. "America's Five Favorite Hobbies." http://blog.modernmechanix.com/2008/11/04-/americas-five-favorite-hobbies/.

Thomlinson, Ralph. *Demographic Problems: Controversy over Population Control*. 2nd ed. Encino, CA: Dickenson Publishing Company, 1975.

Thoreau, Henry David. *Walden*. Boston: Houghton Mifflin Co., 1957.

Thurman, Judith. "First Impressions: What Does the World's Oldest Art Say About Us?" *New Yorker* (June 23, 2008).

Trent, Paul, and Richard Lawton. *The Image-Makers: Sixty Years of Hollywood Glamour*. New York: Crescent Books, 1972.

Trigger, B. G., B. J., Kemp, D. O'Connor, and A. B. Lloyd. *Ancient Egypt: A Social History*. Cambridge: Cambridge University Press, 1983.

Tuchman, Barbara. *A Distant Mirror: The Calamitous 14th Century*. New York: Ballantine Books, 1978.

Turing, Alan. *The Essential Turing: Seminal Writings in Computing, Logic, Philosophy, Artificial Life, plus the Secrets of Enigma*. New York: Oxford University Press, 2004.

Turkle, Sherry. *The Second Self: Computers and the Human Spirit*. New York: Simon & Schuster, 1984.

Turner Classic Movies. *Leading Ladies: The 50 Most Unforgettable Actresses of the Studio Era*. San Francisco, CA: Chronicle Books, 2006.

———. *Leading Men: The 50 Most Unforgettable Actors of the Studio Era*. San Francisco, CA: Chronicle Books, 2006.

Turney-High, Harry Holbert. *Primitive War: Its Practice and Concepts*. 2nd ed. Columbia, SC: University of South Carolina Press, 1971.

Tyerman, Christopher. *God's War: A New History of the Crusades*. Cambridge, MA: The Belknap Press of Harvard University, 2006.

Tylor, Edward Burnett. *Primitive Culture*. New York: Henry Holt and Co., 1889.

UNESCO. *World Illiteracy at Mid-Century*. UNESCO Statistical Division, 1957.

Vance, Ashlee. "Using a Little Body English to Give Electronic Commands." *New York Times* (January 12, 2010)

———. "Watching TV Together, Miles Apart." *New York Times* (January 4, 2010).

Wade, Nicholas. "Chimps and Monkeys Could Talk. Why Don't They?" *New York Times* (January 12, 2010).

———. "Genome Study Provides a Census of Early Humans." *New York Times* (January 19, 2010).

———. "Neanderthal Genome Hints at Language Potential, but Little Human Interbreeding." *New York Times* (February 13, 2009).

Warren, Louis S. *Buffalo Bill's America: William Cody and the Wild West Show*. New York: Alfred A. Knopf, 2005.

Weiner, Stephen, and Chris Couch, ed. *The Rise of the Graphic Novel: Faster Than a Speeding Bullet*. New York: Nantier-Beall-Minoustching Publishing, 2004.

Weizenbaum, Joseph. *Computer Power and Human Reason: From Judgment to Calculation*. San Francisco, CA: W.H. Freeman and Company, 1976.

Westerlund, Lars. *The Extended Arm of Man: A History of the Industrial Robot*. Stockholm: Informationsforlaget, 2000.

Whalen, David J. "Communications Satellites: Making the Global Village Possible." National

Aeronautics and Space Agency. http://history.nasa.gov/satcomhistory.html. (Accessed on July 27, 2007)

White, Lynn, Jr. *Medieval Technology and Social Change*. London: Oxford University Press, 1962.

White, Randall. *Prehistoric Art: The Symbolic Journey of Humankind*. New York: Harry N. Abrams, Inc., 2003.

Wiener, Norbert. *Cybernetics: or Control and Communication in the Animal and the Machine*. Cambridge, MA: MIT Press, 1948.

———. *The Human Use of Human Beings: Cybernetics and Society*, 2nd rev. ed. Garden City, NY: Doubleday Anchor Books, 1954.

———. *The Human Use of Human Beings: Cybernetics and Society*. New York: Avon Books, 1967.

Wile, Frederic. *Emile Berliner: Maker of the Microphone*. Indianapolis, IN: Bobbs-Merrill, 1974.

Wilford, John Noble. "Flutes Offer Clues to Stone-Age Music." *New York Times* (June 25, 2009).

———. *The Mapmakers: the Story of the Great Pioneers in Cryptography from Antiquity to the Space Age*. New York: Vintage Books, 1982.

Wilson, John. *The Culture of Ancient Egypt*. Chicago: University of Chicago Press, 1971.

Wines, Michael. "China Issues Sharp Rebuke to U.S. Calls for an Investigation on Google Attacks." *New York Times* (January 26, 2010.)

———. "Far-Ranging Support for Google's Rebuff to China." *New York Times* (January 15, 2010).

Winston, Patrick Henry. *Artificial Intelligence*. Reading, MA: Addison-Wesley, 1977.

Wittgenstein, Ludwig. *Philosophical Investigations*. London: Basil and Blackwell, 1953.

Wong, Brad. "Illegal Downloads Don't Pose Ethical Problems for College Students." http://www.seattlepi.com/business/230702_downloads30.html. (Accessed on June 30, 2005.)

Woolley, Sir Leonard. *Ur of the Chaldees*. London: The Herbert Press, 1982.

Wortham, Jenna. "Giving Your Phone More Oomph." *New York Times* (January 4, 2010).

Wright, Bradford W. *Comic Book Nation: The Transformation of Youth Culture in America*. Baltimore: The Johns Hopkins University Press, 2003.

Wriston, Walter. *The Twilight of Sovereignty: How the Information Revolution Is Transforming Our World*. New York: Charles Scribner's Sons, 1992.

Yost, Nellie Snyder. *Buffalo Bill: His Family, Friends, Fame, Failures, and Fortunes*. Chicago: Sage Books/The Swallow Press, Inc., 1979.

INDEX